ABSTRACTION

IN RUSSIA

XX CENTURY

in two volumes

volume one

PALACE EDITIONS

Alexander ABAZA

Alexander AGABEKOV

Yury ALBERT

Kirill ALEXANDROV

Nathan ALTMAN

Vladimir ANDREYENKOV

Victor ANDREYEV

Ruben APRESIAN

Valentina APUKHTINA

Maxim ARKHANGELSKY

Varvara ARMAND

Tatyana BADANINA

Boris BAK

Valentina BAKHCHEVAN

Alexander BANDZELADZE

Yevgeny BARSKY

Andrei BASANETS

Garif BASYROV

Alexander BATURIN

Roman BAZAROV

Irina BAZHENOVA

Anatoly BELKIN

Vadim BELOUSOV

BELOZEMTSEVA

Ely BELYUTIN

Igor BEREZOVSKY

Svetlana BESKINSKAYA

Boris BICH

Alexander BOGOMAZOV

Gleb BOGOMOLOV

Sergei BORDACHEV

Leonid BORISOV

Alexander BOYADZHAN

Zhanna BROVINA

Lev BRUNI

Valery CHERKASOV

Svyatoslav CHERNOBAI

Irina CHERNOVA-DYATKINA

Mikhail CHERNYSHOV

Andrei CHEZHIN

Alexei CHISTYAKOV

DANILOV

Victor DANILOV

Djaid DJEMAL

Yevgeny DOBROVINSKY

Alexander DUBOVIK

Vladimir DUKHOVLINOV

Evgeni DYBSKY

Yury DYSHLENKO

Andrei DYUKOV

Giya EDZGVERADZE

Valery EISENBERG

Genrikh ELINSON

Maria ELKONINA

Natalia ELKONINA

Boris ENDER

Maria ENDER

ENVER

Nikolai ESTES

Alexandra EXTER

Tatyana FAIDYSH

Moisei FEIGIN

Pavel FILONOV

Alexander FONIN

Nikolai FYODOROV

Pyotr GALADZHEV

Anatoly GALBRAIKH

Alexei GAREV

Nikita GASHUNIN

Valentin GERASIMENKO

Yury GOBANOV

Adolf GOLDMAN

Clara GOLITSYNA

Kirill GOLUBENKOV

Natalia GONCHAROVA

Yevgeny GOR

Alexei GOSTINTSEV

Ivan GOVORKOV

Vladimir GOVORKOV

Elizaveta GRACHEVA

Grisha GRIGORIAN

Vadim GRIGORIEV-BASHUN

Inna GRINCHEL

Elena GUBANOVA

Semyon GULYAKO

Dmitry GUTOV

Vladimir IGUMNOV

Tatyana IGUMNOVA

Francisco INFANTE-ARANA

Maxim IVANOV

Karl JOHANSON

Boris KALAUSHIN

Victor KALININ

Alexei KAMENSKY

Wassily KANDINSKY

Mikhail KARASIK

Marina KASTALSKAYA

Mikhail KAZAKOV

Victor KAZARIN

Latif KAZBEKOV

Elena KELLER

Pavel KERESTEI

Andrei KHARSHAK

Alexander KHLEBNIKOV

Nina KHLEBNIKOVA

Lydia KIRILLOVA

Natalia KIRSANOVA

Alyona KIRTSOVA

Anatoly KISELEV

Alexander KITAEV

Valery KLEVEROV

Ivan KLIUN

Vladimir KLYUCHNIKOV

Vyacheslav KOLEICHUK

Valery KOLOTVIN

Marina KOLOTVINA

Zenon KOMISSARENKO

Igor KONAKOV

Pavel KONDRATIEV

Vladimir KOPTEV

Mikhail KOPYLKOV

Natalia KORNILOVA

Oleg KOTELNIKOV

Alexander KOZHIN

Yury KRASNOPEVTSEV

Andrei KRASULIN

Lev KROPIVNITSKY

Yevgeny KROPIVNITSKY

Mikhail KRUNOV

Yury KRYAKVIN

Alexander KRYUKOV

Vitaly KUBASOV

Oleg KUDRYASHOV

Mikhail KULAKOV

Igor KUPRYASHIN

Lyudmila KUTSENKO

Leonid LAMM

Lev LANETS

Oleg LANG

Nikolai LAPSHIN

Mikhail LARIONOV

Luka LASAREISHVILI

Levon LAZAREV

Mikhail LAZUKHIN

Victor LAZUKHIN

Vladimir LEBEDEV

Alexander LEONOV

Anna LEPORSKAYA

Bella LEVIKOVA

Valentin LEVITIN

Kirill LILBOK

Dmitry LION

Alexander LIVANOV

Xenia LIVCHAK

Victor LUKIN

Valery LUKKA

Kazimir MALEVICH

Paul MANSOUROFF

Boris MARKOVNIKOV

Vladimir MARTYNOV

Lydia MASTERKOVA

Mikhail MATIUSHIN

Nikolai MATRENIN

Alla MAYEVA

Konstantin MEDUNETSKY

Mikhail MEDVEDEV

Boris MESSERER

Georgy MGALOBLISHVILI

Boris MIKHAILOV

Vyacheslav MIKHAILOV

Yevgeny MIKHNOV-VOITENKO

Artyom MIKOIAN

Alexandra MITLYANSKAYA

Pyotr MITURICH

Grigory MOLCHANOV

Mikhail MOLOCHNIKOV

Nikolai NASEDKIN

Vladimir NASEDKIN

Maria NAZAREVSKAYA

Svetlana NEKRASOVA

Vladimir NEMUKHIN

Georgy NEVSKY

Yury NIKIFOROV

Victor NIKOLAEV

Alexander NOSOV

Lev NUSSBERG

Ivan OLASYUK

Vladimir OPARA

Igor ORLOV

Valery ORLOV

Yevgeny ORLOV

Kharlampy OROSHAKOV

Vadim OVCHINNIKOV

Victor PALMOV

Alexander PANKIN

Tatyana PANOVA

Mikhail PAVLENIN

Leonid PELEKH

Vera PESTEL

Andrei PIVOVAROV

Dmitry PLAVINSKY

Alexander PODOBED

Lev PODOLSKY

Michael POLADJAN

Zhirair POLADIAN

Alexander PONOMAREV

Victor POPOV

Lyubov POPOVA

Marina POPOVA

Olga POTAPOVA

Jean POUGNY

Valentina POVAROVA

Lev POVZNER

Andrei POZDEYEV

Elena PREIS

Oleg PROKOFIEV

Andrei PROLETTSKY

Kirill PROZOROVSKY

Georgy PUZENKOV

Fyodor RABICHEV

Dmitry RAKITIN

Yury RAKOVSKY

Maria RAUBE-GORCHILINA

Lia REIZER

Alexander RODCHENKO

Alexei ROSSAL-VORONOV

Mikhail ROZANOV

Olga ROZANOVA

Yevgeny RUKHIN

Nikolai SAZHIN

Alexander SCHERBININ

Vladimir SEMYONOV

Sergei SENKIN

Elena SEREBRYAKOVA

Sergei SERGEYEV

Valery SHABLOVSKY

Olga SHAGINA

Roland SHALAMBERIDZE

Boris SHAPOVALOV

Sergei SHEFF

Igor SHELKOVSKY

Vladimir SHENGELAYA

Victor SHEVCHENKO

Yury SHEVCHIK

Vyacheslav SHEVELENKO

Olga SHOROKHOVA

Vera SHUBNIKOVA

Lyudmila SHUSHKANOVA

Sergei SHUTOV

Mikhail SHVARTSMAN

Konstantin SIMUN

Alexander SITNIKOV

Vladimir SITNIKOV

Natalia SITNIKOVA

Yury SKOPOV

Boris SMIRNOV-RUSETSKY

Tamara SMIRNOVA

Natalia SMOLYANSKAYA

Igor SNEGUR

Antonina SOFRONOVA

Sergei SOKOLOV

Leonid SOKOV

Marlen SPINDLER

Eduard STEINBERG

Vladimir STENBERG

Varvara STEPANOVA

Vladimir STERLIGOV

Vitaly STESIN

Władysław STRZEMIŃSKI

Nikolai SUETIN

Alexander SUVOROV

Andrei SYRBU

Vladimir TATLIN

Igor TEREKHOV

TEREKLA

Yury TILMAN

Nikolai TIOPLY

Leonid TKACHENKO

Olga TOBRELUTS

Dmitry TOPOLSKY

Inna TOPOLSKY

Yury TRIZNA

Nikolai TSVETKOV

Svetlana TSVIRKUNOVA

Yura TUMASIAN

Boris TURETSKY

Alexei TYAPUSHKIN

Nadezhda UDALTSOVA

Victor UMNOV

Aslangeri UYANAYEV

Yevgeny VAKHTANGOV

VALRAN

Galina VANSHENKINA

Yury VASCHENKO

Anatoly VASILYEV

Yury VASILYEV

Pavel VESCHEV

Elena VESCHEVA

Vladimir VIDERMAN

Yakov VINKOVETSKY

Andrei VOLKOV

Valery VOLKOV

Vladimir VOLKOV

Marta VOLKOVA

Nikolai VOLOGZHANIN

Felix VOLOSENKOV

Alexei VOROBYEVSKY

Diana VOUBA

Igor VULOKH

WOKUD

Natalia WRANGEL

Vladimir YAKOBCHUK

Oleg YAKOVLEV

Vladimir YAKOVLEV

Vasily YAKUPOV

Vladimir YANKILEVSKY

Valery YASHIGIN

Andrei YEFIMOV

Vasily YERMILOV

Yevrosinia YERMILOVA-PLATOVA

Yevgeny YESAULENKO

Nikolai YEVGRAFOV

Alexander YULIKOV

Valery YURLOV

Vladimir ZAGOROV

Alexander ZAGOSKIN

Alexander ZAITSEV

Lyudmila ZARIPOVA

Natalia ZAROVNAYA

Ilya ZAUTASHVILI

Kirill ZDANEVICH

Natalia ZHILINA

Oleg ZHOGIN

Vladimir ZHUKOV

Yury ZLOTNIKOV

ABSTRACTION IN RUSSIA XX CENTURY

volume one

PALACE EDITIONS

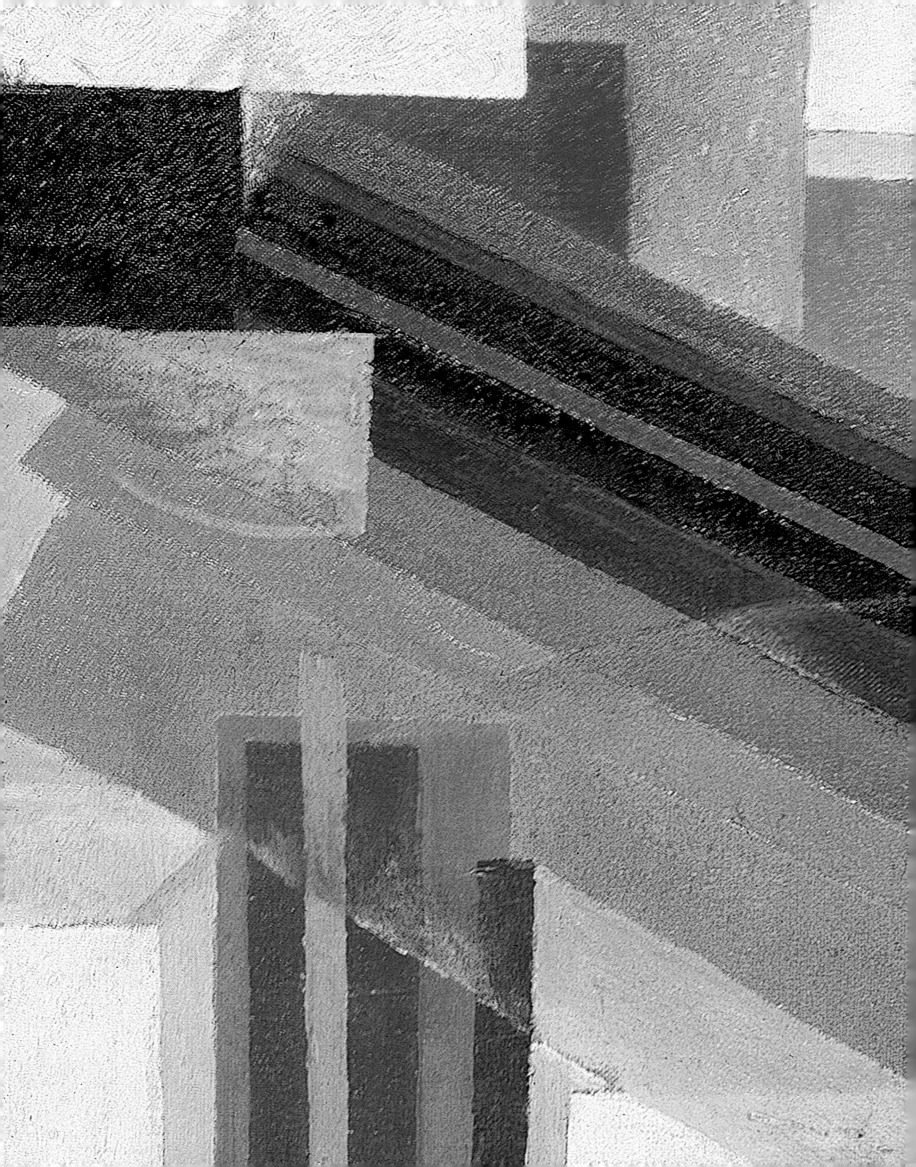

CONTENTS

WITHDRAWN

Sergei Senkin. Suprematism. 1922 (detail)

**The State Russian Museum thanks
the following individuals and institutions
for contributing to the project:**

Moscow

V. A. Rodionov (director of the Tretyakov Gallery);
L. I. Iovleva, A. I. Morozov (deputy directors of the Tretyakov
Gallery); *N. A. Alexandrova, Y. V. Bruk, Y. S. Churakova,
T. S. Gorodkova, L. A. Kashuk, Y. A. Khomyakova,
N. V. Koblyakova, I. V. Lebedeva, L. V. Marts, A. I. Morozov,
A. A. Romanova, T. V. Turtanova* and *A. V. Yerofeyev*
(curators of the Tretyakov Gallery)

N. N. Shinayev, D. Y. Yefimov and *A. I. Gerasimov* (Art-Line Service)

Marina Loshak, Moscow Centre of the Arts

Olga Sviblova, Moscow House of Photography Museum

Aidan Salakhova, Aidan Gallery

Tatyana Chistyakova, Marat Gelman Gallery

Yevgeny Nutovich (Yevgeny Nutovich collection)

Tatyana and *Natalia Kolodzei* (Tatyana and Natalia Kolodzei
collection)

Svetlana Nekrasova (Svetlana Nekrasova collection)

Sergei Popov (Sergei Popov collection)

Vyacheslav Sukharov (Vyacheslav Sukharov collection)

Iraida Shvartsman

Albert Rusanov

Lyudmila Safronova

Leonid Talochkin

Vasilisa Prozorovskaya-Remennikova

Jane Vorhees Zimmerli Art Museum, New Jersey, USA

Galerie Gmurzynska, Cologne, Germany

Judith Rothschild Foundation, New York, USA

ABA Gallery, New York

Kenda and *Jacob Bar-Gera* (Kenda and Jacob Bar-Gera collection,
Germany)

Vladimir Tsarenkov (Vladimir Tsarenkov collection, Paris, France)

Galina and *Maxim Fedorovsky* (Galina and Maxim Fedorovsky
collection, Berlin, Germany)

Ruwim Besser (Ruwim Besser collection, Ratingen, Germany)

St Petersburg

*P. V. Rosso, M. V. Pokhvalinskaya, T. A. Mikhailik,
Y. N. Solovyov, A. P. Storozhenko, A. B. Toloknov,
N. P. Smirnov, V. V. Solovyov, V. I. Belov,
V. M. Tamarov, N. A. Fedotov* and *V. V. Yakovlev*
(Hasenkamp – SRM SP)

City Sculpture Museum

Anna Akhmatova Museum

St Petersburg Creative Union of Artists

Borei Centre of Creativity

Gallery D-137

Marina Gisich Gallery

New World of Art Exhibition Hall

NA.I.V. Gallery

Severnaya Stolitsa Business Centre

Navicula Artis Gallery

Museum of Nonconformist Art

Nevograf Graphic Exhibition Centre

SPAS Gallery

Valencia Art Centre Gallery

Forum Gallery

Mitki-VKhUTEMAS Gallery

Selskaya Zhizn Gallery and Art Journal

Sigmund Freud Museum of Dreams

East European Institute of Psychoanalisis

Gallery On Obvodny

Neptune International Business Centre

Art-Gavan Gallery

Art-Collegia Gallery

Guild of Masters Gallery

Delta Gallery of Modern Art

Boris Kozlov (Boris Kozlov collection)

**The State Russian Museum thanks all artists for
contributing works to the exhibition and catalogue
and for donating works to its collection.**

INTRODUCTION

yevgenia PETROVA
St Petersburg, Russia

Abstraction has long been acknowledged to be one of the key concepts in twentieth-century art. The artists of the Russian avant-garde, above all Wassily Kandinsky and Kazimir Malevich, made a leading contribution to the birth and establishment of this exciting phenomenon. Kandinsky painted his first abstract picture in 1911. In 1913, Malevich formulated the necessity of going beyond the bounds of nothing and starting all over again, with the simple form of the square.

Over a period of little more than ten years, Russia produced a dazzling array of artists working in various non-objective forms. Besides Kandinsky and Malevich, there were also Pavel Filonov, Paul Mansouroff, Lyubov Popova, Alexandra Exter, Olga Rozanova and Alexander Rodchenko – artists now internationally known and celebrated primarily for their contributions to abstract art.

Despite a long interval during the Stalin years, abstraction continued to exist and develop in Russia. Although this movement gave world culture many of its most outstanding names, it remains virtually unknown both outside Russia and in the homeland of one of the leading movements in twentieth-century art.

Dedicated to abstraction in Russia throughout the past century, this publication is the first attempt to bring together the wide range of materials reflecting the various paths trodden by artists working in non-objective forms in the twentieth century. We would, of course, be deluding ourselves if we thought that this book covers all the names, phenomena and works related to abstraction. This album is based largely on the classical avant-garde now in the State Russian Museum in St Petersburg, home to the world's most representative collection of the art of this period. Works created in the second half of the twentieth century have also been contributed by the Tretyakov Gallery, several private collectors and many of the artists themselves (mostly inhabitants of Moscow and St Petersburg). Many works from provincial towns have, unfortunately, not been included in the book or the exhibition of the same name. The same applies to many artists of Russian extraction, such renowned masters as Serge Poliakoff, André Lanskoy and Serge Charchoun, who are now remembered primarily as representatives of those countries in which they made their second homelands.

This album will naturally be followed by other publications supplementing and verifying the information contained within this book. Our aim is to acquaint Russian and foreign connoisseurs with a form of art that is generally little known and often misunderstood.

Many organisations and people have assisted us in this ambitious and arduous task. To every one of them, we would like to extend our heartfelt thanks.

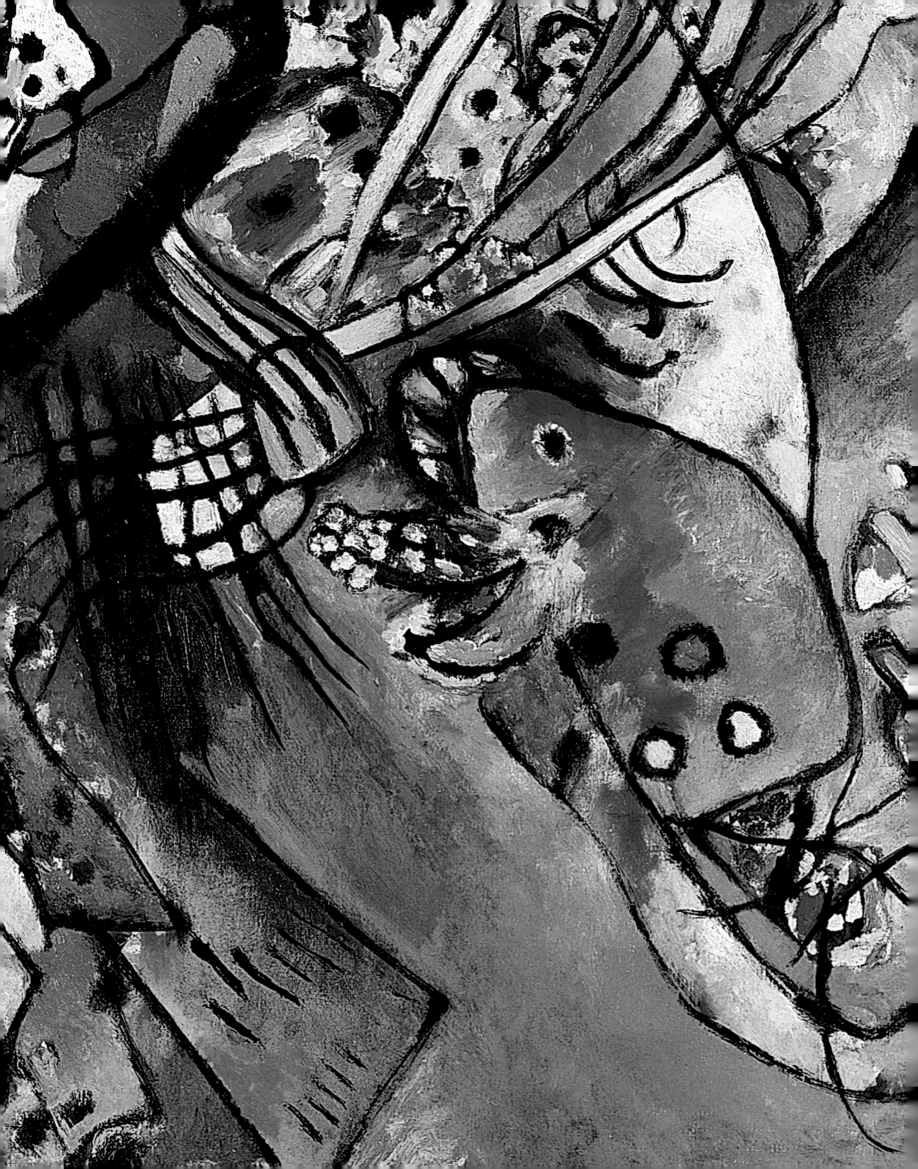

NON-OBJECTIVITY IN EARLY-TWENTIETH-CENTURY RUSSIAN ART

olga SHIKHIREVA
St Petersburg, Russia

The early twentieth century is generally regarded as being a time of exciting discoveries and great delusions. This short period, embracing almost two decades, witnessed the collapse of old values and the birth of new aesthetic and political outlooks. It was the end of the old and the beginning of a new era. The world was in turmoil, and this was reflected in fine art, leading to the diverse experiments that gave birth to the various forms of avant-garde art.

The birth of non-objective art is usually related to 1910, when Russian artist Wassily Kandinsky painted his first abstract composition. Although there were preconditions for the exit into non-objectivity in the art of many European nations, the first to do so was Russia, a country which had previously seemed culturally backward.

In the opinion of the late expert on the Russian avant-garde, Yevgeny Kovtun, Western art historians do not always fully understand the difference between abstractionism and non-objectivity. They therefore refer to the leading masters of the Russian avant-garde as abstractionists, without any clear foundations.[1]

The results of the creative experiments of the non-objectivist and the abstractionist are, at first sight, strikingly similar. The superficial nature of this similarity becomes clear, however, when one compares the works of two contemporaries – Kazimir Malevich and Piet Mondrian. Whereas the Dutch artist often employed ornamental forms in a purely decorative manner, Malevich always sought justification through a "philosophy of existence".

The frequent substitution of the one term for the other is a direct result of the unwillingness of art historians to distinguish between the means and the end. In all fairness, however, it has to be said that few works of abstract art entirely correspond to the dictionary definition of the word "abstract". All abstractions combine the mental, the conceptual and the sensual-contemplative.

It is more natural to refer to the Russian avant-garde in connection with non-objective art, as confirmed by the artists' own statements. In this short yet exciting period, it was perhaps only the Constructivists – who called themselves "engineers of form" – who showed clear leanings towards abstractionism.

Even here, however, the Russians demonstrate their inherent inconsistency. One of the leading members of the Constructivist movement, Alexander Rodchenko, openly derided the comparisons of art with mathematics. Like many others, he essentially experimented in "logical-nonsensical forms."[2]

Three artists in particular – Wassily Kandinsky, Mikhail Larionov and Kazimir Malevich – defined the unique nature of the Russian version of non-objectivity. Russian non-objective art had several unique features. Like everything else linked to the history of the Russian avant-garde, the non-objective compositions of Wassily Kandinsky, Pavel Filonov, Kazimir Malevich, Mikhail Larionov, Olga Rozanova and Mikhail Matiushin evoked inevitable discussions about the "Russi-an spiritualism" that was such an essential part of non-objective creativity in Russia.

Wassily Kandinsky. Two Ovals (Composition No. 218). 1919 (detail)

Belgian critic Michel Seuphor wrote that the history of abstract art began with Wassily Kandinsky and his tenet of "all-permissiveness". The artist allegedly went into his studio one night and failed to recognise one of his paintings, which was lying the wrong way up. From that time onwards, Kandinsky enjoyed complete freedom from imitation.

Wassily Kandinsky circulated Cubism. Like his contemporaries Mikhail Larionov, Kazimir Malevich and Pavel Filonov, the artist was well acquainted with Russian folklore, which provided the inspiration for his free lines and colourful symphonism. In 1912, Kandinsky published his main theoretical work, *Über das Geistige in der Kunst*, in Munich. That same year, his friend Nikolai Kulbin, a doctor, amateur artist and advocate of the new art, read excerpts from the book at the Pan-Russian Congress of Artists. The theories of non-objective art formulated by Kandinsky were very much in the air at that time, and his book enjoyed great resonance in the Russian art world.

Kandinsky wrote that the main task facing artists was the expression of the internal and the spiritual, rather than the external or accidental. He portrayed the spiritual life of humanity in the form of a triangle with unequal sides. The spiritually talented, most of them artists, were clustered around the top. The burden of spiritual vision, however, obliged artists to convey their gift to the crowd. Kandinsky wrote: "This eternally exquisite matter or, as it is more commonly called, spirituality ... does not give itself up to firm expression and cannot be expressed by overtly material forms. The need for 'new forms' has arisen."[3]

Wassily Kandinsky confined his search for new forms to the basic elements of form and colour, which harbour new wealths and opportunities. The artist often compared painting to music, which he regarded as the most spiritual of all art forms. Kandinsky himself sought possibilities for their merging and mutual enrichment. In the 1900s, he was interested in the works of composer Alexander Scriabin and his quests for correspondences between the expressiveness of colour and sound. He also studied A. Zakharina-Ushkovskaya's theory of "colour-sound-numbers" and associated with Russian composer Foma Gartman and Austrian composer Arnold Schoenberg.

Kandinsky was not alone in this respect. The concept of synthesis implied the gradual disappearance of the rigid borders separating the various forms and genres of the arts. In the late 1900s and 1910s, Nikolai Kulbin often read papers on this theme. Kandinsky himself addressed such questions in his correspondence with David Burliuk, Vladimir Baranoff-Rossiné and Nikolai Kulbin.

In October 1910, Kandinsky read a lecture in Moscow to an audience of musicians, philosophers and artists. His paper outlined his thoughts on the parallels between tones in colour and sound.

The artist's theories were based on recent discoveries in psychology, familiar to him from his days at the Moscow University.

The artist believed that each colour and form had its own inner sound and that each colour had its own inner dynamics. In his expositions of his personal concept of abstract art, Kandinsky constantly reiterated that his purely painterly compositions were born from feelings, the only way "to attain artistic sincerity," and that "the soul of a creation ... can never be created by theory alone."[4]

The painterly world of Wassily Kandinsky's *Compositions* and *Improvisations* revealed its spirituality in the subjectless collisions of the lines and paints. Kandinsky called such independent "melodies" painterly counterpoints, each of which attempts to find direct access to the soul, like a musical tone. Painting became non-objective and similar to music, implying that only the deaf could not hear it.

Kandinsky lived in Germany from 1896, only visiting Russia occasionally. He never, however, lost touch with his former homeland. Perceiving the new currents coming from the West, his Russian contemporaries aspired with equal enthusiasm into the world of non-objective art. Mikhail Larionov created his own brand of non-objective painting, Rayonism, in late 1911 and early 1912. In late 1914 and 1915, Kazimir Malevich painted his first Suprematist compositions (conceived back in 1913). Up until the early 1920s, non-objective art acquired a growing number of followers in Russia, even becoming the leading movement for a short period of time in 1917.

Many art historians of the period – and indeed to this day – have associated abstract painting with the consciousness of a confused mind. Beginning with Albert Einstein's theory of relativity, the achievements of science and technology put man in the unique position of knowing more than he was capable of imagining. Most exciting of all was the attempt to imagine the cosmos and the eternity of the universe, and to depict time and the living processes taking place within the organic world, hidden behind outward guises.

Kandinsky often quoted Goethe, who stated that "similarity" was not necessarily an indication of style. Twentieth-century artists aspired to depict not what they saw, but what they knew.

In Russia, this tendency found direct confirmation in the teachings of the Orthodox Church, which believed that the divine essence was incomparable to the material envelope of the surrounding world. Appearances could be deceptive. The structures of Orthodox icons were strictly regulated by church canons and their symbolics of colour had their own interpretations. Unlike West European religious painting, the Russian symbolics did not permit free reading of the canonic image or the mixing of the divine with the human or the mundane.

It should not be forgotten that secular art only appeared in Russia in the eighteenth century, during the reign of Peter the Great. Before then, there had only been religious painting and folkore,

with its rich traditions of decorative ornamentation. Incarnating the spiritual experience of the Russian people, the diverse semantics of the ornamentation of clothes, utensils and peasant furniture compensated for the lack of a representational culture. Constant intercourse with "signs" was a natural feature of the Russian consciousness. In this sense, Russia was closer to the East than to the West. In their manifestoes, the avant-garde artists regarded this as one of the advantages of Russian art.

Wilhelm Worringer's book *Abstraktion und Einfühling* (1908) was popular in Russia in the 1910s. Like the Cubists, the Russian avant-garde was interested in the concept of the "fourth dimension", which was given an original interpretation by the Russian mathematician and mystic Pyotr Ouspensky. Kazimir Malevich, Mikhail Larionov and Mikhail Matiushin were all inspired by the idea of a fourth dimension.

As Ouspensky wrote in *Tertium Organum: The Third Canon of Thought, A Key to the Enigmas of the World* (1911): "The fourth dimension is linked to 'time' and 'movement'." Consisting of an infinite number of elements of the existence of a three-dimensional body – its states and conditions – the fourth dimension was the result of the comprehension of the world by the "extended consciousness". Only then could the world be presented as it really was, and not just as it appeared.

Mikhail Larionov's Realistic Rayonism depicted the invisible. Spatial forms arising from the intersection of the rays emitted by objects, rays invisible to the unarmed eye yet extracted from the darkness of ignorance by the artist's will, paint a partial picture of incomprehensible reality on the canvas. Larionov wrote in 1913: "Rayonism is the doctrine of radiativeness. The radiation of reflected light (colour dust) ... The doctrine of the creativity of new forms ... Conveying the sensations of the endless and the timeless."[5]

The concept of "colour dust" suggests that the basis of Larionov's Rayonism was Impressionism. Despite its absolute freedom of colour relations and mobile texture, severed from the real object and motif, *Rayonist Landscape* evokes sensations of a concealed, sensual link with nature.

This sensation is also typical of Wassily Kandinsky and another contemporary – Mikhail Matiushin. A musician, composer and artist, Matiushin perhaps inevitably, owing to the idiosyncrasies of his talent, embarked on parallel quests for new forms of painterly imagery. In his first compositions of the mid-1910s, the artist sought a visual image of the audible. This quest, however, soon took second stage to a new sensation of space and colour relations in space.

In 1912, Mikhail Matiushin helped to publish the Russian translation of Albert Gleizes and Jean Metzinger's *Du Cubisme*, which also addressed the doctrine of the fourth dimension. He painted several works influenced by the theories of Bernhard Riemann and Charles Howard Hinton, also studied by Ouspensky. Matiushin's concept of "extended vision" – perception of the surroundings at

360 degrees – was based on Hinton's belief that special exercises could help man to perceive the fourth dimension. From 1918 onwards, Mikhail Matiushin engaged in research at his studio of spatial realism at the Academy of Arts in Petrograd and then at the department of organic culture at the Institute of Artistic Culture: "I set myself the problem of a centrally perceiving person, consciously acting across the entire surroundings. Man in the future will, at any moment, see, feel, hear and sense the amplitude of everything that surrounds him. I can foresense how this score of life, read by the intellect, will create what mankind is still even hesitant to dream about."[6]

The relationship between science and art intensified at the start of the twentieth century, justifying the searches for "inner meaning" and "inner movement". Artists studied philosophical treatises and essays on physics, mathematics, optics, biology, botanics and psychology, in apparent contradiction of their spontaneous natures. This period in Russian art left as its heritage, mainly in theories, a bewildering mixture of positivism, mysticism, rationalism and creative recklessness. Sensual experience and knowledge freely intermingled in the compositions of Mikhail Matiushin and his students. Matiushin's version of non-objectivity reflected the processes of nature; as he wrote in his diary in December 1922: "I was the first to signal the return to nature, which is beyond the left-wingers, the new in art, struck dumb and deadened by the West and 'non-objectivity'."[7]

Each artist rejected subject and narration in his own particular way, inventing his own system of symbols. Wassily Kandinsky discovered abstraction. Pavel Filonov also freely employed abstraction in his art, subordinating the plastics of the painting to the whimsical and intricate fantasies of his own mind. Kazimir Malevich invented Suprematism, logically approaching non-objectivity via Cubo-Futurism.

Kazimir Malevich showed thirty-nine non-objective compositions at the 0.10. Last Futurist Exhibition in Petrograd (1915–16) under the general title of the New Painterly Realism. It should be noted that the word "Realism", as understood by the Russian avant-garde, had until then implied almost the complete opposite in art. Now, the word did not lose its sense; it merely acquired a different meaning.

Malevich proclaimed the higher, universal nature of Suprematism in relation to all other trends and movements in art. The artist regarded Suprematism not as a movement, but a universal artistic system, a new plastic canon with endless spheres of application.

Among the works shown at the legendary 0.10 exhibition, heralding the birth of Suprematism, were *Painterly Realism of a Footballer: Colour Masses in the Fourth Dimension, Movement of Painterly Masses in the Fourth Dimension* and *Painterly Realism of a Peasant Woman in Two Dimensions (Red Square)*. Malevich explained: "I want to show that I regard real forms as heaps of form-

less painterly masses which create a picture that does not have anything in common with life."

Malevich employed the simplest geometric figures – circles, squares, crosses, triangles and rectangles – in his pictures of the "new reality". Taken in absolute purity, they were the first principles of his language of art and the constituent elements of his painterly formulae, with the same sacral meaning in the artist's mind as in that of a medieval alchemist. Malevich regarded the circle and the square as the most topical and economic forms of human initiative. Black and red were the height of pure tension; white represented the heighest tension of colour in general. One recalls here Kandinsky's own discourses on white: "White, although often considered as no colour ... is a symbol of a world from which all colour as a definite attribute has disappeared. This world is too far above us for its harmony to touch our souls. A great silence, like an impenetrable wall, shrouds its life from our understanding. White, therefore, has this harmony of silence, which works upon us negatively, like many pauses in music that break temporarily the melody."[8]

Malevich associated the colour white with the sensation of cosmos and eternity. In both cases, this interpretation of colour coincided with the symbolism of the colour in Russian icons.

Russian artists were interested in the semantics of form and colour, as reflected in such writings by their contemporaries as Pavel Florensky's *Celestial Signs (Reflections on the Symbolics of Colours)* (1919) and *Dictionary of Symbols* (1922).

A mathematician and an Orthodox priest, Pavel Florensky sought an integral model of culture based on the geometric structure of all the components of its heritage of visual images. He examined the triangle, rectangle, cross, circle and spiral in the course of his research.

Kazimir Malevich's "first elements" – circle, square and cross – constitute the basis of the canonic compositional structure of all icons. *Black Square* was first shown at the 0.10. Last Futurist Exhibition as an icon; according to the Russian tradition, it was hung in the right-hand or "red" corner. Malevich wrote to Alexander Benois in 1916: "I have one bare icon of my time, without a frame." During the artist's lifetime, *Black Square* became a symbol of his Suprematism and its sublime expression.

Malevich wrote that *Black Square* was "constructed in the fifth (economy) dimension" as "the last Suprematist plane on the line of the arts, painting, colour and aesthetics, extending beyond their orbit." In the interpretation of philosopher Pyotr Ouspensky, the fifth dimension was the vital factor without which it was impossible to comprehend the fourth dimension – the height to which the consciousness must rise before it can simultaneously see the past, present and future.

Intuition and mystical revelations might seem far removed from the logical constructions of Malevich's system. The artist's creative achievements, however, contradict this point of view. In Malevich's non-objective compositions, sensation and intuition preceded the geometric construction of the painting structure. Not surprisingly, the artist included icon-painting in the genealogy of Suprematism, calling Suprematism a "philosophy" in *Die gegenstandslose Welt*, his theoretical work published in Germany in the 1920s.

Many of Malevich's contemporaries – Ivan Kliun, Jean Pougny, Olga Rozanova, Lyubov Popova, Alexandra Exter and Alexei Morgunov – were drawn into the orbit of his "force field". While the artist had many students and followers, they all developed the formal achievements of Suprematism without reference to its specific spiritual substance. The one exception was Olga Rozanova, whom Malevich regarded as "the only female Suprematist". Writing in 1999, Richard Cork called Rozanova's non-objective compositions "luminous, sensual abstractions." [9]

Often mentioned in association with Kazimir Malevich, Jean Pougny made an important contribution to the Suprematist movement. Pougny, however, was probably the most inconsistent of all Malevich's followers. Lightly improvising, he simultaneously worked in different manners, varying the themes of his plastic experiments. Pougny's innovative art embodies an inherent aestheticism and refinement; his most successful works are such light-hearted compositions as *Still-Life with Letters. Spectrum Flight*.

Emigrating to Western Europe in the early 1920s, Jean Pougny publicly denounced non-objective art and his erstwhile idol, Kazimir Malevich. [10]

Ivan Kliun was perhaps Malevich's most faithful follower. Up until the mid-1920s, Kliun showed a clear preference for non-objective painting, aspiring to perfect the colour basis of Suprematism. He was also among the first to successfully transfer non-objective experiments into sculpture.

Among the other contemporaries of Kazimir Malevich, Alexandra Exter is celebrated for her rich and fiery compositions. Exter's creative energy was augmented by her natural perception of Italian Futurism, turning her non-objective canvases into dynamic vortexes of colour.

Equally explosive in terms of their emotional power and unfettered tones are Lyubov Popova's works of the late 1910s and early 1920s. Popova's famous series of non-objective compositions, *Painterly Architectonics*, can be regarded as a step on the road from Cubo-Futurism to Suprematism diverging in the direction of Constructivism. Like Olga Rozanova's Suprematism, Popova's "lyrical" Constructivism was full of realistic feelings.

Members of the next generation of artists showed works alongside Malevich's canvases at one of the few state exhibitions of non-objective art held in the new Soviet republic – Non-Objective Creativity and Suprematism (Moscow, 1919). One artist contributing to the show was Alexander Rodchenko, who was influenced by

both Kazimir Malevich and Vladimir Tatlin. Rodchenko summarised their experiments, varying the "elementary particles" of painting.

Alexander Rodchenko decided to emulate Malevich's series of *White on White* paintings by creating his own cycle of *Black on Black* compositions in 1918. Brilliantly successful in terms of plastic minimalism, this series is dominated by the formal aspect, relegating the spiritual substance to second place.

Rodchenko created numerous non-objective compositions in painting and graphic art in the 1920s. He also produced a number of spatial constructions. In comparison to Malevich, Rodchenko employed increasingly complex geometric figures – ellipses and hexagons.

Alexander Rodchenko summed up his experiments with non-objective forms in painting in 1921, when he contributed three canvases to the 5 x 5 = 25 exhibition in Moscow. Each work is painted one of the three primary colours – red, yellow and blue.

Rodchenko followed the path of invention and introduced the principles of non-objective painting into design, architecture and photomontage: "Invention (analysis) and not synthesis is the engine ... I am an inventor of new discoveries from painting. Christopher Columbus was not a painter or a philosopher; he merely discovered new countries."[11]

Alexander Rodchenko's words opened a new chapter in the history of non-objective art in Russia. Although political factors meant that this history was never written in Soviet Russia, it still retained living impulses for subsequent work in the realm of non-objectivity.

As Vera Stepanova, Rodchenko's wife, wrote in 1919: "Non-objectivity is, for the time being, merely the concept of a new great era of Great Creativity, unseen prior to this time, intended to open doors and secrets much more profound than science and technology."[12]

notes to the text

[1] Kandinsky and Malevich in fact moved consistently towards non-figurativeness in their art: "The artist proceeds from general structural laws that are philosophical in character, concretising them in non-objective forms" (Yevgeny Kovtun, "The Third Way to Non-Objectivity", *The Great Utopia: The Russian and Soviet Avant-Garde 1915-1932*, Bern/Moscow, 1993, p. 64). Malevich regarded non-objective forms as a deduction from the sum of observations enriched by the intuitive feeling of concealed meanings. Writing in his theoretical work *Concerning the New Systems in Art*, he states: "Nature consists of diverse signs" (1919). This seemingly insignificant phrase reveals his understanding of non-objectivity.

Accepting that abstraction is an element in a process of cognition consisting of the abstraction of a series of immaterial qualities and links of the object, with the isolation of the most important ones, it follows that the abstractionist moves from the personal towards the harmony of the general, whereas the non-objectivist moves from the general towards its emblematic expression. Bearing in mind the degree of conditionality, what we are dealing with here is a version of "new objectivity" unlike the world of usual things.

[2] N. Punin, *An Excursion to the Russian Museum: The Department of Modern Art*, 10 December 1927, Russian Museum Manuscript Department, No. 6, Sheet 77.

[3] Wassily Kandinsky, *Concerning the Spiritual in Art*, Dover Edition.

[4] Wassily Kandinsky, *Concerning the Spiritual in Art*, Dover Edition.

[5] *Russian Avant-Garde: The Uncompleted Chapters*, Palace Editions, 1999, p. 11.

[6] *Devoted to Russian Avant-Garde*, Palace Editions, St Petersburg, 1998, p. 27.

[7] *Devoted to Russian Avant-Garde*, Palace Editions, St Petersburg, 1998, p. 25.

[8] Wassily Kandinsky, *Concerning the Spiritual in Art*, Dover Edition, p. 39.

[9] Richard Cork, "Rebels with a lost cause", *The Times*, 12 May 1999.

[10] Jean Pougny emigrated to Finland in late 1919. In 1920, he settled in Germany, where he published an analysis and critique of modern art in 1922.

[11] "Sistema Rodchenko", *Sovetskoe iskusstvo za 15 let. Materialy i dokumentatsiya*, Moscow/Leningrad, 1933, p. 114.

[12] V. Agarykh (Stepanova), "Bespredmetnoe tvorchestvo", *Sovetskoe iskusstvo za 15 let. Materialy i dokumentatsiya*, Moscow/Leningrad, 1933, p. 111.

Alexander Rodchenko. Black on Black. 1918
Oil on canvas. 84 x 66.5. Russ. Mus.

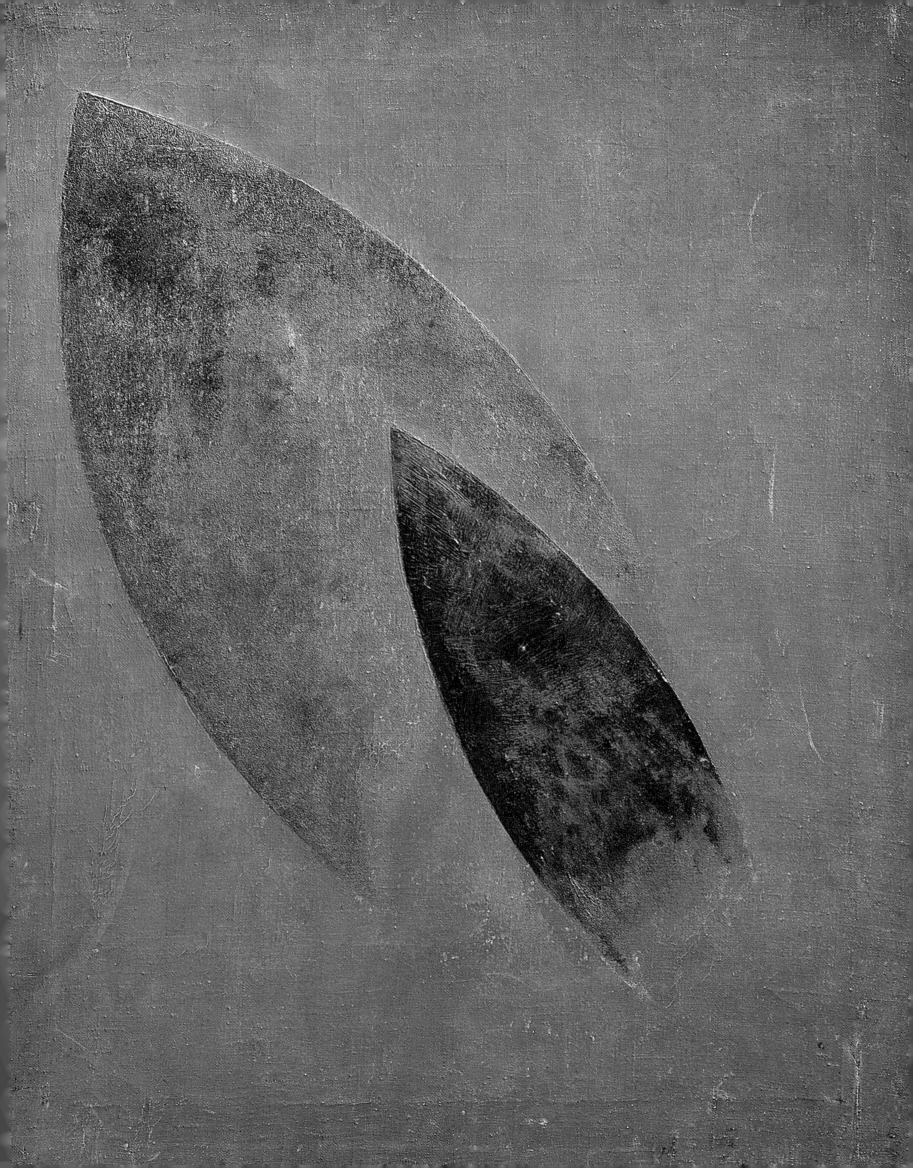

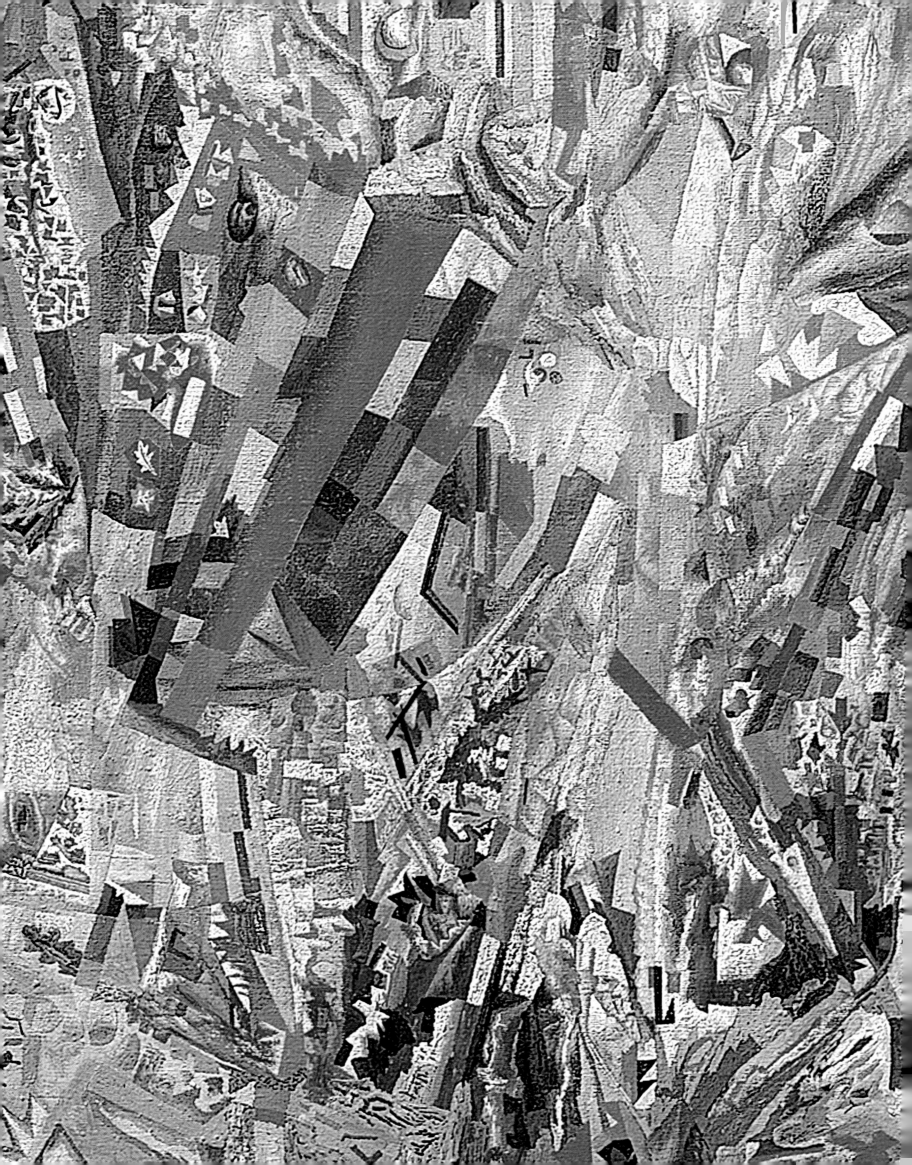

ABSTRACTION AS THE PLACE OF THE PAINTERLY EVENT

concerning the question of non-objectivity

jean-claude MARCADÉ
Paris, France

Abstraction is, without a doubt, the dominating line in twentieth-century art – the line of modernity or the "avant-garde". Abstraction represents just as an important a revolution in twentieth-century thought as *Phenomenology* (to which *Historical Abstraction* is related) inasmuch as both Phenomenology and abstraction followed the same path – the path of reduction. There is no need to list the demarcation principles of the stylistic forms of abstraction – lyrical, geometric, naturalist, "informal", gestural, conceptual, etc. Any work of art in which objects are manifested in a configuration different to that to which the human vision is accustomed is generally referred to as an abstraction. There is what I would call "naturalist abstraction" – describing not isolated figures with distinctly outlined contours, but pieces of surrounding nature outside any context, such as the play of the sky and the water, a shadow on the floor, part of a wall or a piece of material. All this relates to the subject of *iconography* or *iconology*, which the majority of museum-goers often confuse with the *painterly as such*, which permeates any image and has manifested itself for as long as art has existed. This manifestation of the *painterly as such* lies beyond the bounds of all forms of conveying reality, forms subject to all possible stylistic variations and the appearance of "progress". I refer here to the *painterly as such* – the same for all possible styles and artistic resolutions and only indirectly submissive to the whims of the socio-historical course of humanity or technological innovations. Even if socio-historical and technological elements compel the creator to adapt to the dynamics of the "grub-house" (Malevich's expression) of economics and offer some resistance, this is necessary to over-power and overcome, so that the *painterly as such* can break through. I would not want, however, this aspect to be misinterpreted. I do not imply an apology of "art for art's sake" or the systematic material support of the artist by the state, i.e. his "bureaucratisation". While the artist's relationship with the world and the place that the artist occupies in society are real, existing problems, this is not the subject of my essay. I am profoundly convinced that these "problems" are linked, above all, to the true orientation of the creative act, and not to socio-political regulation. A discussion of this orientation is thus of great importance in the present day.

We shall not discuss here the devices of artistic incarnation, the artist's handicraft as such. The main aim of this essay, as will soon become clear, is to demonstrate the *necessity* – as well as the inadequacy – of the "artistic kitchen" brought out by abstraction. This is nothing other than a prop which the artist cannot do without, present here with the aim of *bringing out* something else.[1]

Only in the light of the "painterly as such" could Henri Matisse claim that "all art is abstract".[2] The French master was clearly implying that abstraction is the very existence of painting and that its appearance as a form at the start of the twentieth century should be regarded as a culminative moment or *acme* in the course of the development of abstraction in the history of art; the moment when abstraction paints by itself, bringing out on the canvas that which is

Pavel Filonov. Formula of Spring. 1922 (detail)

not brought out in an objective representation, yet which epithetically permeates all the objects. From 1910 onwards, rejecting four centuries of Renaissance academicism and annulling the conditional codes of the representation, the twentieth-century artist came face to face not with the visible world, the representation of which was thought to have been triumphantly grasped thanks to "scientific perspective", but with Reality, with the truth of existence, in all its nakedness, with its essential requirement, free of objectivist mediation. From now on, depending on the degree to which artists realised that the visible world is only one of a multitude of possible manifestations of the essence of the object, the mimetic representation of nature lost its force and was cast open to doubt. The painterly became, above all, the organising force of a self-sufficient space, only one of the possible expressions of which is *easel painting* (related to a definite historical era) alongside other expressions in which the act of thought, the conceptual impulse, the gesture and the existential act all participate to an equal degree. We refer here not to the reproduction of the visible world, in line with theoretical doctrines dating back to Aristotle's *mimesis*, readings actually repudiating themselves in artistic practice, inasmuch as the *painterly as such* was always the concern of the great masters of the past, independent of the style of the period. We refer instead to the creation of a place in which the *painterly event* unfolds. Writing in *Concerning the New Systems in Art* (1919), Malevich stated: "Only a few artists regarded painting as an action in itself. Such artists do not see houses, hills, skies or rivers as such; for them there are only painterly surfaces. It is therefore unimportant to them whether they will be similar, whether water or the plaster of a house will be expressed, whether the painterly surface of the sky will be painted above the roof or at the side. Only the painting grows and is conveyed and transplanted onto the canvas in a new and orderly system." [3]

Of the three pioneers of abstraction in the twentieth century – Wassily Kandinsky, Kazimir Malevich and Piet Mondrian – Malevich was the only one to take the radical step into the unknown, into Nothing, into absolute non-objectivity, into the essential rhythm of the world, into the *painterly as such* – to that place where the light is no longer the illusory light of the sun, but the light of Black and White, from where all lights emanate and to where they must return: "Intuition is the grain of infinity and everything visible on our globe scatters itself in it. Forms originate from the intuitive energy overcoming the infinite, from whence the varieties of forms also originate as instruments of movement. The globe is nothing other than a ball of intuitive wisdom which must run along the lines of the infinite." [4]

Although Kandinsky was the first to bring to the forefront the autonomous nature of the painterly space and its intention – the creation of a self-sufficient world – in philosophical terms, he remained at the stage of Symbolist dualism, dividing the world into the internal and the external. Kandinsky visualised and made "internal sounds" visible. His canvases are a representation of "abstract" vision, for he aspired to bring out not the visible material object, but its spiritual essence. An acquaintance with the description of the symbolics of colours in Kandinsky's works is sufficient to understand how heavily this approach is overburdened by cultural and subjective psychologism.

Addressing Mondrian's abstractionist approach, one sees that a consistent departure from the object led the artist to the creation of a new painterly code of semiological equivalents of the object – functioning autonomously, but with a concrete object as their reference.

In Malevich's painting, this question was resolved in an altogether different manner, for the first time in the history of art. Between *Black Quadrangle* (1915) and *White on White* (1918) the reference ceases to be merely to the elimination of the object in painterly art, with the aim of creating a new object, to the subjectivism of the description of the "internal world"; or to purism in the establishment of a code of purely representational relationships, to the formalism of elements combining in a self-sufficient manner. The reference is to the liberation of the glance in the direction of *das Sein* through the pronouncement of *das Seiende* beyond parentheses, in accordance with Martin Heidegger's later expression "In this pronouncement of *das Seiende* beyond parentheses, the glance is liberated for *das Sein*." [5]

Herein lies Malevich's Copernican revolution, anticipating Heidegger's Phenomenology. It is not man enjoying the freedom to create "small, self-sufficent worlds", but *freedom enjoying man*. [6] From Nothing, from non-objectivity, from the living life of the world comes "arousal", i.e. the rhythm of this freedom. When Malevich writes that he has "liberated the Nothing", is this "liberation of the freedom" not true abstraction? We can thus see that abstraction is not merely another "painterly recipe", but, as the French philosopher Emmanuel Martineau wrote of Malevich's Suprematism, "a new *spirituality* in which man, becoming like the Nothing and the 'non-objective' God, can himself learn to become absolute freedom." [7] Rephrasing the aforementioned quotation from Heidegger, we can thus say that abstraction "makes the glance free for the Nothing".

From Malevich onwards, abstraction casts doubt on the "paramounce of vision", showing that both empiricist and noetic visions are, in reality, nothing more than blindness. Man cannot see or picture anything; only the existing is revealed to him. Yet this is, in fact, what is not revealed to man – *manifestation* without form, without colour, without borders – and what abstraction reveals on the surface of the canvas or through the organisation of the painterly space. The *Erscheinung-manifestation* opposition is thus one of the key questions set by painterly abstraction. Abstraction imparts a

whole new status to the artist – the status of not merely a professional or skilled master, but a sublime spiritual being through whom the energies of the universe and the rhythm of non-objectivity, which are one single living world, break through.

One begins to understand the unjustified nature of the attempt to reduce the revolutionary art of 1910–20 to the general, faceless term of "constructivism". The word "constructivism" has become applied to absolutely everything, becoming a "hollow sound". Constructivism, however, represents a completely concrete, historically dated (1921–22) and ideologically defined movement. While it only comes into contact with the abstraction discussed here superficially, iconographically, there is a considerable difference, even from the iconographic point of view, between "geometric constructivism" and the "inclination towards the geometric" in Suprematism.

While it is possible to pick out many diverse trends within "constructivism", the main line of the dominating "Constructivism", i.e. the Soviet Constructivism of the 1920s, implies modelling life with the help of art, in accordance with social, moral, ideological and economic imperatives. Constructivism aspires to a state in which art becomes life, whereas Suprematism, taking abstraction to the highest point of expressiveness, aspires for life to conform itself to

art, in accordance with the imperatives emanating from the "liberated Nothing", i.e. aspires towards that state in which life becomes art. Art as a means or art as an end in itself – this was the essence of the controversy in revolutionary Russia in the 1920s.

Abstraction, in the full meaning of the word, is thus an *ecstasy* directed into the world as non-objectivity, the only real world; a *manifestation*, the conquering of which is an incessant battle – or, in Malevich's words, a "war" – steeped in alarm. As Heidegger wrote: "Timidity reposes not far from the fear and terror of the abyss."[8]

The essential freedom of abstraction is that in which state there are no "literary dramas", ideology, *Weltanschauung* or even states of the soul, yet there is the essence of the *painterly as such*. This tread of the unrevealed, manifesting itself in painterly rhythm, naturally goes against the entire dominating life living cheerfully on nice little pictures and hedonism (what Malevich called "painterly pornography"). Today, abstraction is clearly once again experiencing a phase of semi-underground existence. Yet is this *Verheimlichung* not a feature of the most painterly existence – always concealed, enigmatic, abstract? Consequently, there is no pessimism when ascertaining that abstraction is currently experiencing a new and unprecedented wave of censure.

notes to the text

[1] Cf. "Sicher ist, daß man unter 'Kunst' mehr und größeres verstehen muß als nur Meisterschaft, Handwerk, Gewerbe," *Malewitsch, Suprematismus – Die gegenstandslose Welt,* Du Mont-Schauberg, Cologne, 1962, p. 84.

[2] Matisse, *Ecrits et propos sur l'art,* Hermann, Paris, 1972, p. 252.

[3] K. Malevich, "O novykh sistemakh v iskusstve" [1919], *Kazimir Malevich. Chernyi kvadrat,* Azbuka, St Petersburg, 2001, p. 132.

[4] Op. cit., pp. 127–128.

[5] Jean Beaufret, *Dialogue avec Heidegger,* Vol. III, Minuit, Paris, 1974, p. 127.

[6] Heidegger, *Wegmarken,* Klostermann, Frankfurt-on-Main, 1967, pp. 82, 85.

[7] E. Martineau, *Malévitch et la Philosophie,* l'Age d'Homme, Lausanne, 1977. Despite the mistaken analysis in the details and useless polemics, the author examines the question of Malevich's "non-objectivity" from the essential point of view, placing it in the context of the historical, philosophical movement of abstraction. In this article, we reproduce many of the assertions from the book which we believe deserve close scrutiny.

[8] Heidegger, op. cit., p. 103.

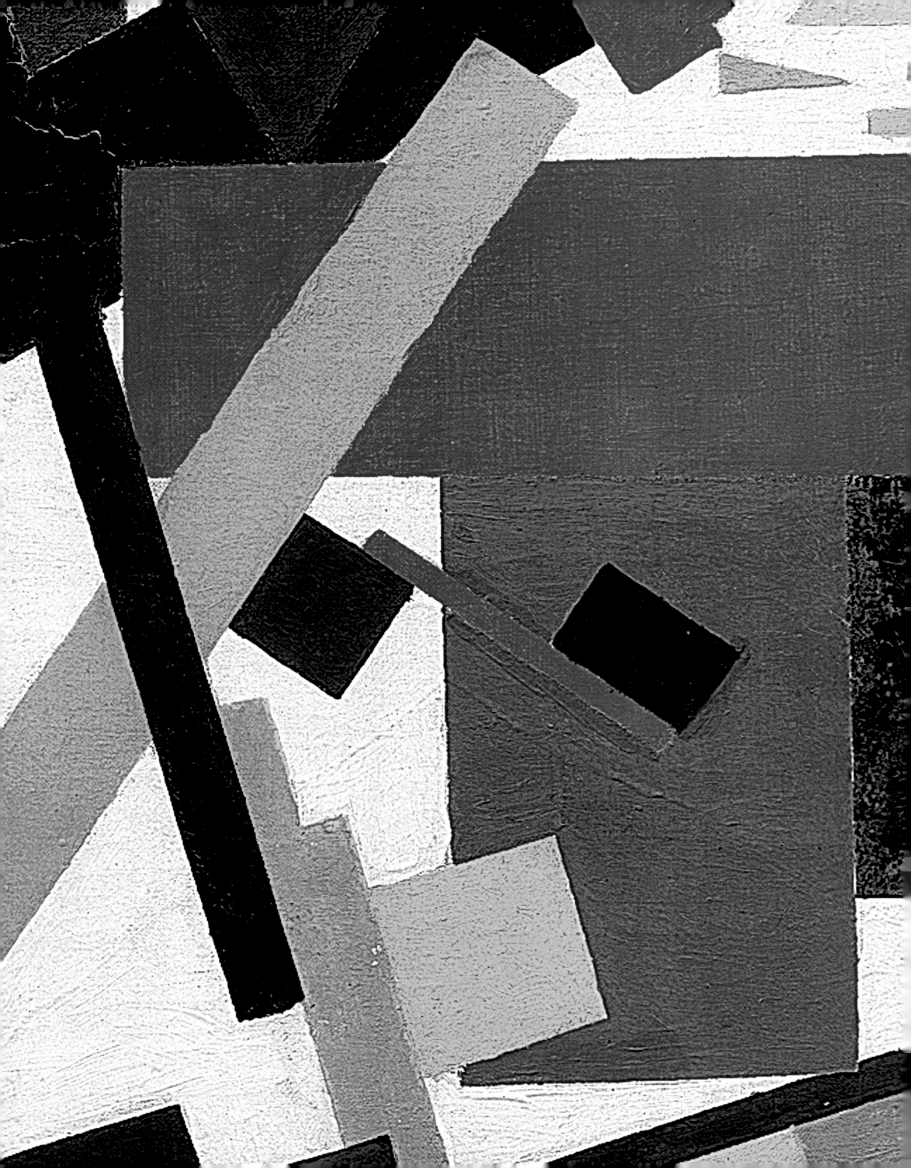

THE ESSENTIAL MYSTICISM OF RUSSIAN AVANT-GARDE ABSTRACTION AND ITS IMPACT ON WESTERN CONTEMPORARY ART

maurice TUCHMAN
New York, USA

I

Abstract art of the twentieth century remains misunderstood by the majority of the viewing public in 2001. Most people, in fact, consider it meaningless. Yet around 1910, when groups of artists moved away from representational art toward abstraction, preferring symbolic color to natural color, signs to perceived reality, ideas to direct observation, there was never an outright dismissal of meaning. Instead, artists made an effort to draw upon deeper and more varied levels of meaning, the most pervasive of which was that of the spiritual.

The genesis and development of abstract art were inextricably tied to spiritual ideas current in Europe in the late nineteenth and early twentieth centuries. An astonishingly high proportion of visual artists working in the twentieth century have been involved with the ideas and belief systems, and their art reflects a desire to express spiritual, utopian, or metaphysical ideas that cannot be expressed in traditional pictorial terms.

Visual artists, from the generation born in the 1860s to contemporary times, have turned to variety of antimaterialist philosophies, with concepts of mysticism or occultism at their core. Terms such as *occultism* and *mysticism* should be defined carefully because of the association with the ineffable that surrounds these words and because they are context-specific: art historians and artists use these terms differently than do theologians or sociologists. In the present context mysticism refers to the search for the state of oneness with ultimate reality. Occultism depends upon secret, concealed phenomena that are accessible only to those who have been appropriately initiated. The occult is mysterious and not readily available to ordinary understanding or scientific reason.

Several ideas are common to most mystical and occult world views: the universe is a single, living substance; mind and matter also are one; all things evolve in dialectical opposition, thus the universe comprises paired opposites (male-female, light-dark, vertical-horizontal, positive-negative); everything corresponds in a universal analogy, with things above as they are below; imagination is real; and self-realization can come by illumination, accident, or an induced state: the epiphany is suggested by heat, fire, or light. The ideas that underlie mystical-occult beliefs were transmitted through books, pamphlets, and diagrams, often augmented by illustrations that, because of the ineffable nature of the ideas discussed, were abstract or emphasized the use of symbols.

Between 1907 and 1915 painters in Russia, Western Europe and the United States began to create completely abstract works of art. It is neither our intention nor our interest here to resolve the issue of who was the first abstract painter or what was the first abstract painting. Instead we are more concerned with how this abstraction evolved and, in particular, how the leading Russian abstract pioneers – Wassily Kandinsky and Kazimir Malevich, and two other European pioneers, František Kupka and Piet Mondrian – moved

Kazimir Malevich. Suprematism. 1915 (detail)

pointedly toward abstraction through their involvement with spiritual issues and beliefs. An examination of their development, and that of the generation following them, reveals how spiritual ideas permeated the environment around abstract artists in the early twentieth century.

In 1912 Kandinsky assessed the work of Matisse, pointing to his search for the "divine" but criticising his "particularly French" exaggeration of color, and the work of Picasso, which "arrives at the destruction of the material object by a logical path, not by dissolving it, but by breaking it up into its individual parts and scattering these parts in a constructive fashion over the canvas". For Kandinsky these approaches represented two dangers in contemporary art: "On the right lies the completely abstract, wholly emancipated use of color in 'geometrical' form (ornament); on the left, the more realistic use of color in 'corporeal' form (fantasy)". Kandinsky advocated a different role for the artist: "The artist must have something to say, for his task is not the mastery of form, but the suitability of that form to its content ... From which it is self-evident that the artist, as opposed to the nonartist, has a threefold responsibility: (1) he must render up again that talent which has been bestowed upon him; (2) his actions and thoughts and feelings, like those of every human being, constitute the spiritual atmosphere, in such a way that they purify or infect the spiritual air; and (3) these actions and thoughts and feelings are the material for his creations, which likewise play a part in constituting the spiritual atmosphere." [1]

Nourishing Kandinsky's eventual commitment to abstraction, which was indebted to his convictions about the spiritual, was the time he spent in Paris in 1906–07 and the lessons he learned from Jugendstil (Art Nouveau in Germany). Cubism was little importance in his artistic evolution. His immersion in spiritual texts, however, seems to have established his rational for abstraction. Kandinsky's paintings were very much a product of his close reading of theosophical and anthroposophical writings by Helena P. Blavatsky and Rudolf Steiner and of the visual impression made by the illustrations to Annie Besant and Charles W. Leadbeater's *Thought-Forms* (1905) and Leadbeater's *Man Visible and Invisible* (1903). Kandinsky's annotations in 1904–08 of Steiner's *Luzifer-Gnosis* reveal much about what he learned in his study of the spiritual. Echoes from Steiner's book may be found in Kandinsky's *On the Spiritual in Art* (1912), perhaps the most influential doctrine by the artist in the twentieth century. From Theosophy, as Sixten Ringbom was the first to demonstrate thoroughly, Kandinsky derived his concept of vibration (directly connected with his use of the acoustic term *Klang*). He believed that human emotion consists of the vibration of the soul and that the soul is set into vibration by nature: "Words, musical tones and colors possess the psychical

power of calling forth soul vibrations ... they create identical vibrations, ultimately bringing about the attainment of knowledge ... In Theosophy, vibration is the formative agent behind all material shapes, which are but the manifestation of life concealed by matter." [2]

As Ringbom summarized, Kandinsky's express purpose was "to produce vibrations in the beholder, and the work of art is the vehicle through which this purpose is served ... The formative factor in the creation of a work of art is the artist's same vibration". Kandinsky's works from the Bauhaus and Paris years feature abstractions that may be associated equally with cosmic and celestial concerns as with vibrations.

Franz Kupka's involvement with the mystical and the occult dated from his early childhood in Bohemia. He was apprenticed as a youth to a saddler, a spiritualist who led a secret society. Kupka's visionary experiences were translated into visual form in his painting as a transperceptual realm in which color is imaginary, space is infinite, and everything appears to be in a constant state of flux. From his training at the Prague Academy with Nazarene artists who stressed geometry rather than life drawing, Kupka came to master golden section theory and practice and perhaps to pass it on later to his neighbors in Puteaux, the Duchamp – Villon family. In Vienna Kupka met Austrian and German Theosophists and found corroboration of his theory of reincarnation; in association with the painter Karl Diefenbach he further developed ideas about the reciprocal relationship of music and painting, and he became a sun worshipper, alert "to hues flowing from the titanic keyboard of color". He credited Nazarenism with a desire to "penetrate the substance with a super-sensitive insight into the unknown as it is manifested in poetry or religious art". [3]

For Kupka, as for the Theosophists, the essence of nature was manifested as a rhythmic geometric force. Consciousness of this force was made possible by disciplined effort as a medium; Kupka was a spiritualist throughout his life. He announced in 1910 that he was preparing to state publicly his beliefs in theosophical principles and spiritualism; his 1910–11 letters to the Czech poet Svatopluk Machar note his fascination with the supernatural world, spiritualism, and telepathy and his need to express abstract ideas abstractly. *The First Step* (1909–13) is a painting whose imagery is rooted in astrology and pure abstraction. The painting may be interpreted as a diagram of the heavens and as a nonrepresentational, antidirectional image referring to infinity and evoking the belief that one's inner world is truly linked to the cosmos. Years earlier Kupka had written of a mystical experience in which "it seemed I was observing the earth from outside. I was in great empty space and saw the planets rolling quietly". [4]

Piet Mondrian joined Amsterdam's Theosophical Society in 1909, but there is evidence that his interest in spiritual ideas began around 1900. Mondrian exposed himself to a variety of theosophical ideas shortly after the turn of the century: he read texts, includ-

ing Schuré's *Les Grands Initiés*, and associated with theosophical sympathizers, including critics, collectors, and painters: in addition, he met the painter Jacoba van Heemskerck in 1908 at Domburg, while visiting the Symbolist Toorop. Unlike Kandinsky, Mondrian did not borrow visual imagery, such as aural projections, from theosophical texts but rather invented an abstract visual language to represent these concepts. His devotion to Theosophy and related beliefs were quite strong. Also contributing to Mondrian's artistic outlook were his impressions of the paintings by the Symbolist generation preceding him, most notably those by Toorop and Thorn Prikker, and the traditions of precise geometry in Dutch art, which set the stage for his experience of Cubism, first encountered in 1910. Mondrian's theories and art were based upon a system of opposites such as male-female, light-dark, and mind-matter. These were represented by right-angled lines and shapes as well as by primary colors plus black and white. His abstract language employed an unusually direct system of equivalents to express fundamental ideas about the world, nature, and human life and to evoke the harmonious unity of opposites.

In some of the spiritual movements that influenced twentieth-century artists, the bond between metaphysical ideas and science was an important element. Metaphysical thinkers, for example, were especially eager to learn about the advances in physics and chemistry. This new knowledge not only was adapted to confirm their beliefs but also allowed them to speculate about the invisible aspects of the material universe. Popularized beliefs about n-dimensional geometry, a theory of geometry based on more than three dimensions, were an essential basis for Russian Futurist movement and the art of Malevich. In the writings of P. D. Ouspensky the properties time and space were united in a concept of the fourth dimension. Malevich fused his interest in the fourth dimension with the occult, numerological notions shared with him by his close friend the poet Velimir Khlebnikov. Malevich's art moved from the Alogical representation of space to its final, totally abstract form: Suprematism. Suprematist works were intended to represent the concept of a body passing from ordinary three-dimensional space into the fourth dimension. Malevich's knowledge of Cubism helped him move in this direction, although he stated that his inclination toward abstraction predated this influence.

As Charlotte Douglas wrote, the generation of Russian artists emerging after the turn of the century sought to break away from Cubo-Futurism in search of a new cosmic unity. Douglas points to *zaum* – the idea of a higher perceptual plane, a superconscious state that allows knowledge beyond reason – as being identical with the samadhi state in Yoga. There were widespread sources in Russian culture for such concepts. John Bowlt explained that occult and mystical ideas were usually disseminated to artists indirectly rather than by textual studies, and he demonstrated that geometric abstraction in Russia were an extension of Symbolist of any meaning in these works, so too was Cubism stripped of its content. This process facilitated an easy formalist reading of abstract art, but it is now widely acknowledged that Cubist works do have content, that they are about something.

The Cubists' considerable interest in the fourth dimension has been established, and more recently it has emerged that occult ideas were associated with the development of Cubism. Jacques Lipchitz testified to the Cubist interest in the occult in a 1963 unpublished interview with Henri Dorra: "The artists made determined, if good-humored searches in the realm of practical magic and alchemy and tried to cultivate their spirit if not actually pursue their ends. Thus, we had read *The Emerald Tablet* by Paracelsus [in fact the work is attributed to Hermes Trismegistus] ... The Cubists were also very much interested in the occult properties of images." [5]

Lipchitz then requested a gold ring, silk thread, and a book of illustrations. He created a pendulum from the thread and the ring and allowed it to swing over the reproductions of paintings by various artists. He then continued: "The oscillations are similar for works by the same artist, different for works by different artists. We used to spend hours playing this game, as if to prove to ourselves that there were intangible properties that transcended physical reality."

Picasso, too, for a brief, but critically important period was affected and nearly inundated by spiritual ideas. His painting of his friend Casagemas may be interpreted as a rapturous expression of communion catalyzed by the death of a close friend; the configuration of this painting was influenced by *Les Courses*, 1905, a painting by the Russian émigré Georgii Yakulov. Yakulov's involvement with mystical ideas was counterpart to Mikhail Matiushin's view of the fourth dimension as the occult myth of the "blue sun". Yakulov's authoritative, early *Abstract Composition* (1913) reveals that his spirituality, nascent in 1905, was overt in 1913. Matisse also exhibited some interest in mystical ideas; specifically, he was attracted to the notion and theosophical ideas. The pervasive idea of cosmic energy was derived from Blavatsky, Buddhist philosophy (nirvana), Ouspensky, and G. I. Gurdjieff.

The sources for the spiritual-abstract nexus in Saint Petersburg, Moscow, Paris, Munich, and New York were limited in number, strikingly similar, and almost simultaneous: Swami Vivekananda's lectures in the United States, such as those at the Chicago World's Fair in 1893, were translated into Russian in 1906; William James was widely translated in Russia, too, and in France, as were Whitman and Ralph Waldo Emerson. The more recondite brand of occultism often appeared in inexpensive paperback editions, such as M. V. Lodyzhenkii's *Superconsciousness and Ways to Achieve It* (1911), which Malevich read, and Albert Poisson's *Théories et symbols des alchimistes* (1891), which Marcel Duchamp read.

Cubism, because of its reduction of objects to increasingly geometric forms, has more often been cited as the intermediary between Post-Impressionism and abstraction. Two points need to

be made regarding the relation of Cubism to early twentieth-century abstraction and to the spiritual issues under discussion. First, with few exceptions (the most notable being, arguably, Malevich), Cubism was not essential to the progress of any major artist working from a representational mode and moving toward an abstract one, whereas exposure to spiritual ideas certainly was. Second, the most fertile aesthetic source for abstract artist working in the first two decades of the twentieth century was Symbolist painting and theory. Symbolism, the mystical wing of the Post-Impressionist generation, contained the seeds of abstract art; abstraction was also catalysed by formal suggestions drawn from Fauvism as well as from Cubism. Abstraction's emergence throughout the twentieth century was continually nourished by elements from the common pool of mystical ideas. Just as the history of early abstract art, as written by many critics and historians of the 1930s through the 1960s, disregarded the presence of a cosmogony. Pierre Schneider cites Matisse's own summary of this prewar stage in his work: "It was a time of artistic cosmogony". For Matisse, Constantin Brancusi, Georges Rouault, and Picasso, the years 1905–10 were characterised by an observable shift "toward the in art", a shift that abruptly terminated with Cubism. The work of these artists and others associated with them was not abstract, but convincing links may be drawn between their spiritual ideas and important aspects of their careers. Conversely, there were certainly abstract artists who were not interested in mystical or occult issues. Artists such as El Lissitzky and Lásló Moholy-Nagy produced purely abstract paintings; instead of consulting nonrational belief systems, they tried to organize the world so that their art was related to idea systems as well as to architecture.

Abstract art that had developed during World War I benefited from the example of Kandinsky's non-figurative formal vocabulary, and many European artists absorbed his vocabulary as well as various occult texts. The development of artists who could utilize pre-existing abstract forms naturally differed from that of the first generation of abstract pioneers, who greatly feared that meaning might be lost along with the discarded object. Artists of a later generation, such as Jean (Hans) Arp, accepted that abstract art was meaningful and indeed spoke to deep philosophical issues. He wrote, "The starting–point for my work is from the inexplicable, from the divine". [6] A single, quivering, inexact shape recurs in Arp's work: the Urform, the double–ellipse, "that archetypal figure, a designation of certain closed curves that resemble the figure 8, described by Goethe in his poem *Epirrhema*:

> Nothing's inside, nothing's outside.
> For what's inside's also outside.
> So, do grasp without delay
> Holy open mystery."

In 1945 the exhibition in New York of two hundred paintings by Kandinsky and the reissuing of *On the Spiritual in Art* were of great interest to the emerging Abstract Expressionists. Barnett Newman, Pollock, Adolph Gottlieb and Rothko may not have shared the so-called spiritual terminology of the earlier anti-materialist philosophies, but they seized upon contemporary counterparts with a fervor fully equal to Mondrian's abiding respect for Blavatsky or Kandinsky's for Steiner. The new American artists became a second wave of abstract pioneers, searching for expressive means appropriate to their generation and asserting the need for universal truths. Their spiritual sources tended to be not Theosophy and Anthroposophy but beliefs and practices associated with native and non-Western cultures: the art of Native Americans (especially Northwest Coast Indian painting), Zen, and Carl Gustav Jung's concepts of archetypal form, including his identification of the mandala in art ranging from that of the North American Indian to that of Asian cultures. In pointing to spiritual sources, Newman steered clear of references to ideas associated with Blavatsky or other occultists definitely out of favor with most New York artists of the 1940s.

Rothko, Newman and Gottlieb sent an indignant letter to the *New York Times* in 1943 protesting that their purpose behind their art was not being properly understood or taken seriously. Their outrage distinguished them from earlier abstract artists who had been reluctant to discuss the underlying meaning of their work. Indeed, one could say that Kandinsky's fears that abstract art risked becoming mere ornament had been realized in the design-oriented abstraction of the 1930s. Certainly this was Newman's view in the mid-1940s: "The present feeling seems to be that the artist is concerned with form, color and spacial arrangement. This objective approach to art reduces it to a kind of ornament. The whole attitude to abstract painting, for example, has been such that it has reduced painting to an ornamental art whereby the picture surface is broken up in geometrical fashion into a new kind of design – image. It is a decorative art built on a slogan of purism." [7]

To this approach Newman opposed his own intentions and those of Gottlieb, Rothko, Pollock and others of the emerging New York School: "The present painter is concerned not with his own feelings or with the mystery of his own personality but with the penetration into the world of mystery. His imagination is therefore attempting to dig into metaphysical secrets. To that extent his art is concerned with the sublime. It is a religious art that through symbols will catch the basic truth of life ... The artist tries to wrest truth from the void." [8]

That certain contemporary artists incorporate mystical and occult ideas into their paintings is quite extraordinary when one considers how the audience for art has changed. In the 1890s private societies and small groups constituted the primary audience for works by Symbolist artists; often artists' groups themselves were their own audience. Such coteries continued to be the painters'

audience for until the 1960s, when the audience for art became a mass audience. Art must now be comprehensible, or at least appear to be comprehensible, to this new, frequently immense group. Occultism, with its references to hidden meanings, is problematic when it becomes part of the content of contemporary art. The fact that Brice Marden, for example, with his interest in alchemical and numerological systems, makes works today that are patently occult in meaning raises intriguing questions about the continuing role of the spiritual as a visible factor in serious contemporary abstract painting.

True spiritual abstraction then need no longer to be doctrinaire and exclusivist.

II

In the eyes of American artists, the Russians stood for an art that could be relevant to large numbers of people, especially those who were not already accustomed to "Museum Art". This stimulated artists of the 1960s who were attempting to move away from the self-oriented expressionism of the Abstract Expressionists. The myth of the Russian artist as a societal catalyst held sway, whether identified with Tatlin's engineering/industrialist inclination or Malevich's anti-utilitarian approach. Artists in America were attracted to the Russian's use of non-art materials in sculpture (including new industrial materials such as steel and plastic), and anti-traditional processes and textural elements in two-dimensional works (such as torn paper in collage). The tremendous charge given to book design also inspired confidence in new bookmaking fifty years later: this most venerable means of communication was thus given fresh life in the age of electronics.

Among artists in America, Ad Reinhardt, George Rickey and David Hare first called attention to the importance of Suprematism and Constructivism. Reinhardt's work most clearly embodies the spirit of Malevich, as Reinhardt himself allowed, while Rickey and Hare took off from the constellation of Constructivist tenets. (In England, where Russian work was seen early on, the artists found it "terribly alien: the Russians 'didn't know how to put paint on,'" as Robert Hughes recalls the attitude in London. In France, Jean Tinguely best comprehended the significance of Malevich and made a brilliant series of kinetic sculpture in the mid-1950s called *Meta-Mécanic* and *Meta-Malevich* reliefs.) Later, Dan Flavin came to be credited by all the artists who emerged in the 1960s as the figure who most effectively pushed the ideas of Tatlin and others toward the foreground of consciousness. By effectively utilizing corner spaces in his own work, by entitling a major series of sculpture "Homages to Tatlin," and by force of conversational argument, Flavin made it necessary for many artists to take Tatlin's precepts into account. Donald Judd was seen by others as expressing this attitude as well.

There is a remarkable concurrence among these painters and sculptors about the nature of the Russian "influence." Jeremy Gilbert-Rolfe identifies the relationship as one of "empathy and reconstitution." [9] For Sol Le Witt, "If you had to find a historical precedent, you had to go back to the Russians"; the "area of main convergence between the Russians and Americans in the 1960s was the search for the most basic forms, to reveal the simplicity of aesthetic intentions." The Americans saw the Russians as most deeply understanding the diversity of abstraction. For Reinhardt, the entire twentieth century came down to a choice between Malevich and Duchamp. By 1974 Malevich was seen by critic John Coplans and others as the father of Conceptualism. Throughout the 1960s and 1970s Russian abstraction had about it the air of a mission, an attribute virtually absent in abstract art now. Mel Bochner came to

understand that "the Russians essentially defined abstraction as having to deal with intellectual content," and that it "has its own emotional intensity." He contrasts this with the different values connoted by Abstract Expressionism, non-figurative abstraction, and non-objective abstraction. Bochner was impressed by the "religious fervor of aesthetics" as practiced by Naum Gabo.

Russian abstract art was admired by some painters for its frank dependence on and derivation from folk art (Patrick Ireland), or for its perceived intention "to understand the art of the people" (Sol Le Witt). Richard Serra disparages the role of the American artist in society: "Every artist I know is working for the shopkeeper, the gallery, or the museum " but "the Russians implied something else." Patrick Ireland also makes the distinction between West and East along socio-political lines; he contrasts "the punishing and rejecting attitudes of Western art" with ideas brought out by the Russians: "The way they included people in a socialist way in art – the extension of art into installations and into typography (especially El Lissitzky) and into architecture, conceiving of the theater-stage as a lethal thing for artists – generally writing them into the social contract." Paradoxically, the deep penetration of television, movies, and photography into art and society in recent decades in the U. S. has served to deprive art of much of its power to influence. In Robert Hughes's view, "The collapse of American formalism links to the rise of Constructivism," and he sees a "nostalgia for belief in the avant-garde as having social effect" coming at a time when this potential is rendered obsolete by the media.

Only certain aspects of the Russian avant-garde were transmitted to the American artists. In the absence of original works of art, information was limited to reproductions that conveyed nothing of the scale, the emphasis on materiality, or the surface qualities of the original. These were mainly black-and-white reproductions, preventing the perception of the boldly contrasted and confidently elemental palette of the Russians. (An extremely interesting exception to this common experience, according to Carl Andre, was Frank Stella's admiration for Malevich's *White on White* in the Museum of Modern Art, "because it was so well painted even though utterly reduced"). But if the Russians could not be seen clearly or fully, the exceptionally acute intelligence of those Americans intrigued by the Russians was compensatory. The Americans were prepared psychologically to glean from the Russian artists as rich a precedent for their own inclinations as possible: The desire to find an alternative to the French line in art remained as compelling for these 1960s artists as it had been for the Abstract Expressionists in the 1950s. "In the 1960s," Patrick Ireland observed, "we talked Paris but looked at Moscow". Some American artists might project more into the Russians' intentions than evidence warranted, but this nevertheless had a salutary effect. Richard

Serra, for example, deduced from Constructivism that the artists "investigated material to find what would justify the structure rather than the other way around," and found corroboration in the Russians' writing and art of the ability to find in material its process "and have that process make the form." For Bruce Boice the Russians' idea of abstraction centered on it "counting for something ... Early abstraction had to have a reason to it, not just a way to prove something." It presented a model of rigor to the emerging generation.

Yet very quickly this bracing rigor turned to complacent and self-indulgent exercising, as the artists themselves now declare. In 1960s Minimalism, Russians' socially conscious endeavor is startlingly inverted: in place of the revolutionary artists' desire to change the world, the Americans of the 1960s appeared to want to "torture the middle class," as one artist put it, with art that was "hostile, aggressive, resistant and boring" (Barbara Rose's words about Minimalism). In reproduction, even the rare color facsimile, a painter such as Malevich appeared neat, clean, and hard-edged-characteristics that dramatically appealed to New York artists in the 1960s and certainly seemed to corroborate their work if not directly affect it. But after Malevich was seen in depth, either by visitors to Amsterdam's Stedelijk Museum or the Guggenheim Museum's retrospective in 1974 (the exhibition then traveled to Los Angeles), Malevich, surprisingly, was seen to be "sloppy" – his "glip", to use Boice's word for the animated squirt of Malevich, is cosmic, and Malevich was seen "not to care or worry" about technique or craft.

Donald Judd saw that Malevich "paints in a freewheeling, practical way ... as if he's busy, with a lot of ideas to be gotten down, and with the knowledge that color, form, and surface are what matter, and that care doesn't have much to do with these." The "somewhat loose geometry" of Malevich doesn't reappear again, in Judd's view, until Reinhardt, Newman, and Noland paint this way, although even they are more "deliberate in the process." Similarly, Jeremy Gilbert-Rolfe was surprised and intrigued by Malevich's "concern with delicacy and the possibilities of abstraction as metaphor." Bochner also suggests that the Guggenheim exhibition disproved the perception of a "cleaner Malevich than is the truth of the matter." Malevich was revealed to be "not really a reductive painter; in fact, of all the painters of the century, his paintings are the most complex and difficult to decode." The exhibition shed light on Minimalism's "Platonic and idealistic" nature, and also that Minimalism was, by contrast, clearly revealed to be an aesthetic tied to industrialism. In Bochner's view, Minimalism was unraveling at that moment, and the Malevich show may have hastened its decline by accelerating the growth of artists such as Robert Smithson and Eva Hess into other directions. Malevich was seen in 1974 as much closer to the then-emerging artists in his "openness" and his way of working directly.

Because of his importance in American art of the 1960s, Frank Stella's admiration for Malevich and other Russians should be

recorded. He regarded *White on White* as an "unequivocal land-mark," an "iceberg": the painting "kept us going, as a focus of ideas," until the appearance of Barnett Newman in the 1950s. Stella points to Flavin's use of the corner as heralding the first impact of Constructivism in the 1960s. He stresses that knowledge of Constructivism was restricted to reproductions and small reconstructions and that the link in sculpture from the early to contemporary periods was therefore "artificial". Interestingly, Stella maintains that Judd, Andre and Flavin were led to Rodchenko by the example of Brancusi, which allowed them to "skip Surrealism and the organic and the figurative."

For artists not attracted to a reductivist aesthetic in the 1960s, the first place to turn was to the work of David Smith. According to Mark Di Suvero, the Park Place group of sculptors – including Frosty Myers, Ed Ruda, Peter Forakis and Robert Grosvenor – formed this cooperative endeavor under the inspiration of Rodchenko and other Russians, the Bauhaus artists, and David Smith. From Smith, the method of constructing from a lexicon of discrete elements was readily absorbed. These Constructivist artists were primarily interested in how and where the Russians located their sculpture: the example of Rodchenko's hanging constructions, certainly, and also Tatlin's corner-bound assemblages. Di Suvero points to the startling asymmetry in Rodchenko and recalls that most sculptors in New York and Europe were still figurative, not abstract, and Rodchenko was not only confidently non-figurative but also innovative in his compositional intentions. "The main problem was to deal with space, non-figuratively, and to charge it with emotion," says Di Suvero, who also remembers the "energy" so admired by Dean Fleming in Russian art. On another level the Russians were important to the Park Place group for their strong social intentions. "That drew us a lot," commented Di Suvero, who stresses the Park Place group's "fight to put works into public – an idea that finally caught on." These Americans thought of themselves as "pioneers, breaking down the capitalist system: we were anti-gallery."

Interestingly, Di Suvero was not taken with Tatlin, as might be expected, but with Malevich. And then in 1962, "Rodchenko was the real discovery." He also speaks with warmth and admiration of Kandinsky: "such a free man – he broke up composition," and one may discern passages in Di Suvero's sculpture that may trace to Kandinsky quite as much as to Franz Kline, whose gestural paintings are often related to Di Suvero's constructions.

For sculptor Carl Andre, whose early work reveals striking affinities to Rodchenko's constructions, Russian art posed "a great alternative to the semi-Surrealistic work of the 1950s such as Giacometti's and to the late Cubism of David Smith." Frank Stella sounds a cautionary note about the Russian's predominant influence upon Andre, citing the example of Brancusi's post-and-lintel sculptures as being of great importance as well. But Andre articulates his fascination with Rodchenko, whose work he knew in photos in *Art News* magazine in the 1950s "where they looked big but you could tell they were not from the end-grain." They were striking to Andre because they were "uncarved ... cuts in space," attached one to the other, sections that were to be glued and nailed. For Andre this meant that doing the work, making sculpture, was a method of thinking. To his eyes there was a "look of nascence" about this work; it didn't have "a second-generation look about it." Andre also points to the "romance that was allowed to form about the work since it wasn't around."

Kandinsky's major status was perceived by Abstract Expressionist generation, but his art was not regarded as germane by the most innovative artists of the 1960s. Most younger Americans inclined toward one or the other pole in Russian avant-garde, and only recently has Kandinsky attracted the kind of compelling attention that is influential upon the formation of artists. This can be traced to the shift in taste in the mid-1970s from "the slick to the crude", from "the simplistic to the complicated". Kandinsky's paintings, for example, were probably more influential upon Stella's *Exotic Birds* than any other. Kandinsky's work had previously been seen by American artists as too pictorial. Di Suvero's interest in Kandinsky, noted above, remains more the exception than the rule. "He works in a naturalistic space. His pictures always fall into deep space and don't come back up front", remarked Bochner. At the end of the twentieth century, when painters searched for the potential in decorative and complex formations, Kandinsky appeared heraldic. Regardless of shifts in taste and need among emerging artists, the Russian remain exemplars of the power of pure imagination in the life of society.

An art historian privileged to be offered a preview, necessarily partial and time-restricted, of the major exhibition *Russian Abstraction in the Twentieth Century*, comes away with more questions than answers.

Kandinsky came to abstraction primarily out of his mystical convictions, as described above. No prior abstraction could serve as his model. Why then did so few Russians in the last two decades of the previous century – after the "blockade" was lifted – explore the aesthetic terrain?

At the same time, a visitor notes that examples of the most dynamic and compelling works of Picasso and Matisse and other radical modernists were on view in St Petersburg and Moscow. Works by these major artists were perhaps as available to the progressive-minded in Russian cities as they were in those of Western Europe and America. Why didn't these works strike a spark in Moscow and St Petersburg as they did elsewhere?

notes to the text

[1] Wassily Kandinsky, "On the Spiritual in Art (1912)", *Kandinsky: Complete Writings on Art,* ed. Kenneth C. Lindsay and Peter Vergo, G. K. Hall, Boston, 1982, Vol. I, pp. 151—152.

[2] Sixten Ringbom, "Art in the 'Epoch of the Great Spiritual': Occult Elements in the Early Theory of Abstract Painting", *Journal of the Working and Courtauld Institutes,* No. 29, 1966, pp. 386—418.

[3] Meda Mladek and Margit Rowell, *Frantisek Kupka 1871—1957: A Retrospective,* exhibition catalogue, Solomon R. Guggenheim Museum, New York, 1975, pp. 13—46.

[4] Mladek, "Central European ... Influences", ibid., p. 26.

[5] Henri Dorra shared with me his typescript of an interview with Jacques Lipchitz, 1963.

[6] Quoted in Michel Seuphor, *The World of Abstract Art,* Wittemborn, New York, 1957, p. 153.

[7] Quoted in Thomas B. Hess, *Barrett Newman,* exhibition catalogue, Museum of Modern Art, New York, 1971, p. 37.

[8] Ibid., p. 38.

[9] In section II all quotes by the following artists and writers are from interviews with Maurice Tuchmann in 1979 – Jeremy Y. Ibert-Rolfe, Sol Le Witt, Mel Bochner, Patrick Ireland, Robert Hughes, Carl Andre, Richard Serra, Bruce Boice, Barbara Rose, Donald Judd, Frank Stella and Mark Di Suvero.

explanatory guide

– Works are arranged in approximately chronological order.

– All dimensions are in centimetres.

– When an artist is represented by various works, he or she appears in order of the earliest work.

– Works created in 2001 are reproduced in those cases when they are part of a series or cycle created over a period of time and begun prior to 2000.

– Due to the numerous publications on the Russian avant-garde in recent years, the biographies of artists working in the first half of the twentieth century are given in abridged form, on an equal par with the biographies of artists working in the second half of the twentieth century.

– Artists working under pseudonyms appear in the biographies section under the pseudonym, followed by the artist's real name in brackets.

– Other forms of creative activities (besides fine art) are only listed in biographies of artists when they played an important role in the artist's career.

– Periods of study in schools of art or studios and the names of teachers are only given in those cases when the artist does not possess a higher education.

– Works without accompanying information on ownership have been specially presented for publication by the artists themselves.

In pure, cold space they fly; pure forms thrown into a rapid run, colliding and jostling, or in a state of inner dynamism, manifest themselves as the static development of colour. Form is colour. A composition of colour relations.

(Nadezhda Udaltsova, 1916)

wassily **KANDINSKY**

... endlessly refined matter or, as it is more often called, spirituality ... does not submit to firm expression and cannot be expressed by too material a form. The imperative necessity for finding new forms has arisen ... Abstract painting of minimalised objective forms, recorded in this way and perceived, the striking predomination of abstract units, confidently reveals the inner voice of the picture.

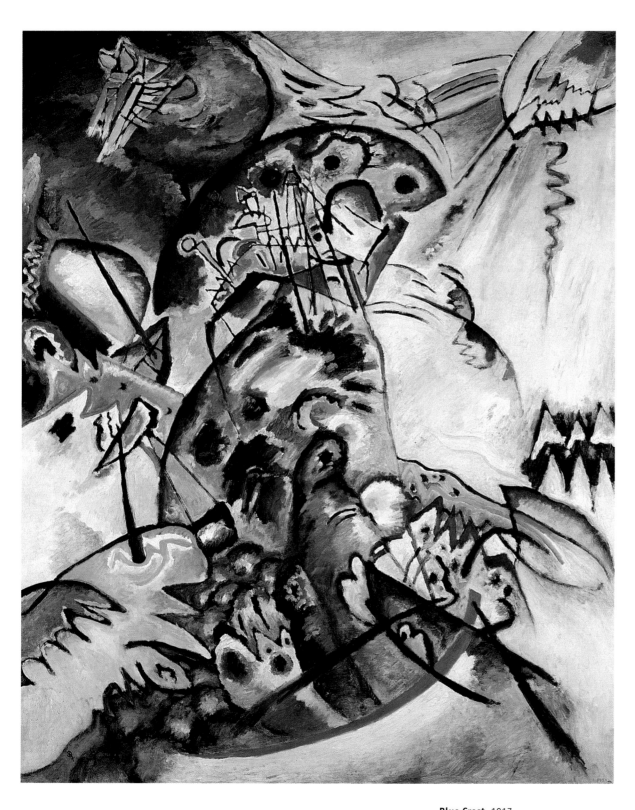

Blue Crest. 1917

Oil on canvas. 133 x 104. Russ. Mus.

Twilight. 1917

Oil on canvas. 70 x 106. Russ. Mus.

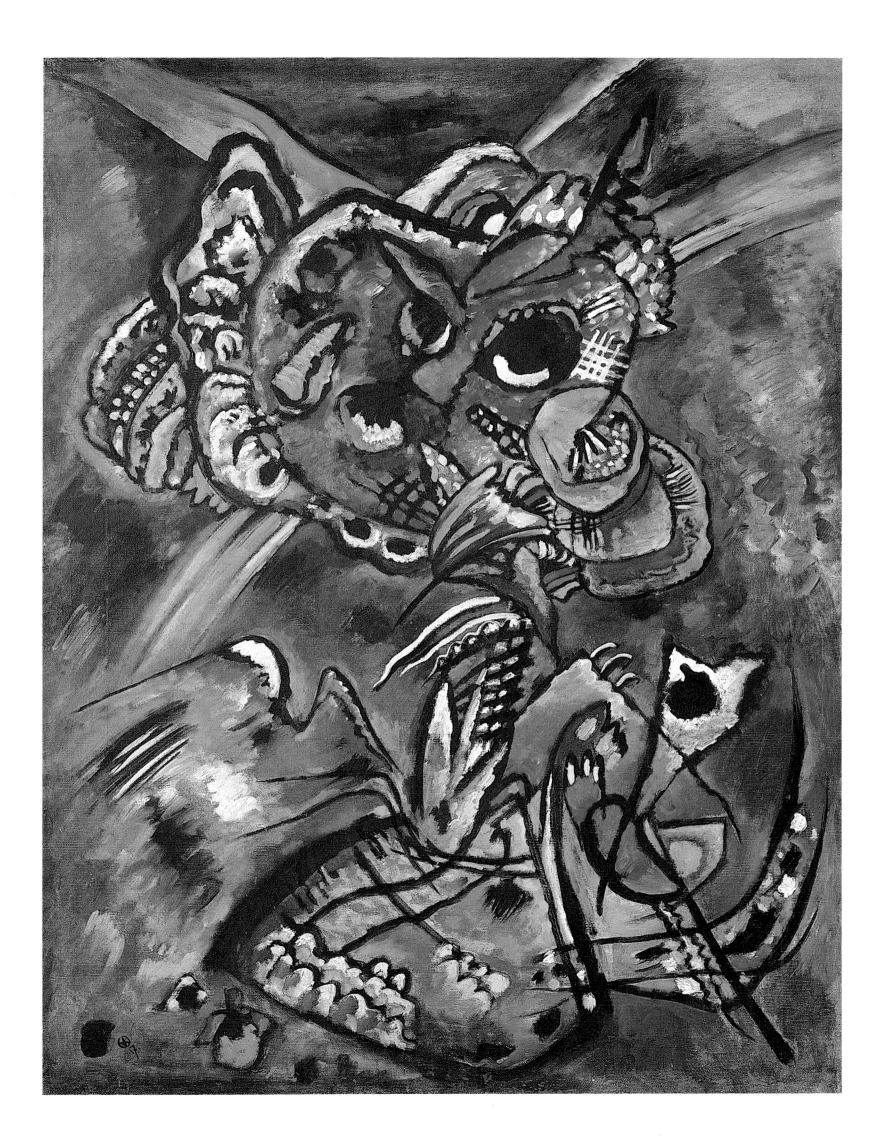

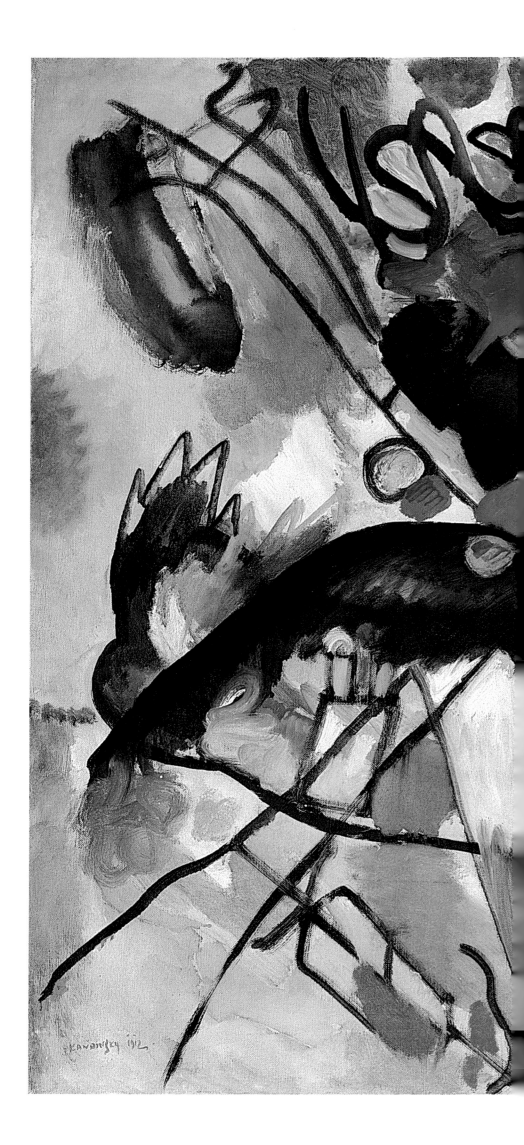

Black Spot I. 1912
Oil on canvas. 100 x 130. Russ. Mus.

On pp. 36–37:
Painting with a White Border (Composition No. 163). 1913
Oil on cardboard. 70 x 106. Russ. Mus.

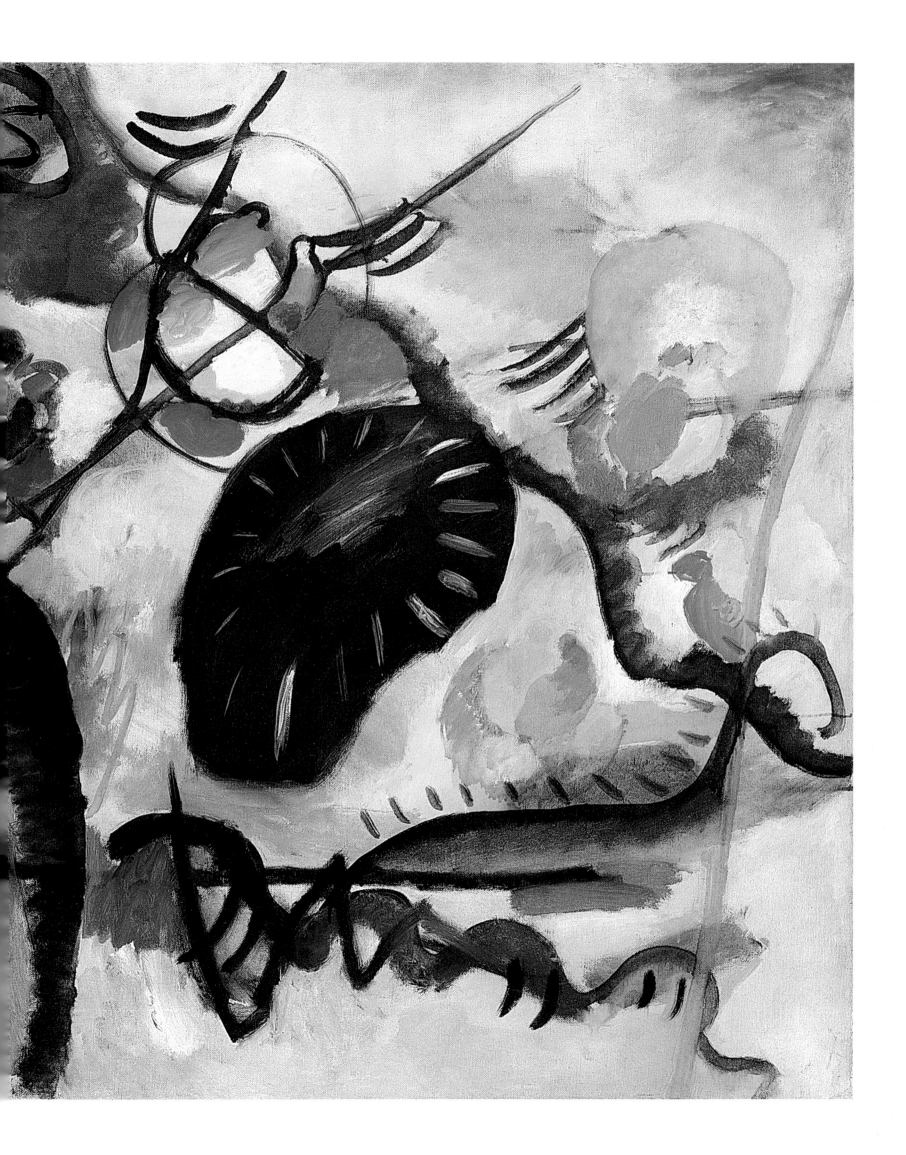

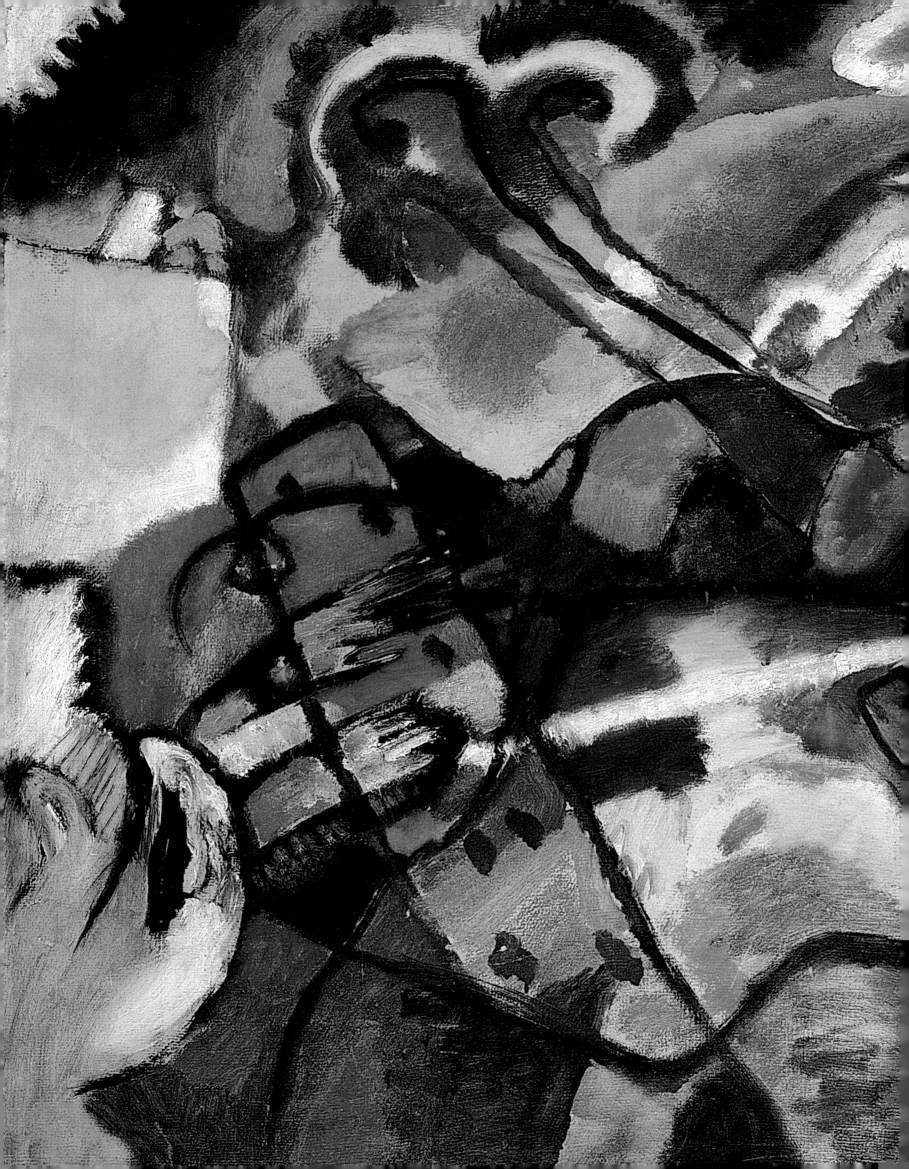

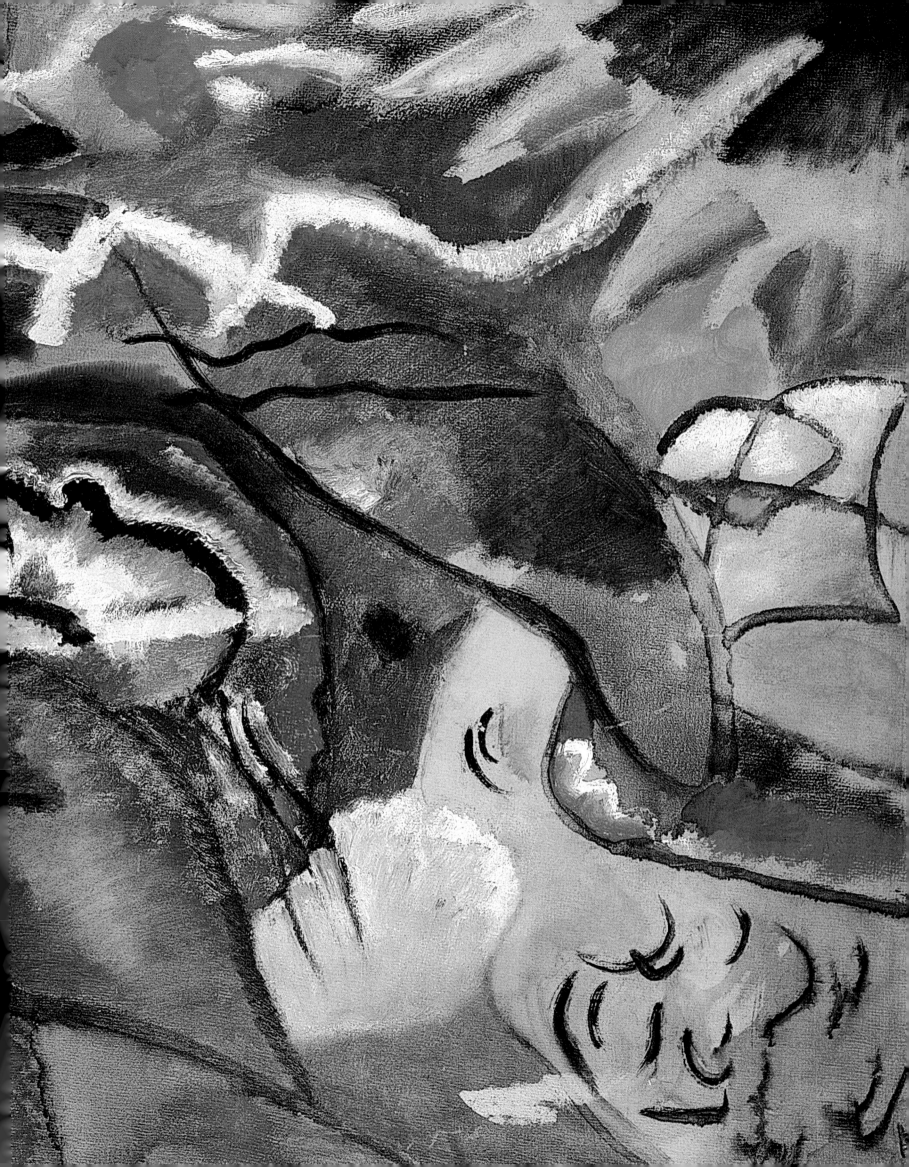

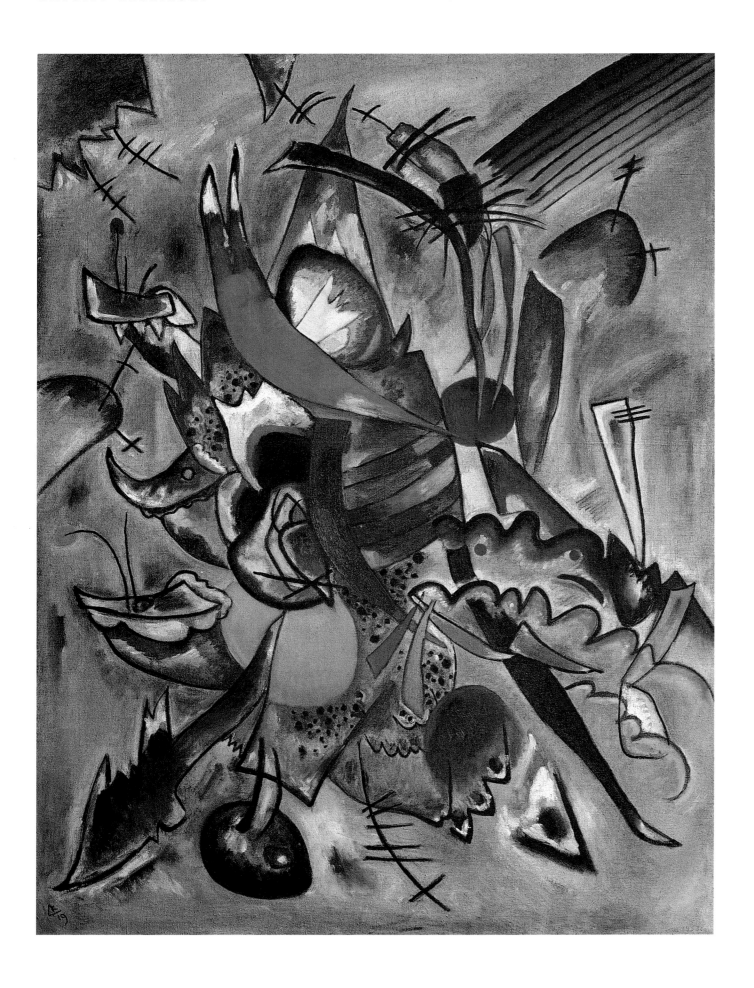

Painting with Points (Composition No. 223). 1919
Oil on canvas. 126 x 95. Russ. Mus.

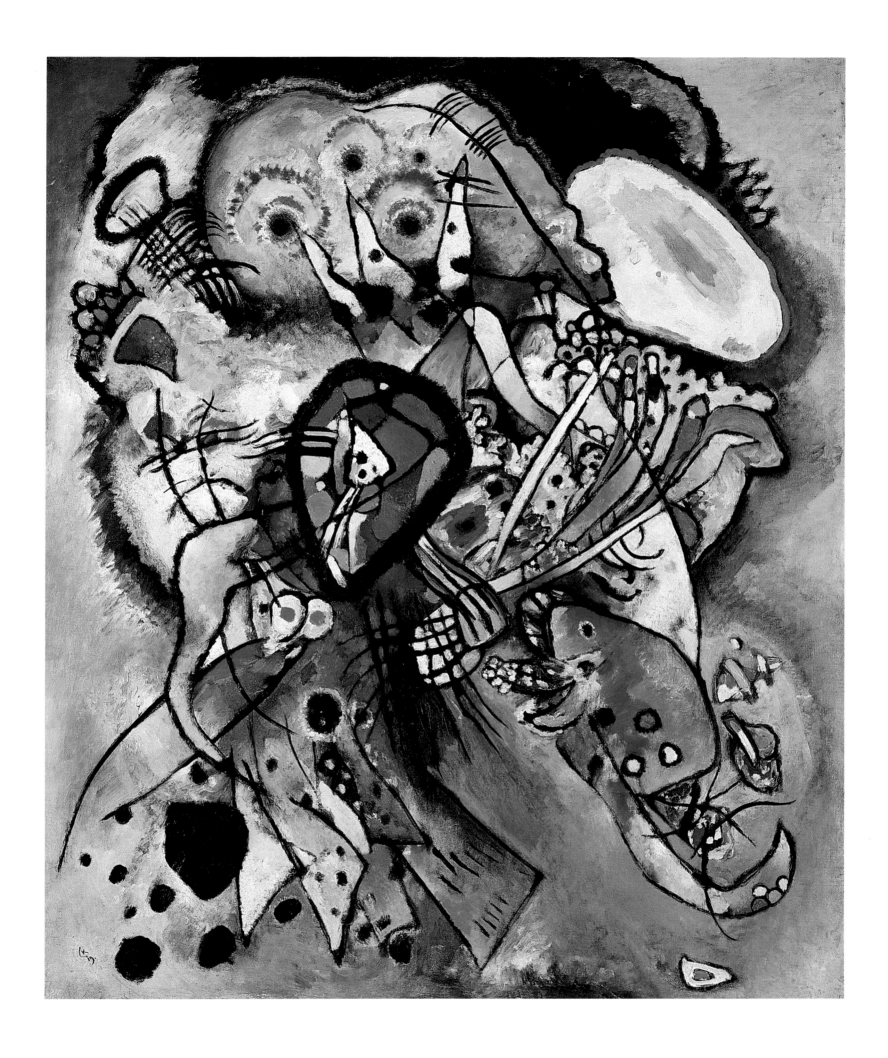

Two Ovals (Composition No. 218). 1919
Oil on canvas. 107 x 89.5. Russ. Mus.

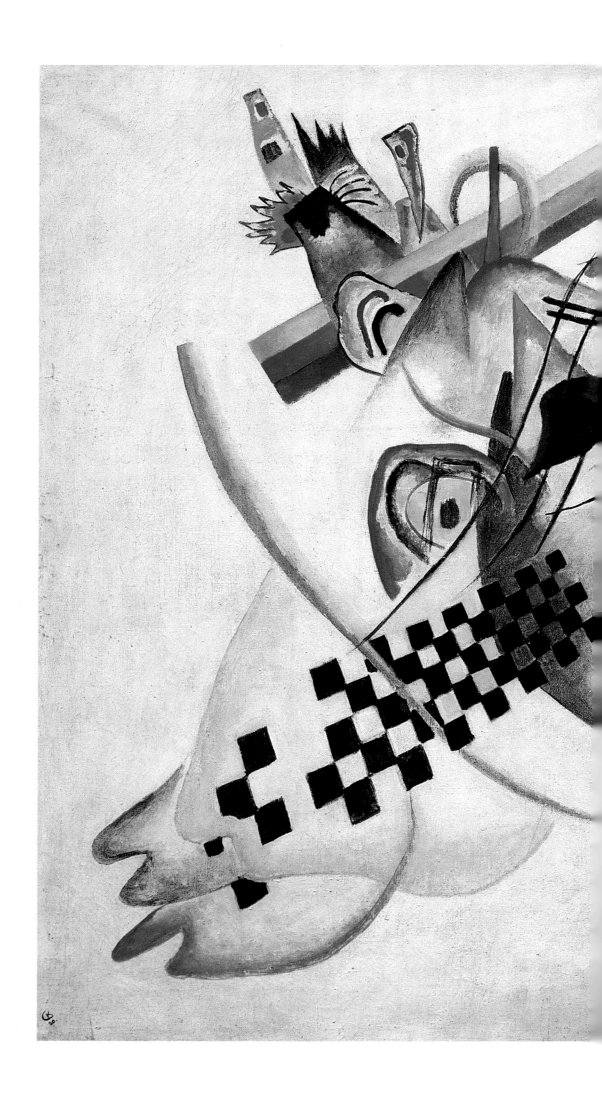

On White (Composition No. 224). 1920
Oil on canvas. 95 x 138. Russ. Mus.

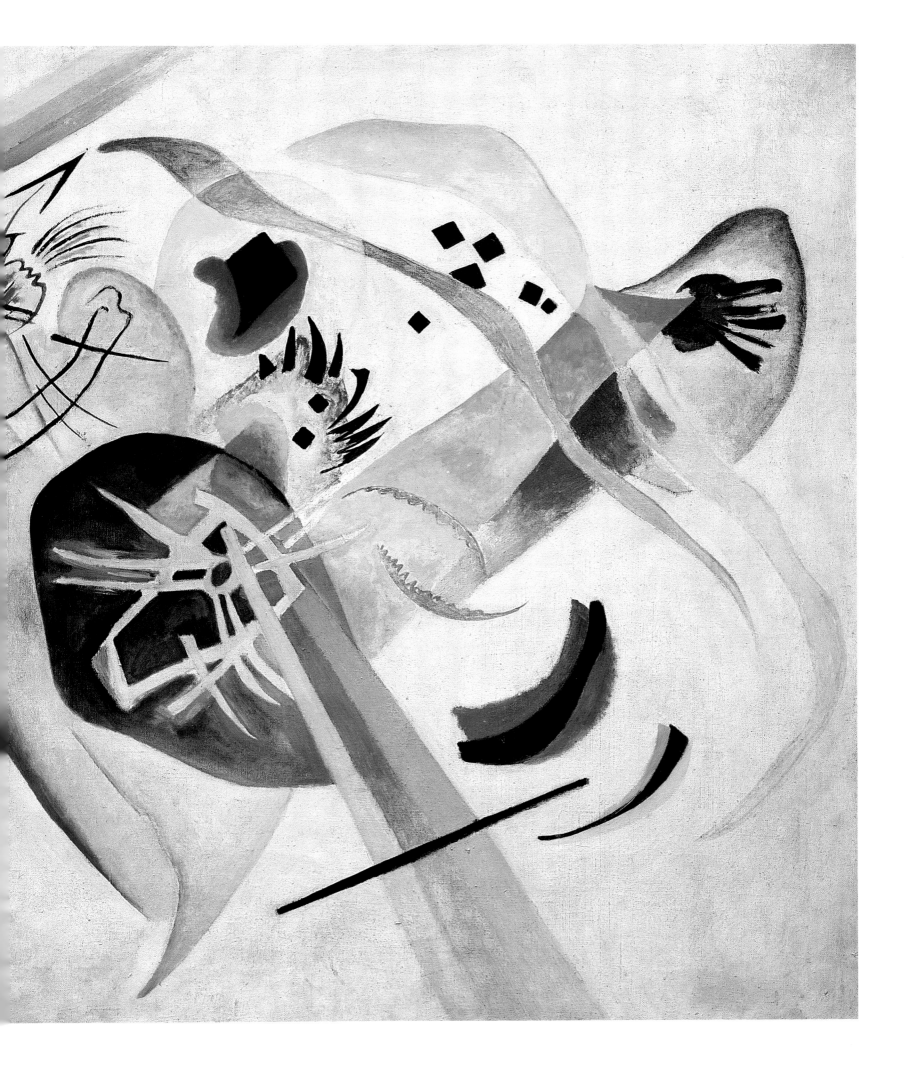

mikhail LARIONOV

A form arising from the intersection of the rays of various objects isolated by the artist's will. Conveying the sensations of the endless and the timeless. Paint construction according to the laws of painting (i.e. texture and colour). The natural demise of all preceding art as merely the object of the artist's observation and, with it, life, thanks to Rayonist forms.

Male Portrait (Rayonist Construction). 1913
Sheet from *16 Dessins M-e N. Gontcharoff et M. Larionoff*
Coloured lithograph. Image: 11.5 x 9.7; sheet: 11.8 x 10.2. Russ. Mus.

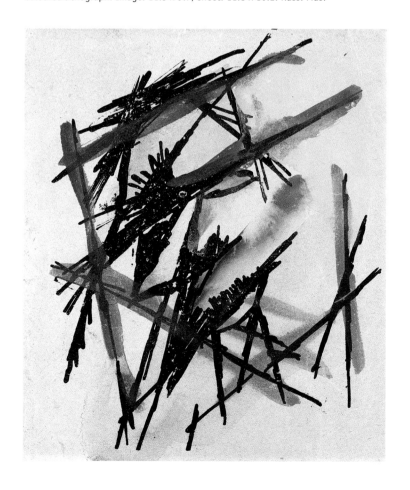

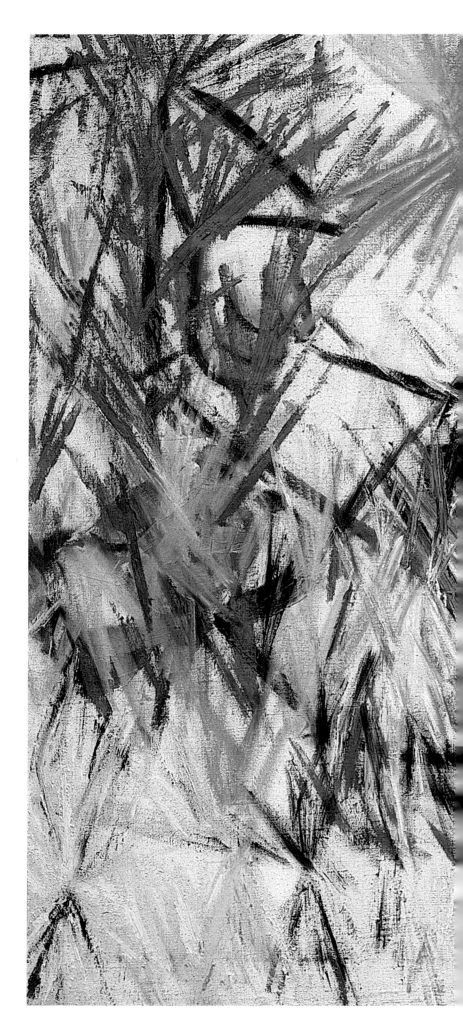

Rayonist Landscape. 1912
Oil on canvas. 71 x 94.5. Russ. Mus.

kazimir MALEVICH

... our world of art has become new, non-objective, pure.
Everything has vanished; all that remains is a mass of material from
which a new form will be constructed.
Forms will live in the art of Suprematism like all living forms of
nature...
A new painterly realism, namely painterly, for in it there is no realism
of hills, sky, water...

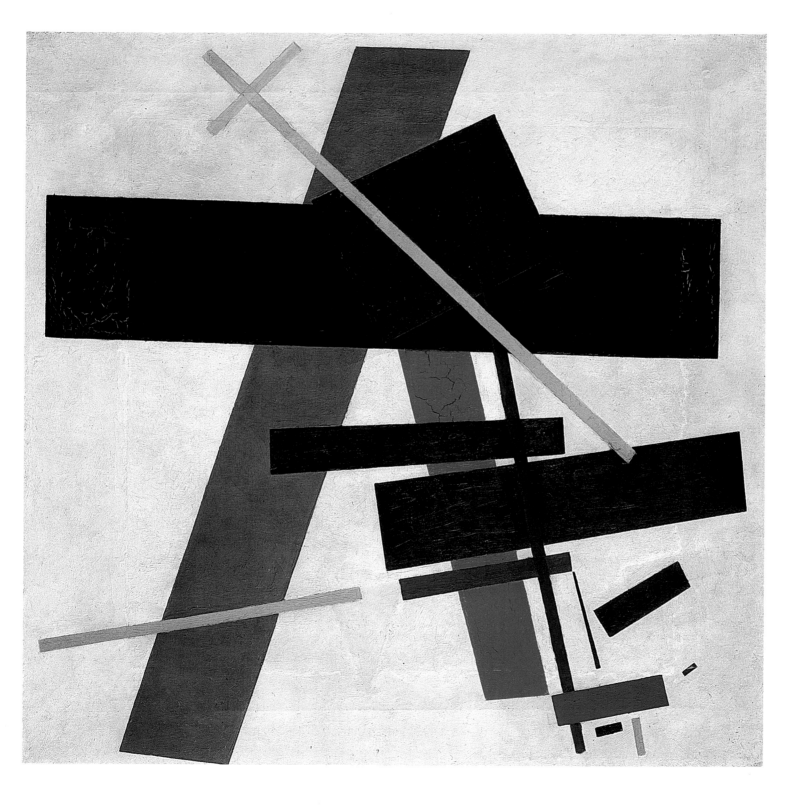

Suprematism. 1915–16
Oil on canvas. 80.5 x 81. Russ. Mus.

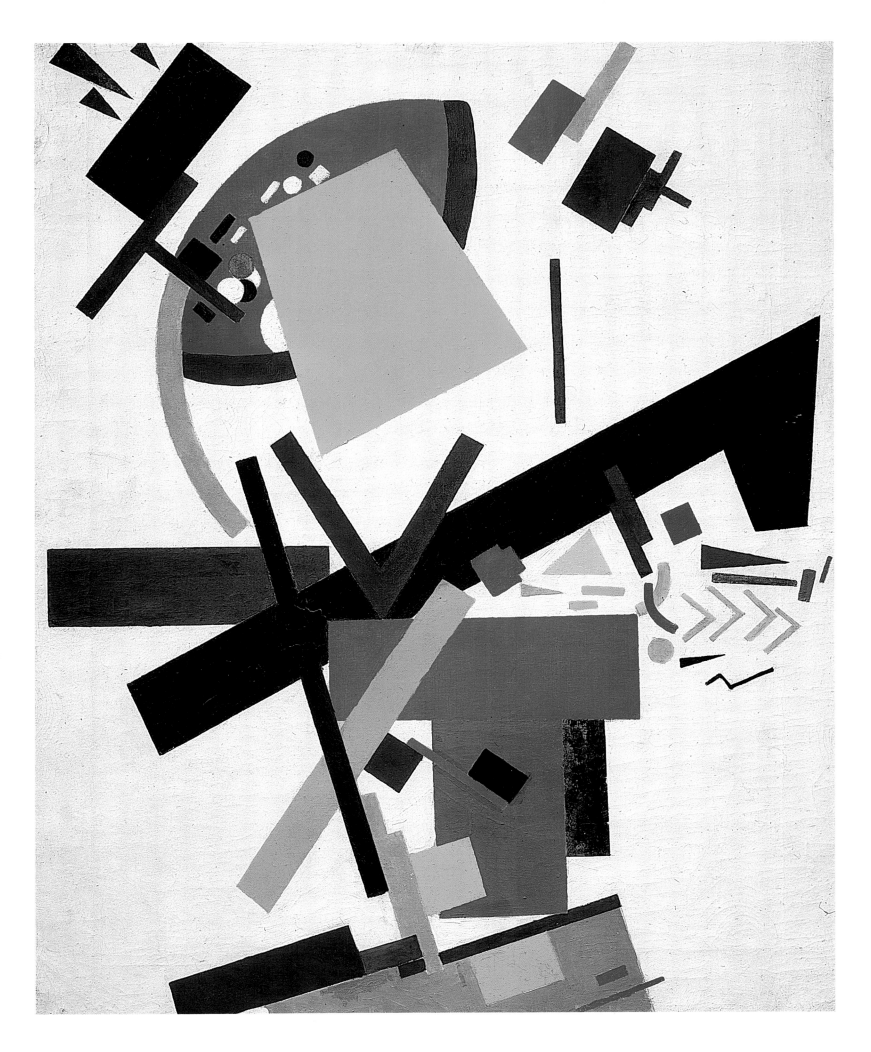

Suprematism. 1915
Oil on canvas. 87.5 x 72. Russ. Mus.

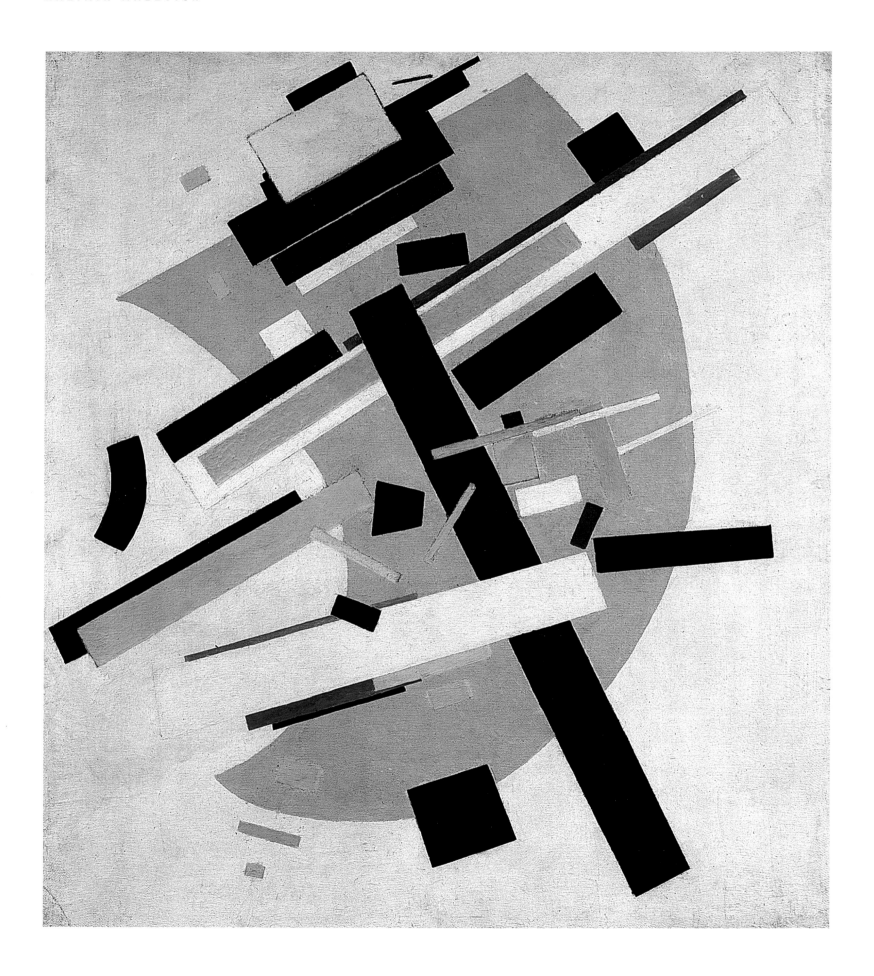

Suprematism (Supremus No. 58). 1916
Oil on canvas. 79.5 x 70.5. Russ. Mus.

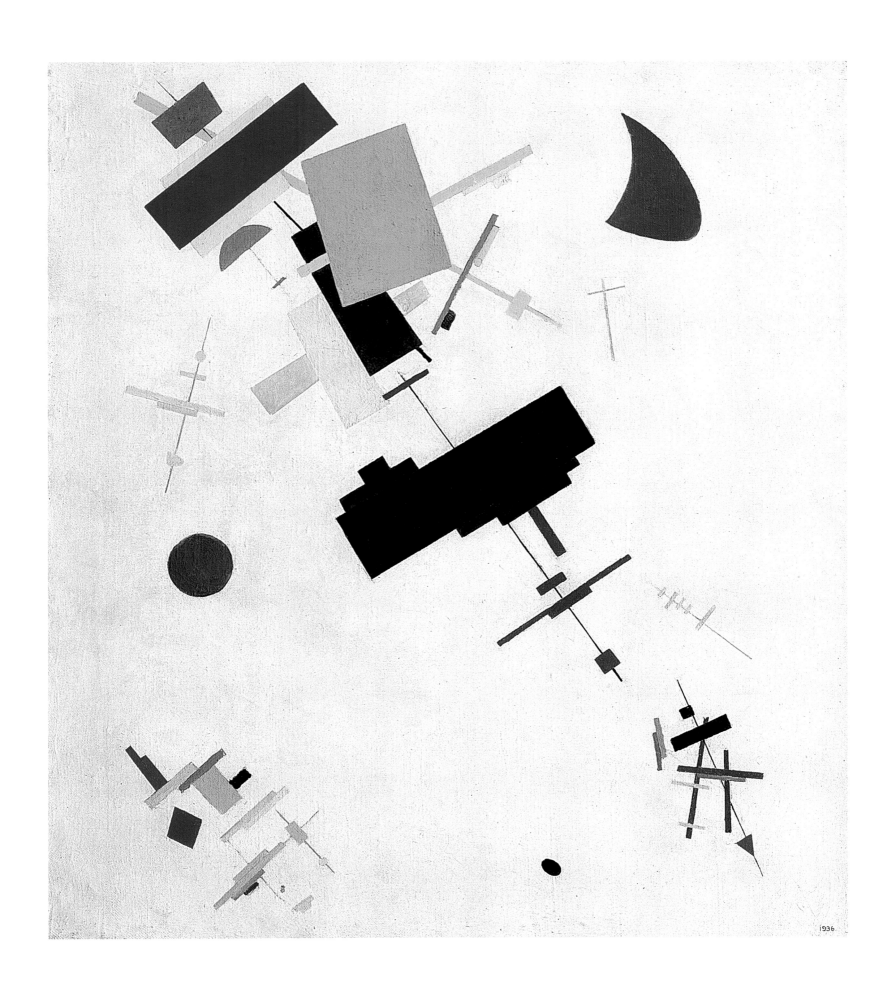

1936

Suprematism (Supremus No. 56). 1916
Oil on canvas. 80.5 x 71. Russ. Mus.

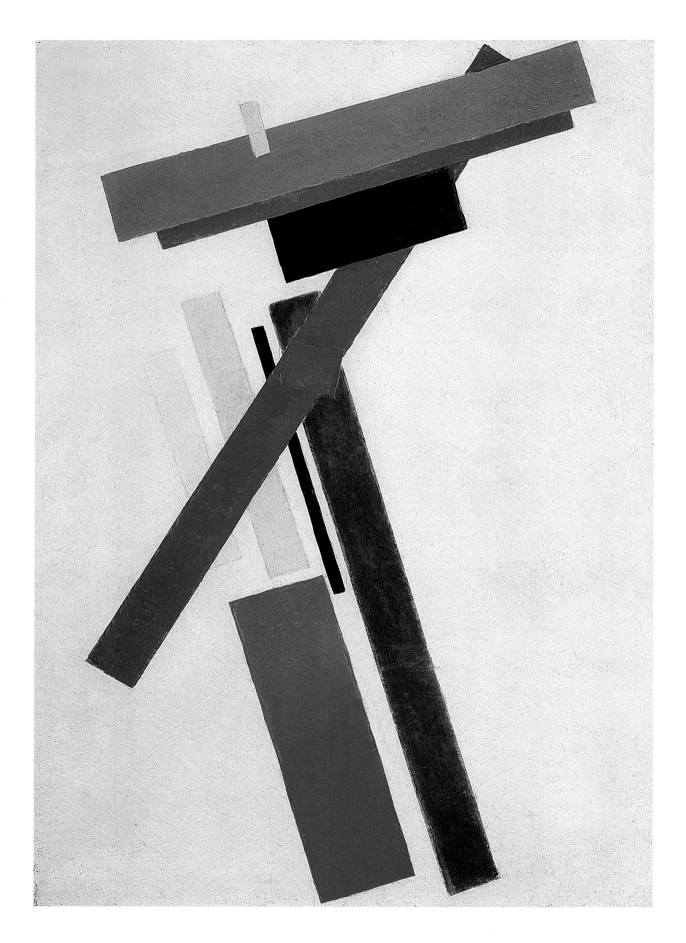

Suprematist Construction of Colour. 1928–29
Oil on plywood. 72 x 52. Russ. Mus.

Suprematism. 1928–29
Oil on plywood. 71 x 45. Russ. Mus.

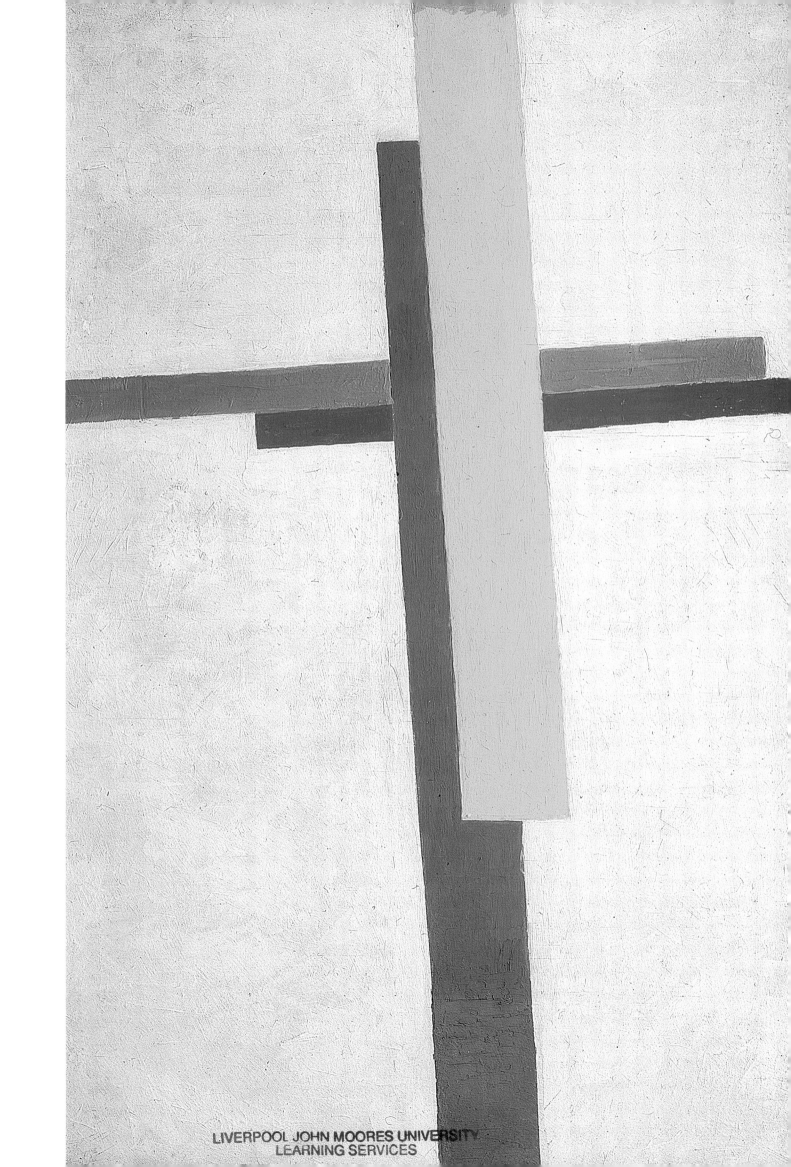

KAZIMIR MALEVICH

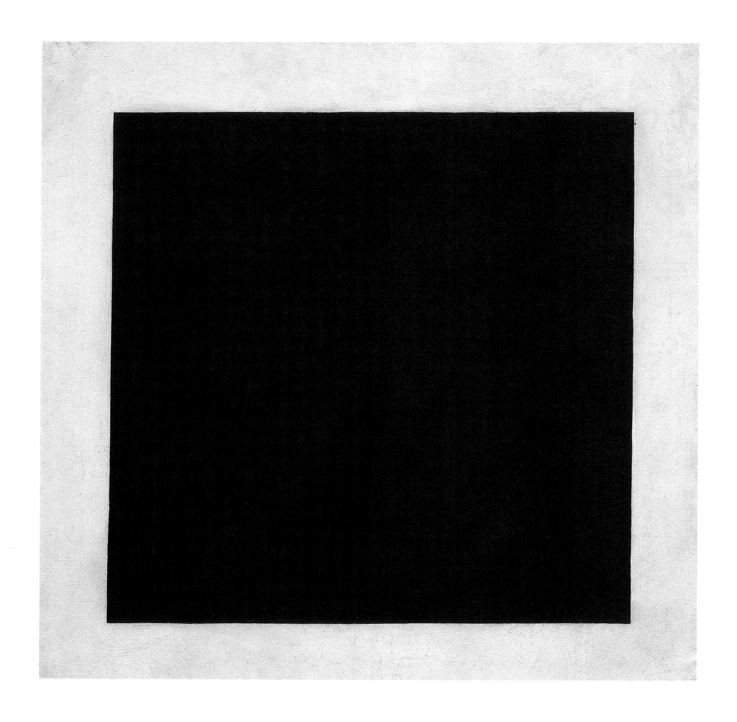

Black Square. Circa 1923
Oil on canvas. 106 x 106. Russ. Mus.

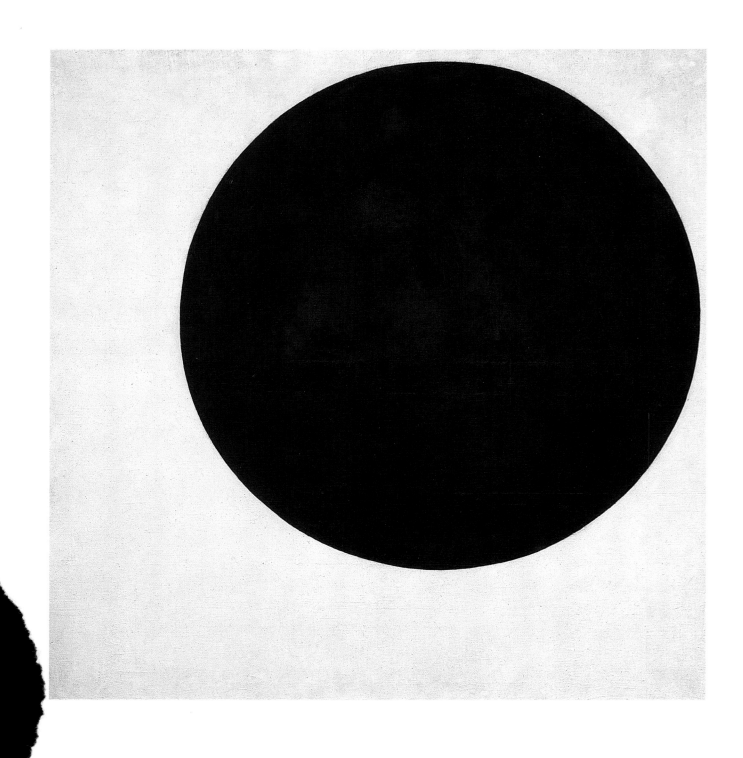

Black Circle. Circa 1923
Oil on canvas. 105 x 105. Russ. Mus.

On pp. 53–55:

Alpha. Architecton. 1920
Plaster. 31.5 x 80.5 x 34. Russ. Mus.

Gota. Architecton. 1923 (?)
Plaster. 85.3 x 56 x 52.5. Russ. Mus.

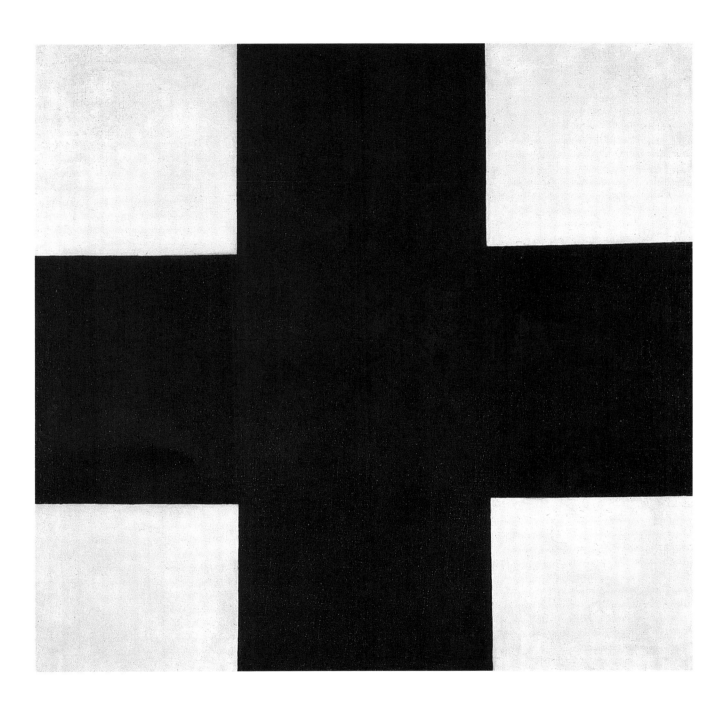

Black Cross. Circa 1923
Oil on canvas. 106 x 106. Russ. Mus.

olga **ROZANOVA**

Non-Objective Drawing. 1913
Sheet from Alexei Kruchenykh's *Duck's Nest of Bad Words*
Coloured lithograph on grey paper. Image/sheet: 17.6 x 12.5. Russ. Mus.

Non-Objective Drawing. 1913
Sheet from Alexei Kruchenykh's *Duck's Nest of Bad Words*
Coloured lithograph on grey paper. Image/sheet: 17.6 x 12.1. Russ. Mus.

Non-Objective Drawing. 1913
Sheet from Alexei Kruchenykh's *Duck's Nest of Bad Words*
Coloured lithograph on grey paper. Image/sheet: 17.6 x 12. Russ. Mus.

Non-Objective Composition (Suprematism). Circa 1916
Oil on canvas. 78.5 x 53. Russ. Mus.

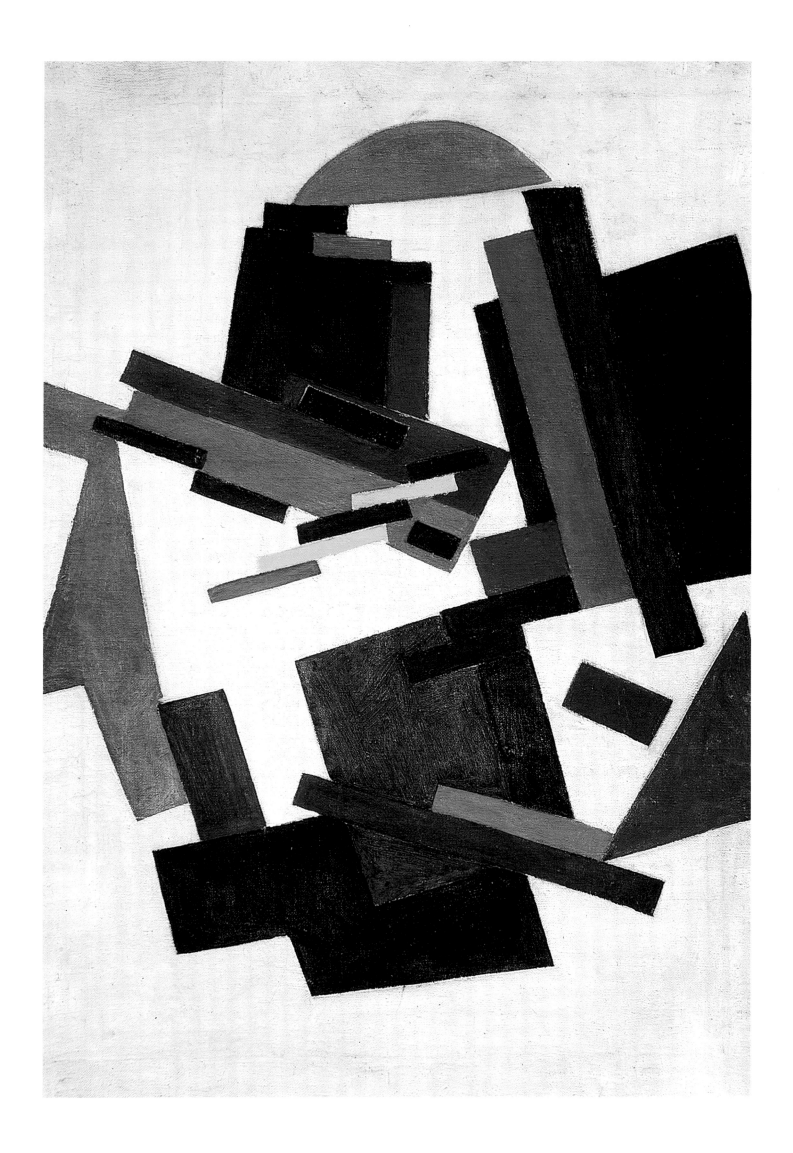

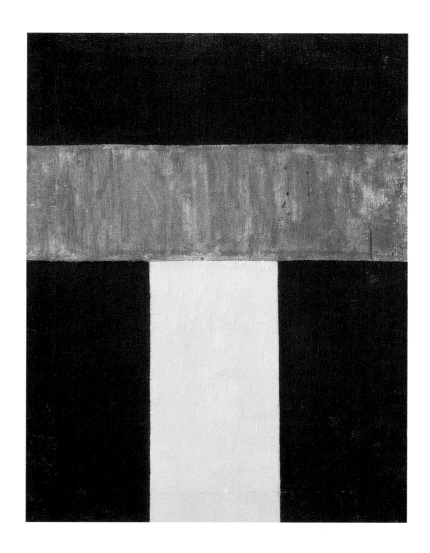

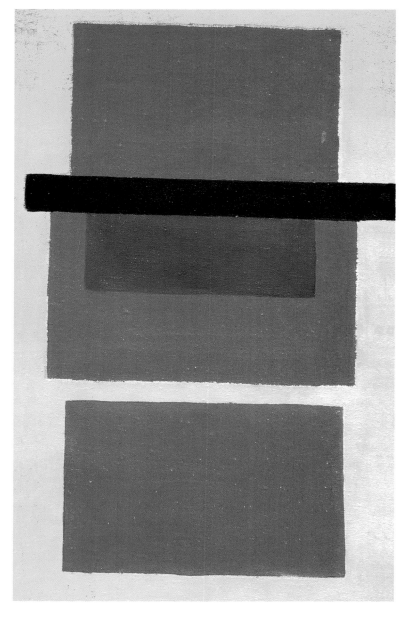

Non-Objective Composition (Suprematism). Circa 1916
Size paint on canvas. 58 x 44. Russ. Mus.

Non-Objective Composition (Suprematism). Circa 1916
Oil on canvas. 62.5 x 40.5. Russ. Mus.

Non-Objective Composition (Suprematism). Circa 1916
Oil on canvas. 85 x 60.5. Russ. Mus.

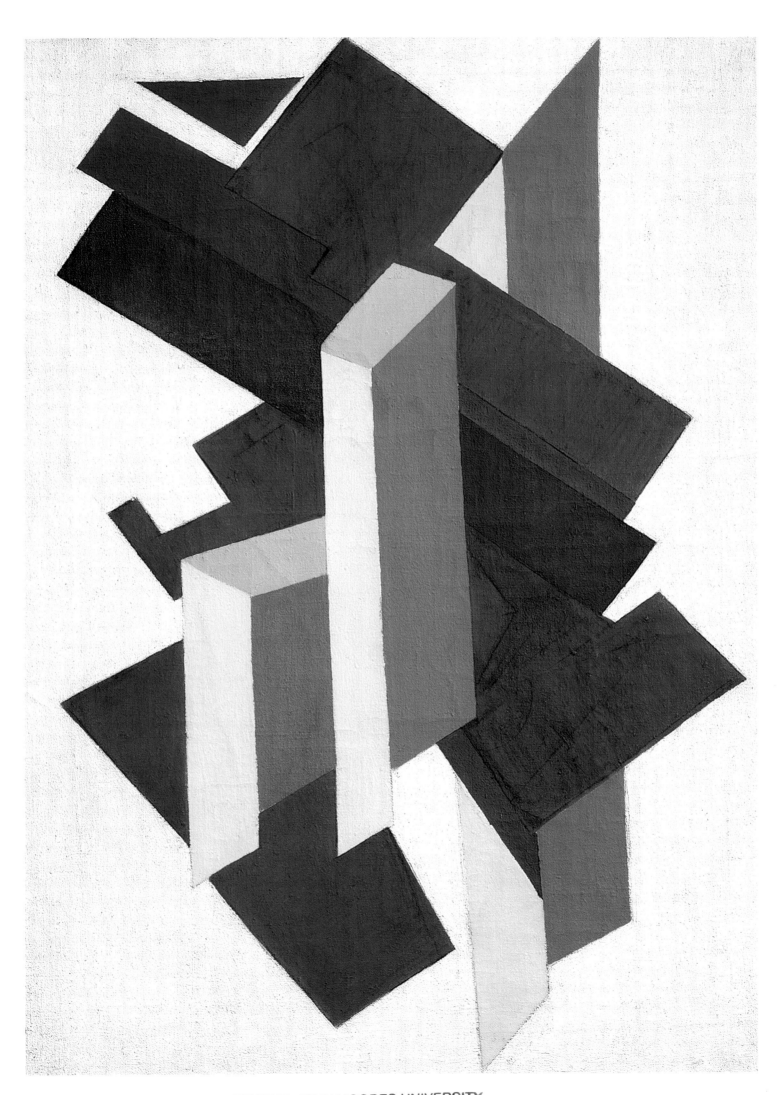

ivan KLIUN

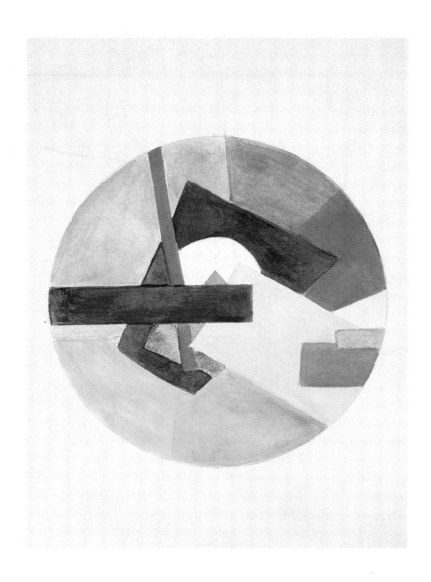

... As the main element of the previous art, colour and paint have not died; they have liberated themselves from the many-centuries bond of nature. They have begun to lead their own lives, to freely develop, to manifest themselves in the New Art of Colour...

Suprematist Drawing. Late 1910s–1921
Graphite pencil and watercolours on paper. 27.7 x 21.8. Russ. Mus.

Non-Objective Composition. 1921
Oil on canvas. 55 x 42.5. Russ. Mus.

Suprematism. 1915
Oil on canvas. 64.7 x 53.5. Russ. Mus.

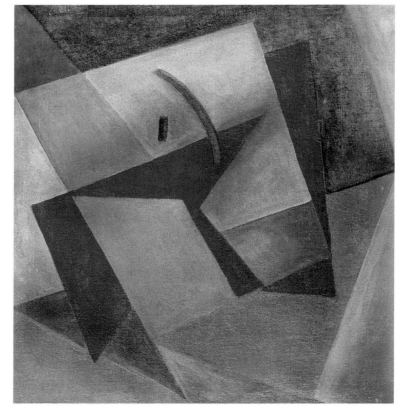

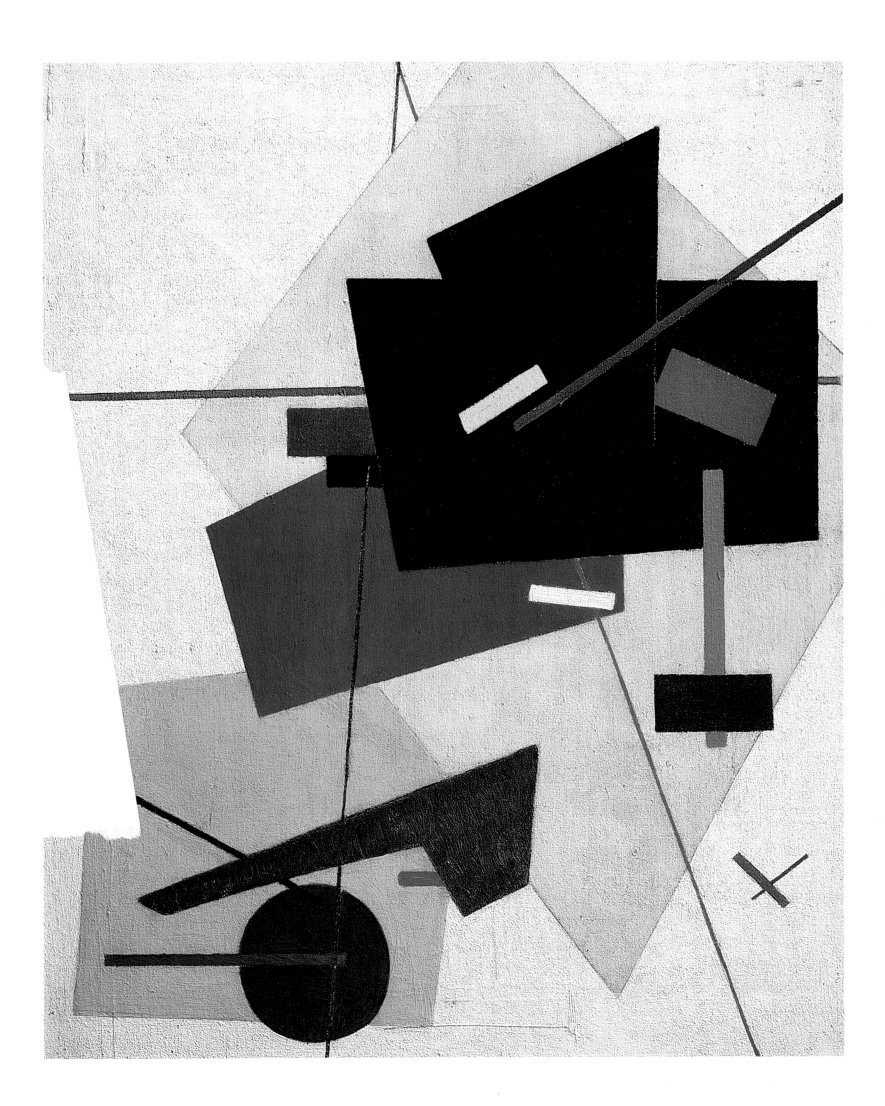

natalia **GONCHAROVA**

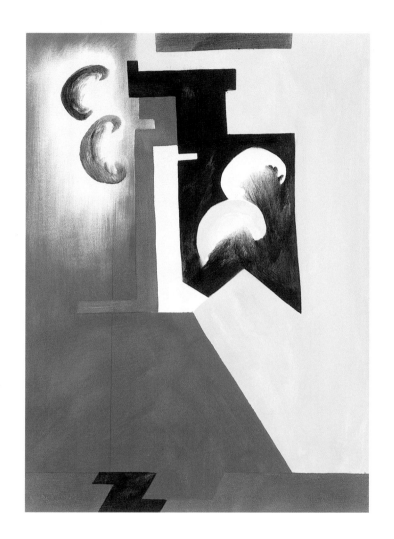

The creative laws within the bounds of colour begin where its timbres are studied and where colour is based on its timbres and tensions... A new form is based on the laws of form, but, of course, by the creative will of the artist. Such forms are not objective in relation to things existing on earth, but are in actual fact ultra-realistically objective. They are therefore based on the laws of pure form ... I confine myself to the bounds of only painting, to the bounds of what, without the designation of form and the state of this form (i.e. its material, because this is the state, if the world is regarded as energy), is tinted any colour.

Non-Objective Geometric Composition. 1920s–30s
Stencilled gouache on paper. 37.6 x 27. Russ. Mus.

Untitled. Mid-1910s
Oil on canvas. 26.6 x 47. Judith Rothschild Foundation, USA

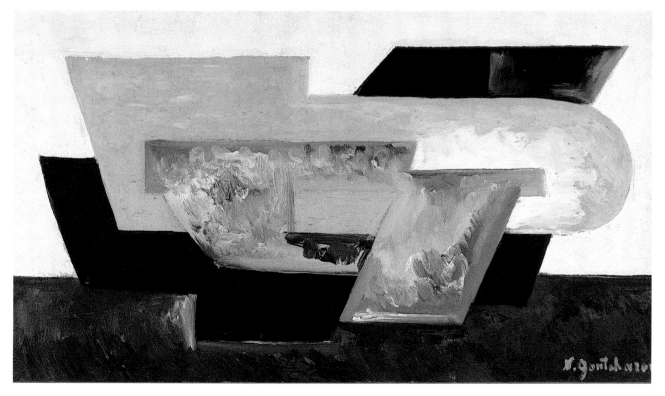

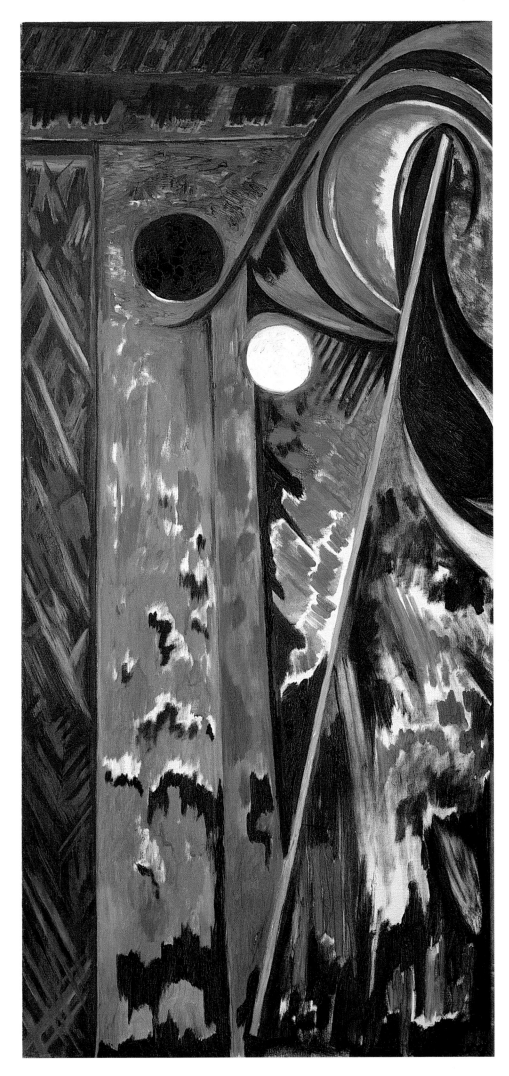

Abstract Composition. Mid-1910s
Oil on canvas. 117 x 52. Private collection, USA

alexandra **EXTER**

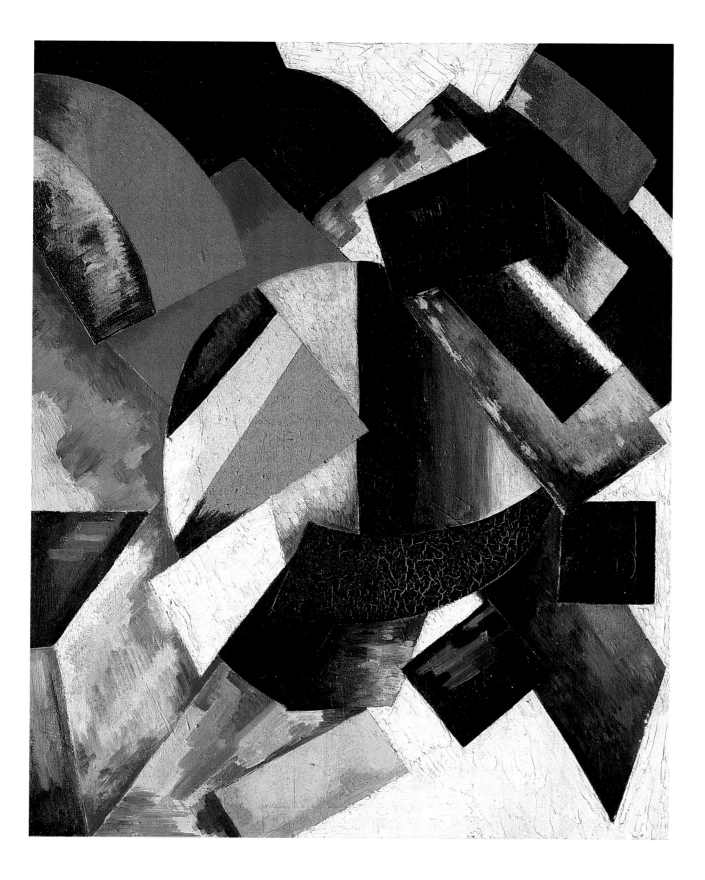

Non-Objective Composition. 1917–18
Oil on canvas. 88 x 70. Russ. Mus.

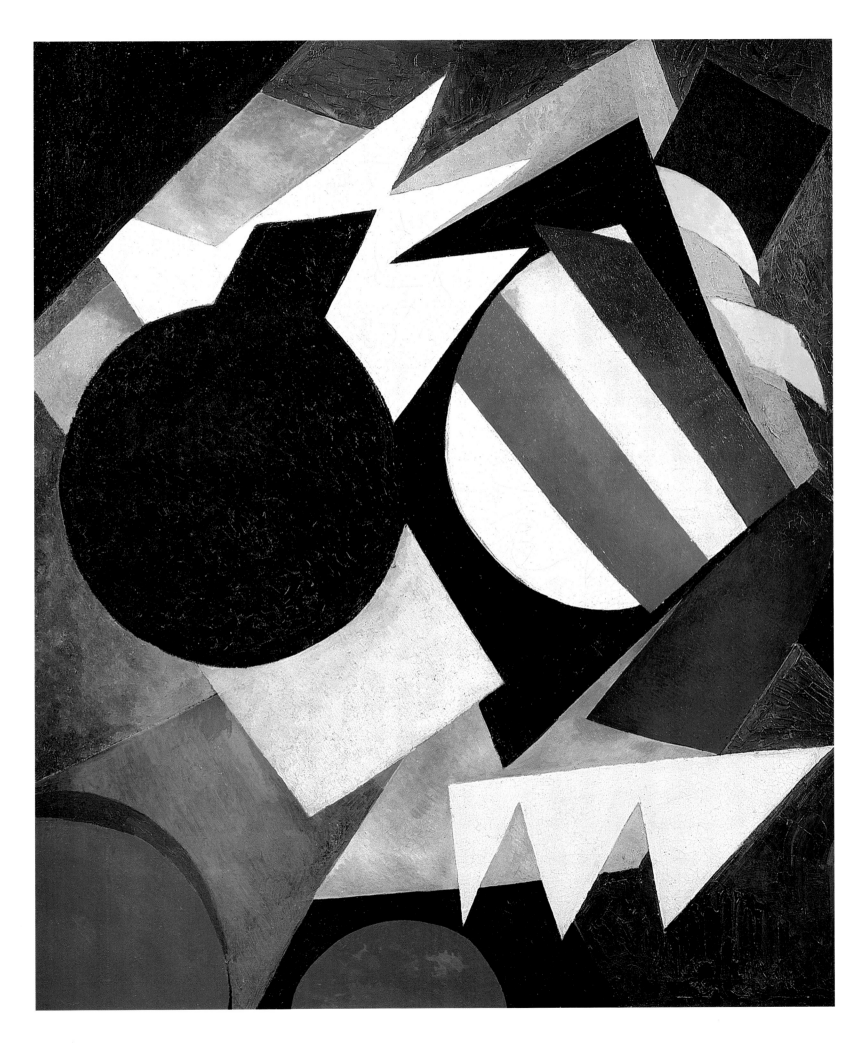

Constructive Still-Life. 1920–21
Oil on canvas. 121 x 100. Russ. Mus.

lyubov **POPOVA**

From an analysis of the volume and space of objects (Cubism) to the organisation of elements, not as means of representation, but as integral constructions (be they colour-planar, volumetric-spatial or other material constructions).

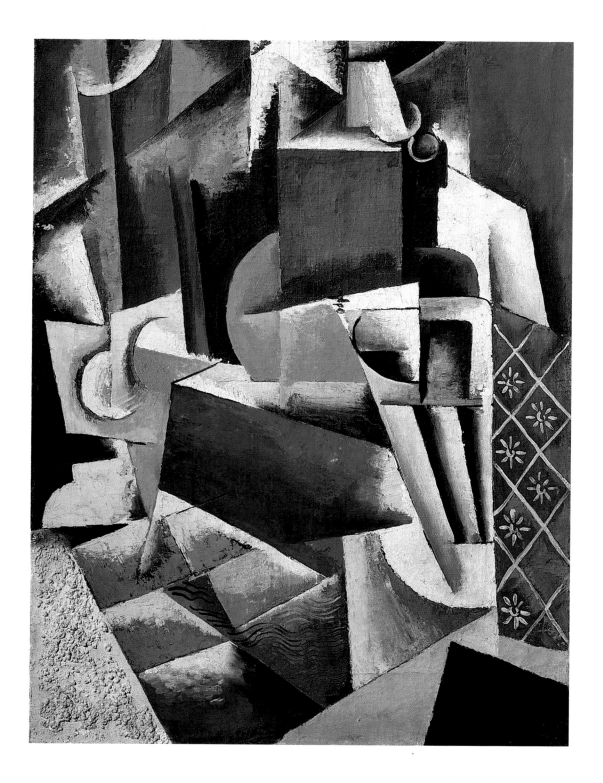

Grocer's Shop. 1916
Oil on canvas. 71.5 x 53.5. Russ. Mus.

Painterly Architectonics. 1916
Oil on canvas. 51 x 33. Russ. Mus.

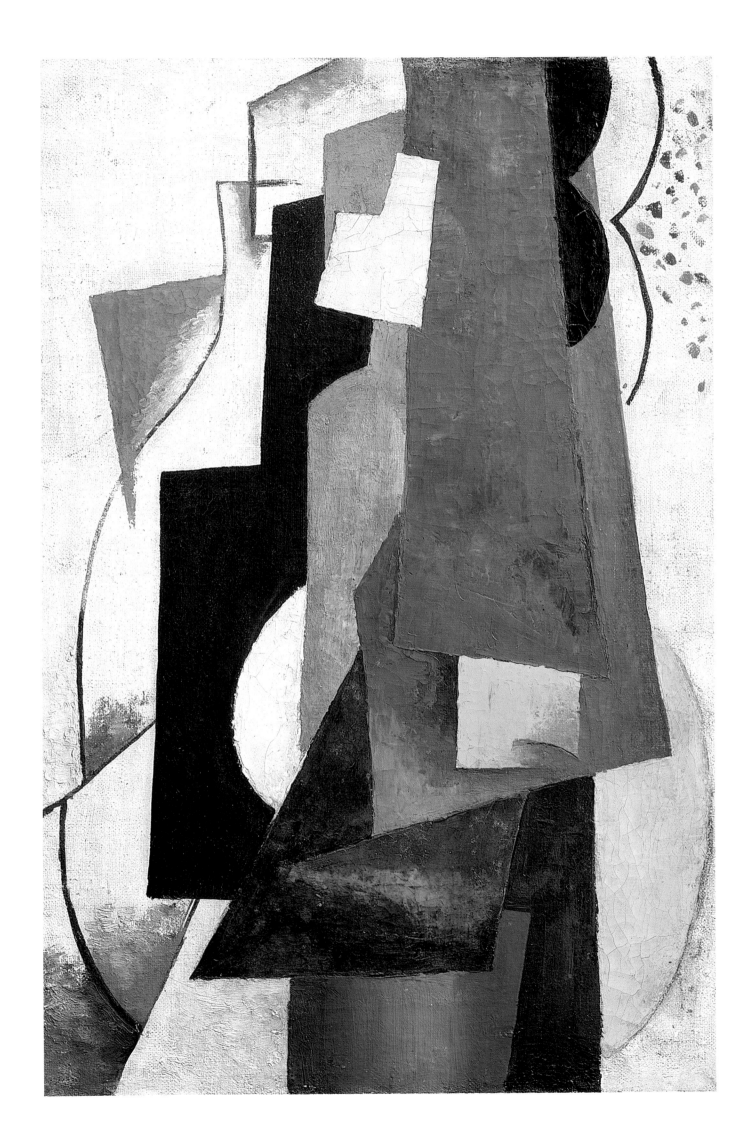

nadezhda UDALTSOVA

In pure, cold space they fly; pure forms thrown into a rapid run, colliding and jostling, or in a state of inner dynamism, manifest themselves as the static development of colour. Form is colour. A composition of colour relations. (From the artist's diary, 1916)

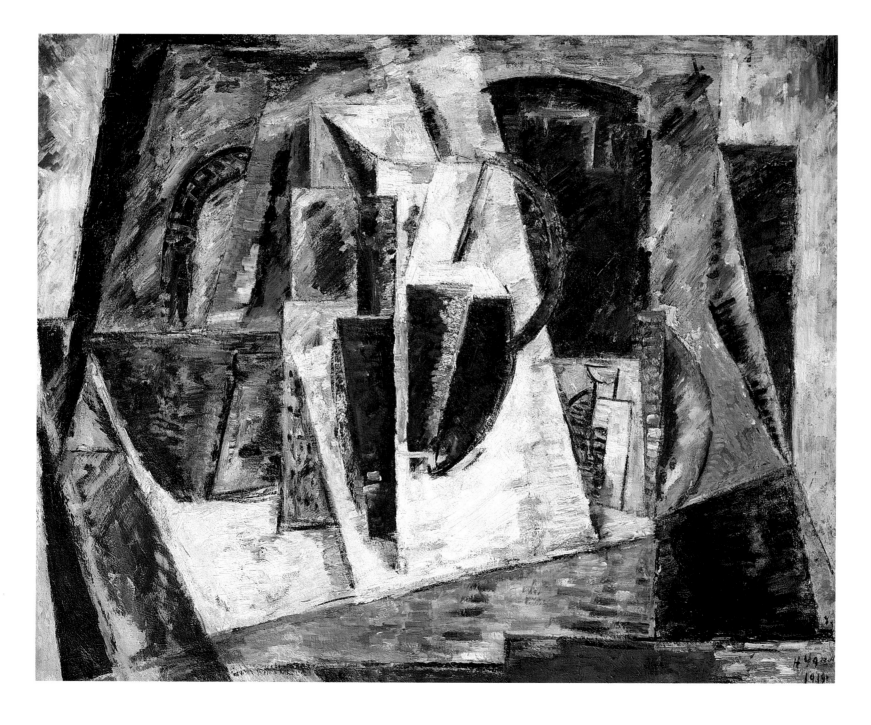

Still-Life. 1919
Oil on canvas. 92 x 108. Russ. Mus.

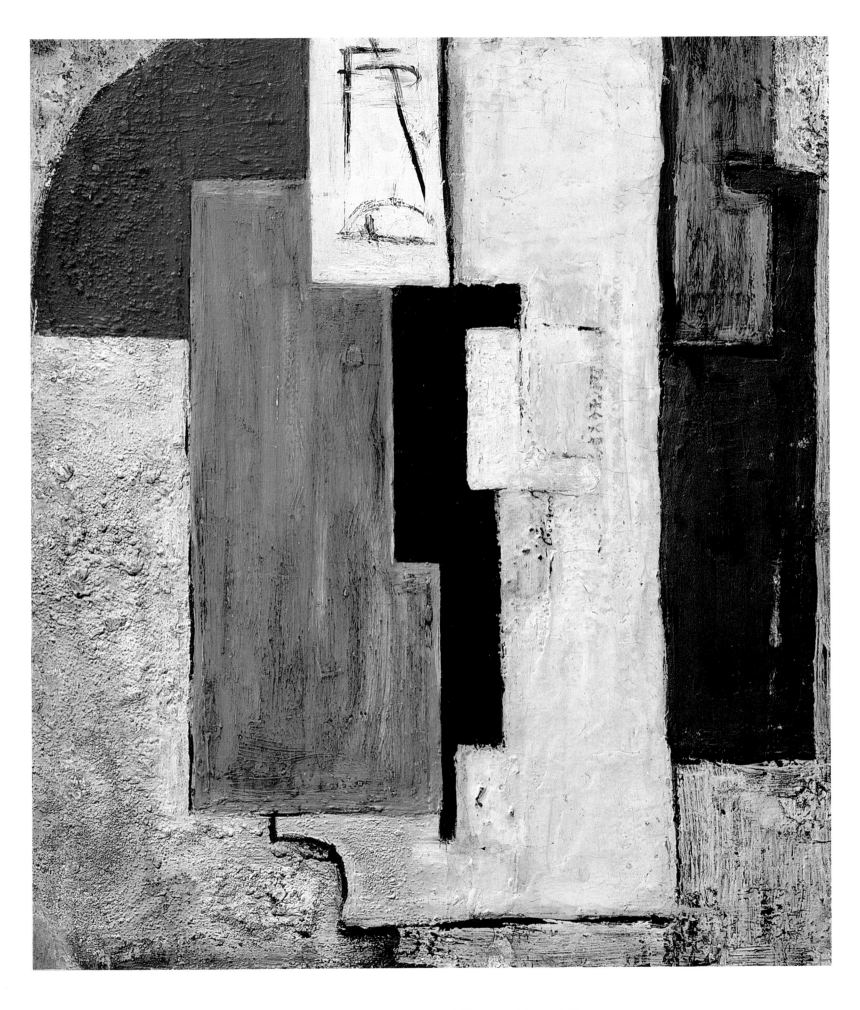

Cubist Composition. 1915 (?)
Oil on cardboard. 51 x 44. Russ. Mus.

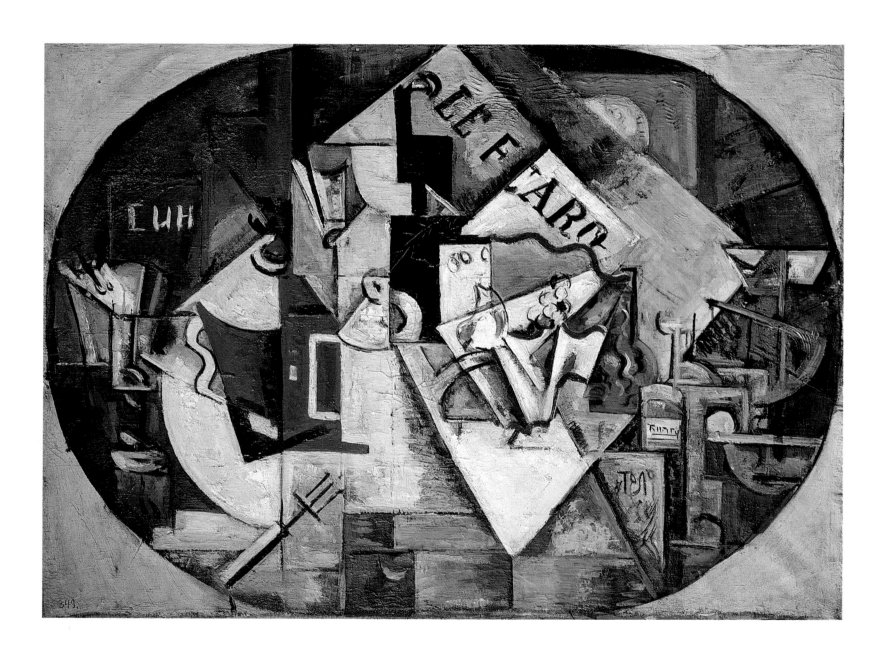

Still-Life. 1914–15
Oil on canvas. 67 x 89. Russ. Mus.

Artist's Model. Cubist Construction. 1914
Oil on canvas. 106 x 71. Russ. Mus.

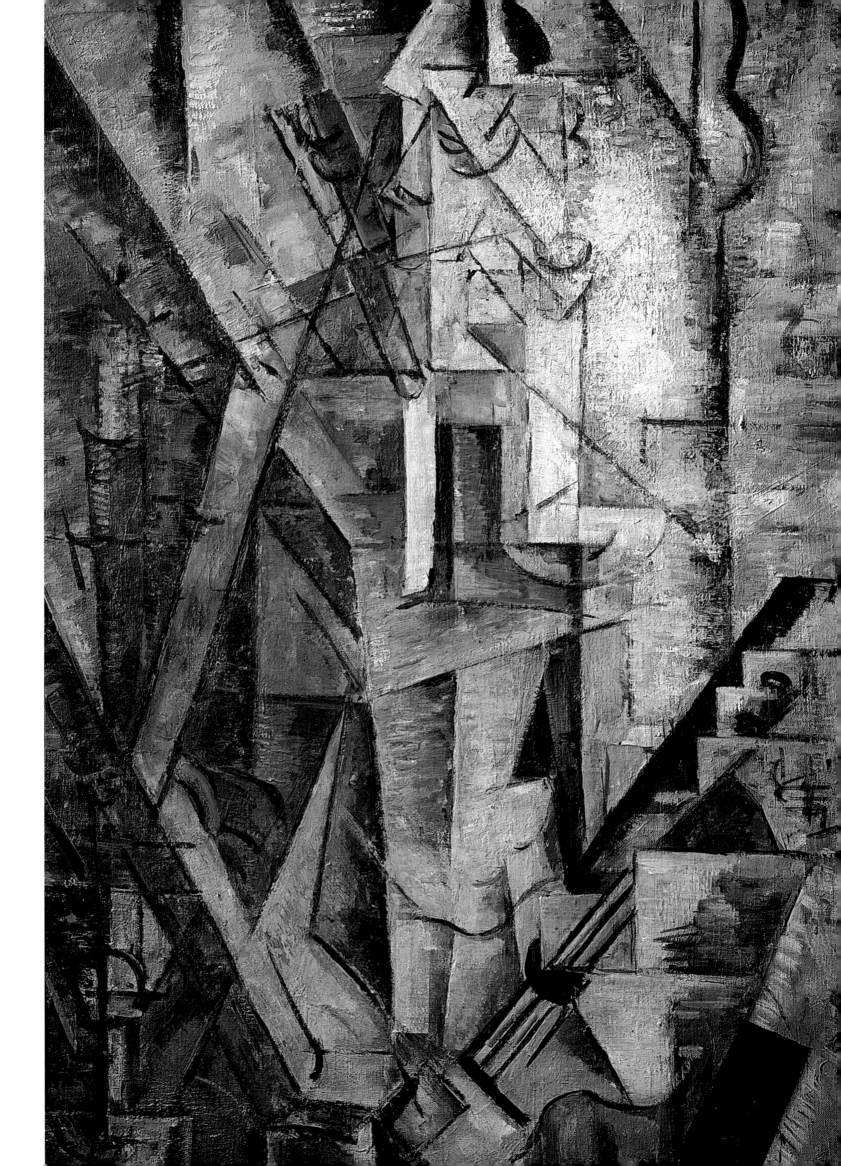

sergei **SENKIN**

A student of Kazimir Malevich in the early 1920s, Sergei Senkin created a series of non-objective painterly compositions and spatial models that might be termed free variations on the "themes" of Suprematism. (O. S.)

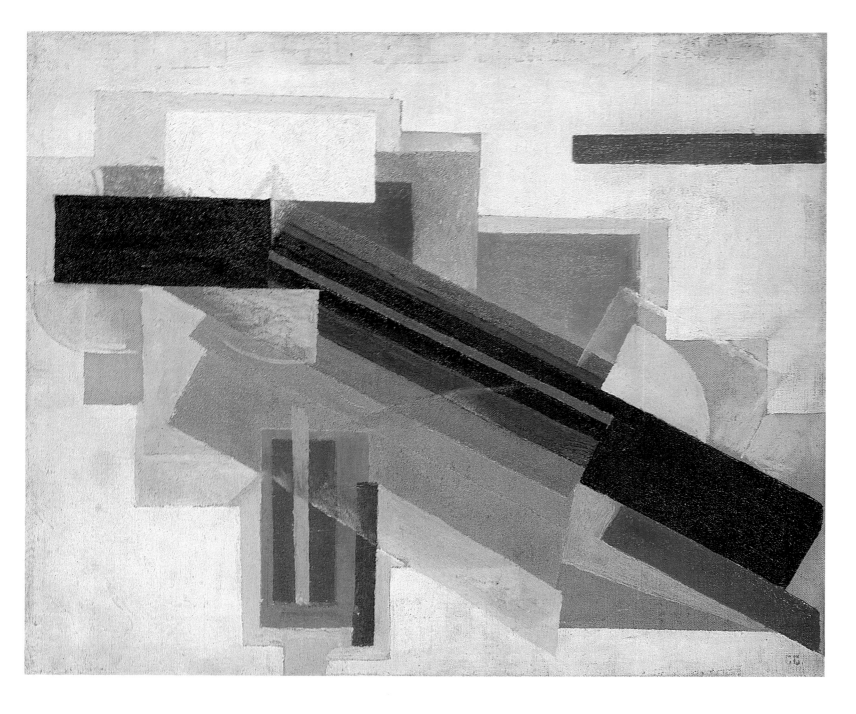

Suprematism. 1922
Oil on canvas. 37 x 45. Russ. Mus.

Suprematism. 1922
Oil on glass. 36.5 x 28. Russ. Mus.

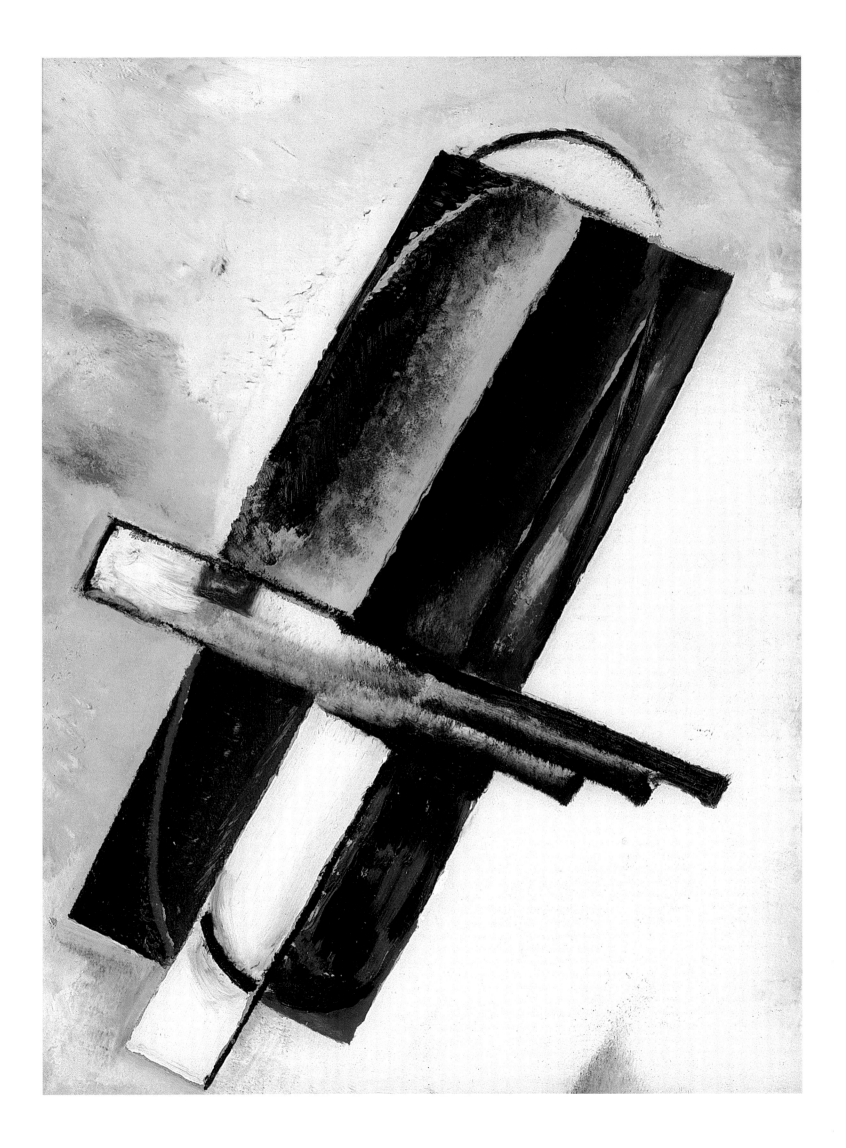

nikolai **SUETIN**

Touching through the formal element leads to the formation of a concept of the world, not in parts, but in fusion...

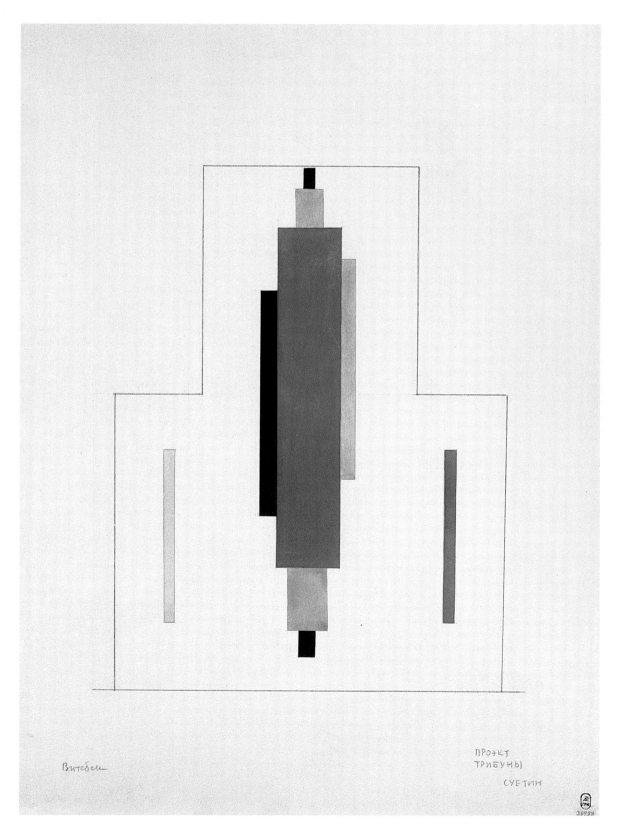

Rostrum Design. Vitebsk. 1920–21
Coloured ink and gouache on paper. 44 x 31.8. Russ. Mus.

Mural Design. Vitebsk. 1920
Coloured ink on paper. 20.3 x 18.2. Russ. Mus.

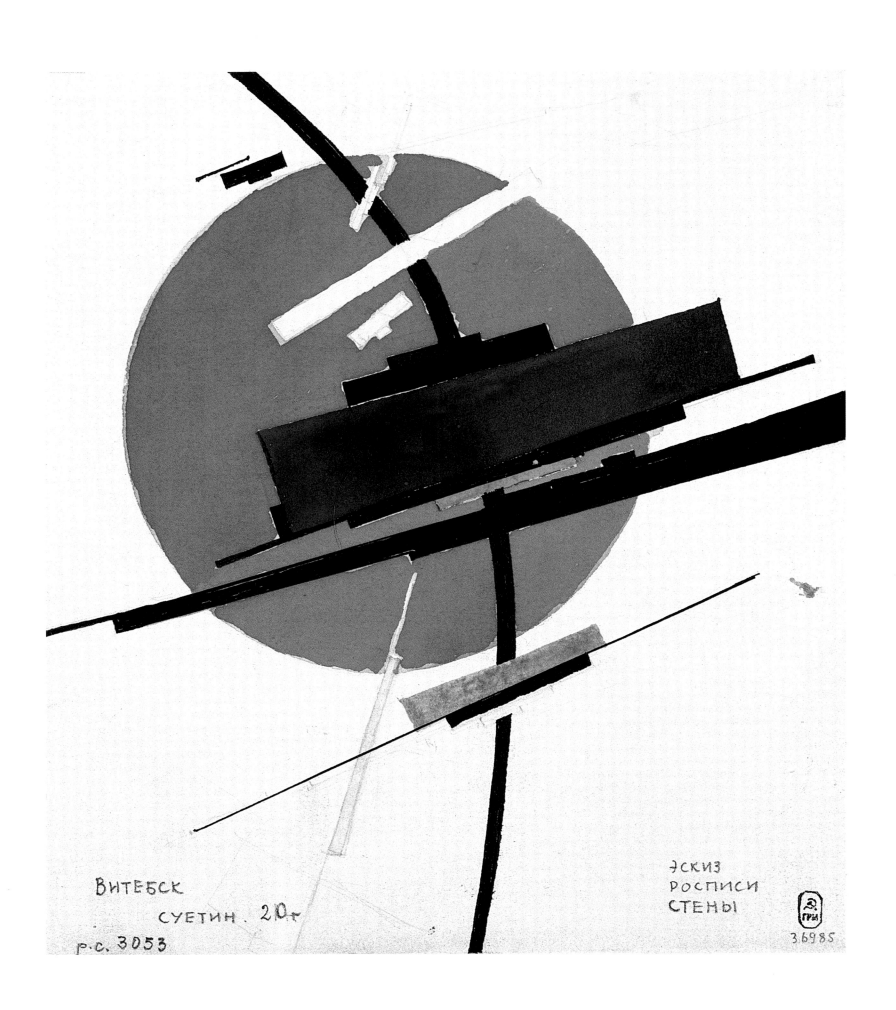

ВИТЕБСК

СУЕТИН . 20г

р.с. 3053

ЭСКИЗ
РОСПИСИ
СТЕНЫ

36985

pavel FILONOV

I know ... see and intuit that in any object are not two predicates, form and colour, but a whole world of visible or invisible phenomena, their emanations, reactions, inclusions, genesis, existence and known or secret attributes which have, in turn, often endless predicates. I reject the doctrine of modern realism and all its right-left sects as non-scientific and dead.

Composition. 1928–29 (?). Unfinished
Oil on canvas. 71 x 83. Russ. Mus.

Formula of Cosmos. 1918–19
Oil on canvas. 98 x 71. Russ. Mus.

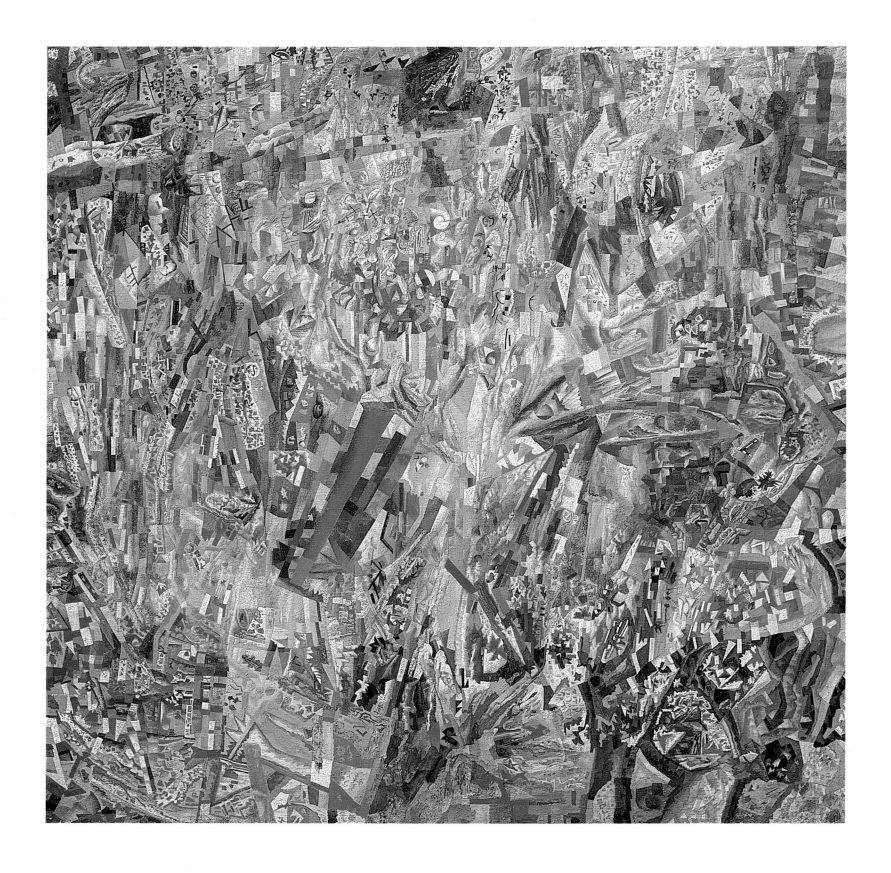

Formula of Spring. 1922
Oil on canvas. 100 x 100. Russ. Mus.

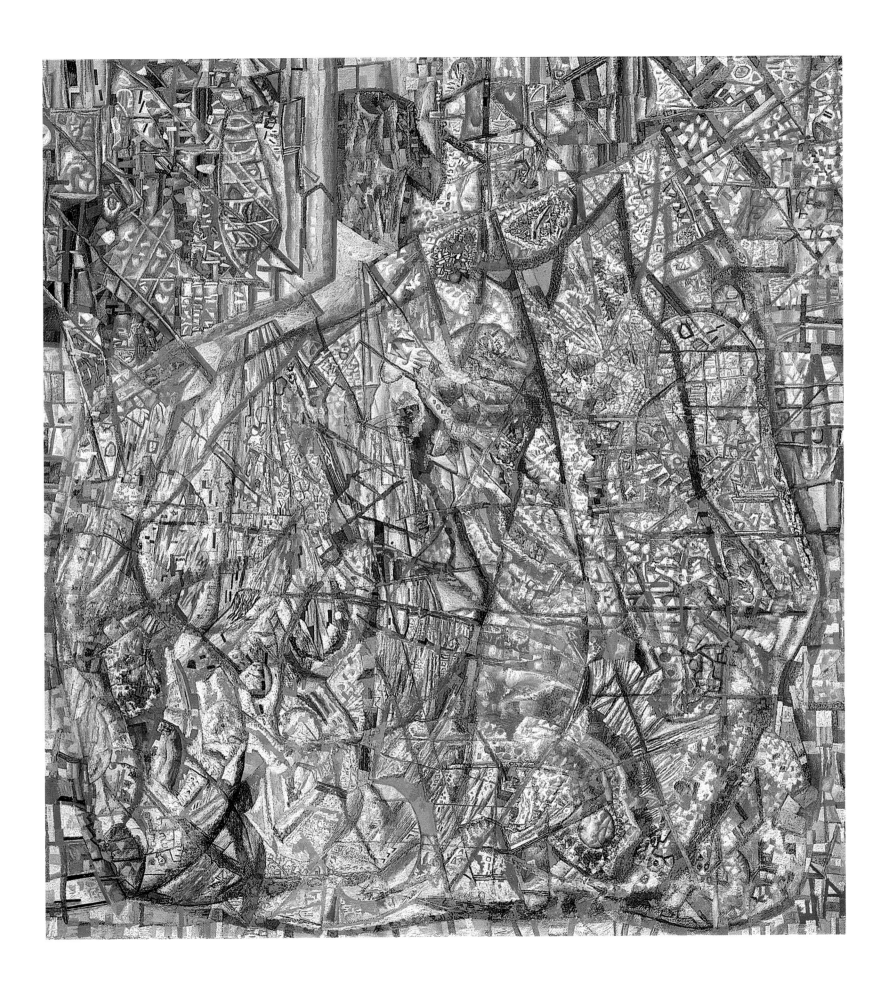

Composition. 1920 (?)
Oil on canvas. 74 x 67. Russ. Mus.

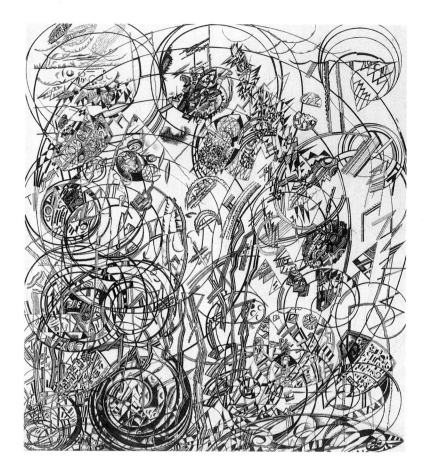

Non-Objective Composition. 1920s
Watercolours, ink and quill on paper. 19.4 x 16.2. Russ. Mus.

Untitled. Non-Objective Composition. 1924
Ink, quill, brush and graphite pencil on paper. 32 x 28.6. Russ. Mus.

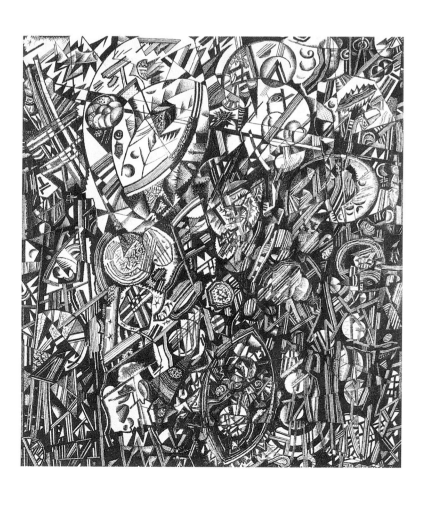

Non-Objective Composition. 1920s
Ink, quill and brush on paper. 46 x 43. Russ. Mus.

alexander **BOGOMAZOV**

*Art is the perfect rhythm of the elements surrounding it. The artist is
a sensual resonator bringing out the painterly differentiation.*

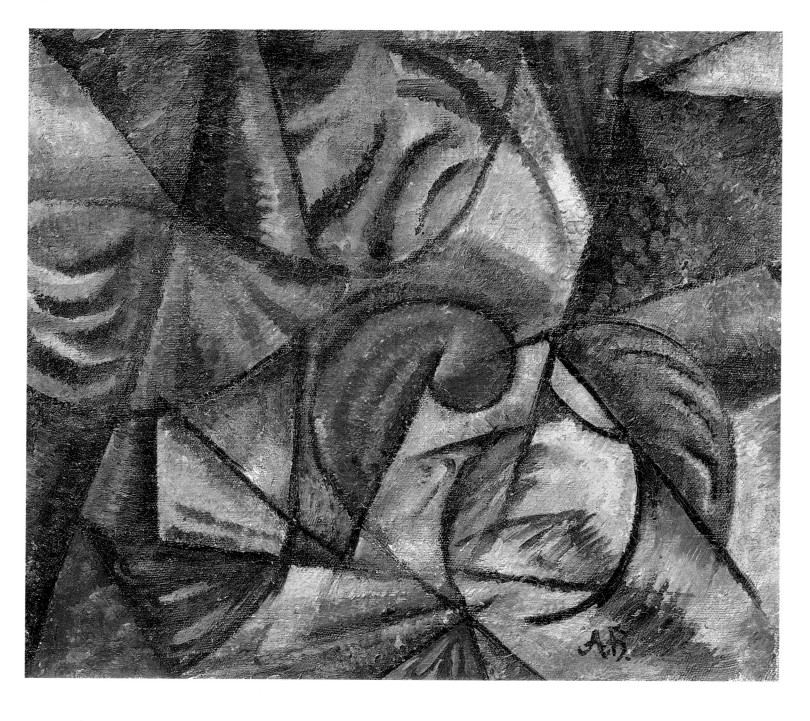

Non-Objective Composition. 1915–16
Oil on canvas. 38 x 43. Russ. Mus.

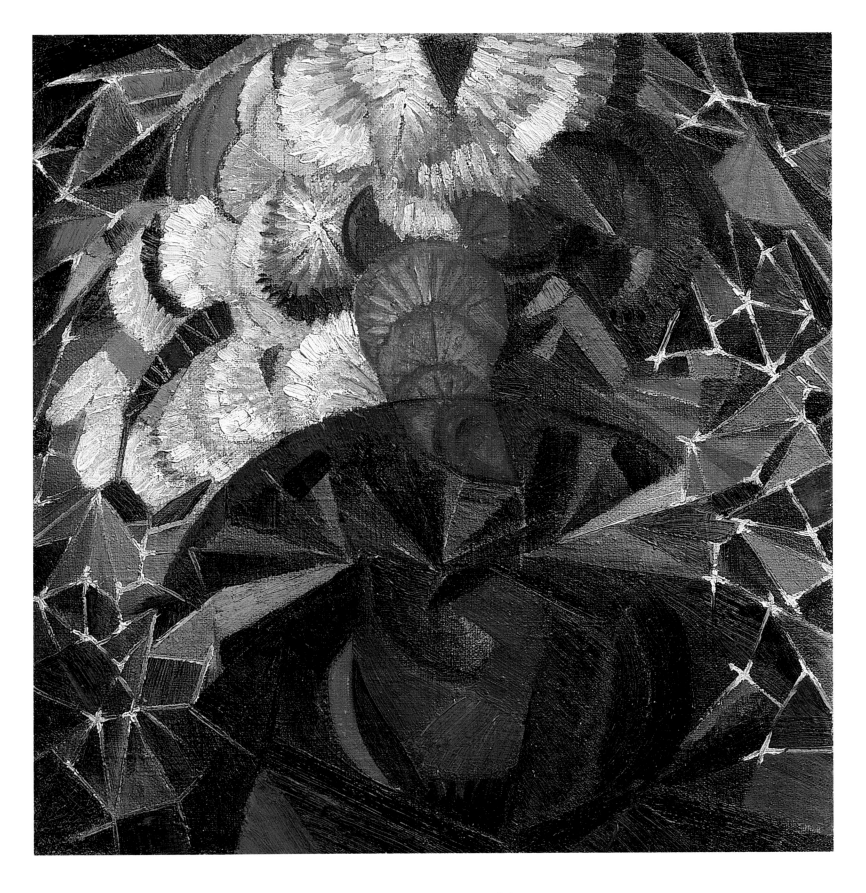

Bouquet of Flowers. 1914—15
Oil on canvas. 39.5 x 40.5. Russ. Mus.

mikhail MATIUSHIN

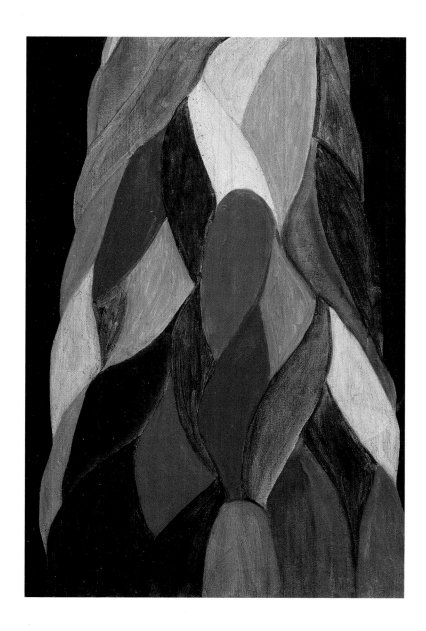

I was the first to raise the sign of the return to nature, which the left-wingers and the new in art, stupefied and benumbed by the West, cannot do.

Movement in Space. 1918
Oil on canvas. 85.2 x 59. Russ. Mus.

Flower of Man. 1918
Watercolours and coloured gouache on paper. 26 x 22.3. Russ. Mus.

Movement in Space. Before 1923
Oil on canvas. 124 x 168. Russ. Mus.

boris **ENDER**

What is called abstract or non-objective painting is the aspiration to bring out the essence of the painterly approach to the representation of an object.

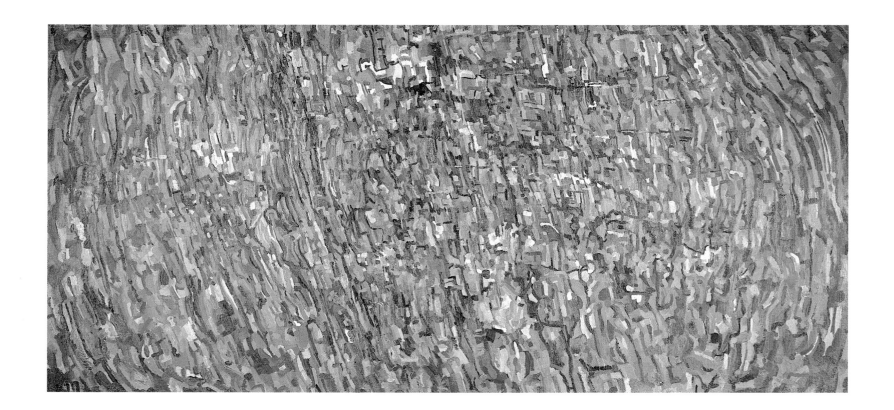

Composition (Colours of Nature). 1917 (?)
Oil on canvas. 98 x 207.5. Russ. Mus.

Colour Composition. 1921
Oil on canvas. 46 x 41.5. Russ. Mus.

nikolai **YEVGRAFOV**

One living stroke, one correct colour, are worth a hundred unclearly expressed canvases ... The most expressive relationships are the relationships of the colour of the shade to the colour of the light. (From the artist's diary, 1940)

Carnival (Version). Late 1930s
Oil on canvas. 80 x 117. Russ. Mus.

maria **ENDER**

Besides the deformation of the model itself, we observe one more typical phenomenon – the impact of the main form on the neutral surrounding environment, which loses its neutrality under the influence of this form and manifests the tendency for a completely definite form, which always contrasts the main form. With the help of the received materials, we have succeeded in showing with all clarity the appearance of a new form contrasting the elementary model form.

Experience of a New Spatial Dimension. 1920
Oil on canvas. 67 x 67. Russ. Mus.

paul MANSOUROFF

I shall not cease to affirm that aesthetics (art) is the property of the savage. Through the austere system of Cubo-Suprematism we have an exit (from abstraction) into Technique.
Only Technique (Utilitarianism – Economy) is the engine of life. Its victory – our Freedom – Freedom of Animals. (From a letter written by the artist, 1973).

Painterly Formula. 1927
Oil on wood. 63 x 131.5. Galerie Gmurzynska, Germany

Five Balls. 1928
Pencil on paper. 56 x 45
Galerie Gmurzynska, Germany

Composition (Untitled). 1934
Oil on canvas. 97.5 x 23
Galerie Gmurzynska, Germany

Painterly Formula. 1927
Oil on wood. 132.5 x 36
Galerie Gmurzynska, Germany

Painterly Formula. 1927
Oil on wood. 78 x 22.5. Russ. Mus.

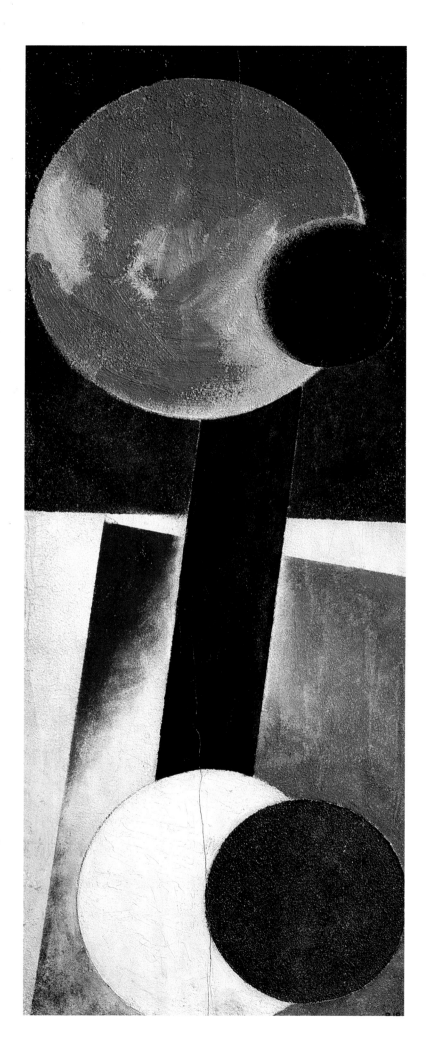

alexander **RODCHENKO**

... I have taken painting to the logical end and exhibited three canvases – red, blue and yellow – affirming:
Everything is over. The basic colours. Every plane is a plane, and there should not be any representations.
(From the artist's memoirs, 1939)

Non-Objective Composition. 1918
Oil on wood. 53 x 21. Russ. Mus.

Composition (No. 56). Red and Yellow. 1918 (?)
Oil on canvas. 90 x 62. Russ. Mus.

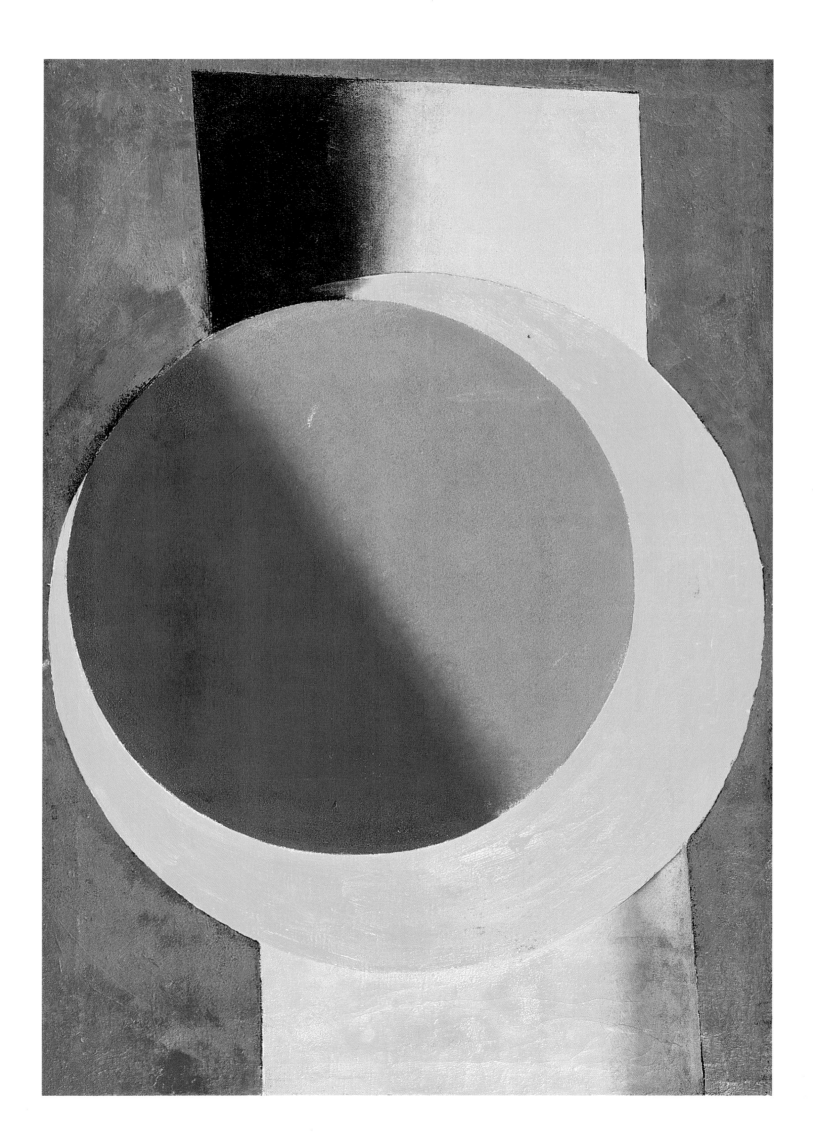

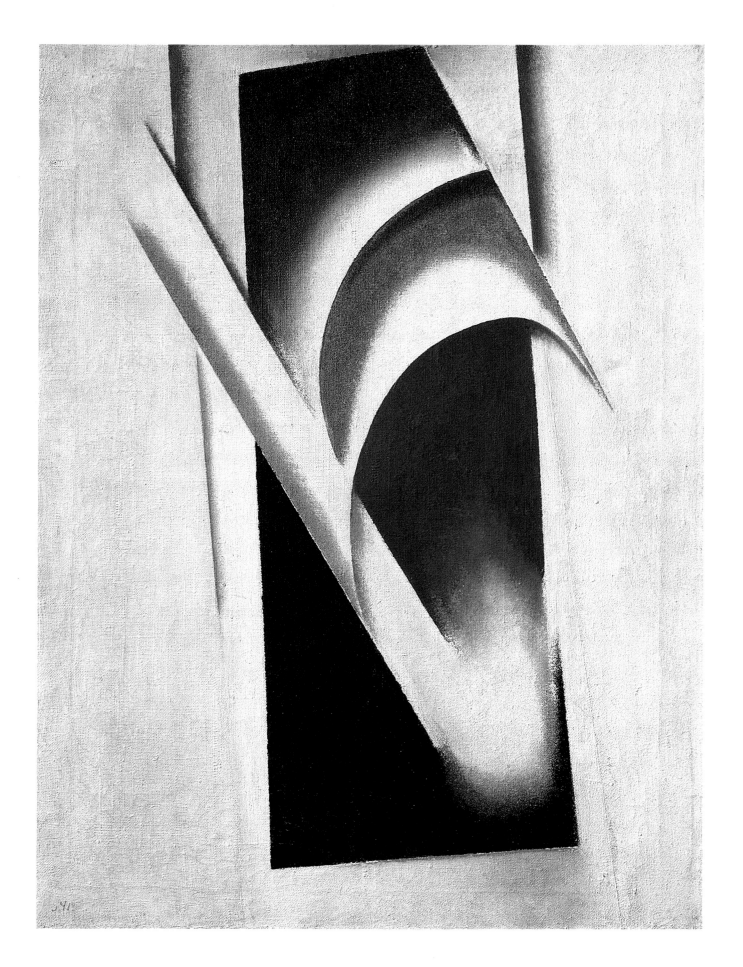

Non-Objective. 1918
Oil on canvas. 71.5 x 52.8. Russ. Mus.

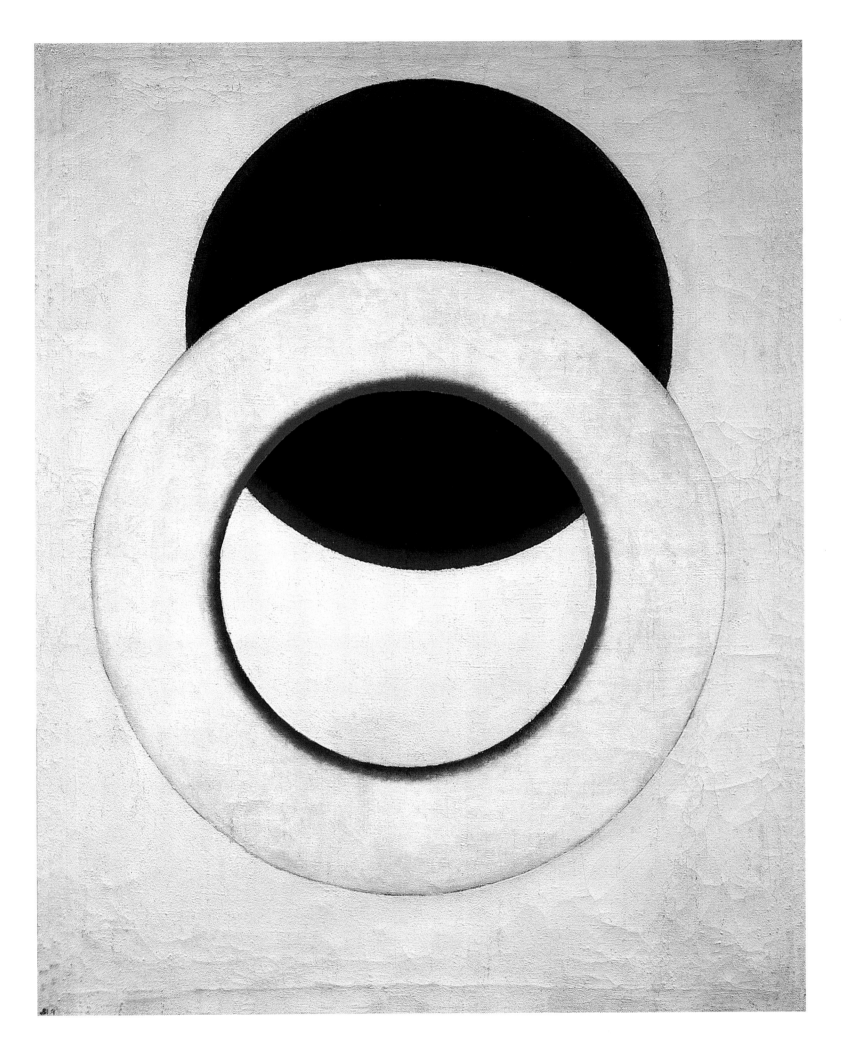

White Circle. 1918
Oil on canvas. 89.2 x 71.5. Russ. Mus.

...The object's freedom from meaning...

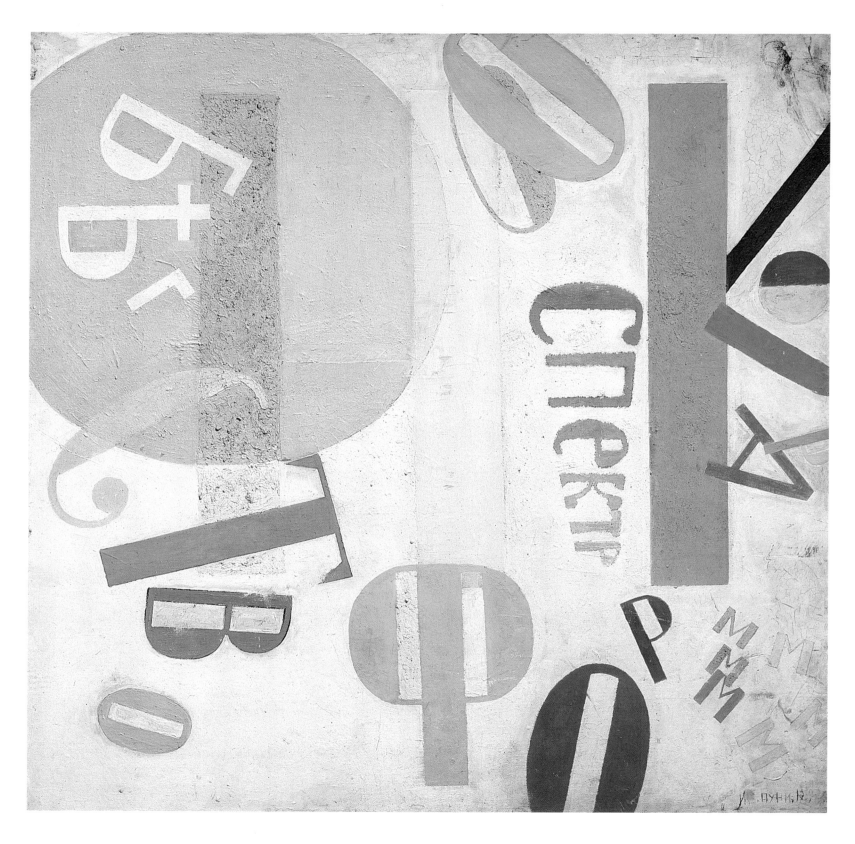

Still-Life with Letters. Spectrum Flight. 1919
Oil on canvas. 124 x 127. Russ. Mus.

Portrait of the Artist's Wife. 1914
Oil on canvas. 89 x 62.5. Russ. Mus.

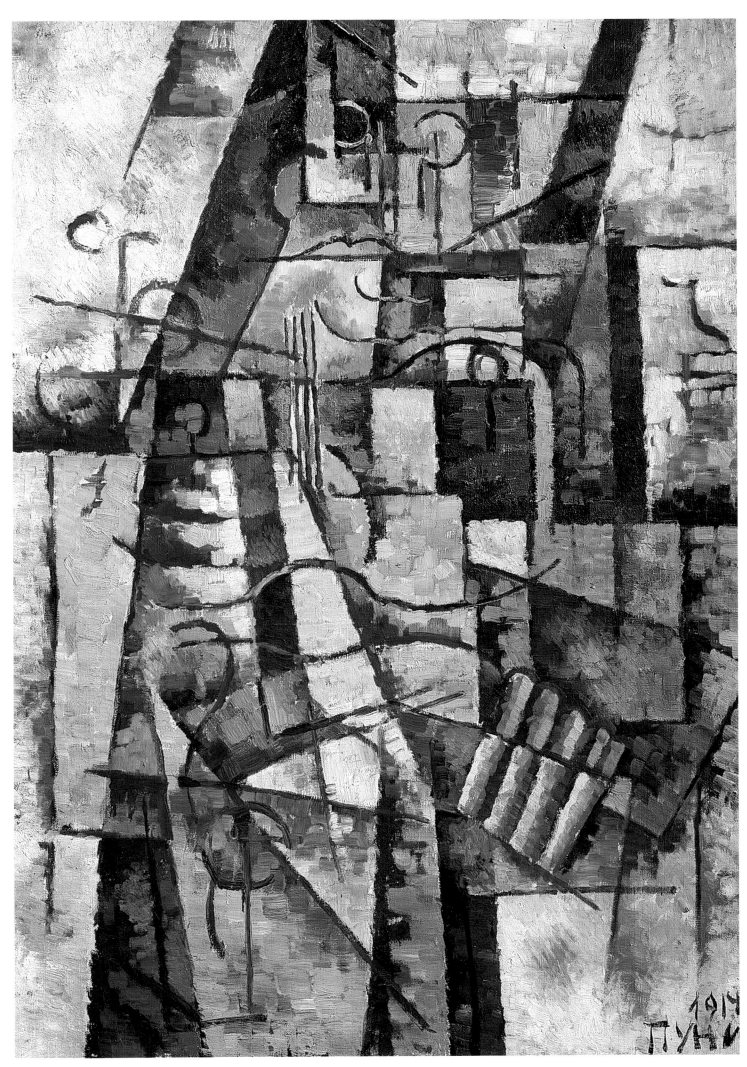

1914

Пуни

nathan ALTMAN

Nathan Altman attempted to bring together abstract forms, nuances of material and words giving the work content. (El Lissitzky, 1920s)

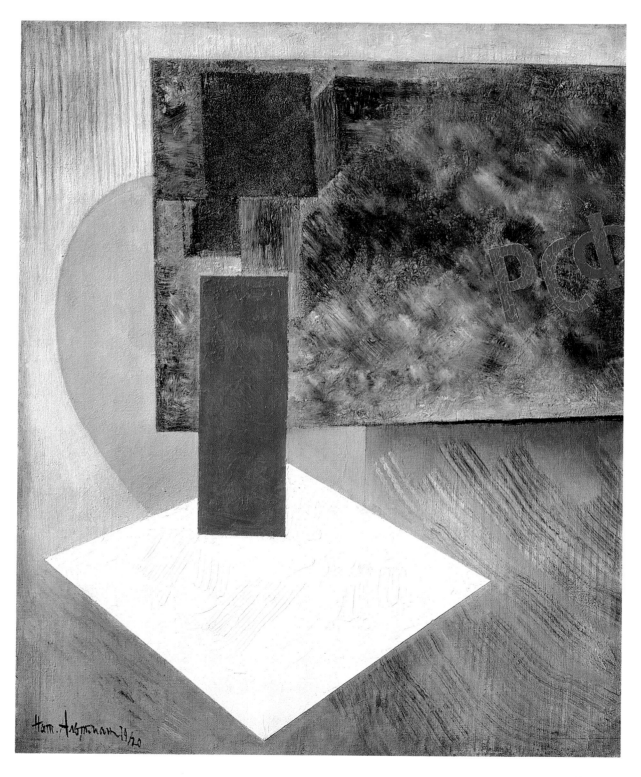

Non-Objective Composition. RSFSR. 1919–20
Oil and enamel on canvas. 48 x 59. Russ. Mus.

Petrocommune. 1921
Oil and enamel on canvas. 104 x 88.5. Russ. Mus.

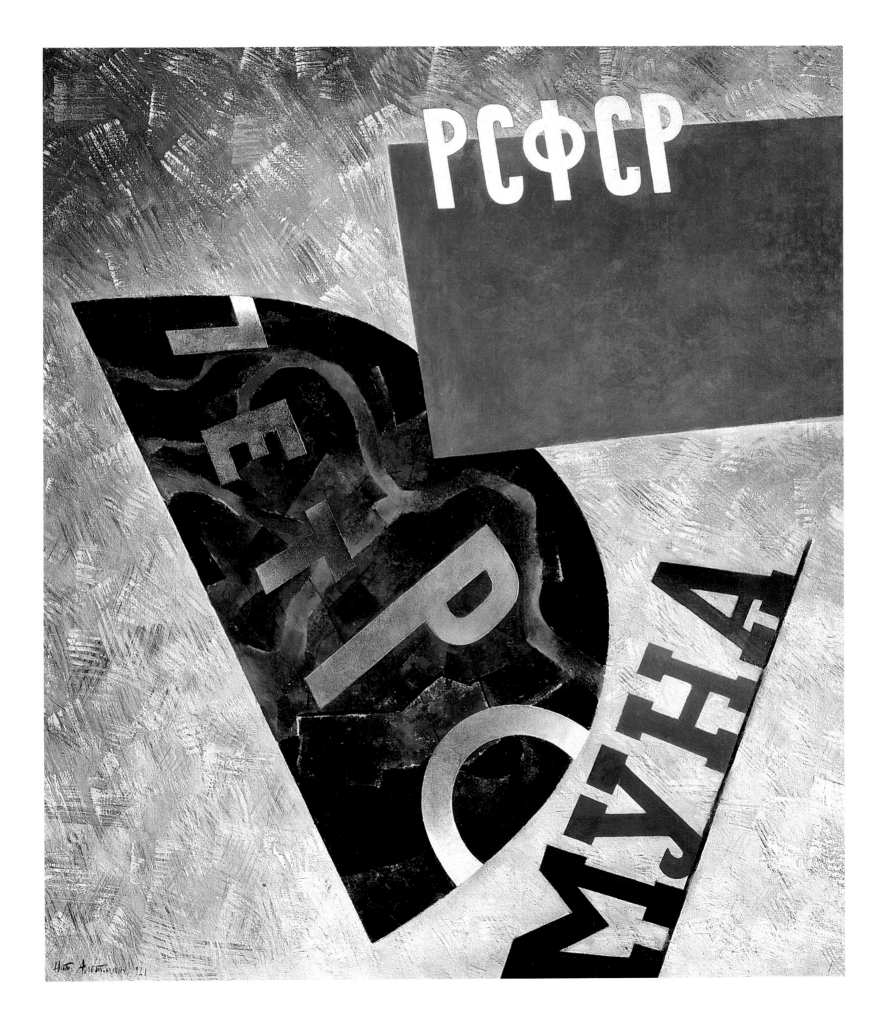

pyotr MITURICH

Artists have finally and irrevocably understood that the language of painting is the most valuable word for expressing all the depths of thinking in the world lying outside us and about the world existing inside us; that painting no longer requires crude textbooks of literary formulae. They have understood that painting is painting, and not a tale or a novel.

Composition. 1920
Ink and white on paper. 21.8 x 16.9. Russ. Mus.

Composition. 1920
Ink on paper. 21.9 x 16.9. Russ. Mus.

Composition. Late 1910s–early 1920s
Lithograph. Image: 21 x 12.5; sheet: 22.7 x 13.2
Russ. Mus.

lev BRUNI

...One must paint in such a way that it is possible to name the colours – this is grey-blue, this is dark-blue, this is brown. But this should also be – body, sky, dress.

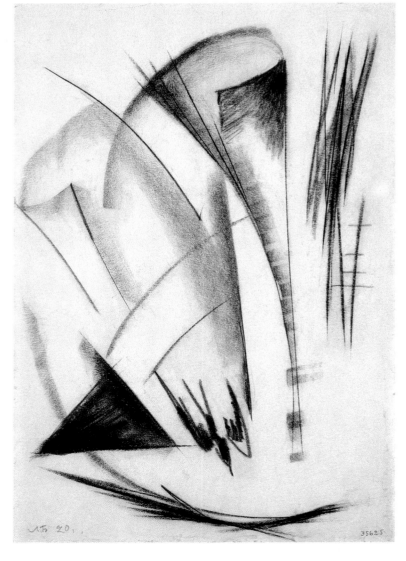

Negatives. Composition. 1921
Ink on paper. 26.4 x 16.7. Russ. Mus.

Non-Objective Drawing. Flight. 1920
Charcoal on paper. 35.1 x 24.2. Russ. Mus.

Mask Sector. 1916
Oil on canvas. 82 x 58. Russ. Mus.

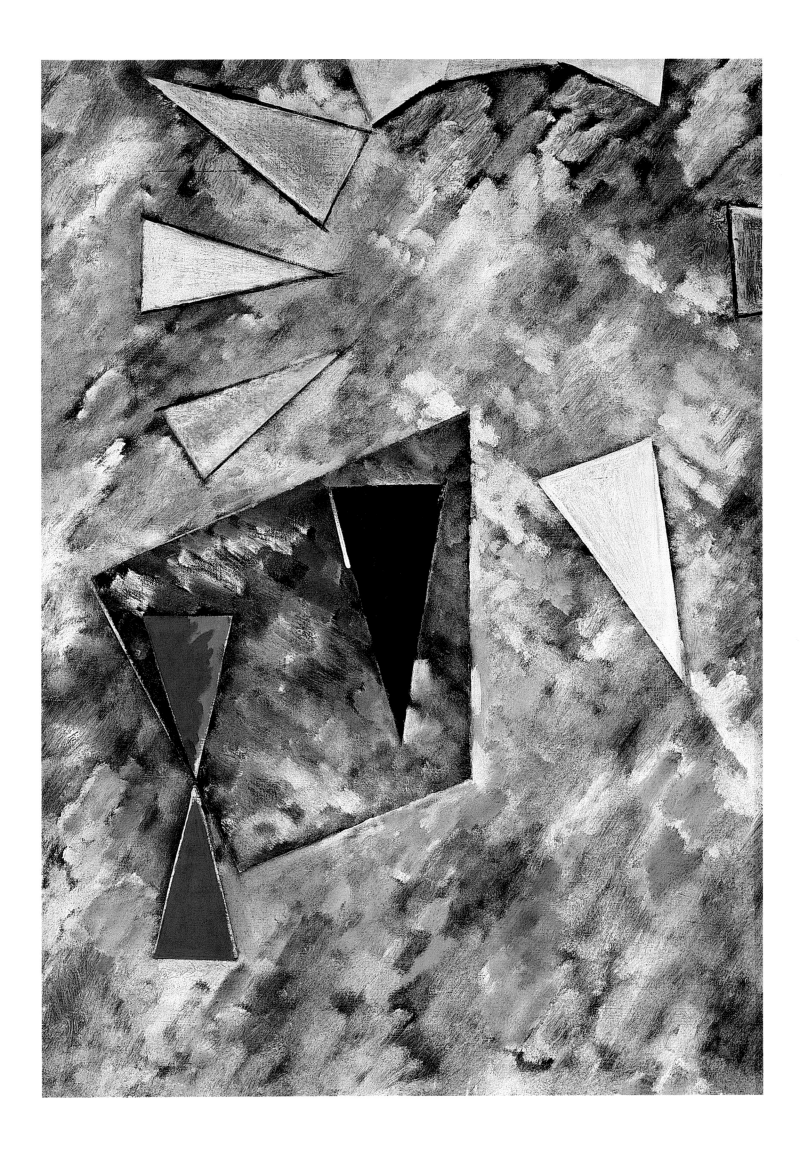

vera **PESTEL**

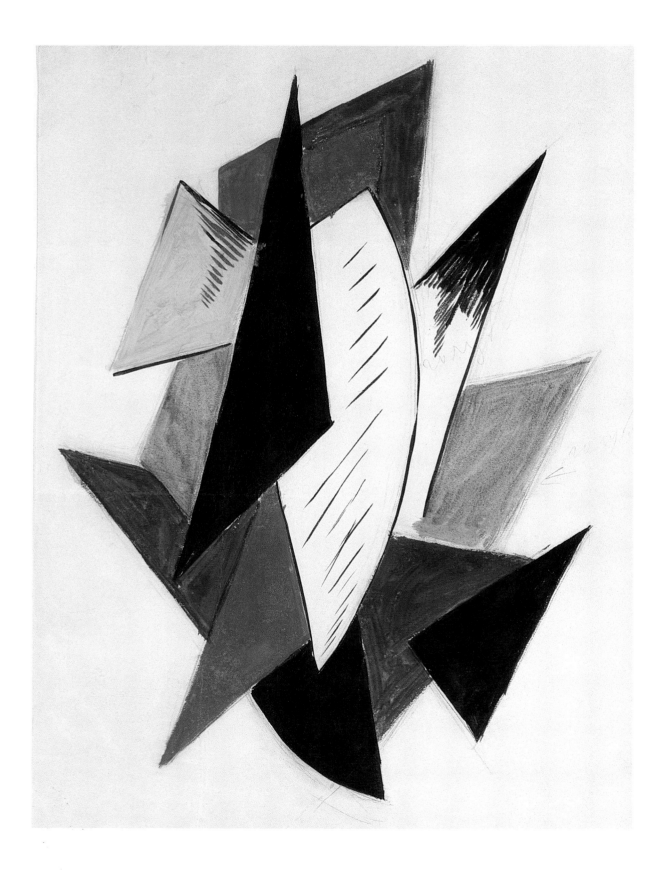

Futurist Composition. 1916–18
Watercolours and ink on paper. 34.9 x 25.8. Russ. Mus.

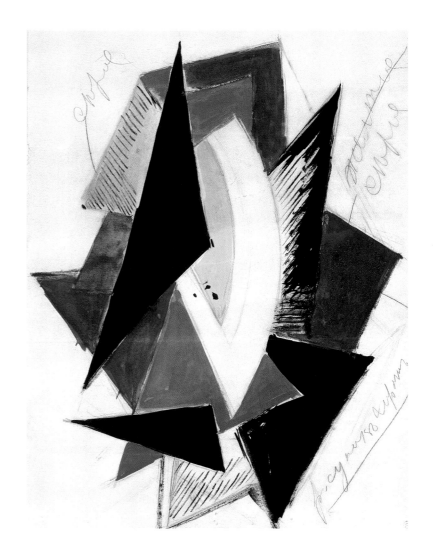

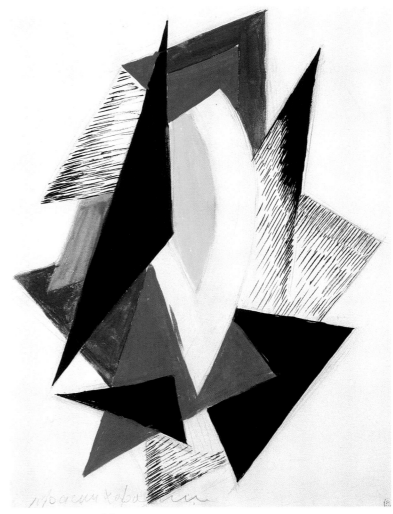

mposition. 1916–18
rs and ink on paper. 34.7 x 25.8. Russ. Mus.

omposition. 1916–18
Watercolours and ink on paper. 34.8 x 25.8. Russ. Mus.

antonina **SOFRONOVA**

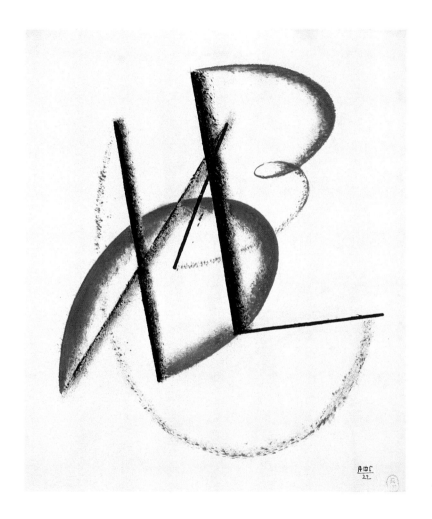

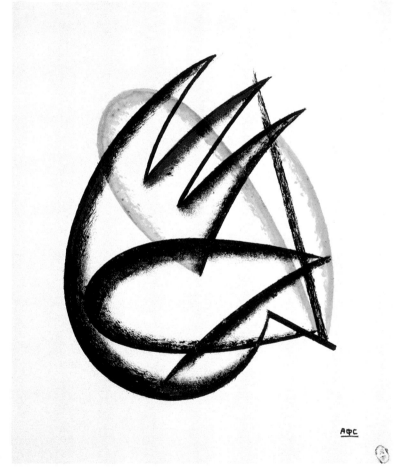

Constructivist Composition. 1922
Oil on paper. 22.5 x 18.1. Russ. Mus.

Constructivist Composition. 1922
Oil on paper. 22.5 x 18.1. Russ. Mus.

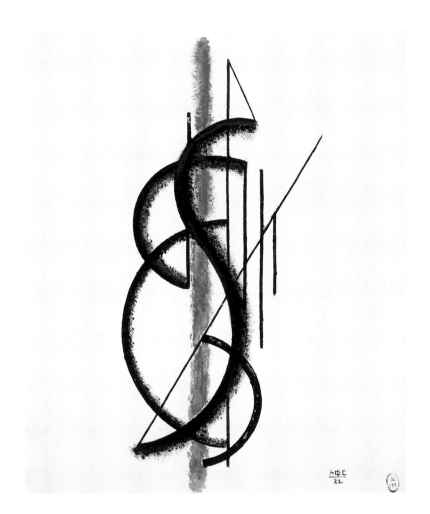

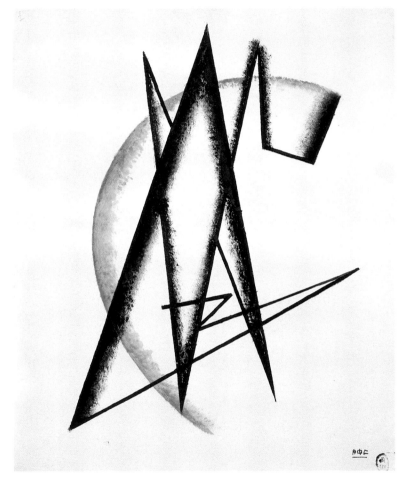

Constructivist Composition. 1922
Oil on paper. 22.5 x 18.1. Russ. Mus.

Constructivist Composition. 1922
Oil on paper. 22.5 x 18.1. Russ. Mus.

nina KHLEBNIKOVA

Nina Khlebnikova pays tribute in her abstract compositions to her interest in Kazimir Malevich's dynamic constructions, demonstrating her membership of the movement with direct quotations of the founding father of Suprematism, particularly his Black Square *and* Black Circle. *(G. P.)*

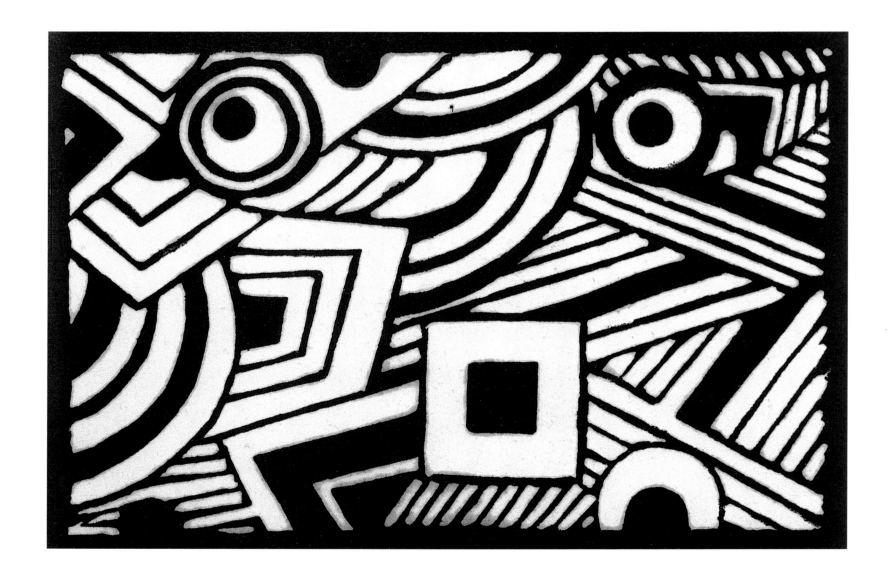

Composition. 1931
Linocut. Image: 10.3 x 15.5; sheet: 22.7 x 32. Russ. Mus.

Composition. 1931
Linocut. Image: 18 x 12.6; sheet: 34.4 x 25.3. Russ. Mus.

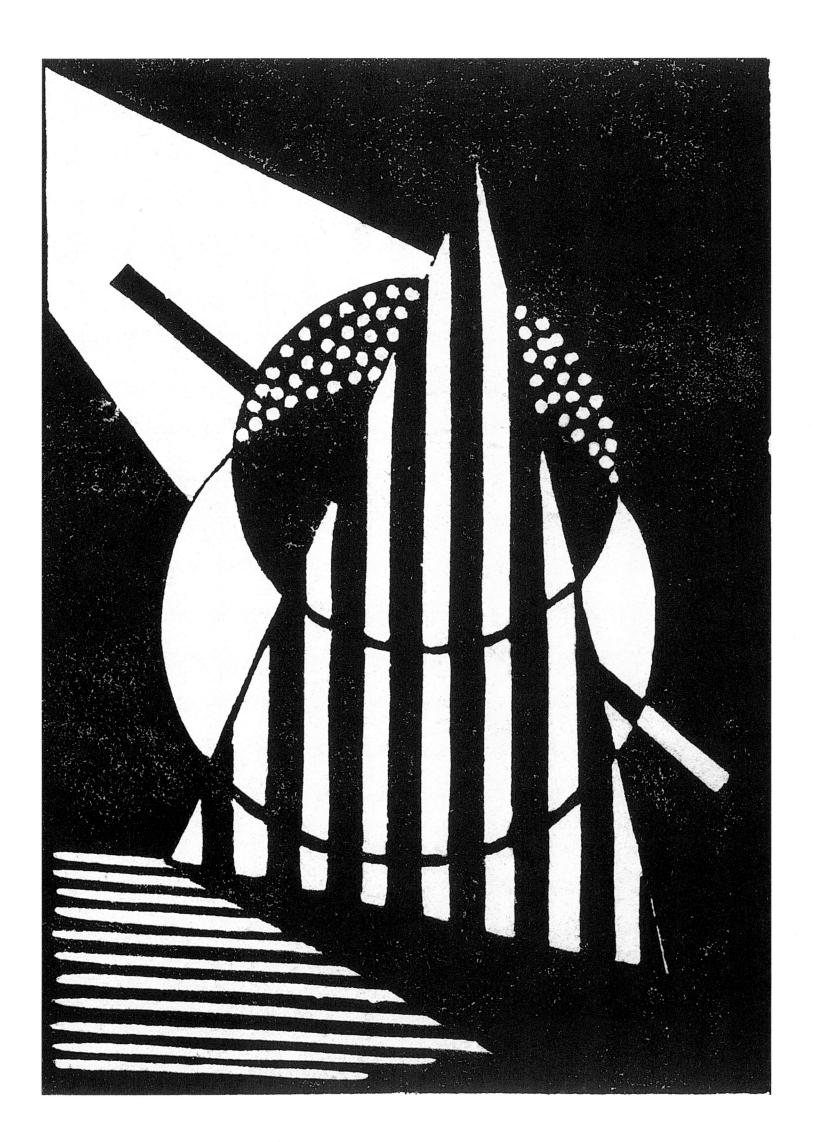

karl **JOHANSON**

Like many artists, Karl Johanson discarded objectivity and subject in his works, and with them the old means of expression. The ... exped-ient form for the new tongue was the line – distinct, s logical. Johanson's non-objective drawings are formulae tions defining the laws of form-creation. (L. V.)

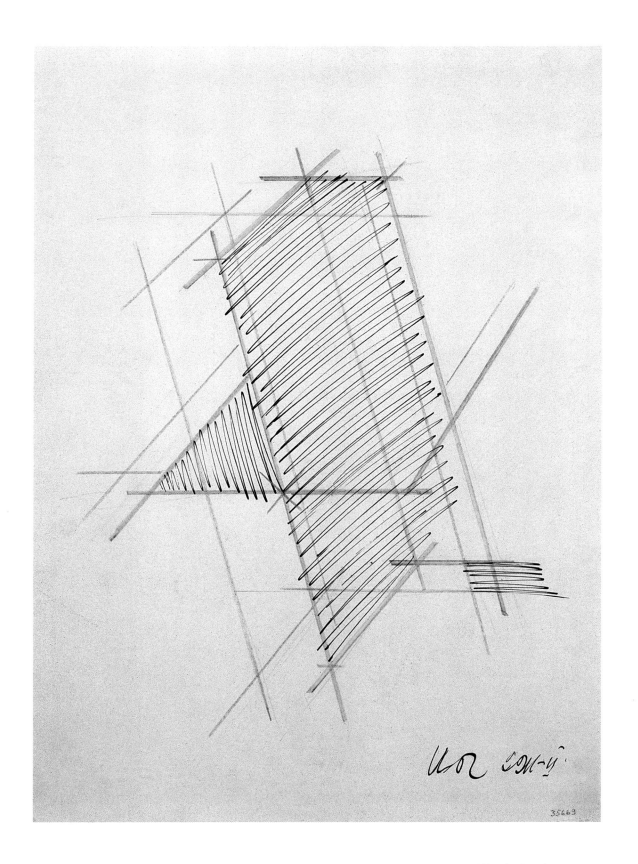

Non-Objective Drawing. 1920–21
Graphite pencil, coloured pencil, ink and quill on paper. 31.5 x 24. Russ. Mus

vladimir **TATLIN**

Non-objective works employing such untraditional painterly and everyday materials as wire, rope, wallpaper and tin, Tatlin's reliefs and counter-reliefs do not depict anything. The artist's choice of the "universal" title of "painterly relief" reflects the innovative feature of his works – their three-dimensionality. Tatlin's reliefs are among the earliest examples of abstract art. (L. V.)

Corner Counter-Relief with Ropes. 1915
Metal, wood and cables. 71 x 118. Russ. Mus.

konstantin **MEDUNETSKY**

The essence of the earth and man's brain are uneconomically dispersed into the manure of the swamp of aestheticism. Weighing the facts on the scales of an honest attitude towards the inhabitants of the earth, the Constructivists declare art and its priesthood to be outlaws.

Colour Construction. 1920
Oil on canvas. 87.6 x 61.5. Russ. Mus.

w ł a d y s ł a w **STRZEMIŃSKI**

Władysław Strzemiński was a vivid Constructivist and rejected realistic painting. His studio presented an interesting sight. It was piled high with crates, pieces of tin-plate, filings and glass objects. This was the palette of Constructivism. Works of the most fantastic form that had nothing in common with the real world were created from combinations of these heterogenous materials.
(From the memoirs of A. A. Korobov)

Still-Life. 1919
Oil, plaster and enamel on plywood.
38.2 x 26. Russ. Mus.

v l a d i m i r **LEBEDEV**

Cubism gave us discipline of thinking, without which there is neither mastery nor purity of the professional tongue.

Cubism No. 4. 1922
Oil on canvas. 107 x 71. Russ. Mus.

Selection of Materials. 1921
Oil and collage on wood and metal. 84.7 x 53.5. Russ. Mus.

vasily **YERMILOV**

Compressed space passed through the creative soul adjoins everything created to the real space of the universe.

Counter-Relief. Early 1920s
Private collection, Paris

victor **PALMOV**

Virtually exhausting all traditional means of impact (subject and thing), the easel picture has now arrived at abstraction and beyond – experimentation – and, as such, has torn away from the diversity of everyday public life. The need to find something realistic which would link it to existing reality has thus appeared. For me, colour has become this reality.

And so I decided to take up colour painting. I set myself the task of working colour, rather than reworking it into illusory reality.

Composition. 1921
Metal and oil on canvas. 64 x 60. Russ. Mus.

pyotr **GALADZHEV**

A distinct rhythmic construction can be noted in the artist's abstract compositions of this period. He distributes forms onto planes with great dexterity, correlates them to one another and attempts to find a dynamic balance between them. (M. F.)

Selection of Materials. 1922
Wood, cardboard, tin, iron, board and assemblage. 35.5 x 34 x 7
Galina and Maxim Fedorovsky collection, Berlin

vladimir **STENBERG**

My task is the exclusive manifestation of the maximum of economics and expediency in relation to the material as the only organising element – of dynamics, space, volume, plane, line and light. (From Creed, 1921)

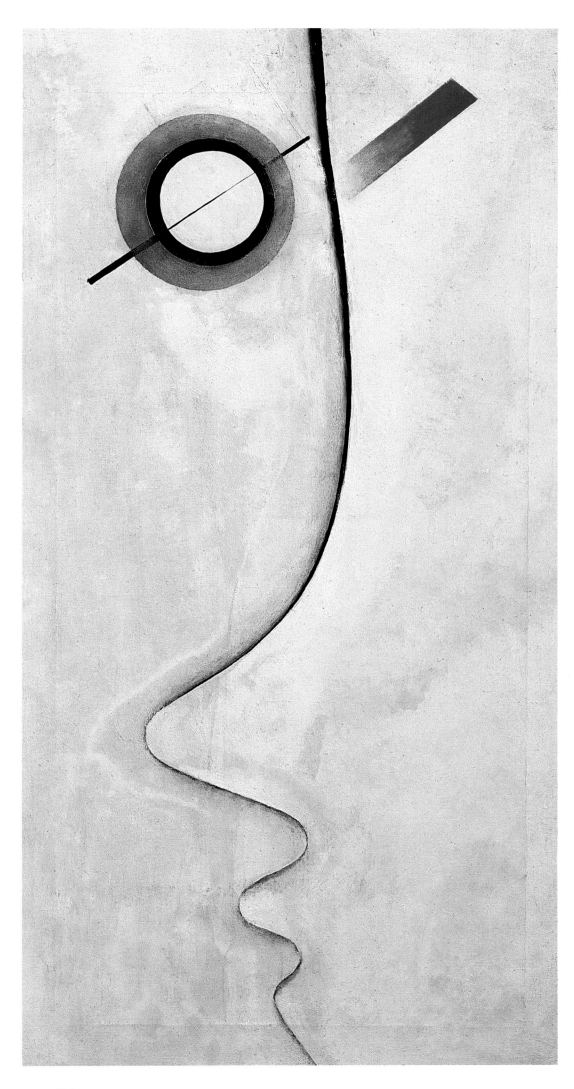

Colour Construction No. 4. 1920
Oil on canvas. 75 x 38.5. Russ. Mus.

DANILOV

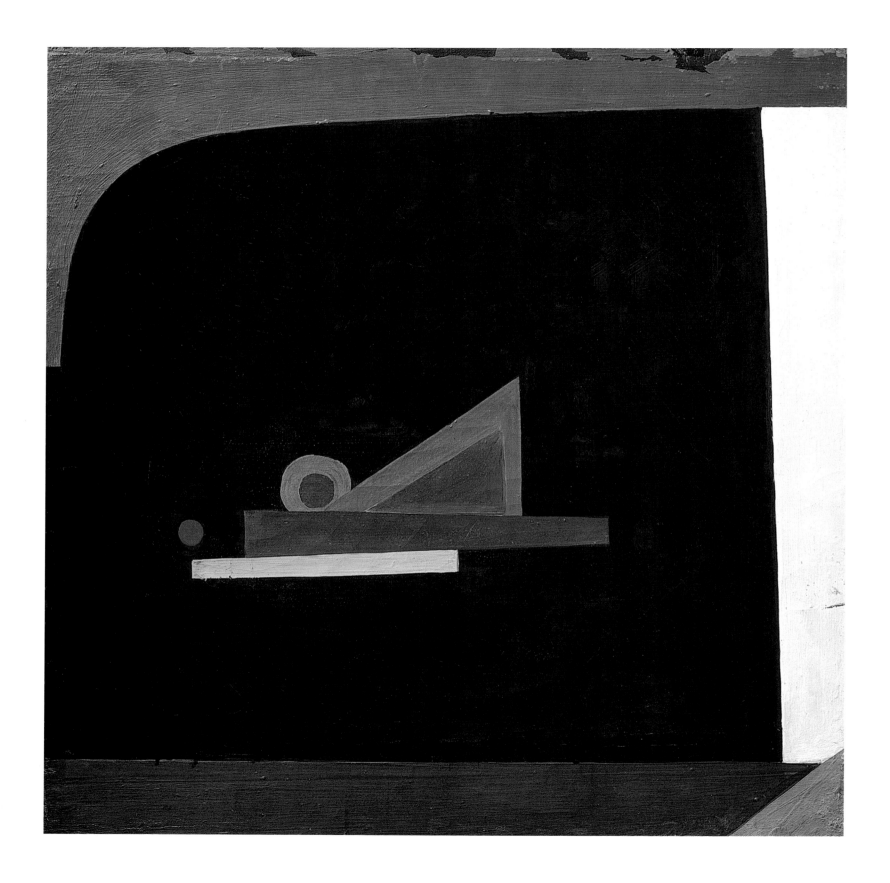

Triangle on Black. 1946
Oil on canvas. 50.5 x 50.5. Russ. Mus.

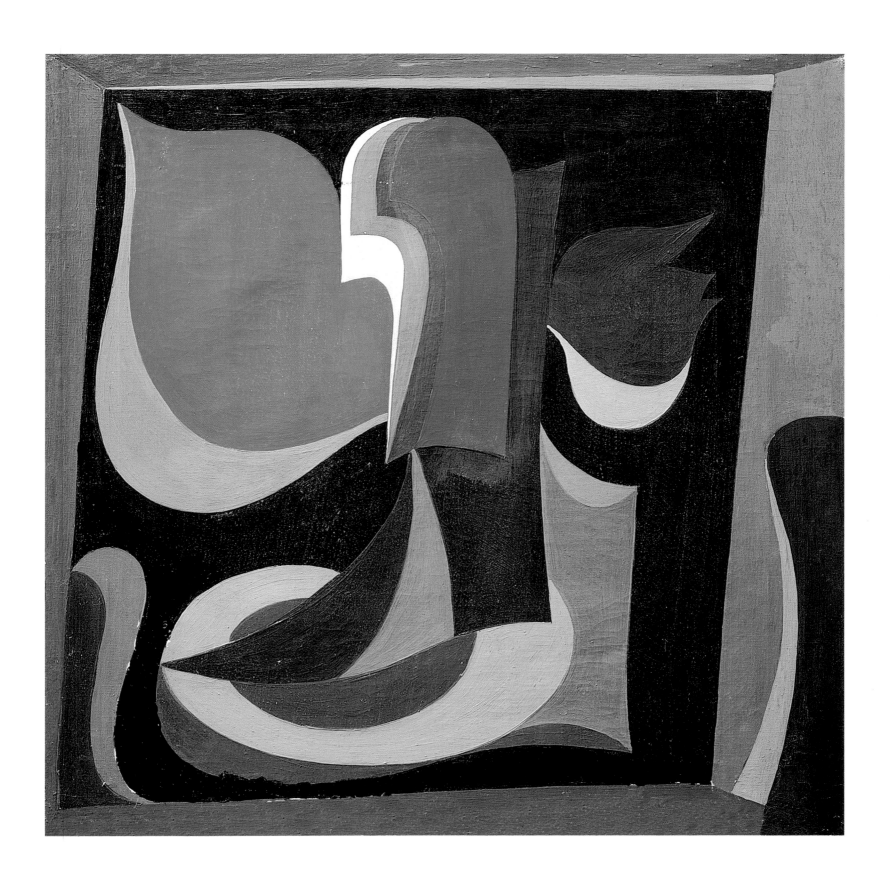

Abstract Composition. 1950
Oil on canvas. 60.5 x 60. Russ. Mus.

ely **BELYUTIN**

Well understanding the main new tendencies in world art and spotting its temporary plastic limitations, Ely Belyutin took its principle of impact as his main plastic premise. He decided, however, to use purely painterly resources to realise the latter. His aim was to turn the resources of painting from artistic qualities into ones of impact. (F. M.)

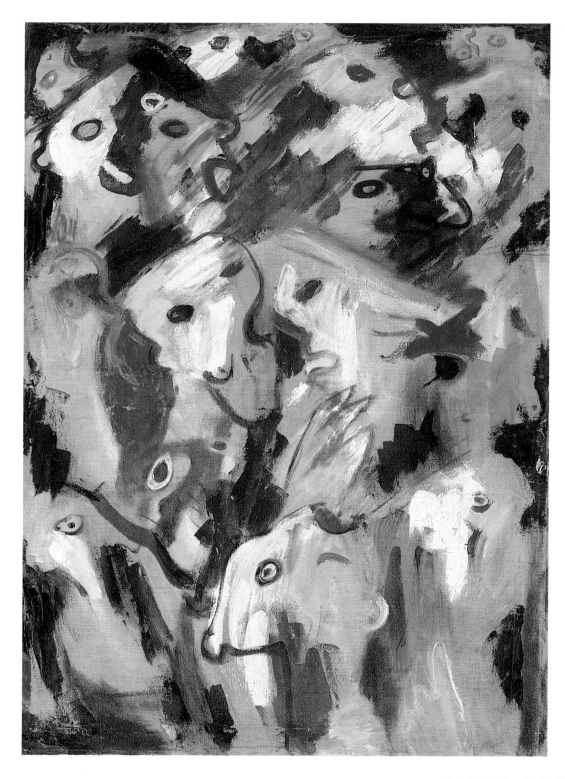

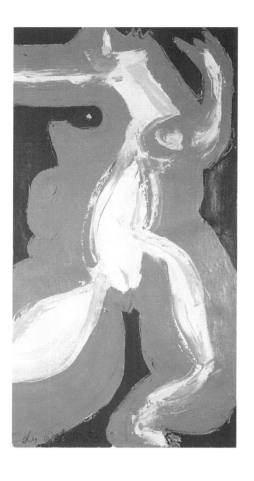

Air-Raid Warning (In the Metro). 1943
Oil on canvas. 132 x 95. Russ. Mus.

Suffering. 1973
Oil on canvas. 131 x 69. Zimmerli Museum, Rutgers University, USA

Landscape. 1952
Oil on canvas. 70 x 107. Zimmerli Museum, Rutgers University, USA

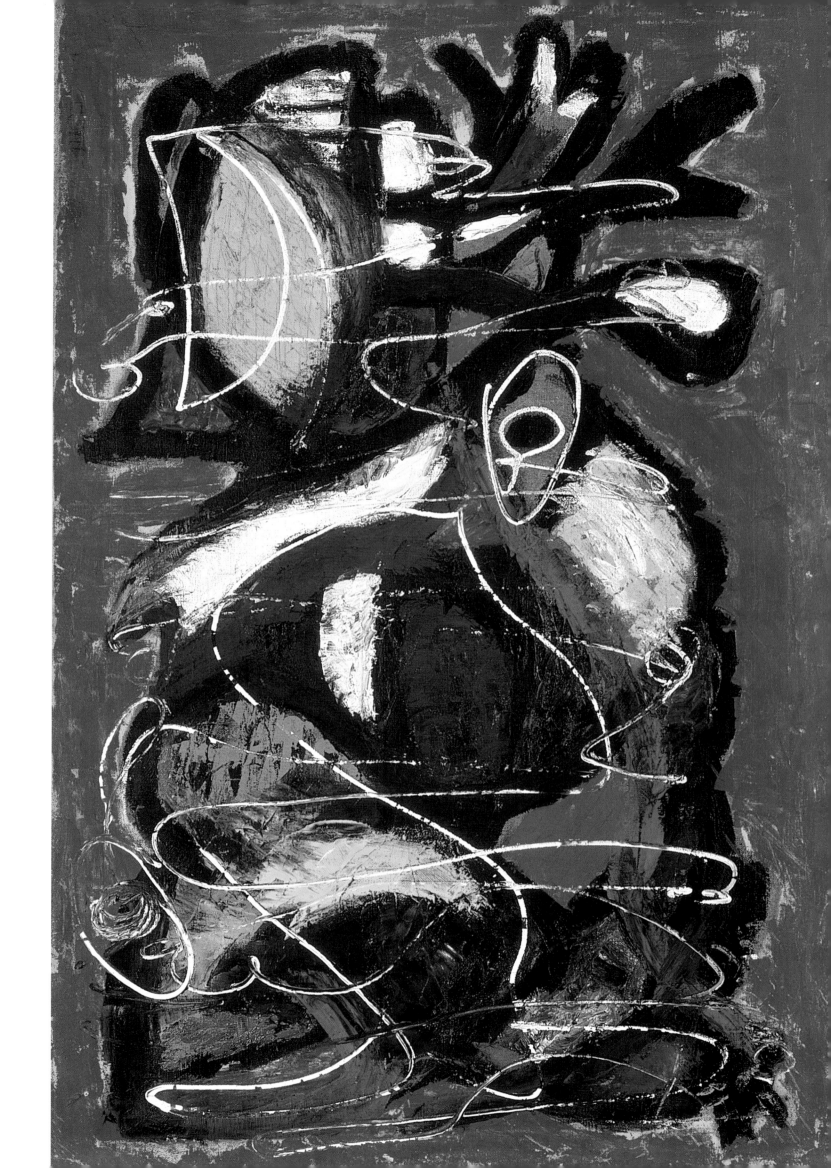

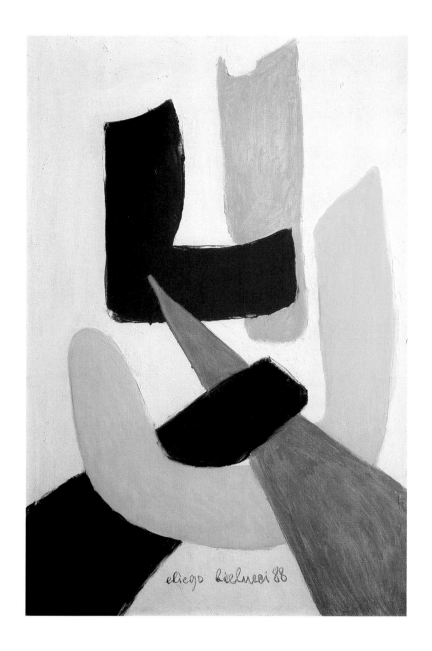

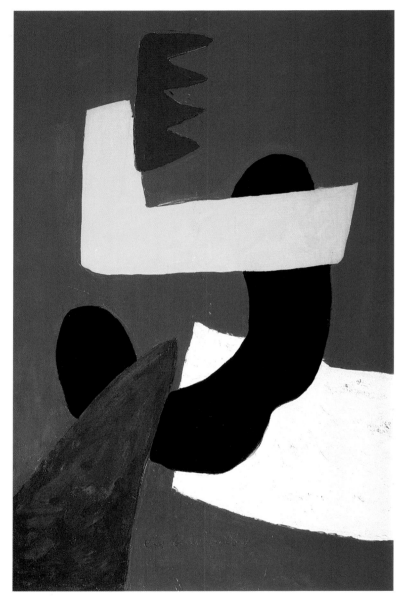

Singer. Modulus. 1988
Oil on canvas. 150 x 100. Russ. Mus.

Man Striding. Modulus. 1988
Oil on canvas. 150 x 100. Russ. Mus.

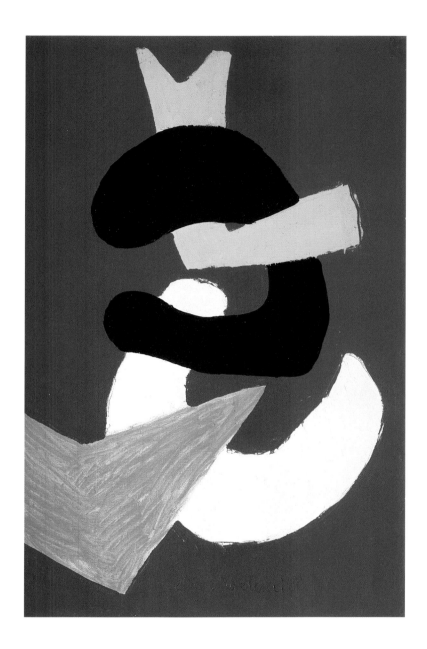

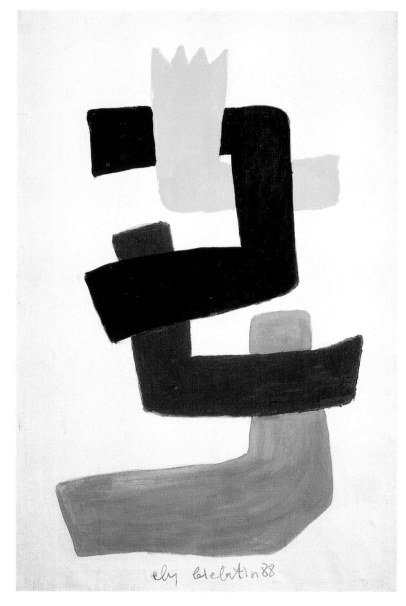

Man with a Sore Chest Running. Modulus. 1988
Oil on canvas. 150 x 100. Russ. Mus.

Man Praying. Modulus. 1988
Oil on canvas. 150 x 100. Russ. Mus.

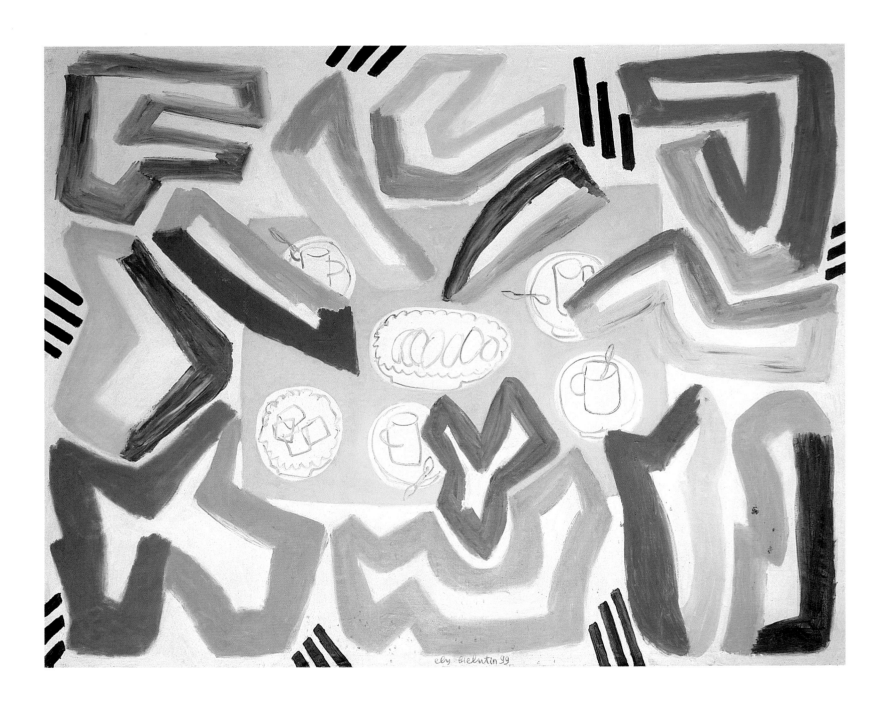

Breakfast. 1999
Oil on canvas. 200 x 265. Russ. Mus.

Quarrel (Moduli). 1988
Oil on canvas. 200 x 150. Russ. Mus.

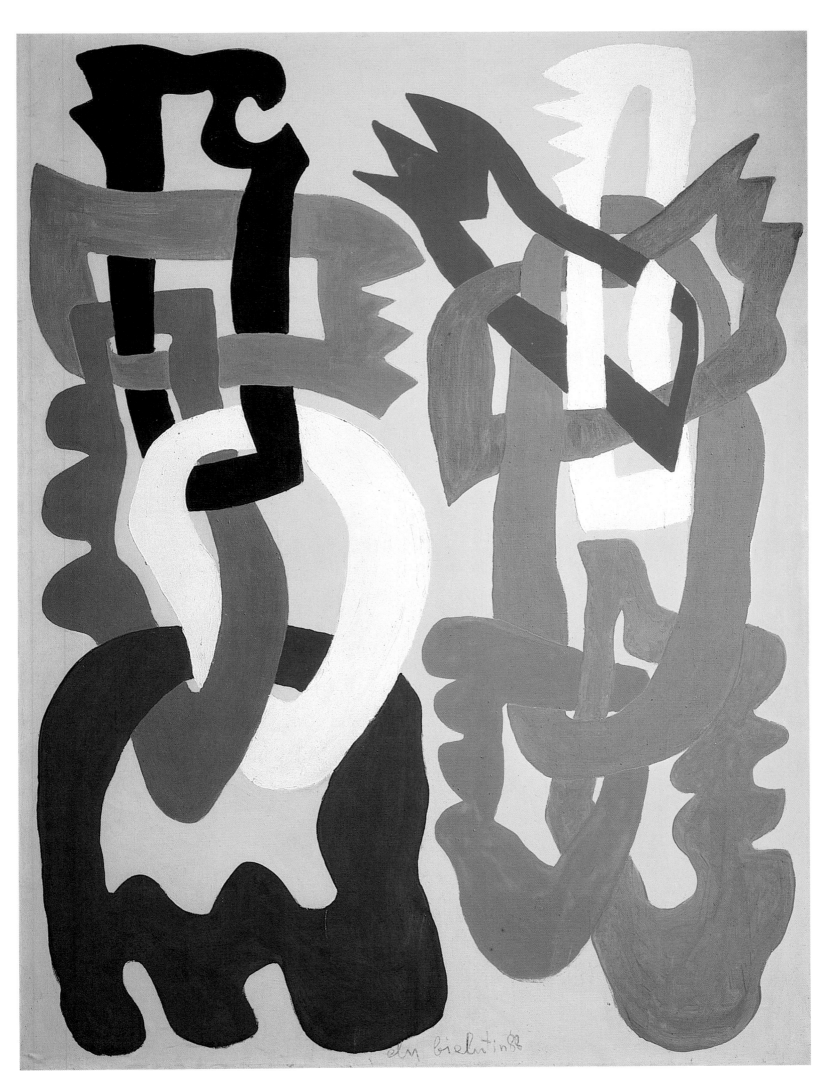

Conversation. 1998. American album
Pastels on paper. 50.8 x 38.3. Russ. Mus.

Mother with Two Children. 1998. American album
Pastels on paper. 50.8 x 38.3. Russ. Mus.

Sheet No. 22. 1998. American album
Pastels on paper. 50.8 x 38.3. Russ. Mus.

ely bielutin 98

vladimir **NEMUKHIN**

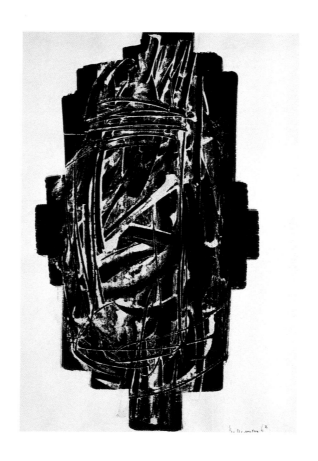

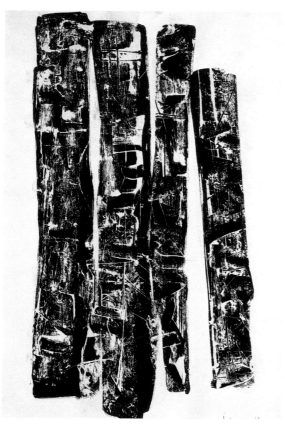

Slipping out of the cradle of Socialist Realism, we turned to abstract art as an absolute form of rejection of artistic routine. Dominating world art at that time, Abstract Expressionism implanted itself in the new Russian soil and entered our flesh and blood. It awoke our subconscious, allowed us to liberate ourselves and gave impulse to formal experiments. It was the deliberate selection of a new confession.

Composition. 1963
Mixed media on paper. 58.5 x 40. Yevgeny Nutovich collection, Moscow

Composition. 1962
Mixed media on paper. 60 x 42. Yevgeny Nutovich collection, Moscow

Composition. 1962
Mixed media on paper. 60 x 42. Yevgeny Nutovich collection, Moscow

Composition. 1962
Mixed media on paper. 60 x 42. Yevgeny Nutovich collection, Moscow

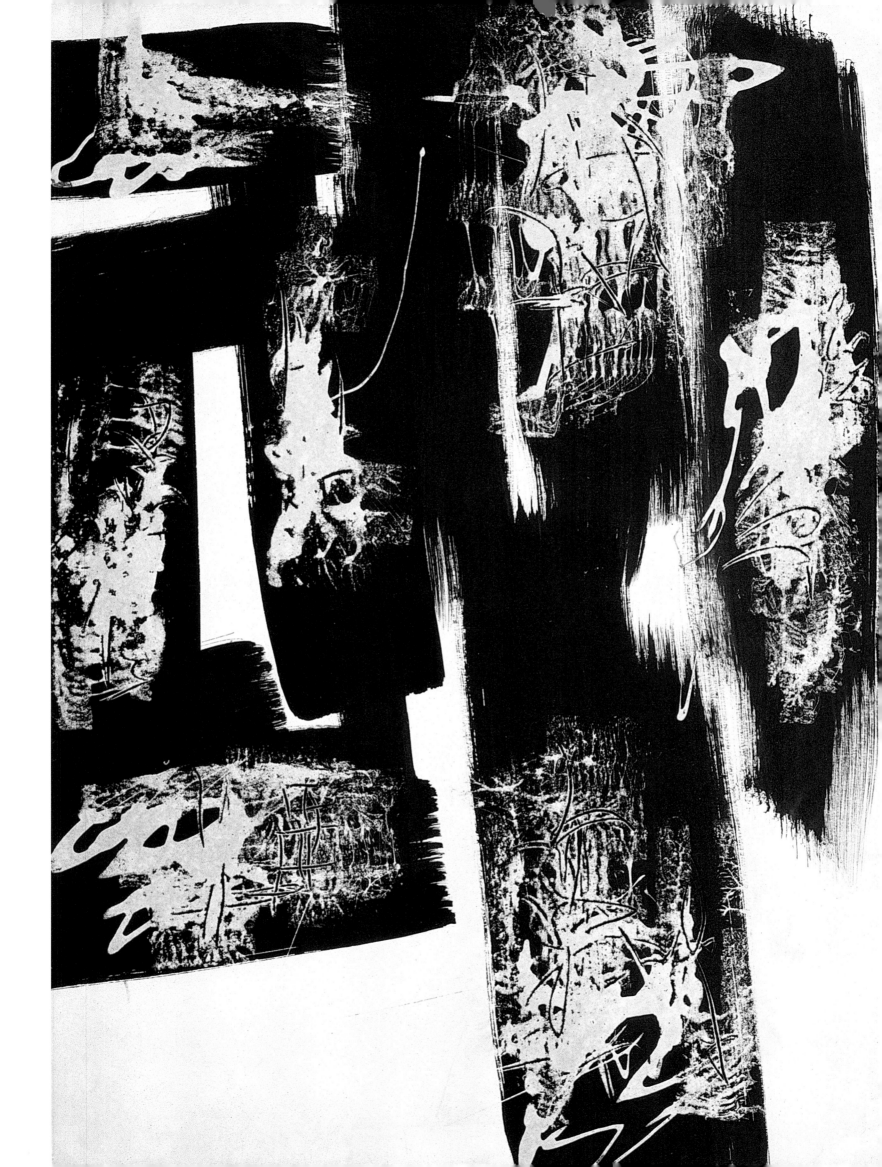

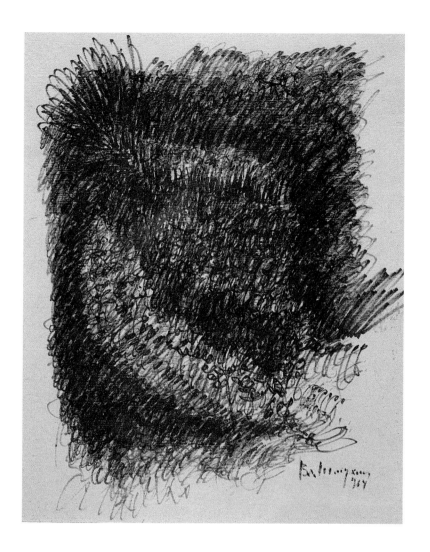

Untitled. 1964
Felt-tip pens on paper. Tatyana and Natalia Kolodzei collection, Moscow

Composition I. 1963
Mixed media on paper. 59.6 x 42.4. Yevgeny Nutovich collection, Moscow

Dedication to Paul Cézanne. 1985
Bronze. Cast in 1998. 20 x 28 x 28. Private collection, Germany

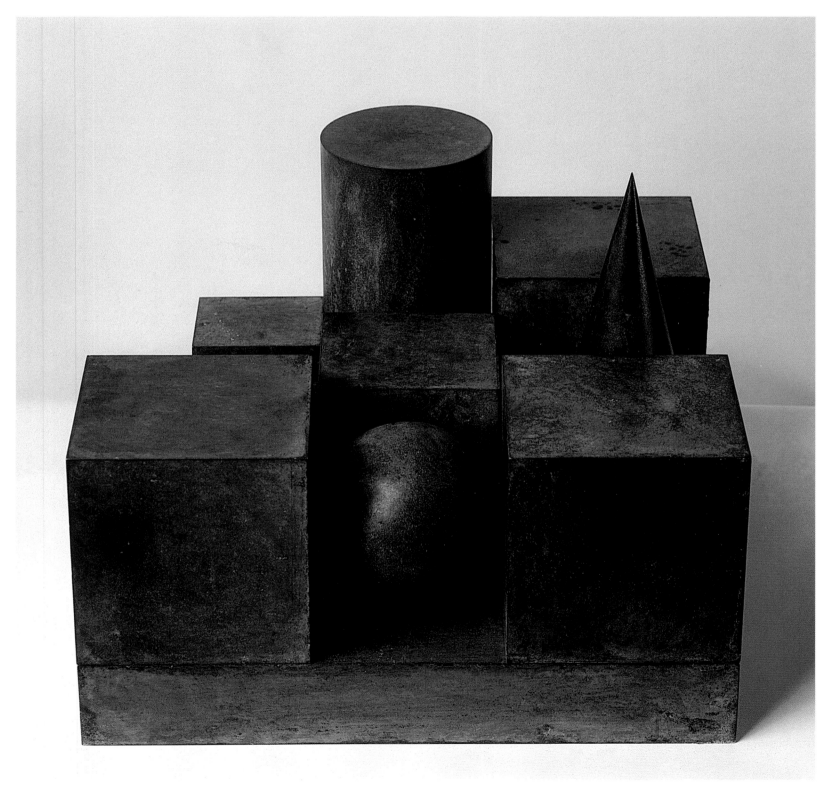

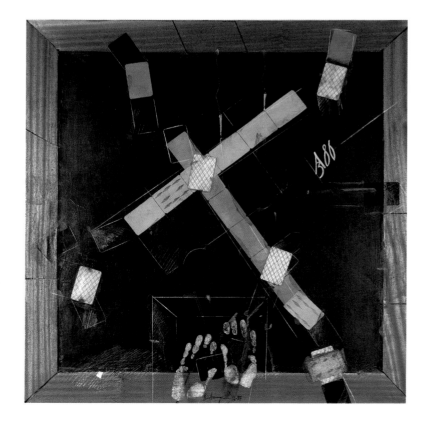

Blue Day. 1959
Oil on canvas. 108 x 156. Yevgeny Nutovich collection, Moscow

Black Card Table (Dedicated to Anatoly Zverev). 1986–87
Oil and playing cards on plywood. 100.1 x 100.7. Zimmerli Museum, Rutgers University, USA

Composition with Collage. 1963
Mixed media on cardboard. 70 x 50. Yevgeny Nutovich collection, Moscow

valery **YURLOV**

Abstract art is, for me, a special feature of the behaviour of objects in space and the overcoming of figurativeness for the sake of finding pure plastics symbolising the unity of the material and the immaterial...

Novogireyevo. 1959
Oil on canvas. 149 x 80. Tret. Gal.

Counter-Form. 1958–89
Oil on canvas. 145 x 60

TEREKLA

*The chance nature of forms and seeming simplicity are unconveyable
tortures in my life foreseen by Someone on high.*

Geometric Composition. 1964
Oil on canvas. 62 x 77.5. Yevgeny Nutovich collection, Moscow

leonid LAMM

In the context of our time, what seems important to me is not merely the purity of form and its intuitive expression, but the factor of its designations, which can be perceived by the auditorium as a moment of the event, deed or action and which provoke a direct sequence of visual interpretations. (How I Fell Out of Malevich's Cradle)

Composition. 1964
Indian ink, watercolours and gouache on paper. 30.8 x 21.5. Russ. Mus.

Composition. Opposition of Spaces. 1956
Indian ink and watercolours on paper. 29.6 x 20.5. Russ. Mus.

Composition (Sun in the Desert). 1975–79
Gouache on cardboard. 48 x 69. Russ. Mus.

Black Cross in White. 1976
Oil on cardboard. 70 x 50. Russ. Mus.

boris TURETSKY

Boris Turetsky's still little-known non-objective painting and graphic art of the 1950s are noted for their well articulated formulation of the "zero position". To a large extent, they are monochrome, black-and-white series. Both black and white stand as original elements, principles on the stage of departure of dynamic correlations, one "floating" into the other. This is not the harmonised dynamics of Yin and Yang, however, but the protoplastic mystery of the separation of light from dark, sky from earth. Such power is included in surprisingly small works. In this sense, they are like the minimalist stylistics of Zen meditations in which one sound is capable of creating an entire world, while the whole world declines in the sound of something dripping. Boris Turetsky's meditative works cannot, however, conceal their hidden, inner tragedy; the state of black dumbness leaves almost no hope... (Y. B.)

Untitled. 1956
Oil on canvas. 106 x 45

Rhythmic Construction. 1957–59
Indian ink and brush on paper. 81.5 x 57.9. V. Sukharov collection, Moscow

Matter. Semi-Circle and Rectangular Pieces. 1959
Indian ink and brush on paper. 81.5 x 57.9. V. Sukharov collection, Moscow

Rhythmic Construction. 1957–59
Indian ink and brush on paper. 81.5 x 57.9. V. Sukharov collection, Moscow

Matter. Medium Pieces. 1959
Indian ink and brush on paper. 81.5 x 57.9. V. Sukharov collection, Moscow

y u r y **ZLOTNIKOV**

Art – in this case, painting – is a model of our psychical life. While art reflects reality, this reflection is transformed, through man. In this way, it represents our specific possibilities as observers and operators. There is a directed control in the structure of art, i.e. a process of not only the sensual reaction to the environment, but also a process of the intellectual operations on the selection and organisation of its elements.

Signal System **Series. Sheet No. 1.** 1958
Tempera on paper. 83.5 x 59.8

Signal System **Series. Sheet No. 3.** 1959
Tempera on paper. 83.5 x 59.8

Signal System **Series. Sheet No. 2.** 1959
Tempera on paper. 83.5 x 59.5

Space. Rhythm. People. 1986
Oil on canvas. 180 x 200. Russ. Mus.

Rhythmic Composition. 1988
Oil on canvas. 104 x 124

Spatial Construction. 1996
Oil on canvas. 104 x 145

Neo-Constructivism **Series. Sheet No. 1**
Watercolours and gouache on paper. 73.3 x 102.2

Neo-Constructivism **Series. Sheet No. 2**
Watercolours and gouache on paper. 73.3 x 102.2

Neo-Constructivism **Series. Sheet No. 3**
Watercolours and gouache on paper. 73.3 x 102.2

yury VASILYEV (MON)

Is it possible to speak about new forms of abstract art? It is. Abstract art contains the idea of subjective feelings. A new content requires a new form. Proceeding from traditions, new forms are required for the expression of new ideas.

Sunset on a Rubbish Tip. 1969
Mixed media and copper foil on fibreboard. 71 x 122. Russ. Mus.

Composition or Junction. 1958
Painted limestone. 34 x 29 x 17

Rocket. Early 1960s
Metal wire on bamboo. 42 x 100 x 34

Bird. Early 1960s
Metal wire on bamboo. 60 x 66 x 50

alexei **ROSSAL-VORONOV**

In order to envisage what art is, one must be in it completely, and try to understand what others do.

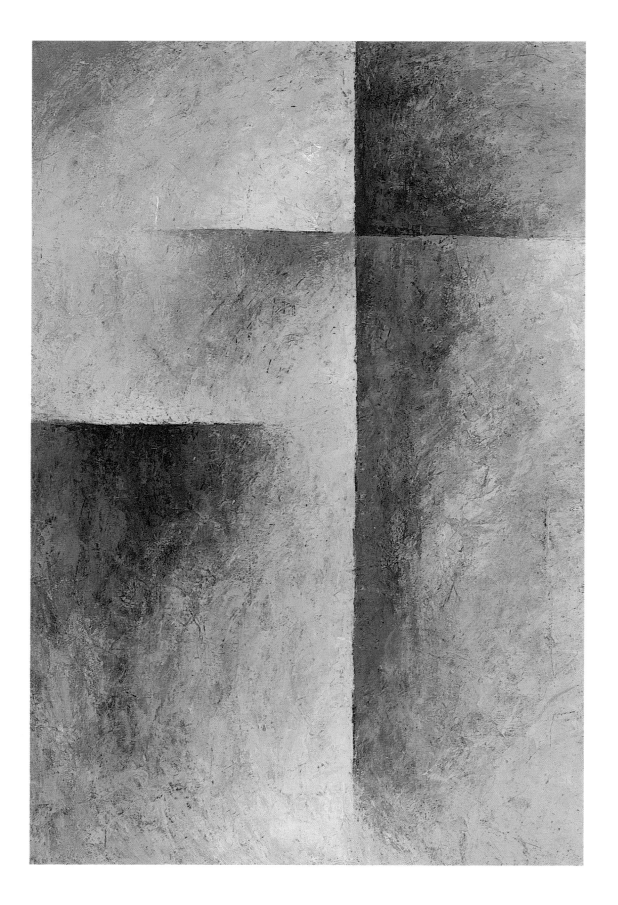

Architectural Motif. 1960
Tempera on plywood and cardboard. 100 x 67. Tret. Gal.

alexander **BATURIN**

Nature teaches the construction of plastic form. If the natural forms coincide with the plastic form inside the artist, this is lucky.

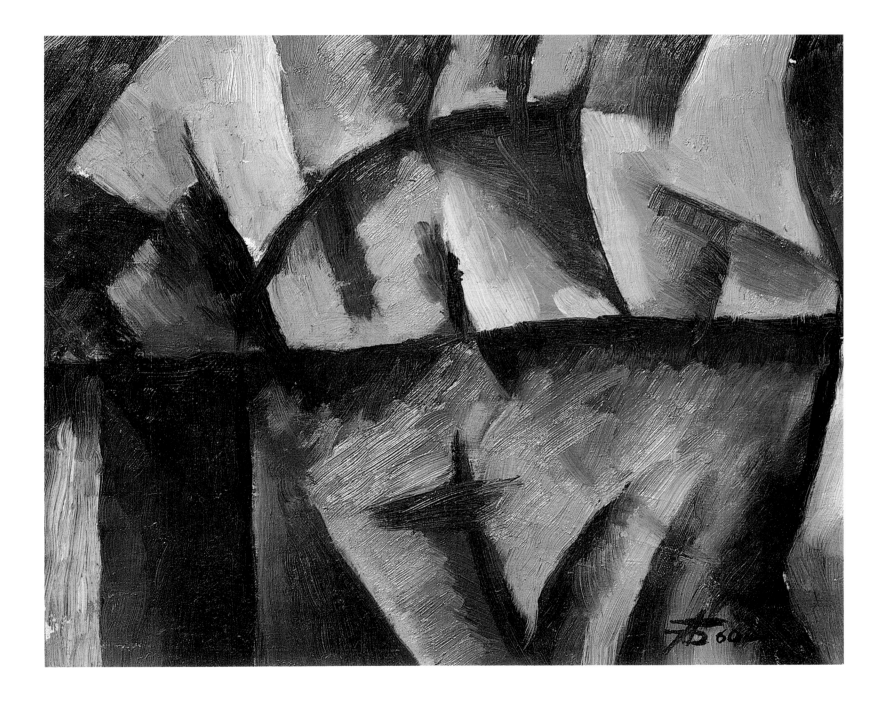

In Pargolovo. 1960
Oil on canvas mounted on cardboard. 25 x 29. Russ. Mus.

mikhail **KULAKOV**

I selected as the object of my inspirations an internal space, which is the same reality as Morandi's table, Rubens' bodies or Klee's ironical-poetic inscription-pictures.

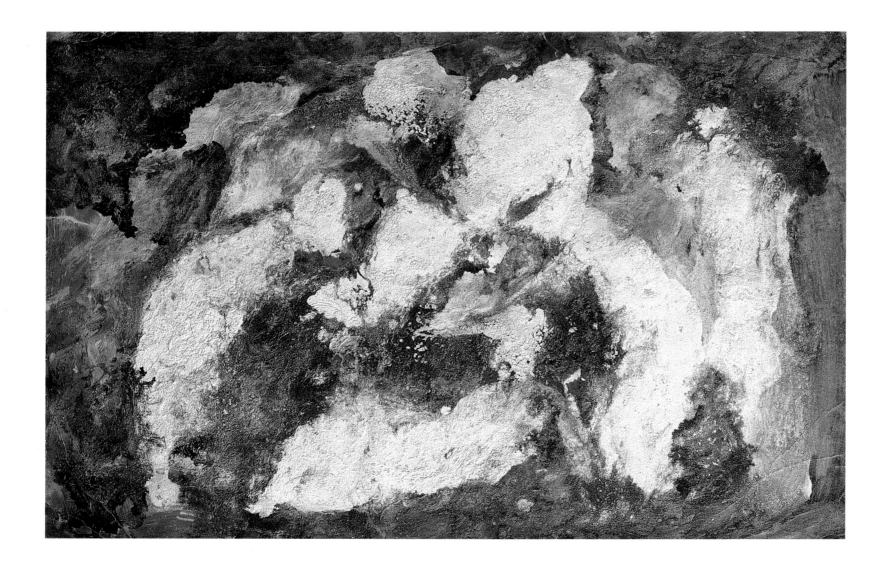

From the *She. He. They* Cycle. 1961
Nitro enamel on fibreboard. 71 x 105. Russ. Mus.

152 | 153

From the *She. He. They* Cycle. 1961
Nitro enamel on fibreboard. 105 x 71. Russ. Mus.

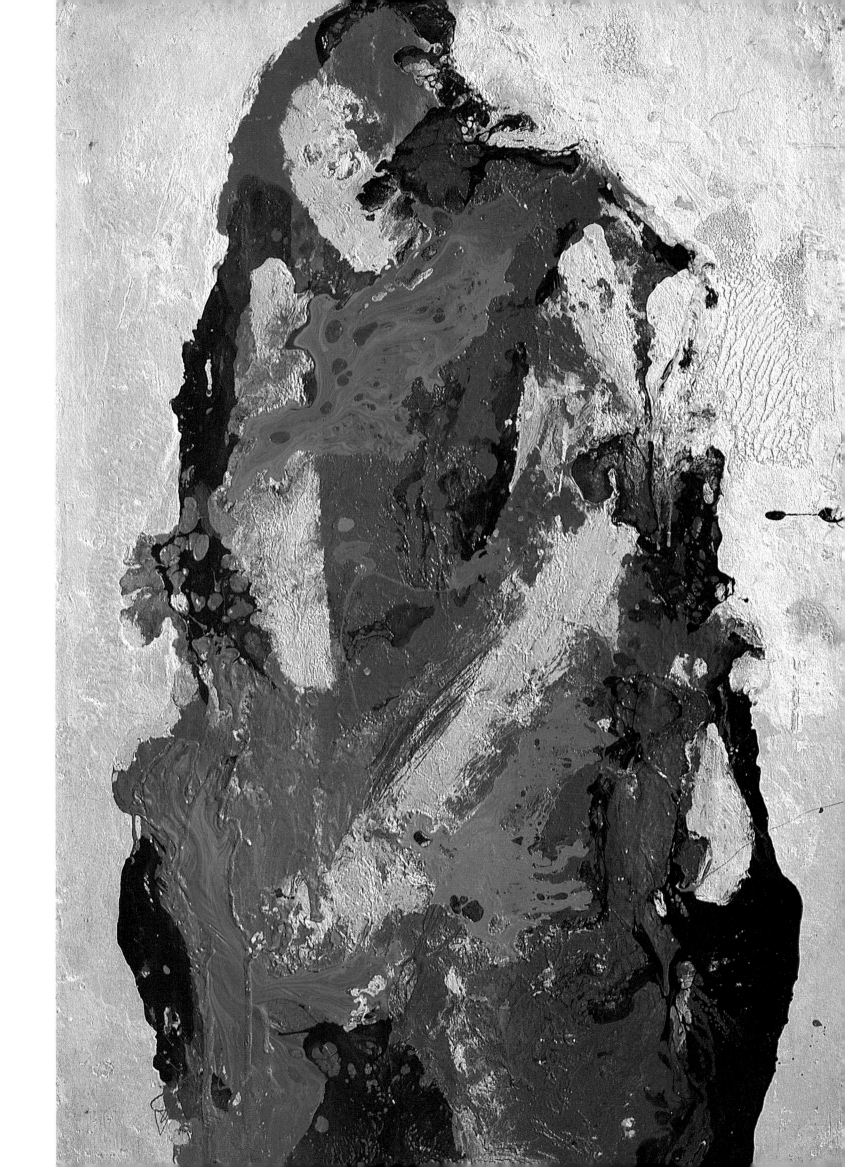

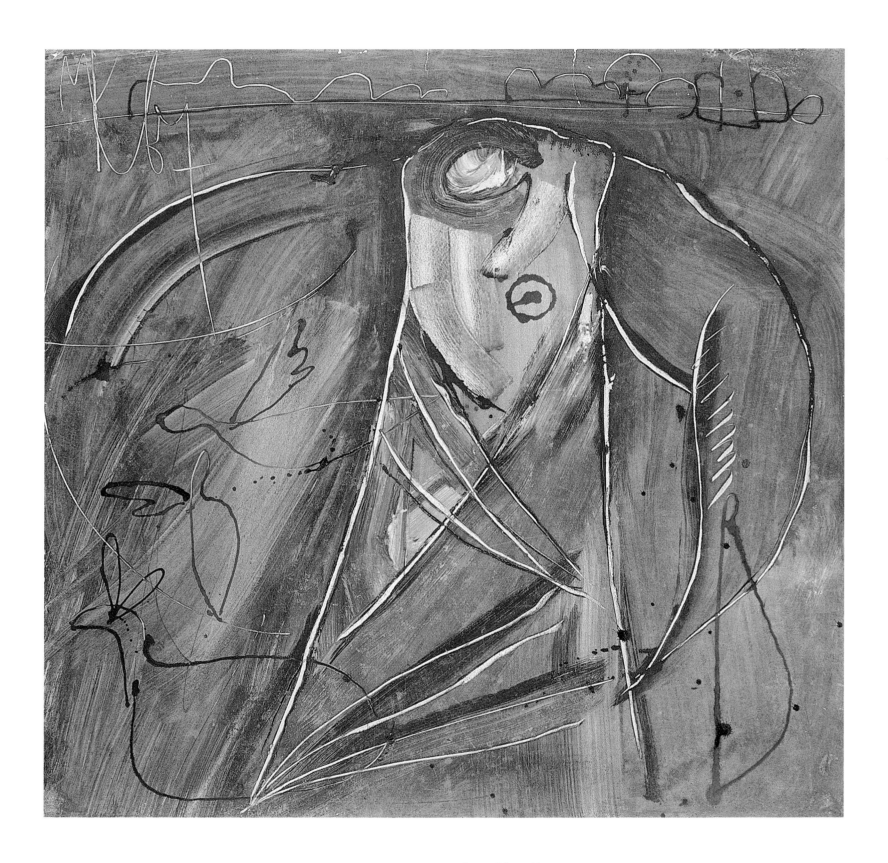

Composition. 1967
Watercolours, gouache and black and coloured Indian ink on paper.
63.2 x 65.5. Russ. Mus.

Sword. 1975
Oil on canvas. 88.6 x 63.7. Zimmerli Museum, Rutgers University, USA

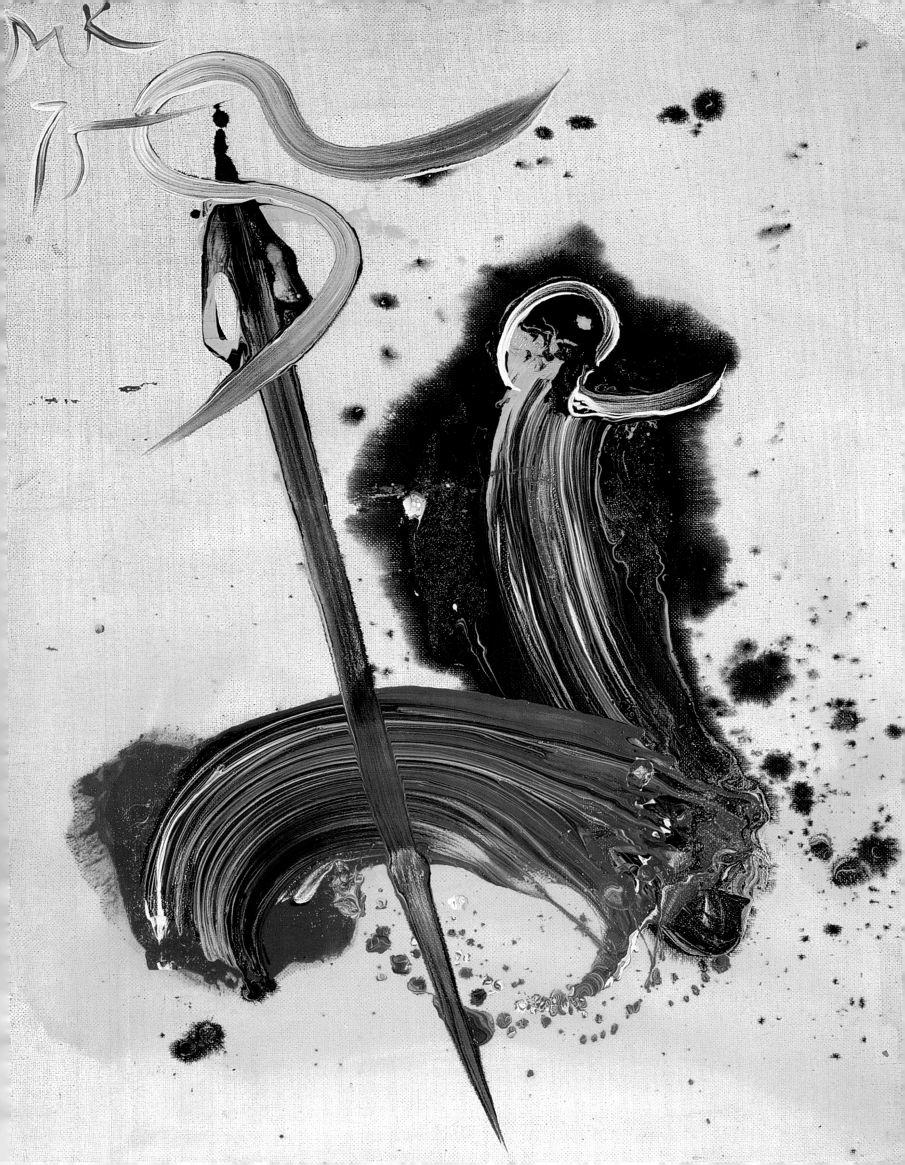

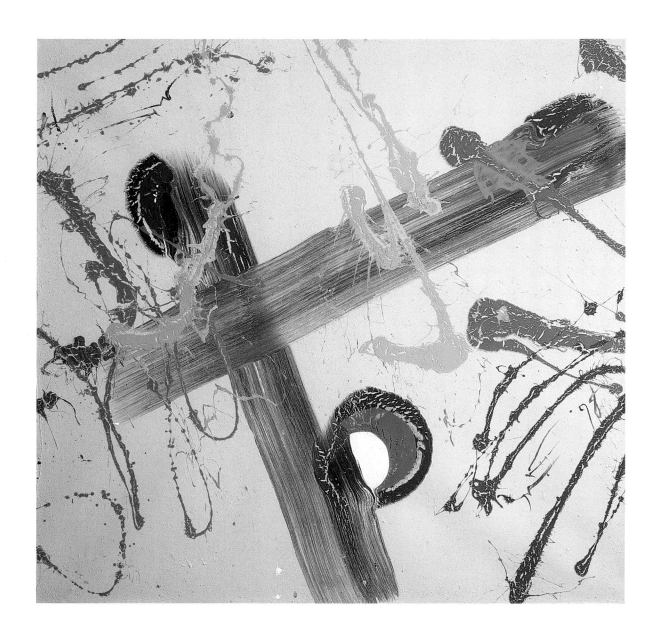

Equilibrium. 1998
Tempera on canvas. 195 x 190

Untitled. 1999
Tempera on canvas. 190 x 200

Stone Flower. 1998
Tempera on canvas. 190 x 190

vladimir **YANKILEVSKY**

From the *Space of Experiences* Cycle. Sheet 2. 1988
Oil pastels on yellow paper. 49.9 x 69.7. Russ. Mus.

From the *Space of Experiences* Cycle. Sheet 1. 1988
Oil pastels on green paper. 50.1 x 64.9. Russ. Mus.

One of the tasks of art is to make the invisible visible.

My theme in art is the battle of the various elements in life and their interaction, which is, essentially, the life that surrounds us ... In order to express my concept of life, it was necessary to create an adequate language, which appeared as a result of a happy union of intuition and intellectual efforts. I converse in this language. I do not know whether a translator is needed for "others" to understand me, but I hope that I employ archetypes and universal emotions accessible to all those whose eyes and hearts are open and who are not restricted by intellectual snobbery.

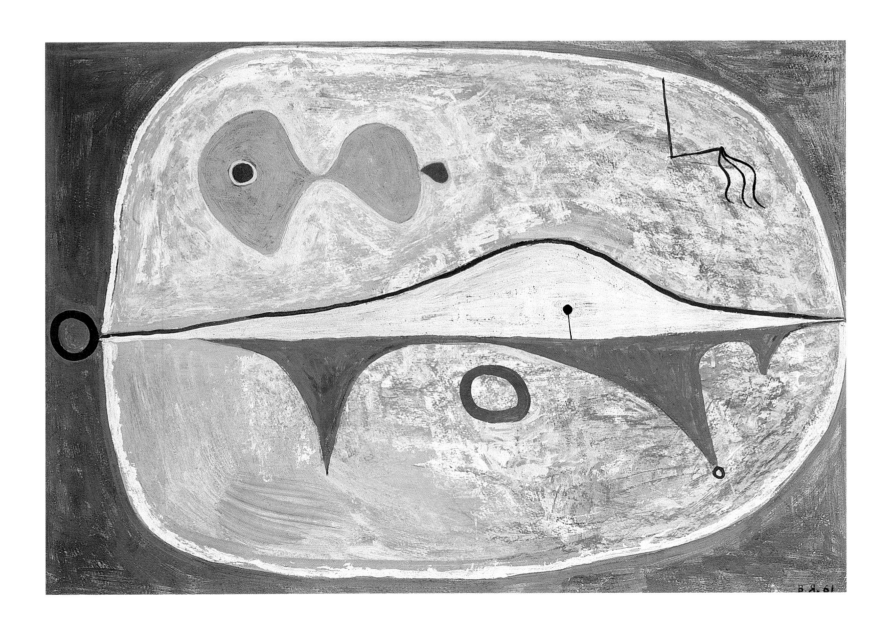

Study No. 12. 1961
Tempera on cardboard. 50 x 70. Russ. Mus.

natalia **ZHILINA**

I relate very well to abstract painting, but only as an exercise for figurative painting.

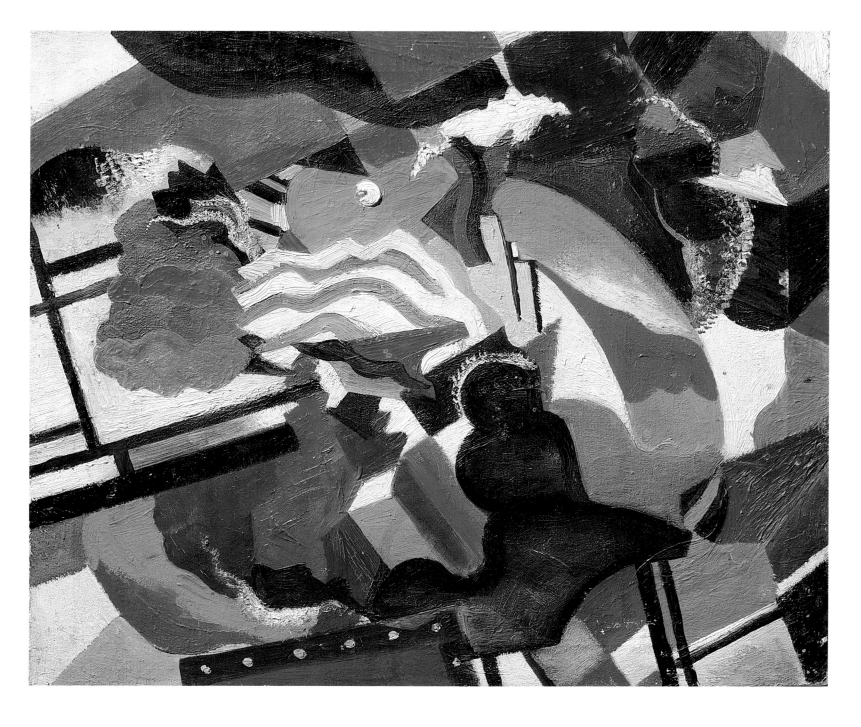

Composition. 1961
Oil on canvas. 63 x 76. Russ. Mus.

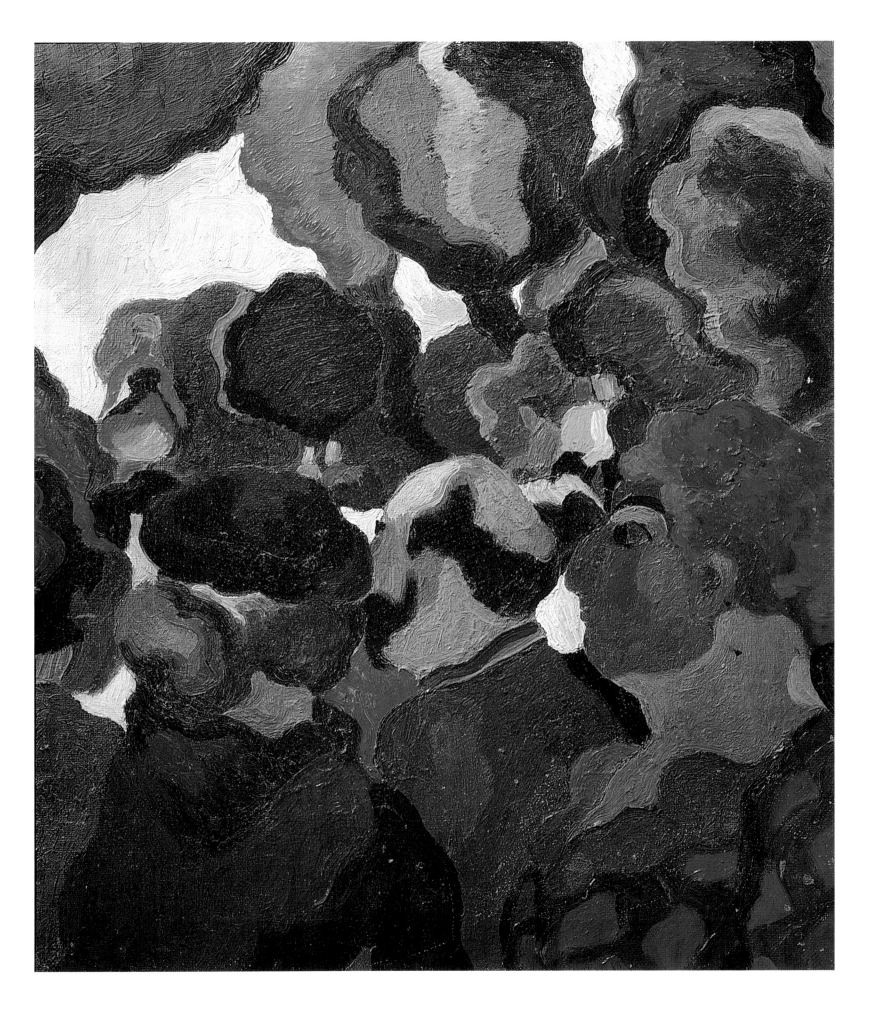

Composition. 1968
Oil on canvas. 37.5 x 48.5. Russ. Mus.

Countenance. 1985
Oil on canvas. 85.5 x 78.5

Countenance. 1985
Tempera on plaster. 38 x 33 x 19

Countenance. 1985
Tempera on plaster. 51 x 25 x 23

yakov VINKOVETSKY

Abstract painting is, for me, the most generalised form of painting, highlighting, unlike the other arts, everything and all that is typical of painting as such.

Foxnose. 1962
Oil on fibreboard. 80.6 x 119.7. Zimmerli Museum, Rutgers University, USA

olga **POTAPOVA**

Olga Potapova's multi-layered oil and tempera paintings radiate an emanance like a precious stone. There are no objects here – the pictures are abstract – only dimmed reflections, glimmerings and plays of colour. Neither are there concrete forms; everything melts, slips away and dissolves. This is often an open composition that seems able to be infinitely moved in all directions, including the entire surroundings in itself, merging with it and merging it with itself. (L. K.).

Blue Composition. 1962
Oil on cardboard. 50 x 36. Yevgeny Nutovich collection, Moscow

vitaly KUBASOV

My concept is associative abstraction. The meaning that I invest in this is a synthesis of the figurative (representational) and abstract languages in fine art. Why associative? Because association, founded on the ancient and possibly genetic memory typical of all people, is always figurative, as it is a recollection of a concrete figurative image.

Case of the Viennese Chair. 1989
Tempera on paper. 73.3 x 50. Russ. Mus.

Composition No. 1. 1989
Tempera on paper. 73.6 x 50.1. Russ. Mus.

Three Temperaments. 1962
Oil on canvas. 150 x 95. Russ. Mus.

Temple Entrance. 1962
Oil on canvas. 105 x 95. Russ. Mus.

lev **KROPIVNITSKY**

It was non-objective, austere painting, conflictive to the point of tragedy and extremely dynamic in both its inner state and plastic structure. It was frugal and ascetic in colouring and expressive and tense in content. It doubtlessly reflected the tension, trials and tribulations of past years. Painting set me free, helping me to cast off my excessive, oppressive burden.

Time and Silence. 1962
Oil on canvas. 152 x 37. Yevgeny Nutovich collection, Moscow

Composition. 1962
Oil on canvas. 93 x 72. Yevgeny Nutovich collection, Moscow

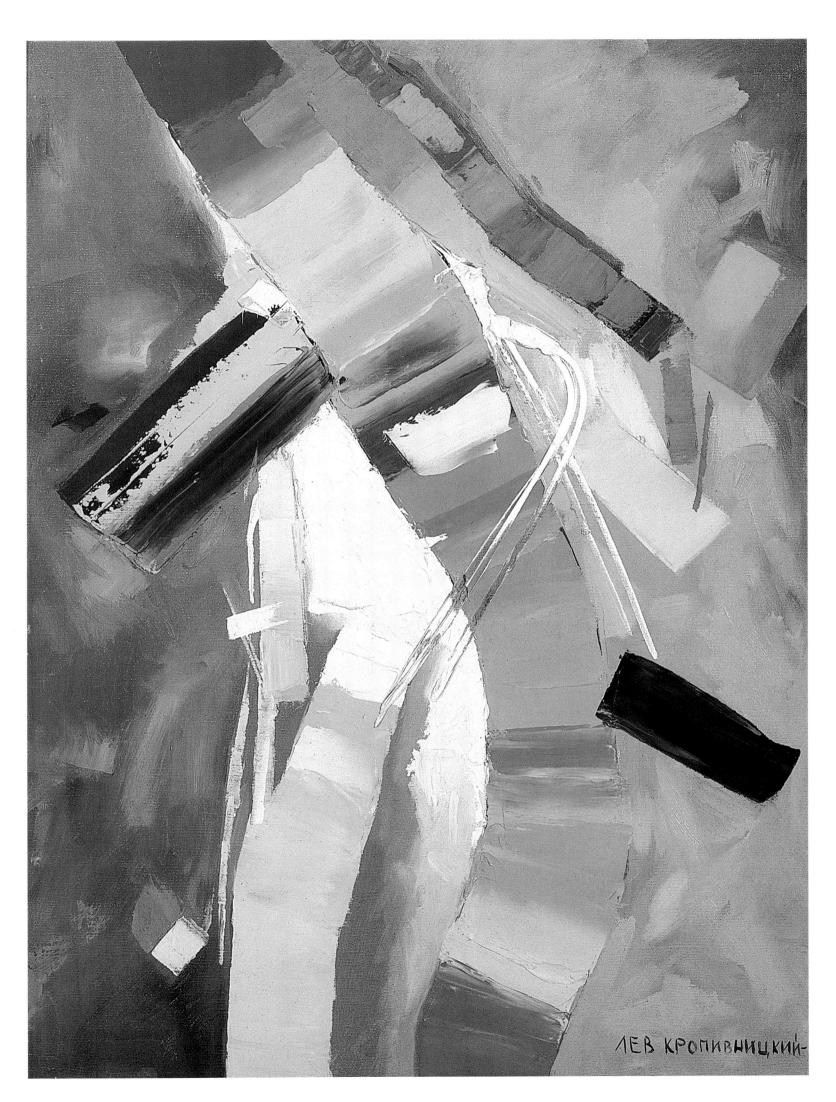

ЛЕВ КРОПИВНИЦКИЙ

marlen SPINDLER

The sign of salvation – clarity – is achieved by exaggerating forms. My clarity underscores the line of thought. My creed is the creed of any decent, upright man – freedom in art. For this I spent eight years in prison.

Black Stallion 1973
Tempera on canvas. 102 x 128

Blue Composition. 1962
Tempera on canvas. 104 x 140.5

lydia MASTERKOVA

The refined rhythmic movement [of Masterkova's drawing] always seemed to me to be like music. Hence the words of the common friend of all artists, the innovative poet Seva Nekrasov:

> *Lydia Masterkova*
> *Paints in orchestration*

I believe that this relates to the general impression from her pictures, from both the colour and the drawing. (L. K.)

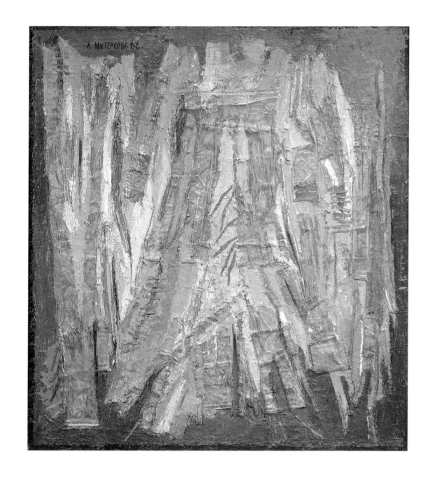

Cathedral. 1966
Oil, brocade and collage on canvas. 93.5 x 83
Yevgeny Nutovich collection, Moscow

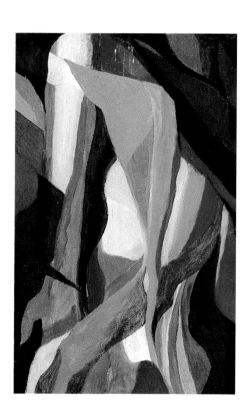
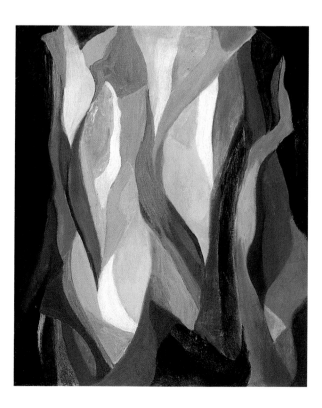
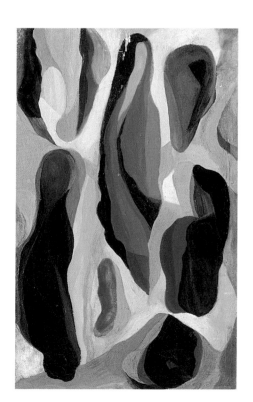

Triptych. 1963
Oil on wood. 50 x 105. Yevgeny Nutovich collection, Moscow

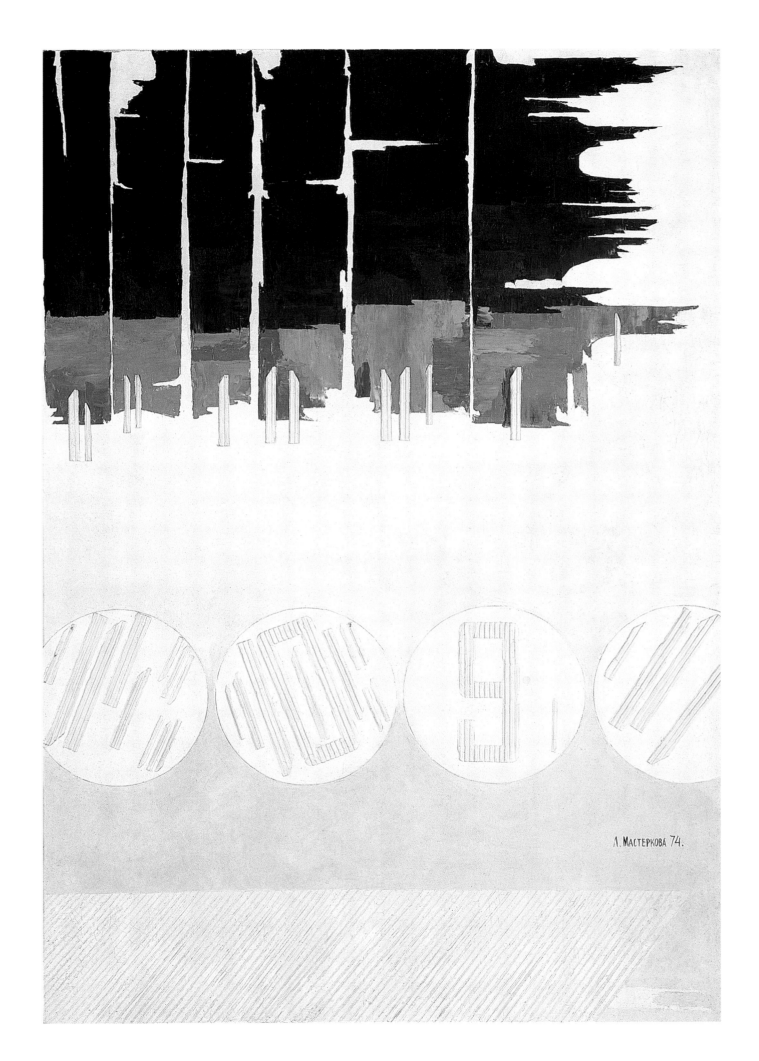

Untitled. 1974
Oil and collage on canvas. 121.5 x 83. Zimmerli Museum, Rutgers University, USA

The picture is not a document; it is a form of life.
... I am interested in colour deformations, i.e. the non-coincidence of
the colour of the object and its form in art.

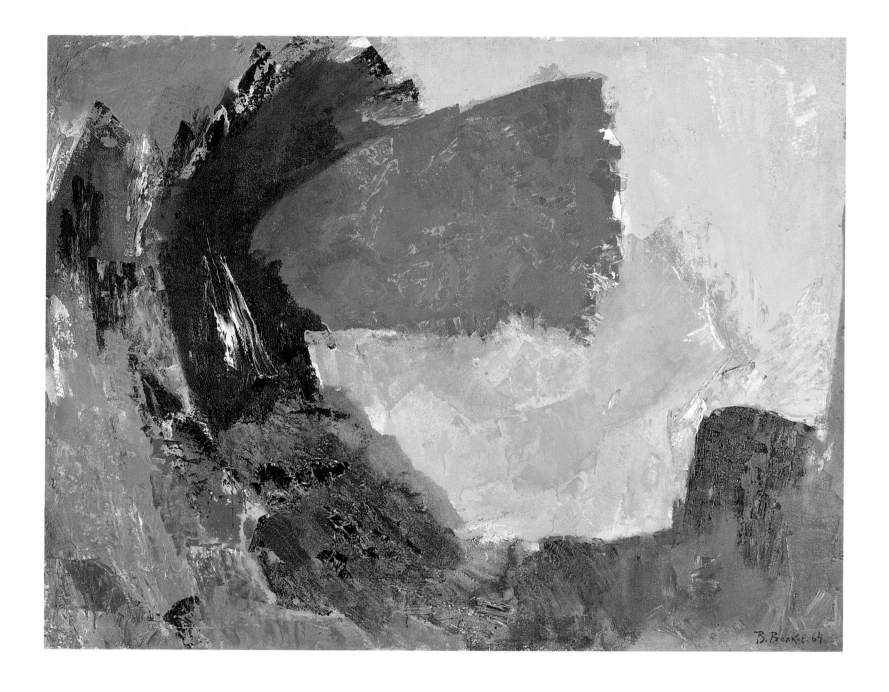

Red Spot. 1963–64
Oil on canvas. 95 x 121.5. Tret. Gal.

Composition (Nocturnal Naples). 1972
Oil on canvas. 111 x 79.5. Russ. Mus.

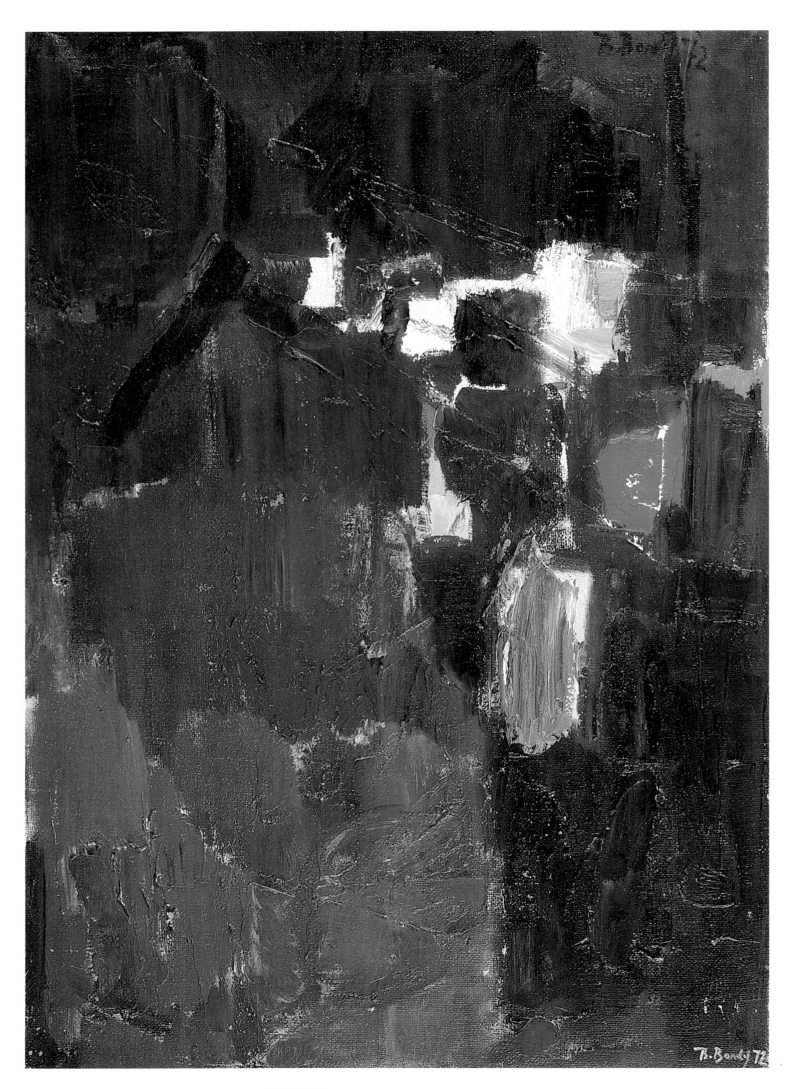

alexei **TYAPUSHKIN**

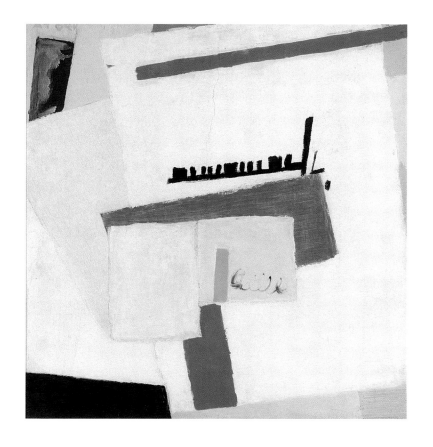

Composition, colour and tone are resolved like a mathematical formula – distinct, harmonious, simple and beautiful. Placed at the forefront of Alexei Tyapushkin's canvases, symmetry and composition enload all the details, lending a sense of mystery to each patch. (A. S.)

Painterly Experiment. 1964
Oil on cardboard. 52 x 48.5. Yevgeny Nutovich collection, Moscow

Projection of an Emotional Explosion. 1964
Oil on canvas. 73 x 103. Yevgeny Nutovich collection, Moscow

Aesthetic Experiment. 1967
Oil and collage on cardboard. 73.5 x 48. Tatyana and Natalia Kolodzei collection, Moscow

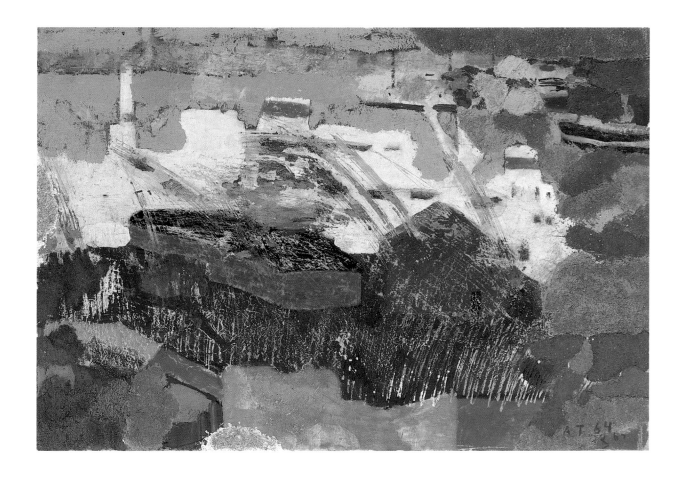

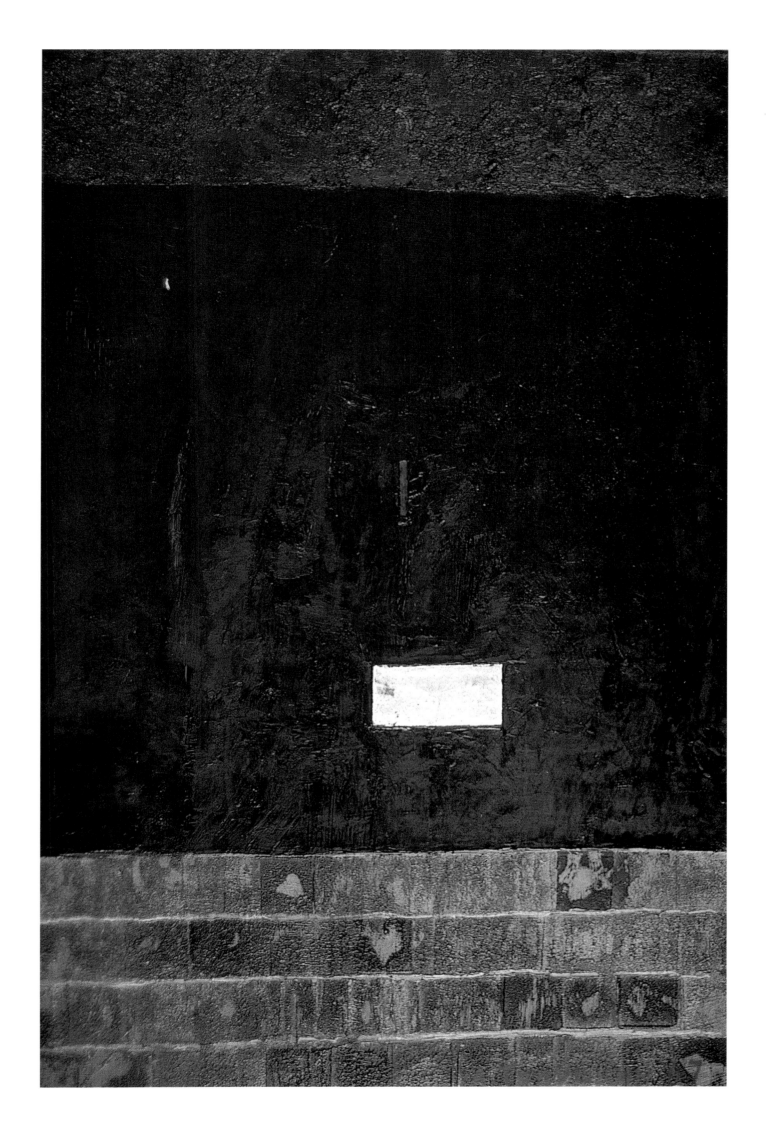

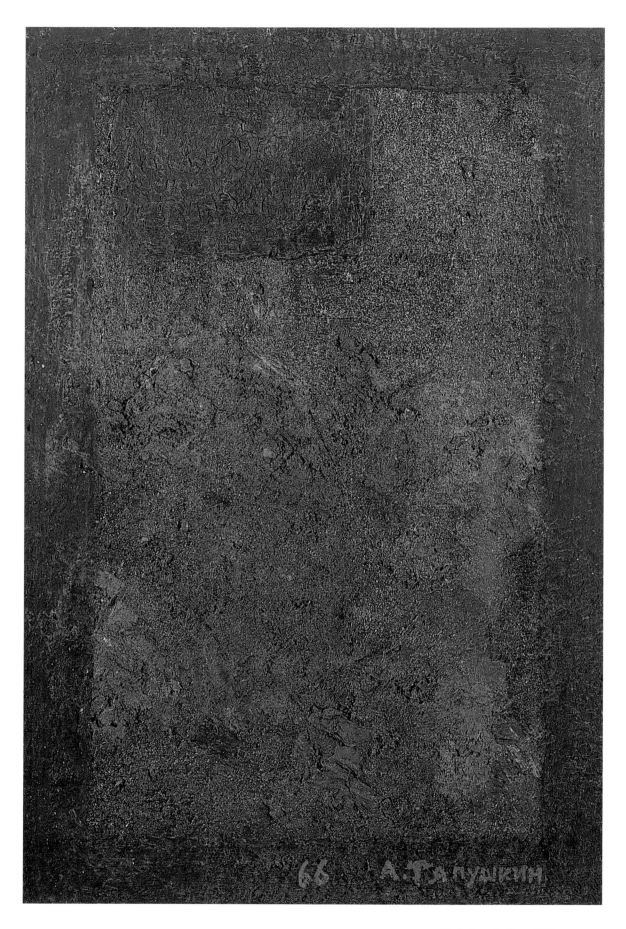

Mysterious Surface. 1966
Oil on canvas. 60 x 40. Tatyana and Natalia Kolodzei collection, Moscow

Emotional Detail (Pattern). 1967
Oil on cardboard. 75 x 65. Tret. Gal.

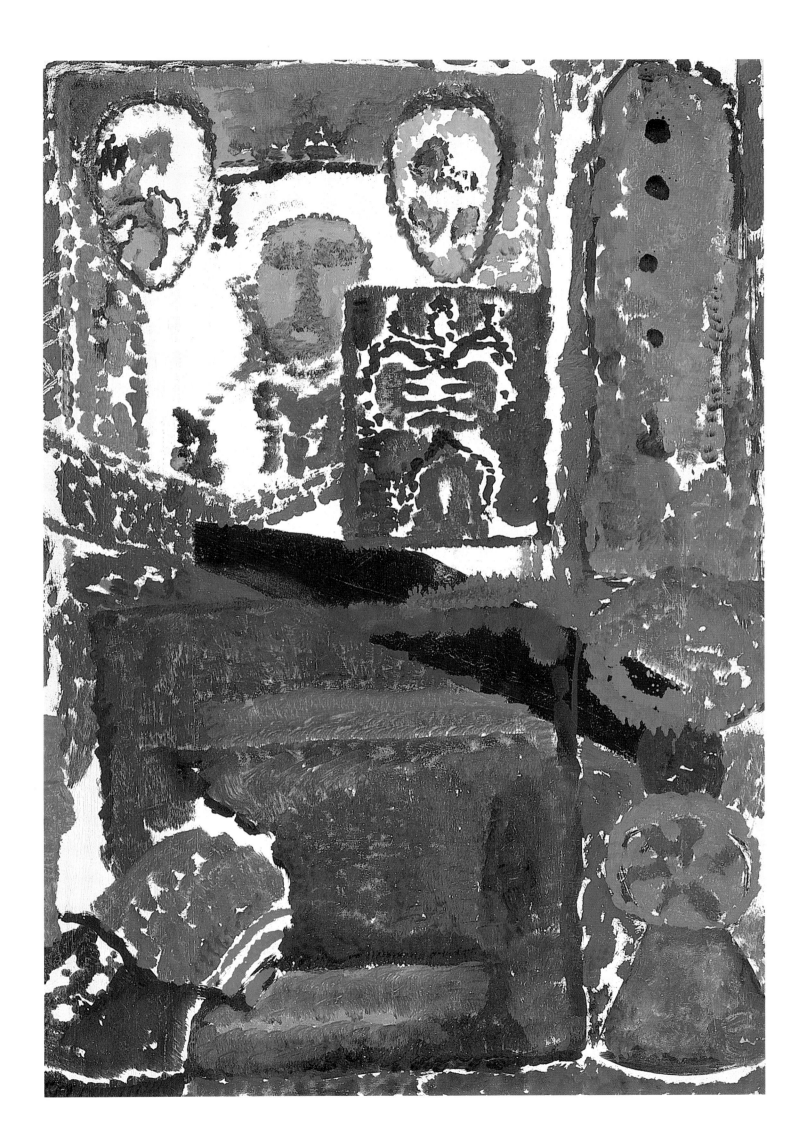

francisco **INFANTE-ARANA**

The infinity of the arrangement of the world was the first strong impression I received by the time I had passed through a schooling in academic drawing in Moscow. Subordinating myself to this impulse, I attempted to designate the nature of infinity, its breathing. The works I did – drawings, geometric painting, designs and constructions – were built in such a way that they expressed a total continuation, both deeply and widely, beyond the bounds of the frame-limitation. Visual elements repeated one another, infinitely diminishing or growing.

Point in its Space. 1964. Version No. 5
Oil on canvas. 93.5 x 92

**Space – Movement – Infinity
(Project of a Kinetic Object).** 1963
Indian ink and tempera on fibreboard. 70.3 x 91. Zimmerli Museum, Rutgers University, USA

Red Spiral. 1965
Tempera on cardboard. 99.5 x 49.5. Tatyana and Natalia Kolodzei collection, Moscow

Kolodzei Blizzard. 1965
Tempera on cardboard. 104 x 52. Tatyana and Natalia Kolodzei collection, Moscow

Spiral. Multi-Colour in the Space of a Spiral. 1965
Gouache and tempera on paper. 103.5 x 52. Russ. Mus.

lev NUSSBERG

Crossing. 1961
Tempera on paper. 45 x 61. Russ. Mus.

Like music, abstract art spiritually cleanses man, helping him to rise above the crude foundations of life and to escape, if only for a minute, the fustiness of daily life (the social dirt and vulgarity of which are rudely forced on the philistine, particularly the nouveaux riches, under the guise of pop artists, smirking and bestrewing anecdotes: "but ... the Emperor has no clothes!").

Mentally open and naturally predisposed towards everything new and unusual, coming into contact with ABSTRACT ART, people are capable of experiencing not only an emotional catharsis, but also intellectual-spiritual delight, ecstasy from soaring into different, almost transcendental, intellectual spheres of pure BEAUTY and true FREEDOM!

Organised Flow of Lava in a Crystallised Environment. 1962
Tempera on paper. 42.6 x 28

Spiral. Lava in a Critical Environment. 1962
Tempera on paper. 49 x 35. Russ. Mus.

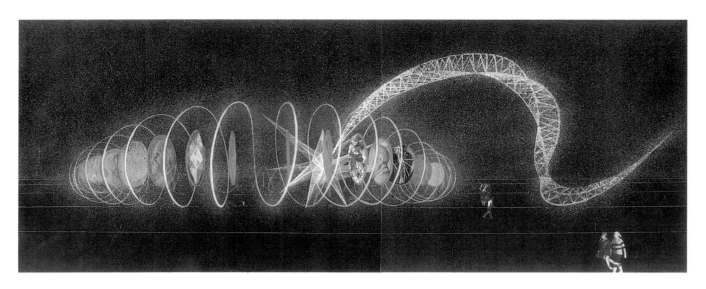

Spiral. 1963 project design (in collaboration with G. Bitt). 1966
Tempera on paper. 19.5 x 48.5

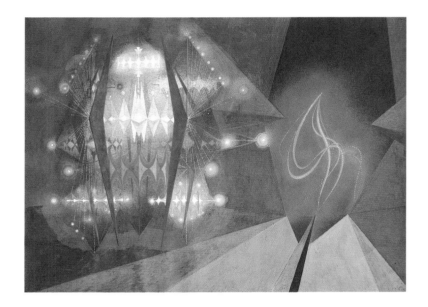

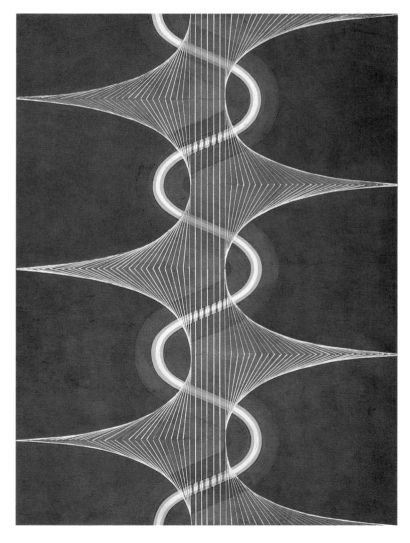

"There ... and Here" (Contrasts). 1964–65
Tempera on paper. 42.7 x 61.2. Russ. Mus.

Vertical Spiral in the Cogs of an Electromagnetic Field. 1962
Tempera on paper. 48 x 33

yury **KRYAKVIN**

Abstraction is the mirror of the soul.

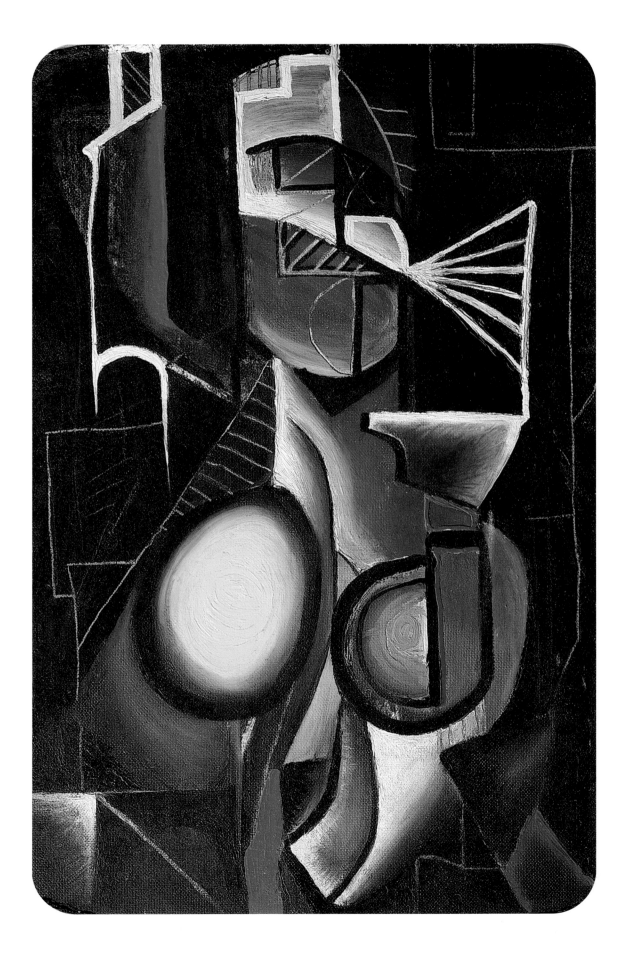

Composition. 1968
Oil on cardboard. 77 x 51.5. Russ. Mus.

vyacheslav **KOLEICHUK**

A special movement in the development of form-creation was linked to the modelling of paradoxical "impossible" objects in space ... The creation of "impossible" graphic constructions intensified the problem of their perception ... The creation of objects with elements of intellectual play containing both a certain visual task and its resolution thus became possible.

Mast. 1967
Tempera on cardboard. 99.5 x 35.5. Tatyana and Natalia Kolodzei collection, Moscow

sergei **SHEFF**

... From painting I demand no fragments and no sentimentality. The object should be compositionally complete, just as the world (planet), colour and volume are organised without chance features or impudence. Dialectics are required – space simultaneously with the plane. As with Rublev and the other great and anonymous masters.

Composition. 1973–78
Oil on fibreboard. 81.5 x 70. Zhanna Brovina collection, St Petersburg

First People on the Moon. 1969
Oil on fibreboard. 69 x 81. Boris Kozlov collection, St Petersburg

Nostalgia for Perfection. 1966
Oil on cardboard. 44 x 44.5. Boris Kozlov collection, St Petersburg

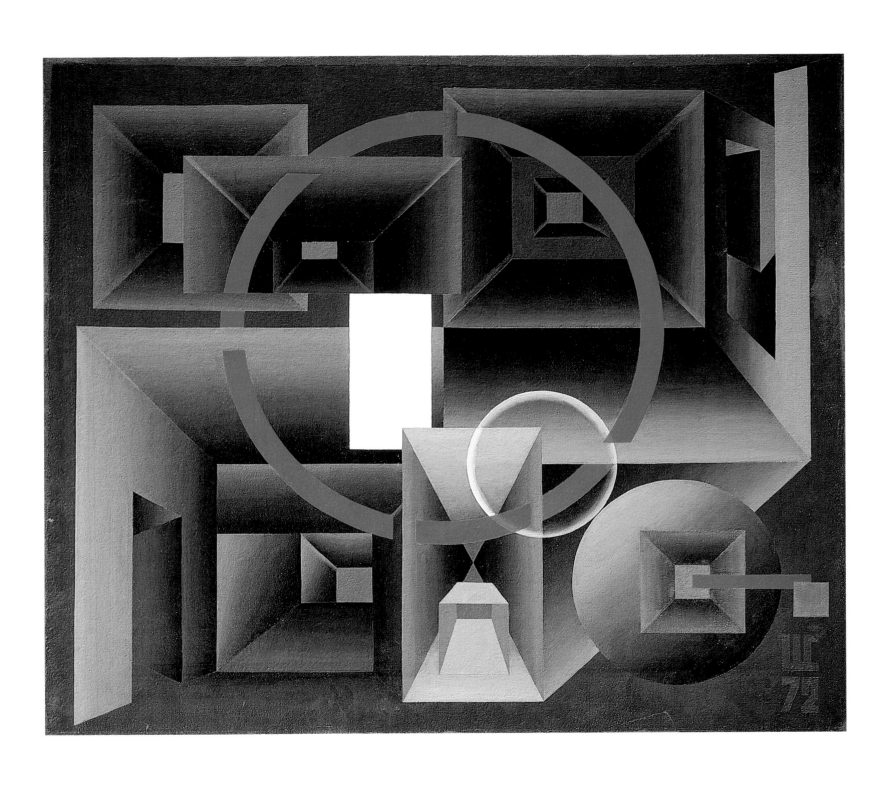

Large Labyrinth. 1972
Oil on fibreboard. 101 x 115.5. Russ. Mus.

alexander **PANKIN**

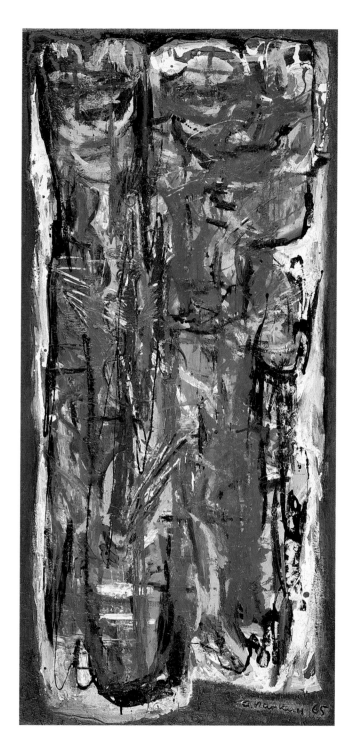

The era of abstract art will probably still experience a golden age in the twenty-first century. One of the possible vectors of its development, in my opinion, is close contact with science, the realisation of mathematical abstraction and scientific objects in art. This is the path towards "objective" art, based on aloofness from the subjective impact of taste on the work.

Two Figures. 1965
Oil and collage on canvas. 188 x 84

Three Figures. Glance. 1992
Oil on canvas. 100 x 128

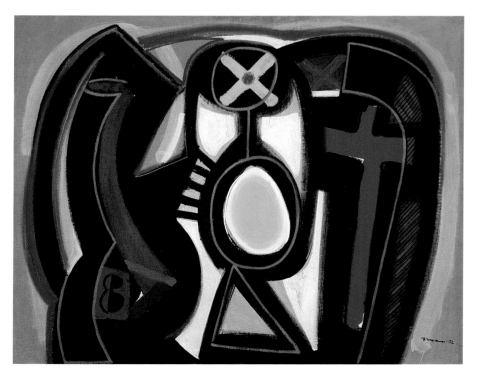

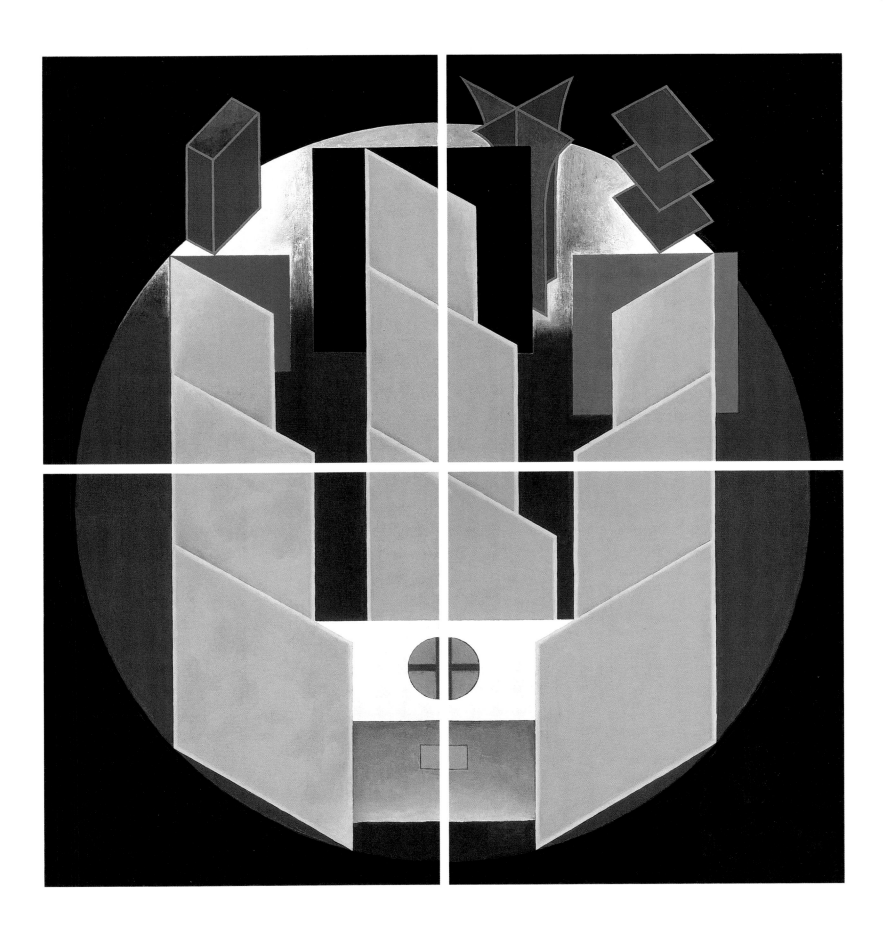

Three Figures. 1998. Four-part composition
Oil on canvas. 204.4 x 192.8. Russ. Mus.

mikhail **LAZUKHIN**

Here, for me, is a living link between Suprematism and what I call the humanitarian element of man.

Silvercloud. Undated. 69/125
Coloured printing and silk-screen print on paper.
Image: 30.9 x 31.7; sheet: 52.1 x75. Russ. Mus.

Departure. Undated. 88/100
Coloured printing and silk-screen print on paper.
Image: 45.6 x 38.1; sheet: 45.6 x 71.2. Russ. Mus.

Soliloquy: Skylark. 1991. 1/70
Offset printing and lithograph on paper. 59.5 x 54.5. Russ. Mus.

Atarax. Undated. A/ P
Coloured printing and silk-screen print on paper.
Image: 5.2 x 4.9; sheet: 19.9 x 19.9. Russ. Mus.

Tribute-2. Undated. 18/30
Coloured printing and silk-screen print on paper. 47 x 67. Russ. Mus.

Tribute-1. Undated. 21/35
Coloured printing and silk-screen print on paper. Image: 20.1 x 20.1; sheet: 45.7 x 33. Russ. Mus.

Jay-1472. 1972
Stencil printing on etching. Image: 76.9 x 45.2; sheet: 106 x 66. Russ. Mus.

Raya L. 1971
Watercolours, aerograph and gouache on cardboard. 76.2 x 60.6. Russ. Mus.

Triad. Undated. 8/50
Coloured printing and silk-screen print on paper. Image: 31.4 x 31.3; sheet: 52.2 x 36.8. Russ. Mus.

yevfrosinia **YERMILOVA-PLATOVA**

I do not remember exactly what year it was, but an exhibition of Goncharova, Larionov and the Burliuks in Kherson made a great impression on me. It left an indelible print on my entire oeuvre.

Spring Rhapsody. Mid-1960s
Oil on canvas. 76 x 68. Yevgeny Nutovich collection, Moscow

VALRAN

In abstractionism, painting has finally reached the ultimate concentration of "art for art's sake", when the "form" completely absorbs the "content" and celebrates its triumph. The next step is deliverance from the material basis and exit into virtual space.

Composition (Das Rheingold). 1993
Oil on plywood mounted on canvas. 100 x 120

boris BAK

Painting, abstract painting, completely discloses the elements – colour, light, compositional constructions, patches, lines, forms, etc. Painting, abstract painting, painting in all its diversity, cannot be related or explained in words. Words are the enemy of painting. Malevich's genius – the black square – is reduction to the atom of painting. That is the elementary particle of painting, like the electron in physics.

Forces. 1995
Oil on cardboard. 53 x 45

... To Valery Isayevich Rudoi. 1997
Oil on cardboard and metal. 55 x 52

yevgeny **RUKHIN**

My first canvases were symbolic in motifs and had far from traditional forms – for example, there were triangular, square, round canvases and other geometric forms. They were often completely abstract, non-objective. I was interested above all in relief and colour.

... From 1963 to 1967, I sought new techniques, new paints, surfaces, styles and dimensions which went from the abstract to the superrealist. From the very outset, I was interested in expression and the life of the surface of the canvas.

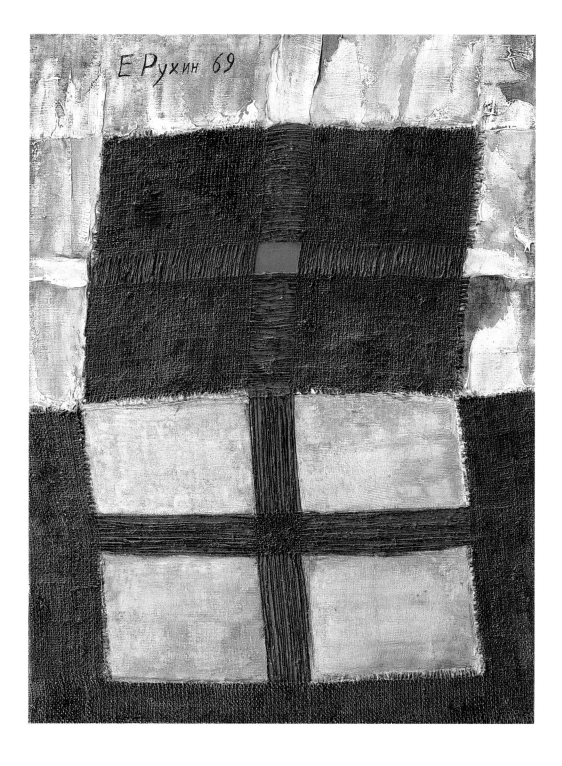

Untitled. 1965
Oil on canvas. 83 x 54
Private collection, Moscow

Untitled. 1969
Oil on canvas. 85 x 62
A. N. Vasilyev collection, St Petersburg

eduard **STEINBERG**

By the 1970s, the lightened landscape/still-life had taken the form of spatial-geometric compositions. Organic forms were replaced by the cross, circle, triangle, square, prism and sphere. The formulation of my inner concept was thus born. Not to tear up, but to synthesise the mystical ideas of the Russian Symbolism of the 1910s and the plastic ideas of Suprematism or, to be more exact, the ideas of Kazimir Malevich.

Composition. 1970
Oil on canvas. 100.5 x 110. Russ. Mus.

Composition. December 1976. 1976
Oil on canvas. 115 x 69. Zimmerli Museum, Rutgers University, USA

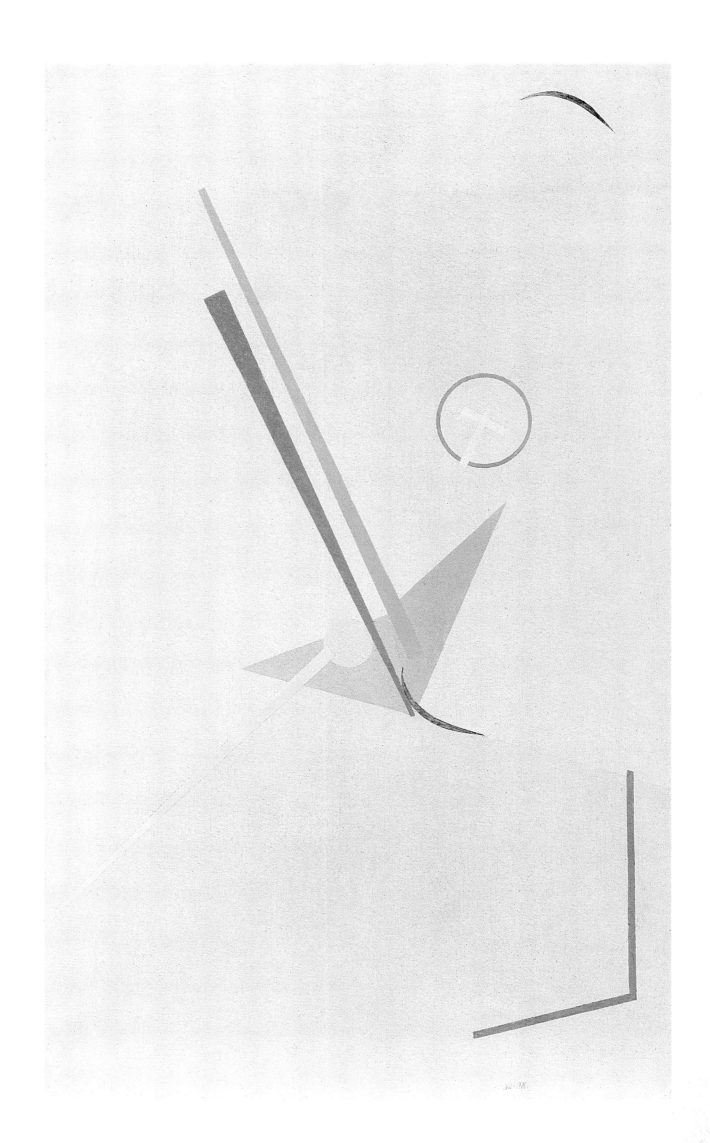

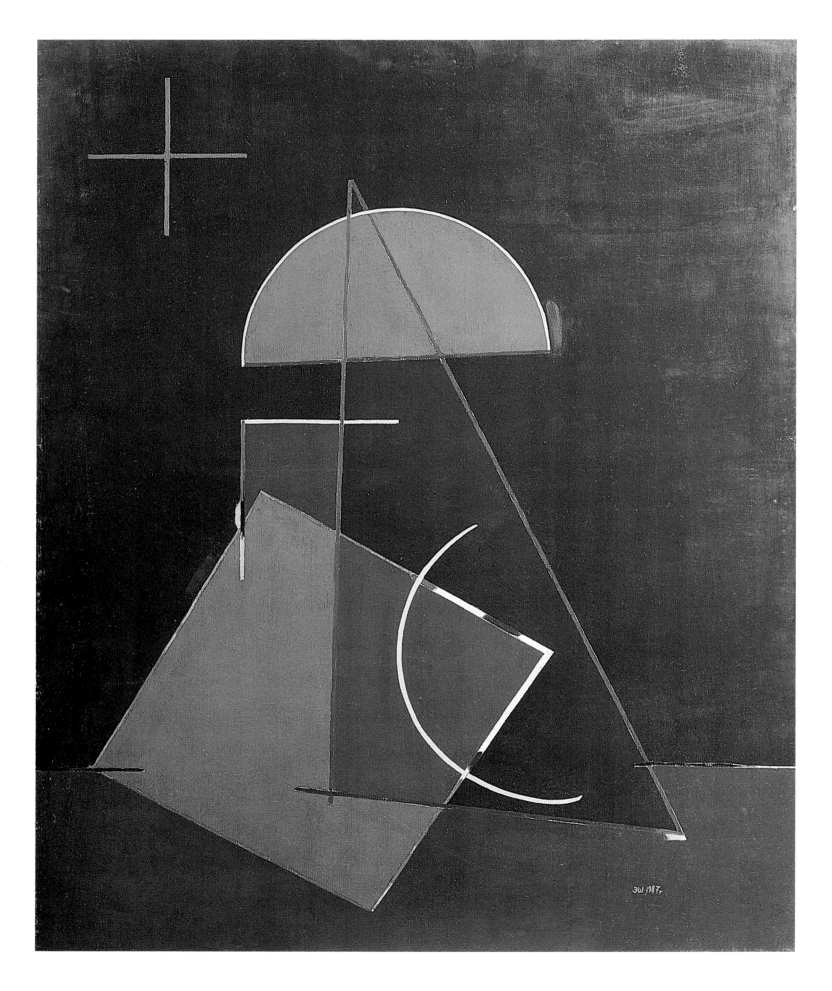

Composition. 1987
Oil on canvas. 120 x 97. Russ. Mus.

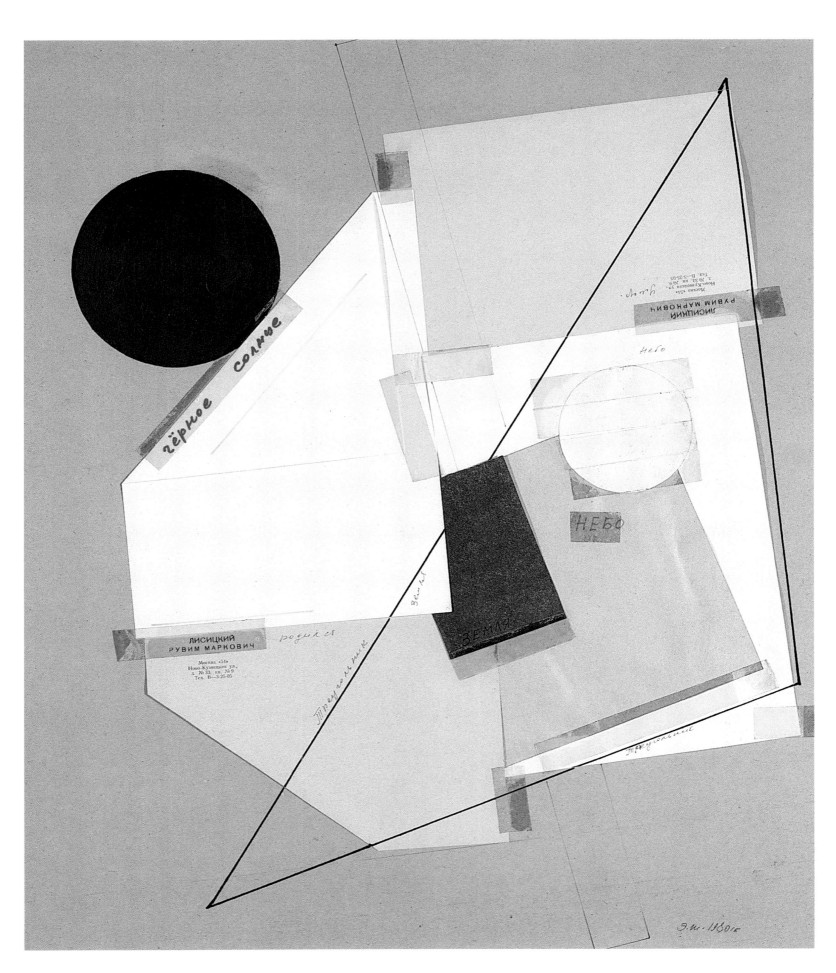

Black Sun. 1980
Sellotape, collage and mixed media on cardboard and coloured and tinted paper
58 x 48. Russ. Mus.

vladimir **STERLIGOV**

Some draw the mundane – with feeling. Others replace it with abstraction. Happy, however, are those who combine the force of abstraction with the economic measure of feeling. Then there is harmony ... The image is more realistic than reality.

Sea No. 6. Music. 1962
Oil on canvas. 40 x 55.5. Russ. Mus.

leonid **SOKOV**

Interest in abstractions was, for me, a temporary phenomenon. When you look at Russian culture in general, you see that this is a culture of ideas. Even the art of the 1920s – formal and abstract – was placed at the service of the revolution, i.e. at the service of ideology and propaganda.

Abstraction. 1967
Wood. 60 x 27 x 17.5

pavel **KONDRATIEV**

Whenever I experience difficulties – illusory vision – I have two ways out. I either go inside forms from the borders according to the principle of madeness or I proceed from Cubism.

Little Fires. 1968
Pastels on grey paper with watermarks. 38.6 x 31.4. Russ. Mus.

Composition. 1971
Pastels on paper. 29.7 x 21.2. Russ. Mus.

Composition. 1971
Pastels on paper. 21.1 x 29.8. Russ. Mus.

Composition. 1968
Oil on cardboard. 49 x 33. Russ. Mus.

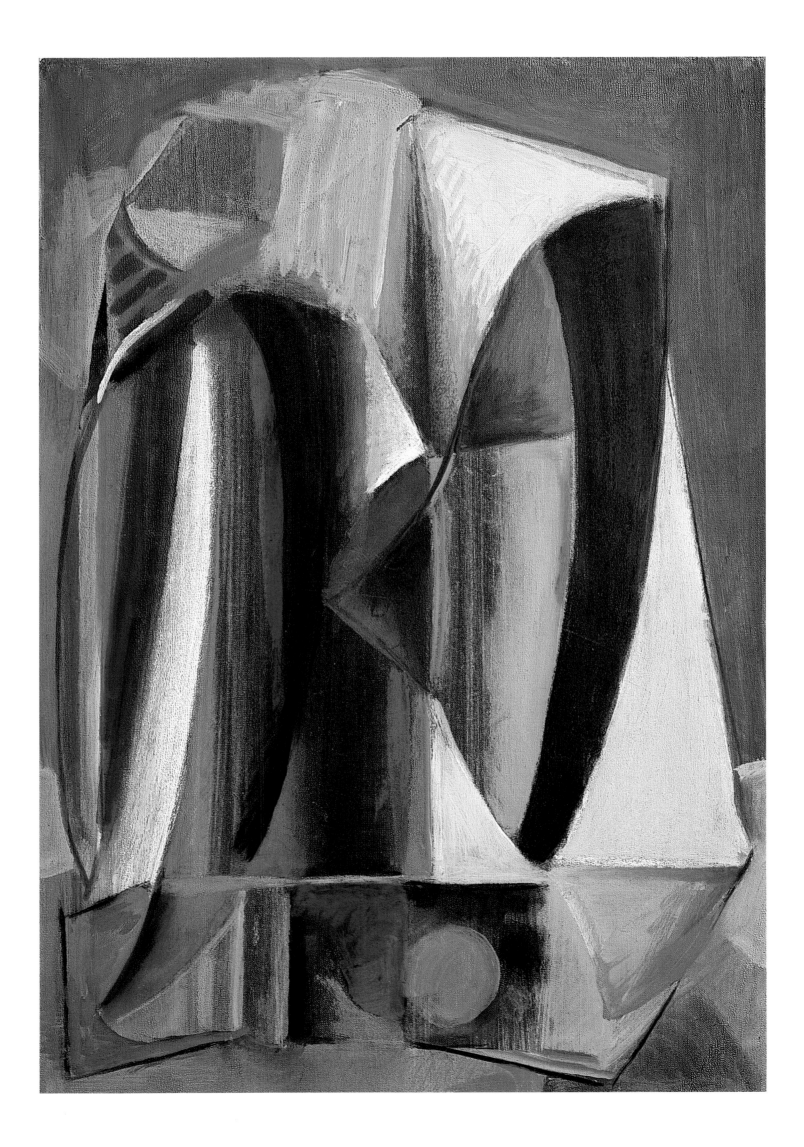

vladimir VOLKOV

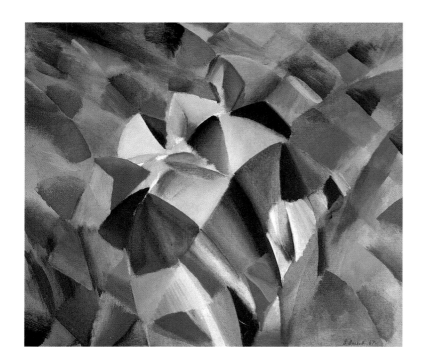

The path of the artist inevitably passes along the edge of a knife – between the Scylla of order and the Charybdis of the irrational, between freedom and necessity, between the Scylla of naturalism and the Charybdis of formalism, between the logics of common sense and the alogism of the absurd and nonsense.

Walking on a Field. 1967
Tempera and polyvinyl acetate on canvas. 75 x 84. Russ. Mus.

Composition with Two Bystanding Figures. 1983
Oil on cardboard. 49.5 x 70. Russ. Mus.

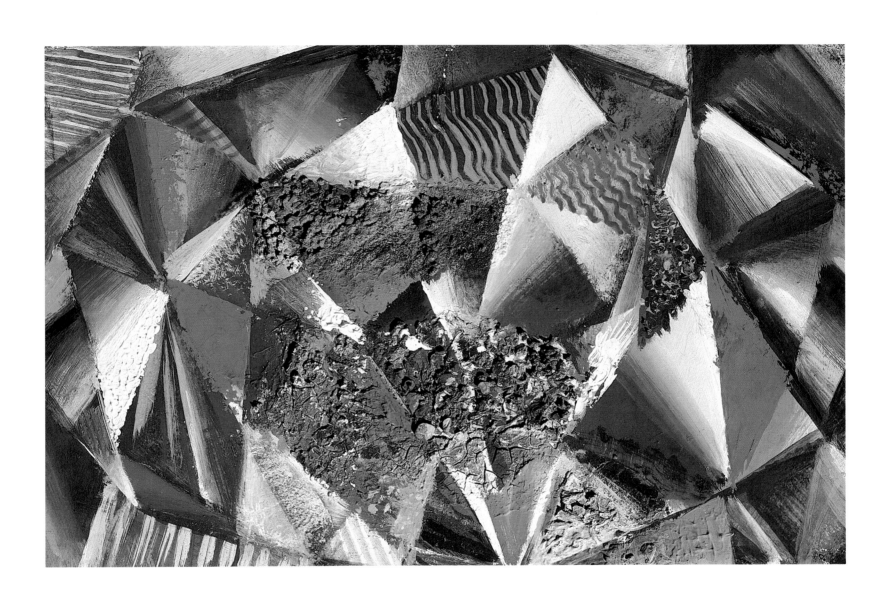

Textures. 1971
Tempera on cardboard. 34 x 49.5. Russ. Mus.

Rural Theme. 1971
Watercolours on paper. 48.7 x 63.2. Russ. Mus.

Figures. Late 1970s
Watercolours on paper. 48.2 x 51.5. Russ. Mus.

Staircase. Lenin Prospekt. 1987
Oil on canvas. 100 x 65

White Landscape. Ribbons. 1975
Tempera on canvas. 57 x 85. Russ. Mus.

Haberdashery. 1969
Tempera and polyvinyl acetate on cardboard. 57 x 85. Russ. Mus.

Figure. 1982–84
Tempera on wood. 62 x 15 x 13

Figure. 1985–87
Tempera on wood. 50 x 16 x 5

valery YASHIGIN

The canvas is a battlefield without borders and the artist is constantly in a state of tragic collision with the canvas. Purity. Space is created. Submerging into it, I break its silence, extracting its secret. And it, the secret, is born.

The symbol is an expression of the energy of life in action. The tension created by the symbol extends the world and its limits infinitely.

Grey Painting. 1972
Oil on canvas. 63.5 x 81. Russ. Mus.

Black Disc. 1973
Lithograph. Image: 63.1 x 47.8; sheet: 71.8 x 53.8. Russ. Mus.

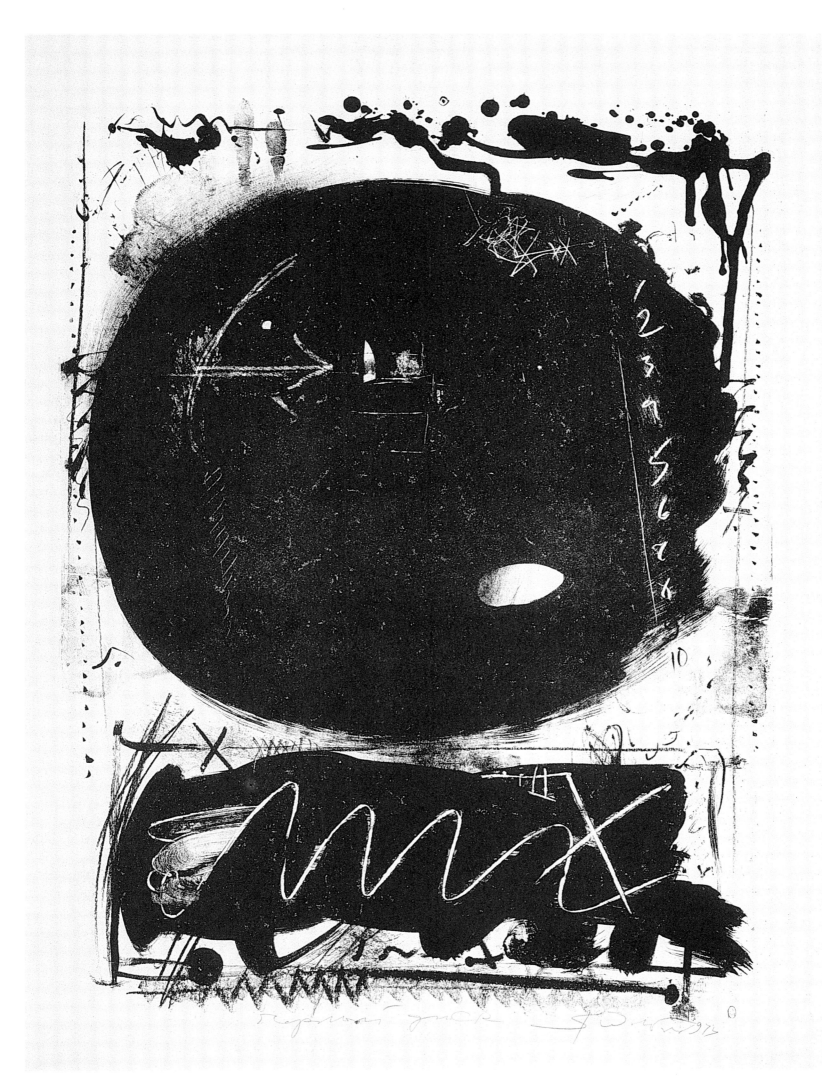

VALERY YASHIGIN

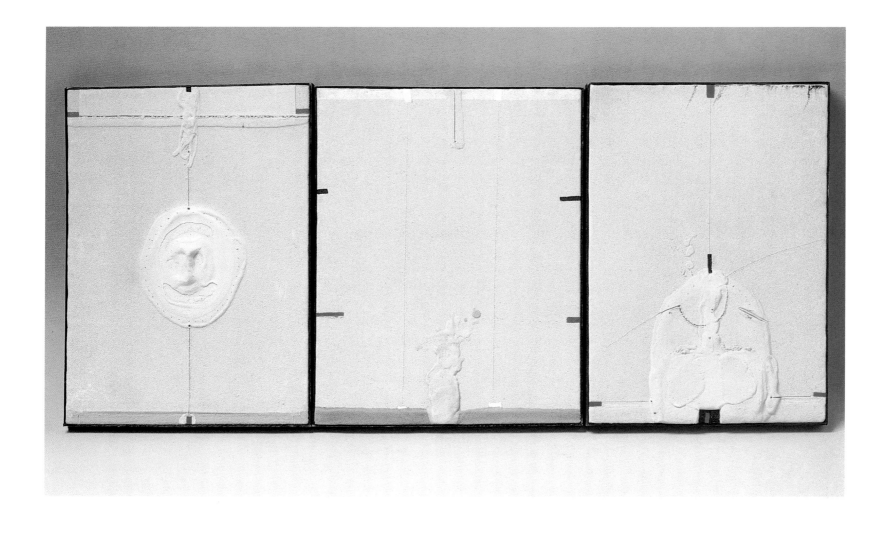

Space in White. 1980. Triptych
Mixed media on canvas. 40.5 x 28; 40.5 x 31.5; 40.5 x 29

Black Landscape. 1980
Mixed media on fibreboard. 102 x 86. Russ. Mus.

Spatial Composition. 1982
Mixed media on canvas. 80 x 61.5

Relief. 1980
Mixed media. 90.5 x 73.5

Dry Landscapes. 1982
Mixed media. 90 x 65

Landscape with a Red Arch. 1981
Mixed media on canvas. 103 x 91. Russ. Mus.

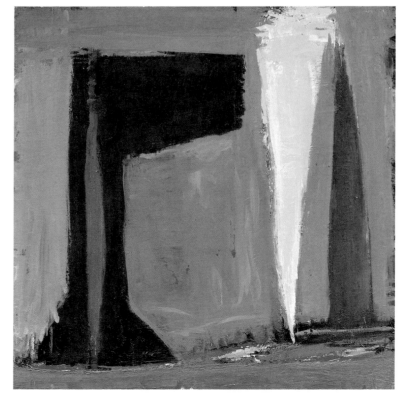

Lilac Cone. 1992
Oil on cardboard. 127 x 84

Black Flag. 1989
Oil on canvas. 127 x 126.5

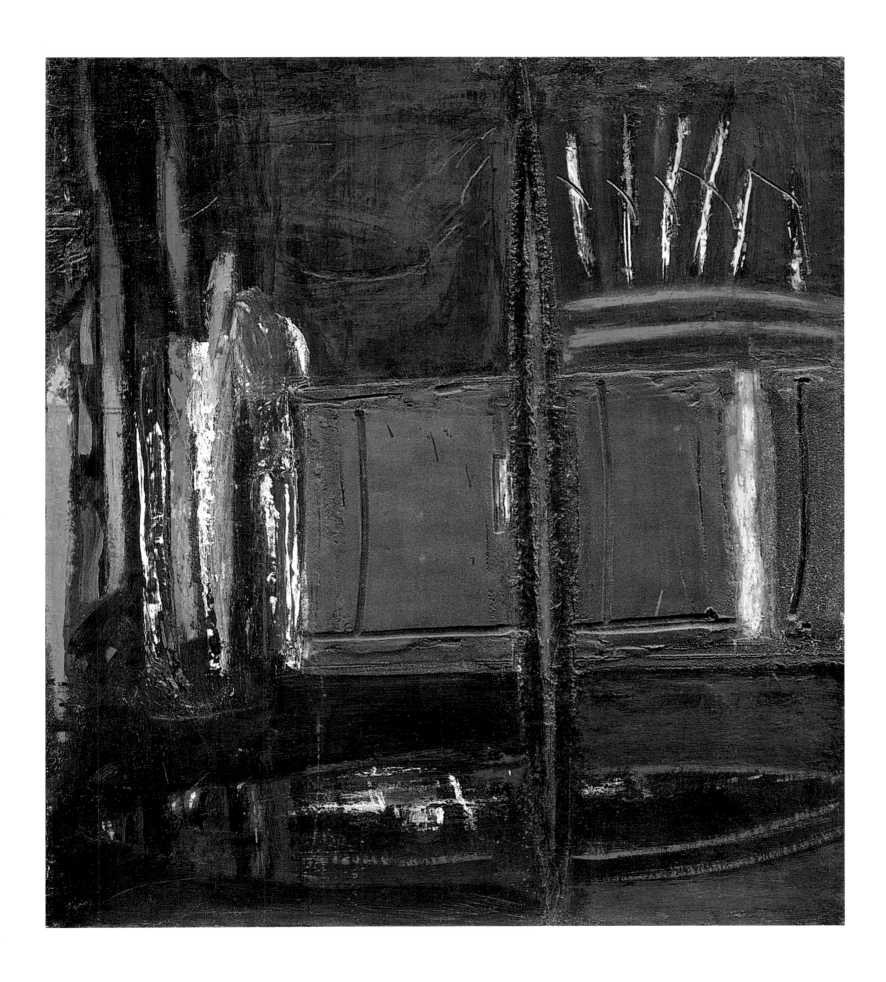

Untitled. 1988
Mixed media on canvas. 94.5 x 85. Russ. Mus.

alexander **LEONOV**

Alexander Leonov's talent is the ability to perceive the everyday as a single painterly surface. The artist does not seek another reality; he is mostly concerned with the painterly attributes in what already exists. Any genre seen only from this point of view inevitably turns into abstraction. Serving as the artist's starting point, a simple picture from life thus dissolves into a boundless sea of potential meanings. (L. B.)

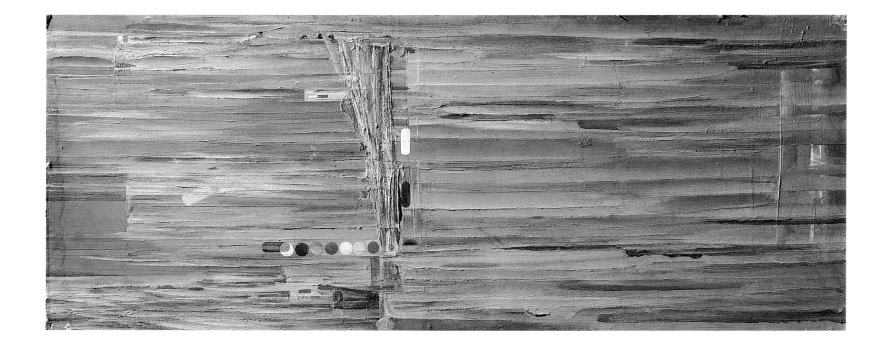

Composition. 1970s
Oil and tempera on fibreboard. 105.5 x 42.5. Russ. Mus.

Wall. 1964
Mixed media on fibreboard. 44.7 x 42.5. Russ. Mus.

yevgeny MIKHNOV-VOITENKO

Artists generally aspire to change the world. My aim is to create it.

Untitled. 1976
Gouache on paper. 37 x 78.3. Zimmerli Museum, Rutgers University, USA

Composition. 1974
Monotype. Image: 41.9 x 29.6; sheet: 41.9 x 29.6. Russ. Mus.

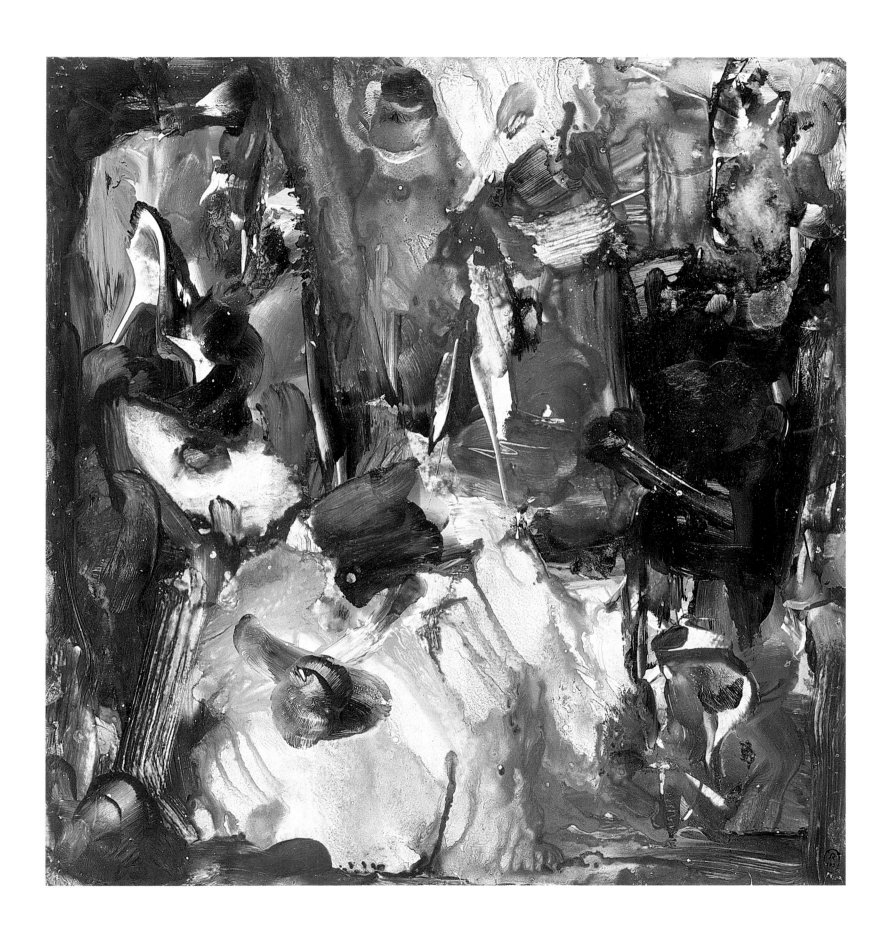

Composition. 1983
Mixed media on paper. 30.2 x 28.5. Russ. Mus.

Composition (Abyss)
Mixed media on fibreboard. 151 x 145. Russ. Mus.

Composition. 1972
Mixed media on cardboard. 145 x 149. Russ. Mus.

Composition (Brown). 1965
Oil on canvas. 64 x 46. Russ. Mus.

Composition (On a White Background). Late 1950s
Oil on canvas. 138 x 271. Russ. Mus.

Composition. Late 1950s
Oil on canvas. 107 x 250. Russ. Mus.

Composition (On a White Background). Late 1950s
Oil on canvas. 156 x 218. Russ. Mus.

zenon KOMISSARENKO

Son of a housepainter, student of Kazimir Malevich, friend of Ivan Kudryashov and admirer of the oeuvre of Mikalojus Ciurlionis, or rather his astrological outlook, Zenon Komissarenko overcame the pull of gravity towards the surrounding world and turned his gaze first towards the expanses of the sea depths, then to lunar landscapes, before finally resting on the dynamics of cosmic elements in the manner of large spots of pointillism, employing a mixed technique. (M. A.)

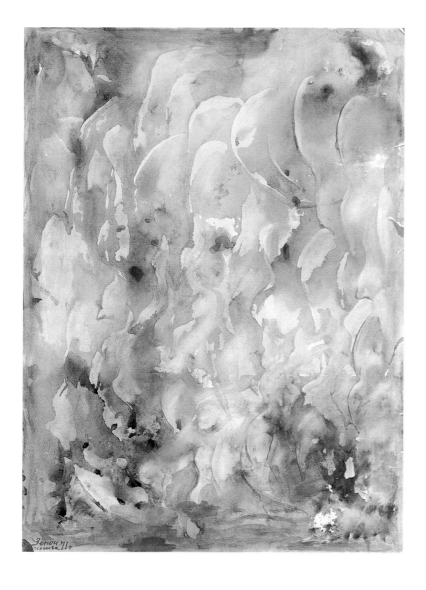 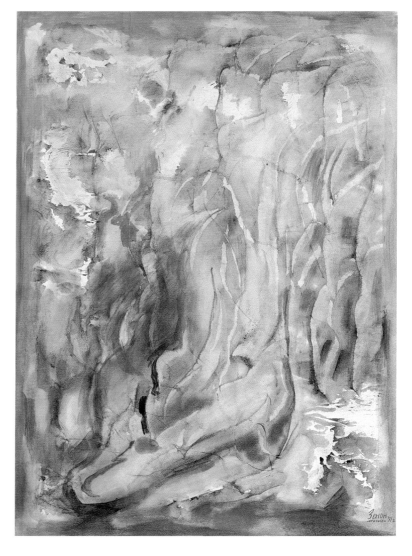

Bach No. 1. 1971
Watercolours and gouache on paper. 91 x 66. Russ. Mus.

Bach No. 2. 1971
Watercolours, gouache and coloured pencil on paper. 89.5 x 62.2. Russ. Mus.

Colour Music No. 2. 1970
Watercolours, gouache, white and coloured pencil on paper. 87.3 x 58.3. Russ. Mus.

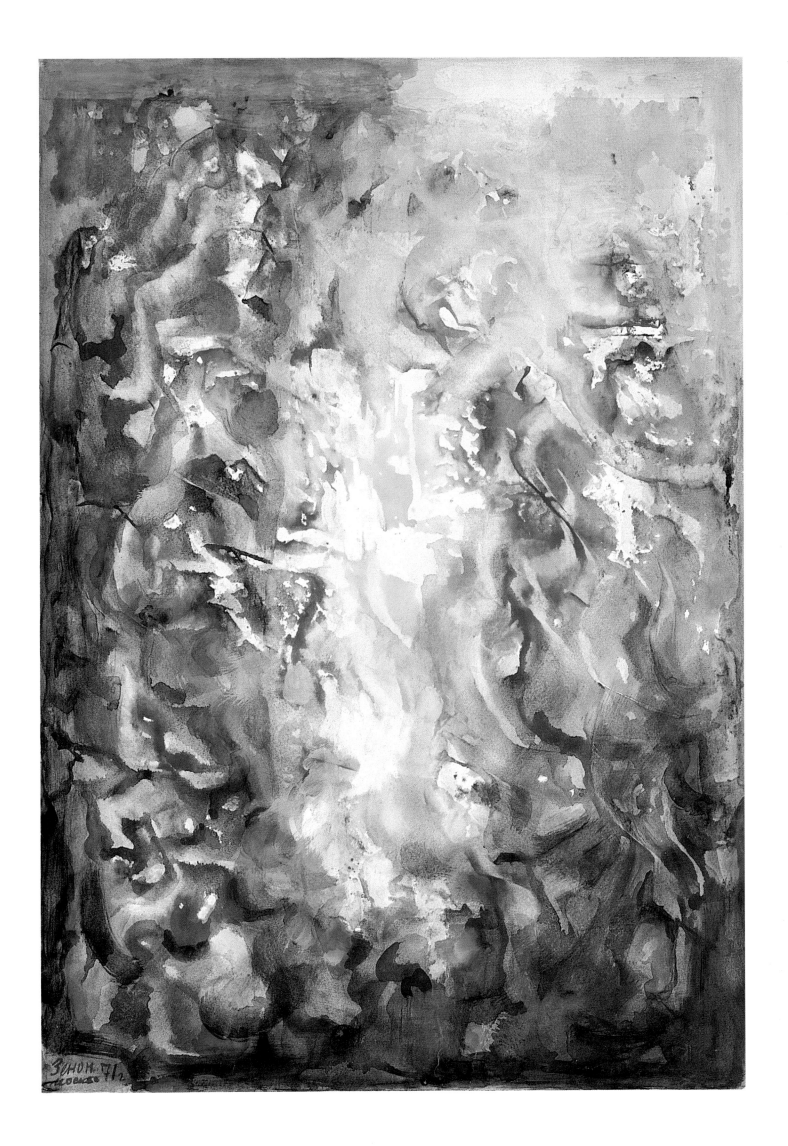

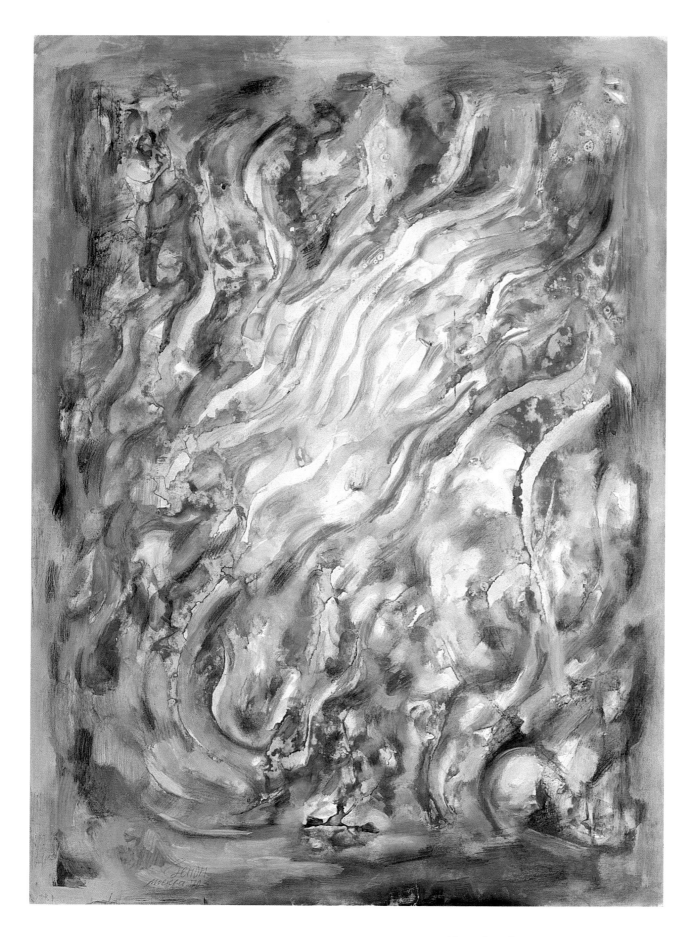

Flame of Passions. 1970
Watercolours, gouache and coloured pencil on paper. 85.8 x 61. Russ. Mus.

Colour Music No. 1. 1972
Watercolours, gouache, white and coloured pencil on paper. 86.7 x 62.3. Russ. Mus.

Зенон

boris **KALAUSHIN**

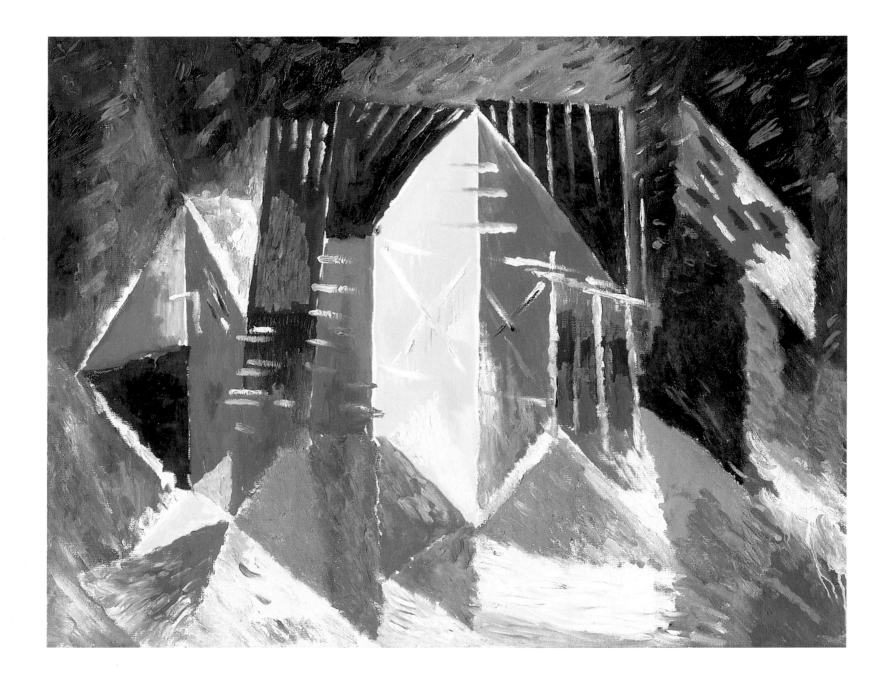

The work and task of art remain thinking in the elements of artistic form, immersion in an endless process. Complex structures, construct-ions, the overcoming of the chaos of impressions, dissonances, con-tradictions and contrasts are transformed by art into the New Harmony. Into a complex harmony often transforming destructive disharmony into harmonic equilibrium and unity.

Building a House. 1992
Oil on canvas. 90.5 x 105.5

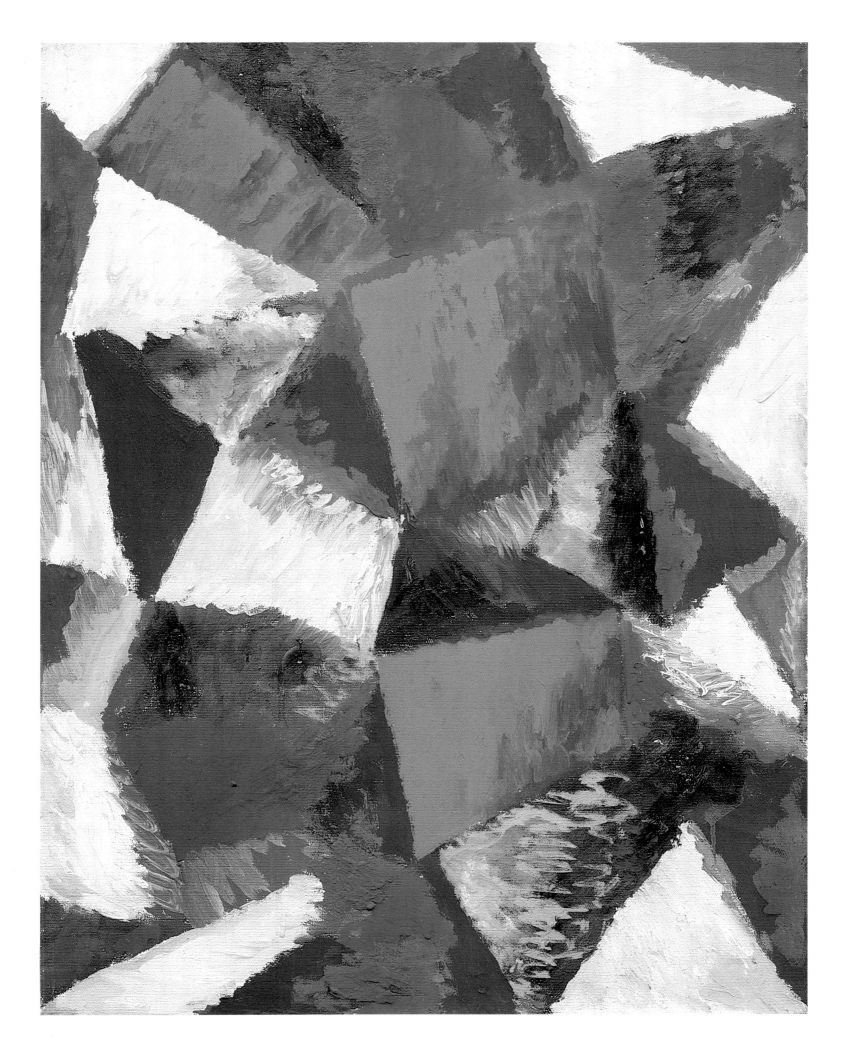

Landscape. Abstraction (Rooftops). 1970s
Oil on canvas. 79.5 x 63. Russ. Mus.

alexander **SITNIKOV**

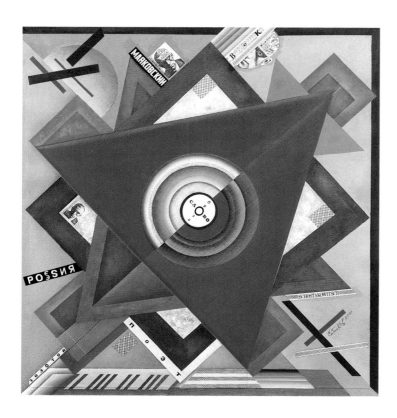

Abstraction is a plastic formula of the presentiment of Time and Space in their emblematic equivalent of the event of the Soul and Meaning of the World. (From the Tatyana and Natalia Kolodzei archives, 2001)

Mayakovsky. 2000
Oil on canvas and collage. 85 x 80. Tatyana and Natalia Kolodzei collection, Moscow

Metamorphoses. 1987
Oil on canvas. 97 x 92. Russ. Mus.

Space of Love. 1963
Oil on canvas. 45 x 59.5. Tatyana and Natalia Kolodzei collection, Moscow

valery **CHERKASOV**

By the early 1970s, the conceptualist period of the creation of objects ... had started to cross over into the period of the creation of abstract works of painting. (T. N.)

Composition (No. 3204). 1970s
Oil on fibreboard. 55 x 70.8. Russ. Mus.

Composition (No. 3205). 1970s
Mixed media on fibreboard. 55 x 70.8. Russ. Mus.

Composition (No. 3199). 1970s
Mixed media on fibreboard. 55 x 70.8. Russ. Mus.

Composition. 1970s
Mixed media on fibreboard. 54 x 55. Russ. Mus.

moisei **FEIGIN**

I felt that I had grasped something in life, that I had learnt something. I constantly set myself new tasks, however, each time coming to the conclusion that I do not know anything and that I should begin learning all over again.

Solar Batteries. 1973
Oil on fibreboard. 92 x 70. Russ. Mus.

Two Houses. 1966–76
Oil and foil on canvas. 100 x 80. Russ. Mus.

valentina **POVAROVA**

I think that the sensation of communion with the highest elements of life arises through works. This offers moments of happiness and helps to overcome the sense of being lost in the world. One probably works because of this. A work, as a whole, is a metaphysical object. If this succeeds, the artist is happy.

Composition (Glass). 1970s
Watercolours, white and wax pencil on paper. 41.8 x 30.5. Russ. Mus.

Establishment. 1979
Oil on canvas. 72 x 49

Crystallisation. 1994
Oil on canvas. 73 x 54. Russ. Mus.

VALENTINA POVAROVA

Houses. 1975
Tempera on cardboard. 47.4 x 32.8. Russ. Mus.

Window. 1976
Tempera and wax pencil on paper. 51.9 x 36.2. Russ. Mus.

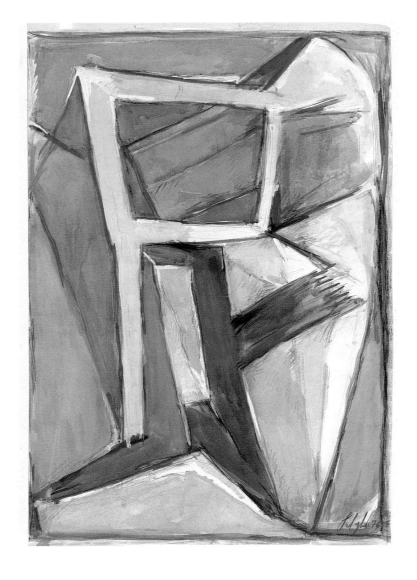

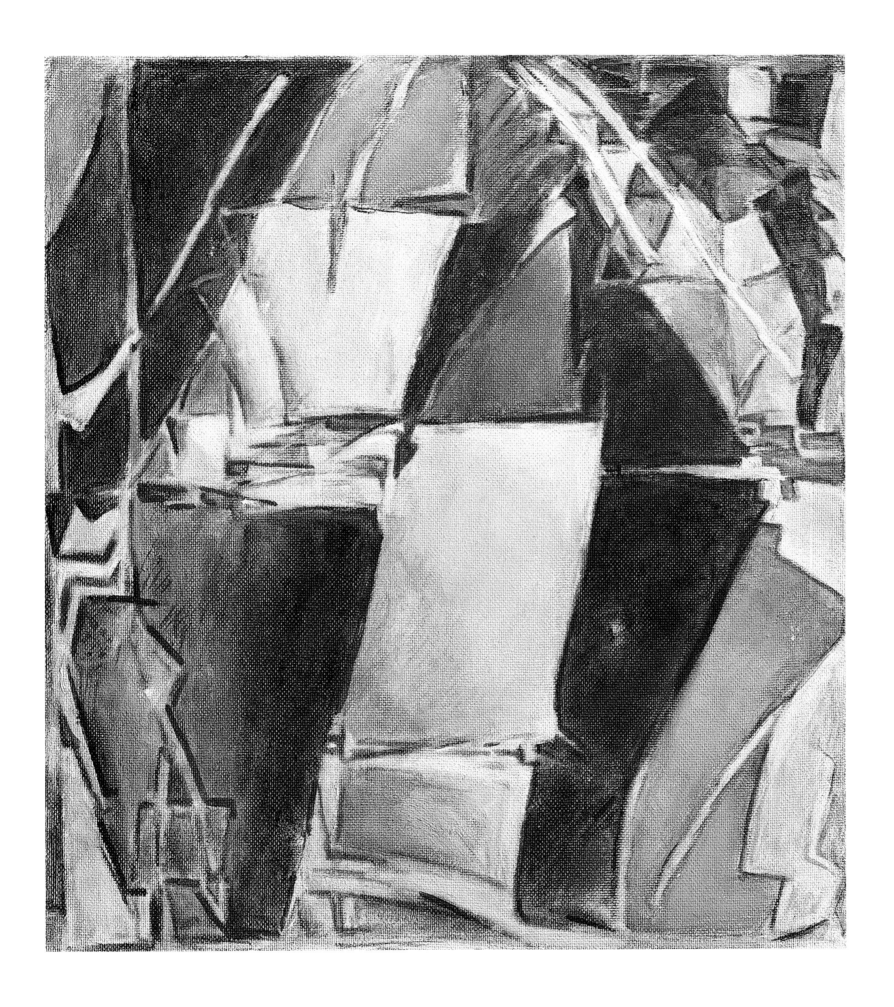

Composition. Crystal. 1980s
Oil on fibreboard. 57.5 x 51.5. Russ. Mus.

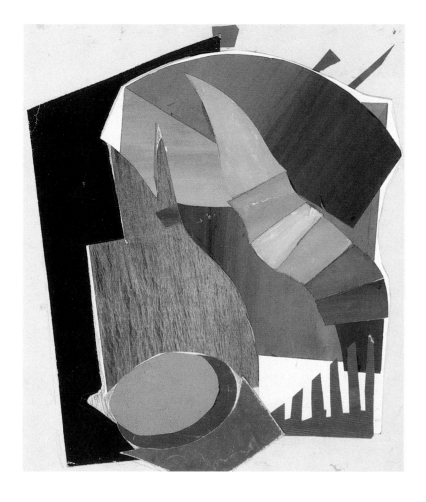

Twilight. 1994
Collage and gouache on cardboard. 27.5 x 24.2. Russ. Mus.

Dynamic Composition. 1993–94
Collage and gouache on cardboard. 32.7 x 28.3. Russ. Mus.

Textures. 1986
Mixed media and collage on cardboard. 49.2 x 32.2. Russ. Mus.

Red Circle (3). 1999. From the *Signs* cycle
Oil on fibreboard. 80.5 x 69.5. Russ Mus.

Space of White (1). 2000
Oil on canvas. 60 x 64

Energy (2). 1996. From the *Energy* cycle
Oil on canvas. 73 x 54. Russ Mus.

alexei KAMENSKY

I regard myself as an impressionist artist. An impression is something that is "impressed", i.e. somehow penetrates into the depths and remains there... An impression is a touch by the seen ... One expression of an impression, however, does not create a picture. A picture does not simply convey or relate; it is more than just a means of information and contact. A picture should be a new phenomenon in the world. It should live and, in order to live, it must first be born.
Unlike the birth of a living being, such as a child, who is first of all born and then educated, the picture has to be "educated" for a long time before it can be born.

Fire in the Fireplace (No. 2). 1996
Oil on canvas. 50 x 35

Girl Lusha. 2000
Oil on canvas. 50 x 35

Landscape. 1969
Oil on canvas. 50 x 70. Russ. Mus.

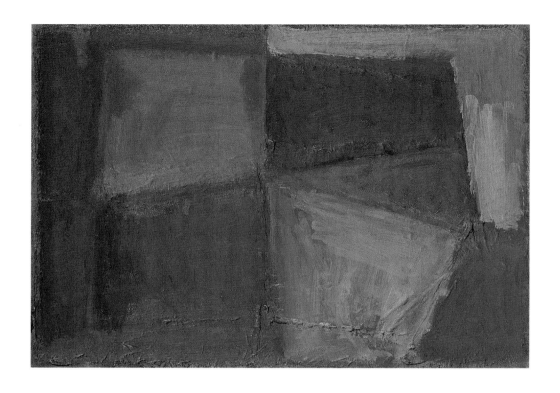

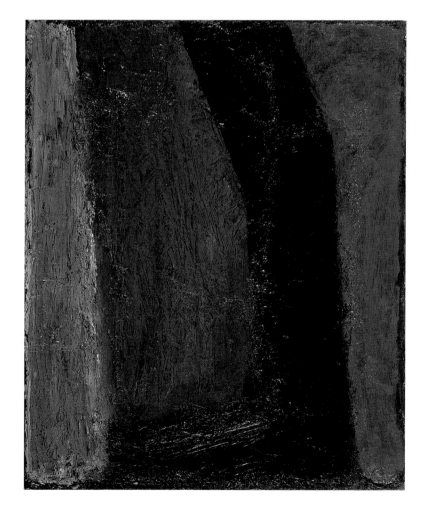

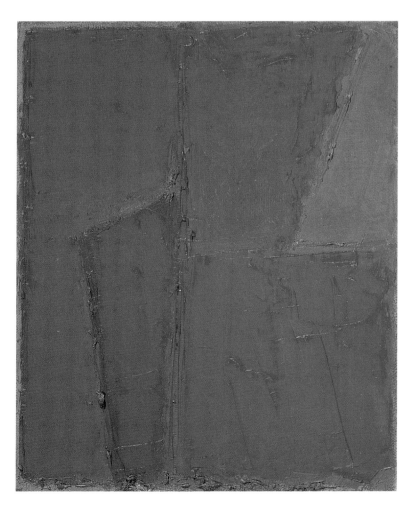

Colours of the Evening Sky. 1998
Oil on canvas. 50 x 70

Portrait of Lena Tubareva. 1992
Oil on canvas. 50 x 40. Russ. Mus.

Talented Young Fiddler. 1999
Oil on canvas. 50 x 40

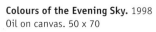

Summer in the Crimea. 2000
Oil on canvas. 53 x 79. Russ. Mus.

igor **VULOKH**

Igor Vulokh's painting is the painting of light. Its white colour breaks down the limitations of colour. His graphic art is filled with colour. Composed of large and bright patches, as if bearing an inner source of light, Vulokh's abstract compositions on paper impart a multi-layered and multi-spatial effect, the sensation of air and the reality of the landscape. (I. F.)

Wall. 1985
Oil on canvas. 120 x 80. Yevgeny Nutovich collection, Moscow

Shadow. 1970
Oil on canvas. 70 x 100. Yevgeny Nutovich collection, Moscow

Wall. 1987
Oil on canvas. 50 x 70. Russ. Mus.

igor SNEGUR

Abstract means the immaterial. A thought or an idea can be immaterial. So what is the main idea of the abstract? In my case, it is the correlation and interaction of the amorphous and geometry. Geometry is always finite and static, while the amorphous is always non-static and infinite.

Amorphous-Geometry 3. 1982
Tempera on paper. 54 x 79 (in the light). Russ. Mus.

Ovals-Diagonals. 1997
Acrylic on canvas. 77 x 92. Russ. Mus.

Architectons in a Landscape. 1993
Acrylic on canvas. 100 x 120. Russ. Mus.

Amorphous-C. 1972
Tempera on paper. 54.8 x 79.5. Russ. Mus.

Amorphous-E. 1972
Tempera on paper. 54.1 x 79.4. Russ. Mus.

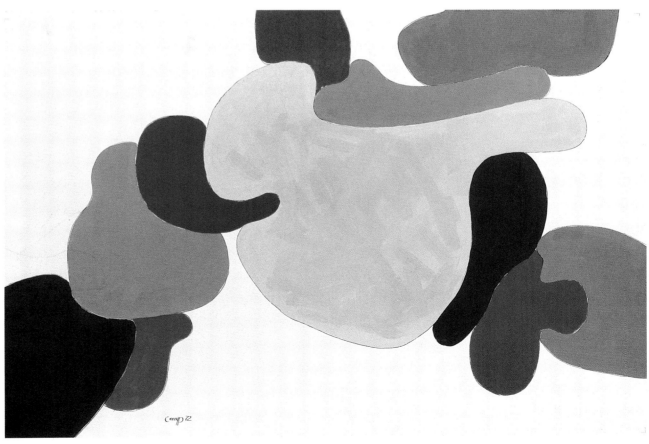

konstantin **SIMUN**

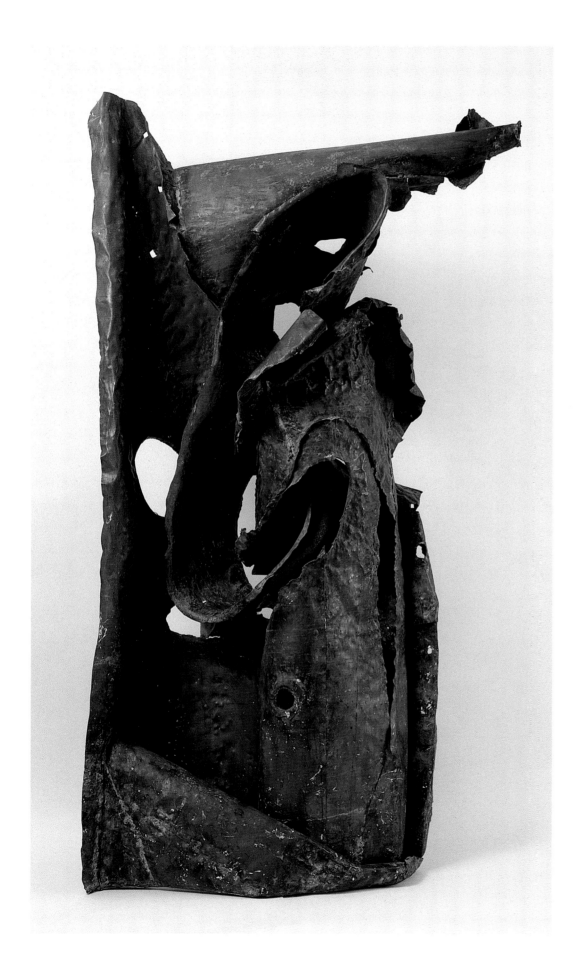

Pablo Casals. 1970s
Beaten copper. Height 200

lev LANETS

There is no non-objectivity in life or, it follows, in art, only a great deal of non-spirituality.

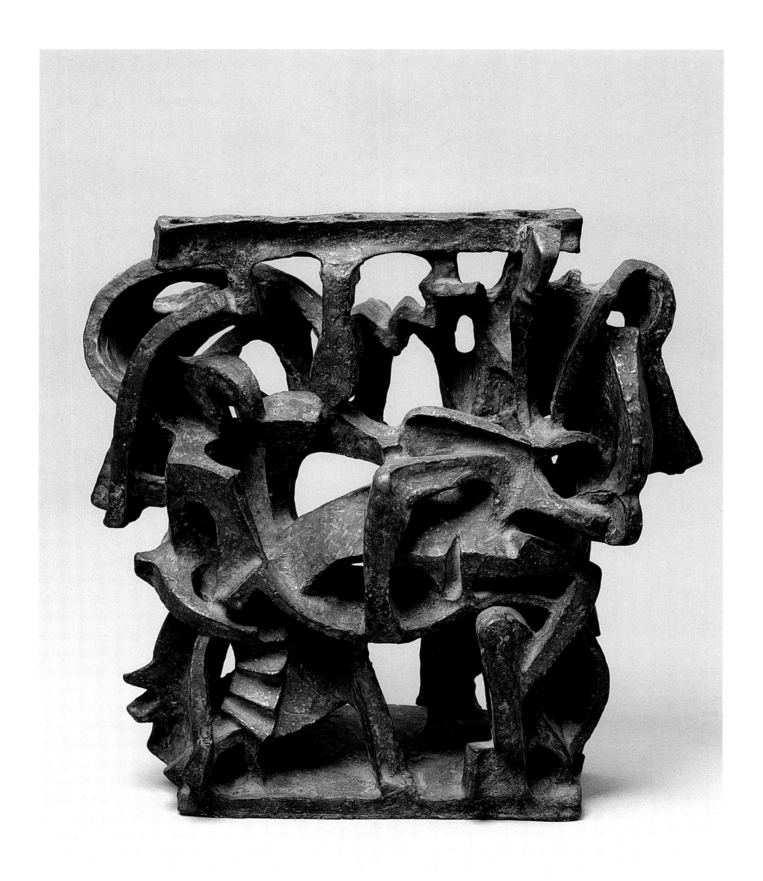

Requiem (Candlestick in Minor). Model for a monument. 1972. Cast in 1990
Bronze. 38 x 39 x 20. Russ. Mus.

maria RAUBE-GORCHILINA

Maria Raube-Gorchilina's oeuvre is concentrated in the microcosm of the human soul, in the natural element of forest thickets, house-plants and flowers, parkland, still-lifes, decorative ornamental panels and objects of domestic and folk life. She is a woodgoblin, a researcher of the human soul and a recorder of suffering folk persons. (M. A.)

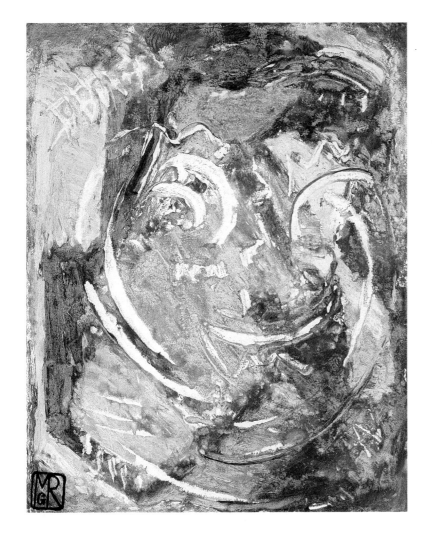

Composition No. 2. Mid-1970s
Monotype. Image: 54.9 x 42.1; sheet: 66 x 51.9. Russ. Mus.

Composition No. 1. 1974
Monotype. Image: 54.7 x 42.1; sheet: 66 x 48.1. Russ. Mus.

Composition No. 4. Mid-1970s
Monotype. Image: 55.1 x 42.5; sheet: 67.2 x 50.4. Russ. Mus.

Composition No. 3. Mid-1970s
Monotype. Image: 55.1 x 42.4; sheet: 69.2 x 50.4. Russ. Mus.

yevgeny **KROPIVNITSKY**

Yevgeny Kropivnitsky was the eldest artist and poet and the intellectual guru of the Lianozovo group. (M. S.)

Green Composition. 1974
Oil on cardboard mounted on plywood. 30 x 42. Russ. Mus.

Yellow and Green (Yellow-Green Composition). 1974
Oil on cardboard. 30 x 40. Russ. Mus.

Abstraction. 1970s
Oil on cardboard. 31 x 35. Russ. Mus.

Grey and Pink. 1970s
Oil on cardboard. 39 x 29.5. Russ. Mus.

yevgeny YESAULENKO

Yevgeny Yesaulenko's abstractions are not non-objective. He has created a Surrealist world of objects without titles and landscapes … a world of whimsical mutants retaining the external attributes of three-dimensional reality, yet losing logical links with it. This is the earth long before or long after our birth. Remaining unrecognised, his pictures endeavour to awaken the secret memory slumbering deep within us. (L. B.)

Fantastic Landscape. 1974–75
Oil on canvas. 59.2 x 52.5. Russ. Mus.

Petrified Forest. 1976–77
Oil on canvas. 79.5 x 89.5. Russ. Mus.

Petrification. 1973
Oil and enamel on canvas. 70 x 50. Russ. Mus.

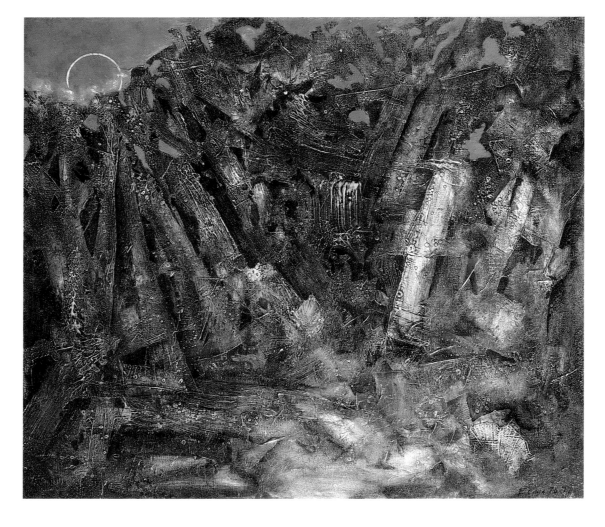

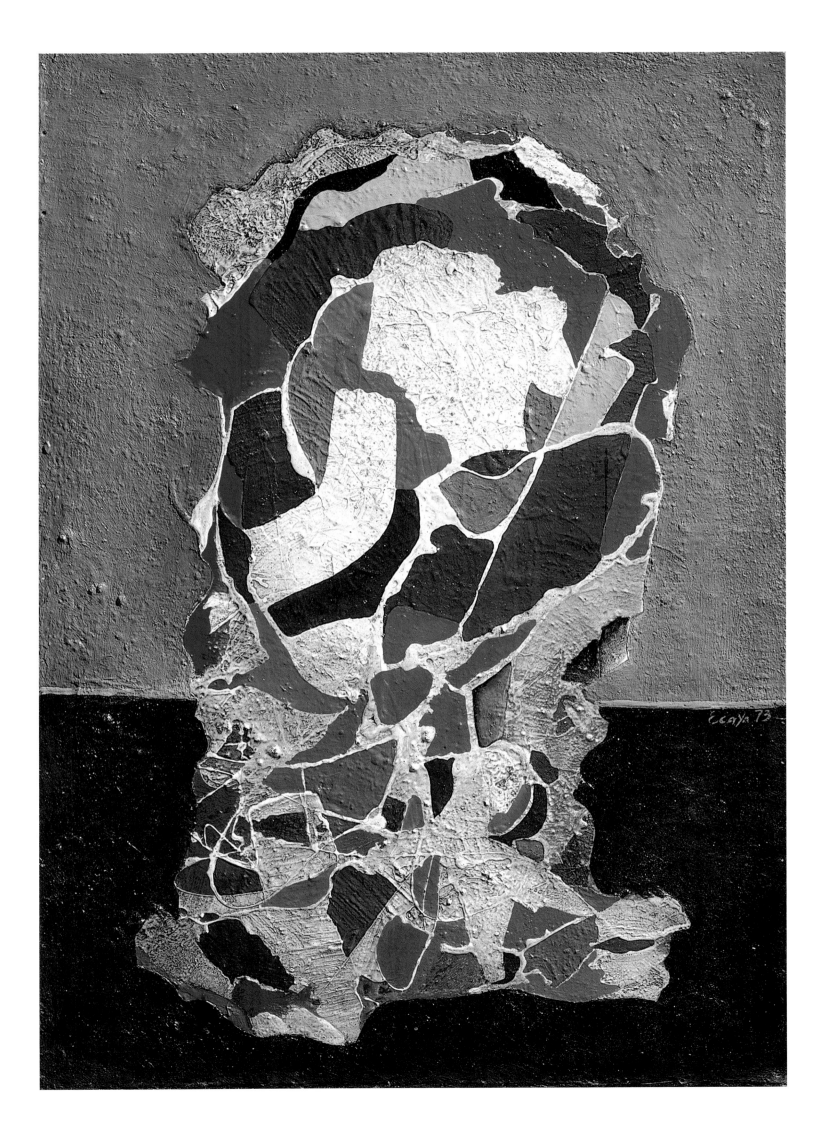

mikhail **KOPYLKOV**

Like other "isms", abstractionism is the transcription of reality.

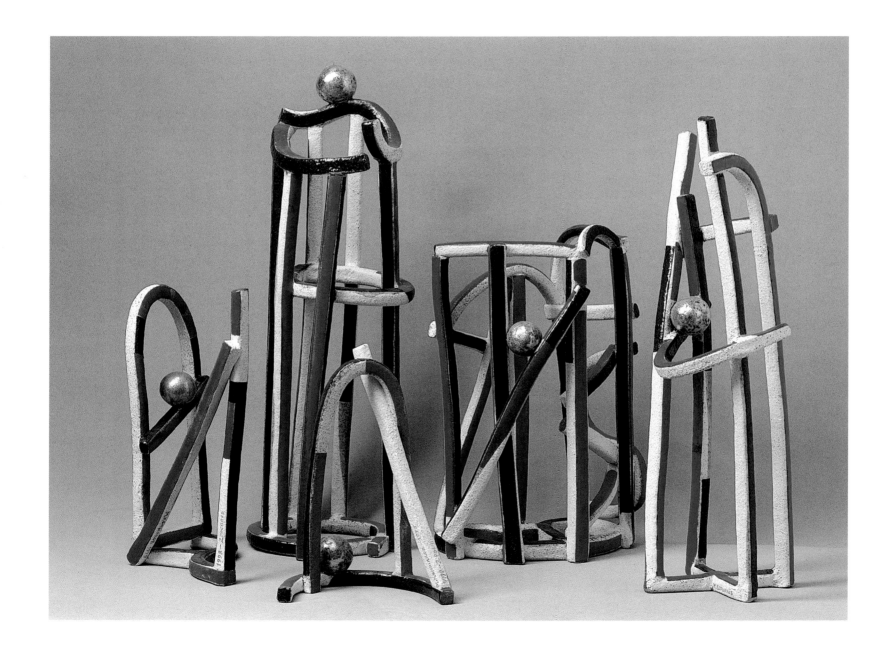

Celebration. 1975–98
Composition from five fragments. Shamot, salts, glazes, decol and gold gloss
25 x 17.5 x 10; 31.5 x 23 x 12; 36 x 23 x 15; 48 x 17 x 15; 52.5 x 20 x 17

victor **LAZUKHIN**

Victor Lazukhin's abstract works are a quest for perfection of an organised kind. The alternation of elements of various colours creates interdependent forms subordinated to a single whole. The minimalism of forms is used to express philosophical ideas of the immensity of space and time. (L. V.)

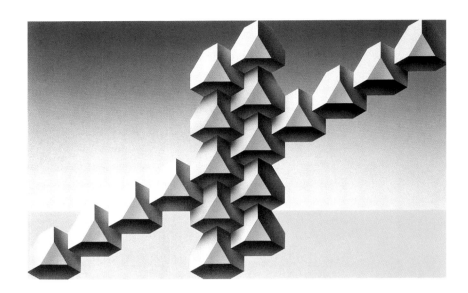

On the Verge. 1983
Watercolours and aerograph on cardboard. 76 x 101. Russ. Mus.

Rain. 1974
Coloured silk-screen print on cardboard. Image: 74.2 x 99; sheet: 74.2 x 99. Russ. Mus.

nikolai **VOLOGZHANIN**

I consider my art to be religious, only not in the traditional sense. The object of my research and study is everything that concerns nature — from my native landscape to outer space.

Morning. 1991
Oil on canvas. 74 x 90. Russ. Mus.

Composition. Mid-1970s
Oil on canvas and plywood. 80 x 110
Yevgeny Nutovich collection, Moscow

vladimir **YAKOVLEV**

From the general to the whole, from the whole to the details, from the details to eternity.

Composition. 1973
Gouache on cardboard. 85.7 x 61.2. Tatyana and Natalia Kolodzei collection, Moscow

valery KLEVEROV

Klever was a fixator of the idea, a fixator of the spirit, a fixator of the inner world of man, whom he learnt to see, taking as his basis, like Gogol, one of the dominating characteristics for the individual in question or passions. *(Alexander Sushko,* An Artist from the Country of the Enigmatic Seventies, *St Petersburg, 2000)*

Composition. 1973
Oil on plywood. 70.5 x 40.5. Russ. Mus.

zhanna **BROVINA**

IMAGES of objects protrude from the crystalloid structure of the forms and colours. The changing state of the visible world is taken to a stabler system. Before us lies ANOTHER reality.

Composition. 1983
Oil on fibreboard. 53 x 40

Composition. 1975. Cast in 1990
Bronze. 47 x 29 x 31.5

maxim ARKHANGELSKY

The profundity of such spiritual penetration does not, unfortunately, always date back to the integral sources of primordial existence; it often diverges in the direction of the subdivision and degradation of the inner content of the artistic image, through the substitution of the general for the private. This is a typical device of any act of abstraction, giving the artist the opportunity to arouse the viewer's reaction with a striking accent, spurring him on towards joint co-creation with the artist.

Secrecy. 1972
Oil on canvas. 63 x 51. Russ. Mus.

St Matthew's Gospel (Earth Element). 1973
Oil on canvas. 99 x 74. Russ. Mus.

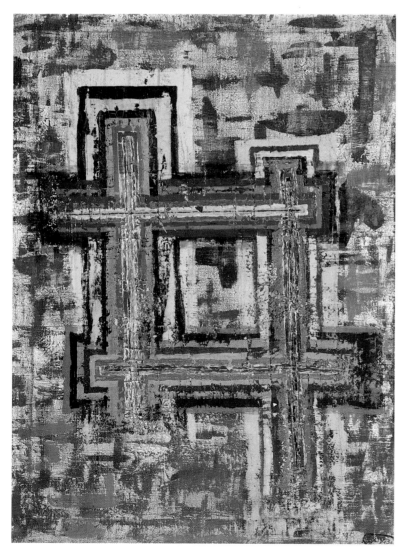

Interaction. 1977
Planer on copper. 158 x 45 x 35.5. Russ. Mus.

Tropical Flower. 1975
Planer on copper and latten. 182 x 50 x 42. Russ. Mus.

Acoustic Composition. 1977
Planer on copper. 151 x 40 x 36.5. Russ. Mus.

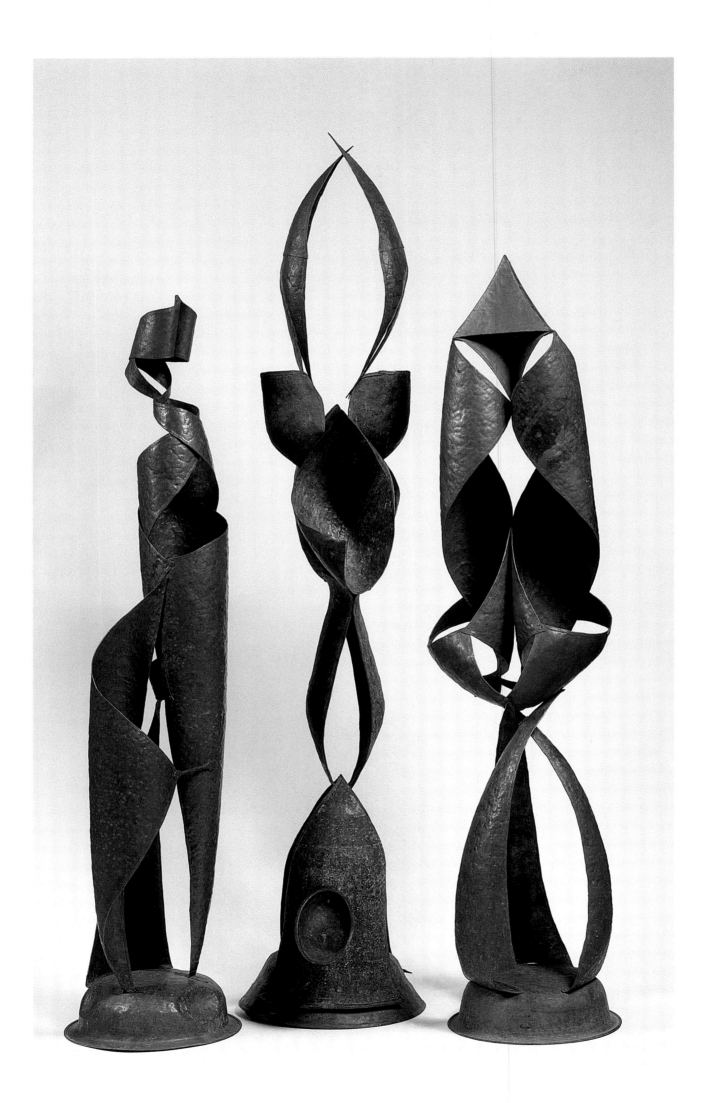

ENVER

Expression is a state of feelings and actions transforming real objects into images of abstract expressiveness. The will and energy of a force moving upwards reign in expression as a spiritual state; the permanent explosion, fountain and splash of the overfilled and heated substance of the start and conception of an expanding universe-thought. Expression does not appear for the first time in the artistic arena, yet it is represented for the first time by the retortion of a deideologised sensation-purification and is not tied down to barriers.

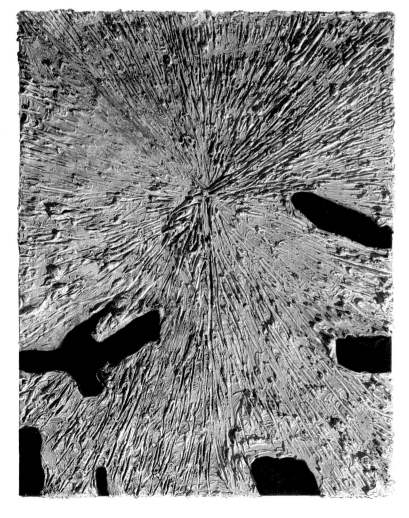

Extremely Indefinite in Red. 1977–78
Oil on canvas mounted on wood. 61 x 50 x 6.5

Extremely Indefinite in Grey. 1977–78
Oil on canvas mounted on wood. 74 x 57 x 8

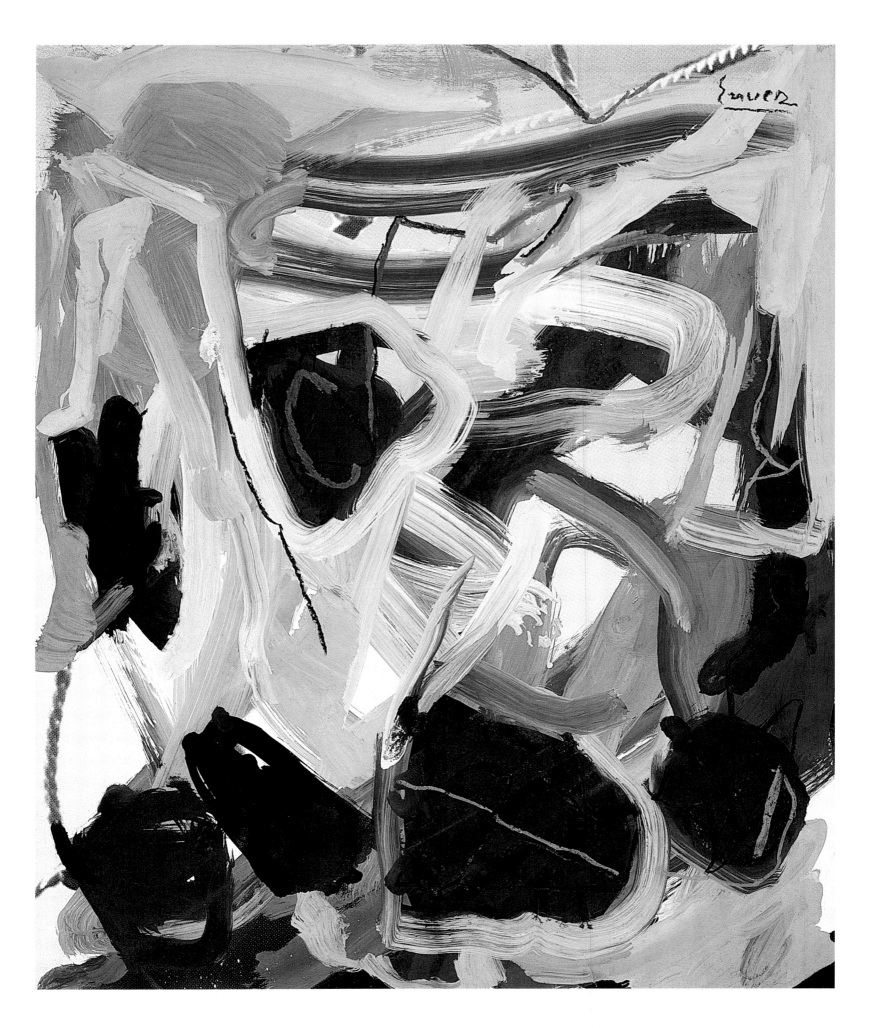

Balance with Kurosava. 1998
Indian ink, acrylic, pastels and wax chalk on paper. 70 x 60. Russ. Mus.

oleg **KUDRYASHOV**

The language of forms lets one retire into one's shell and hold a dialogue with one's nature, the nature of the imagination, not saying anything aloud, using a hint to resurrect in the memory the forms of the irreal, irrational world, where there also is everything.

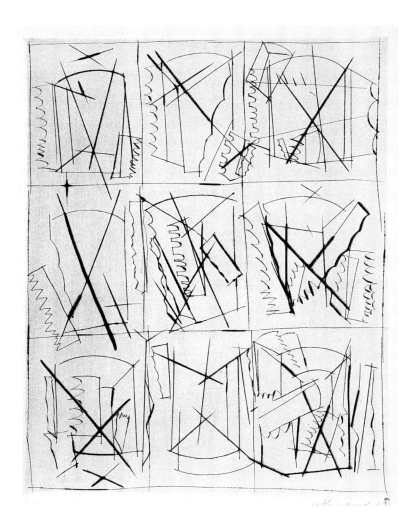

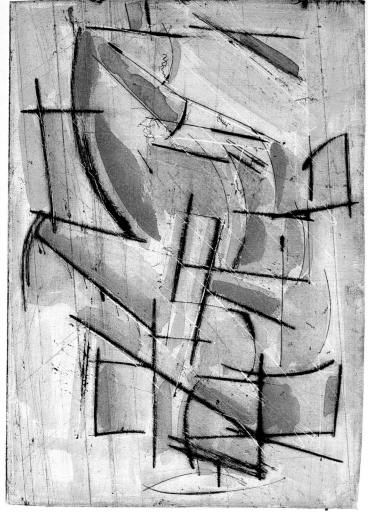

Nine Stamps. 1975
Brace on drypoint. Image/sheet: 49.9 x 38.9; sheet: 56.7 x 46.2. Russ. Mus.

Sculpture Design. 1983
Brace, watercolours and metal filing on drypoint. Image: 23.1 x 15.9;
sheet: 40.2 x 30.4. Russ. Mus.

sergei **BORDACHEV**

Sergei Bordachev's energetics took the artist with spiral inevitability to that height when, not looking back at anyone, he became an inimitable creator of abstract painting. (M. B.)

Black Cracks. 1990
Oil on canvas. 121 x 141. Tret. Gal.

Crow in a Village Yard at Night. 1973
Watercolours and gouache on paper. 59 x 41
Private collection, Germany

Composition. 1977
Watercolours and gouache on paper. 59 x 42.5
Private collection, Germany

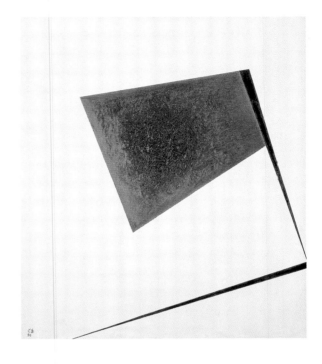

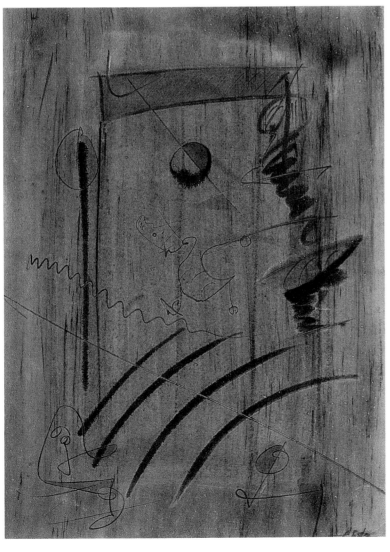

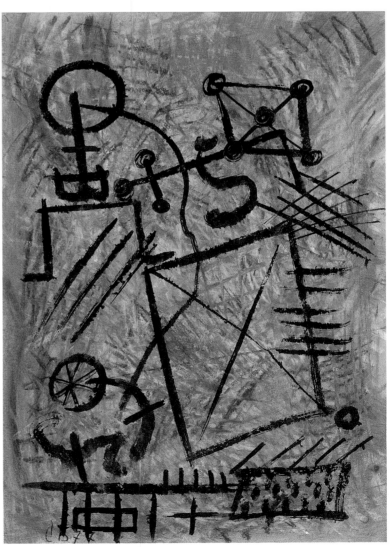

oleg **YAKOVLEV**

White on white. If I were Kazimir Malevich, I would have written something on this. But firstly, I am not him, and secondly, he is not me...

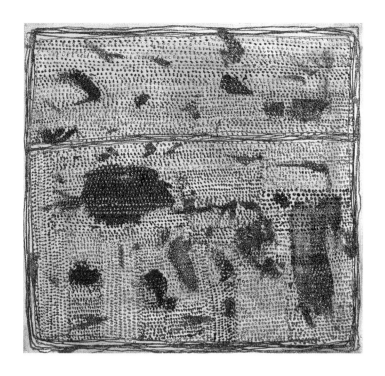

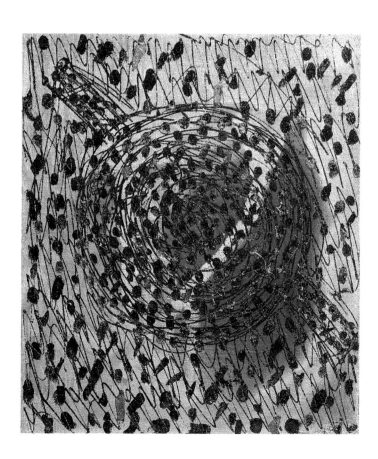

Supresupresupre. 1990
Mixed media and aluminium paint on canvas.55 x 45.7. Russ. Mus.

Maxiart. 1992
Oil and mixed media on canvas. 50.2 x 50.2. Russ. Mus.

Composition. 1976
Oil on canvas 56 x 46.5. Russ. Mus.

Maxiart. 1991
Mixed media and aluminium paint on canvas. 55 x 46.2. Russ. Mus.

igor SHELKOVSKY

There is a general rule of a philosophical kind saying that there are no objects which are not like (albeit remotely) some other object. It thus follows that the most abstract picture will inevitably recall something having place in real life. With a bit of effort, even the most radical picture, such as a purely white or black canvas, will represent either a white light or a dark night. Any combination of paints or painterly effects, any play of textural surfaces or improvised rhythms, the dynamics of lines and the play of patches, harmony or disharmony, can be encountered and identified in our everyday life, in "natural nature", or in such forms of artificially created nature as the city.

No. 188. Object
Tempera on wood. 17 x 38.5 x 4.8. Russ. Mus.

Untitled. 1978. Object
Oil on wood. 23.5 x 30.2 x 17. Russ. Mus.

Untitled. 1988. Object
Oil on wood. 58.5 x 106.5 x 6. Russ. Mus.

maria ELKONINA

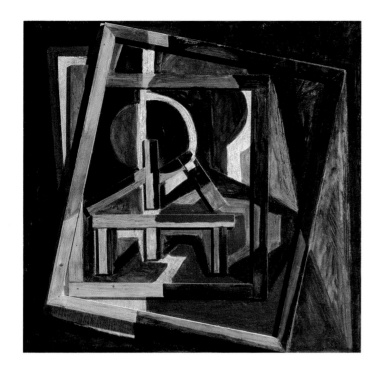

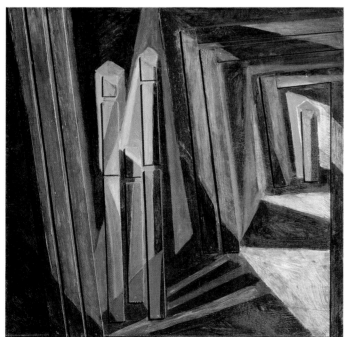

I seek my own path in art, my own form and my own space. I work on the problem of complex space, the essence of which lies in the conflict of objects and non-objects. Through form I express the complexity and tragic element of my time. All my objects are made on wood. Great spatial complexity is achieved by the introduction of a wooden relief.

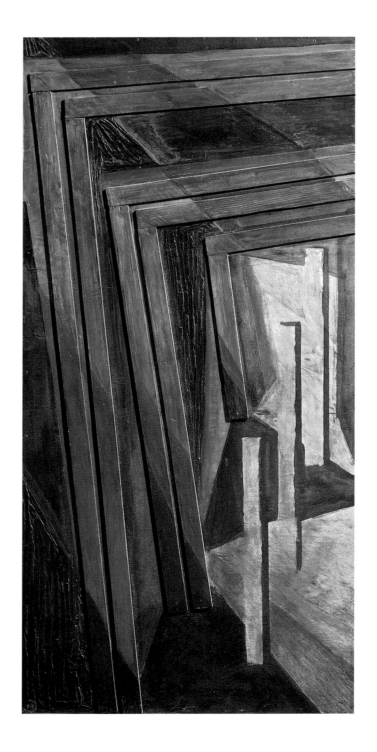

Still-Life with Frames. 1980
Oil on wood. 100 x 100

Red Interior. 1978–79
Oil on wood. 100 x 100. Russ. Mus.

Interior. 1979
Oil on wood. 150 x 70

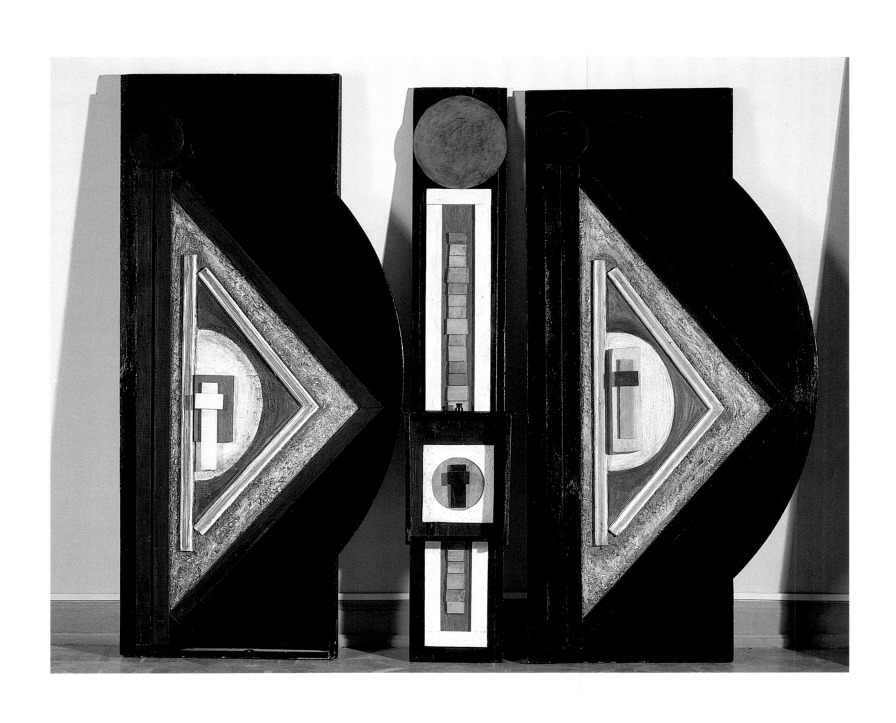

Composition with Crosses. Triptych. 1980
Oil on wood. 177 x 85 x 12; 174 x 33 x 12; 174 x 85 x 12. Russ. Mus.

mikhail **SHVARTSMAN**

Nothing should be introduced into the canvas (picture), everything has to be obtained from the canvas. Only this can bring out the unique world of the individuum and thus enrich the world. Here is meekness. Deformation is fracture, fabrication, falsehood, illustration and empty chatter.

Consecration. 1987
Tempera on plywood mounted on canvas. 75 x 50.5. Private collection, St Petersburg

Forefather. 1974–77
Levkas and tempera on board and canvas. 100 x 75. Russ. Mus.

yury DYSHLENKO

If classical painting proceeded from the representation of an object in space and, through this object, attempted to depict the whole world, I describe the space in which the appearance of an object is merely expected. I go in this direction towards the object. I make its appearance more and more likely. Like the viewer, I want this appearance. That is what true synthesis is.

I Thought That I Would Die For Freedom When You Return. 1979
Collage on paper (mixed media). 12 x 6

I Will Die For Freedom In A Specific Place. 1979
Collage on paper (mixed media). 12 x 6

I Died For Freedom A Few Days Before You Came. 1979
Collage on paper (mixed media). 12 x 6

I Said That I Will Have Died For Freedom By Five O'Clock. 1979
Collage on paper (mixed media). 12 x 6

I Am Dying For Freedom (This Is My Activity At The Current Moment in Time). 1979
Collage on paper (mixed media). 12 x 6

I Died For Freedom in May, Not Counting Public Holidays. 1979
Collage on paper (mixed media). 12 x 6

After I Have Died For Freedom, I Will Be Free. 1979
Collage on paper (mixed media). 12 x 6

I Will Die For Freedom The Next Time. 1979
Collage on paper (mixed media). 12 x 6

I Left The Hotel, Caught A Cab And Died For Freedom. 1979
Collage on paper (mixed media). 12 x 6

I Will Already Have Died For Freedom When You Come. 1979
Collage on paper (mixed media). 12 x 6

I Said That I Would Die For Freedom The Next Time. 1979
Collage on paper (mixed media). 12 x 6

When The Time Comes, I Die For Freedom. 1979
Collage on paper (mixed media). 12 x 6

mikhail **CHERNYSHOV**

In the early 1960s, I created a large series of symmetric collages, employing simple and unusually bright toy colours. These works were not intended to create a positive effect. Their claim to be easel art provoked the viewer. Symmetry and wallpaper monotony were little used at that time. My choice of direction in art was based on my interest in the works of Malevich and the Russian Constructivists. Experimentation with pure geometric forms was my task from the very outset. It was only really possible to become acquainted with Russian Suprematism and Constructivism from Western publications; the Malevich and Tatlin exhibition at the Mayakovsky Museum was thus a major event in Moscow..

Composition. 1979
Tempera and pencil on cardboard. 45.8 x 53.8. Tatyana and Natalia Kolodzei collection, Moscow

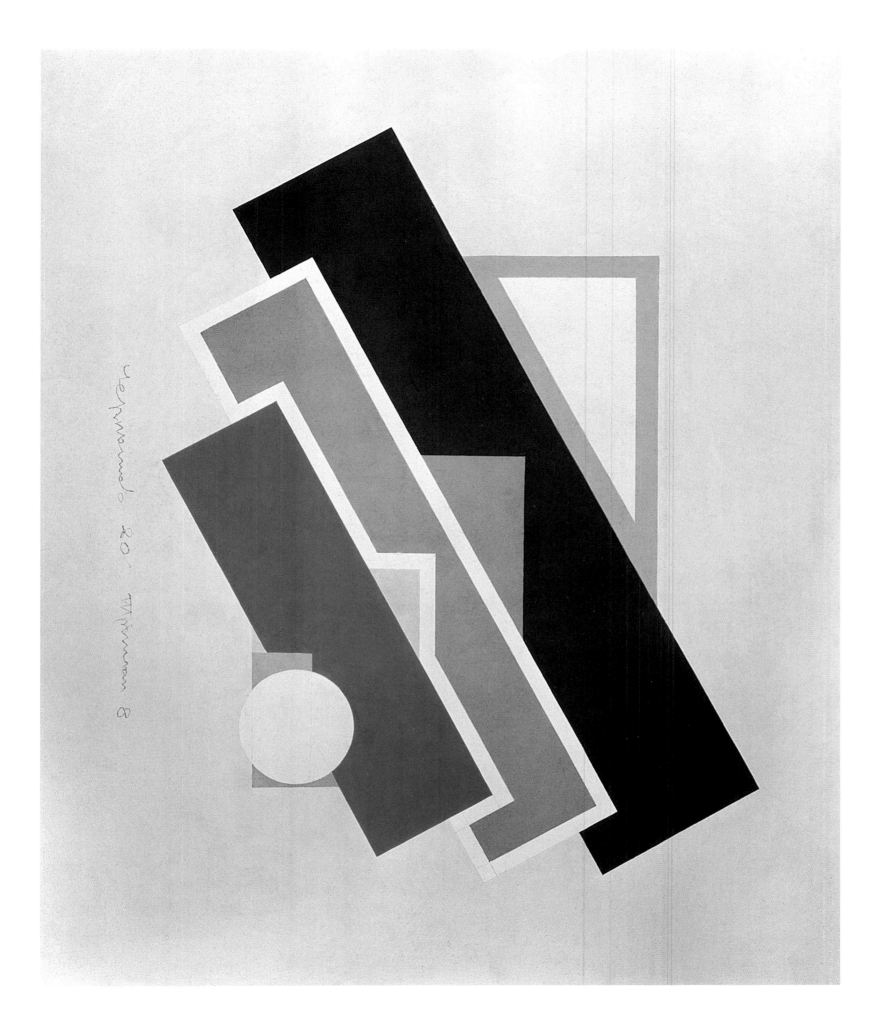

Triplane 8. 1980
Gouche and tempera. 45.4 x 54.1. Tatyana and Natalia Kolodzei collection, Moscow

Composition No. 1. 1984
Collage on paper. 45.9 x 60.9. Russ. Mus.

Composition No. 3. 1983
Collage on paper. 45.8 x 60.9. Russ. Mus.

Composition No. 4. 1983
Collage on paper. 45.7 x 60.7. Russ. Mus.

Composition No. 2. 1983
Collage on paper. 46 x 61. Russ. Mus.

yury GOBANOV

Having one's own painterly formula, reworking the numerous forms of nature to translate one's ideal into a living form of art.

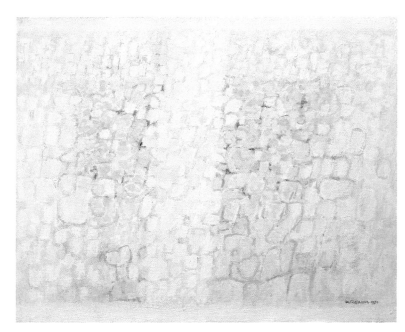

Structural Landscape. 1999
Oil on canvas. 75 x 85

Landscape with a Tree. 1991
Oil on canvas. 90 x 110

Reflections in White. 1991
Oil on canvas. 78 x 90

Abstract Composition. 1979
Oil on canvas. 60 x 70

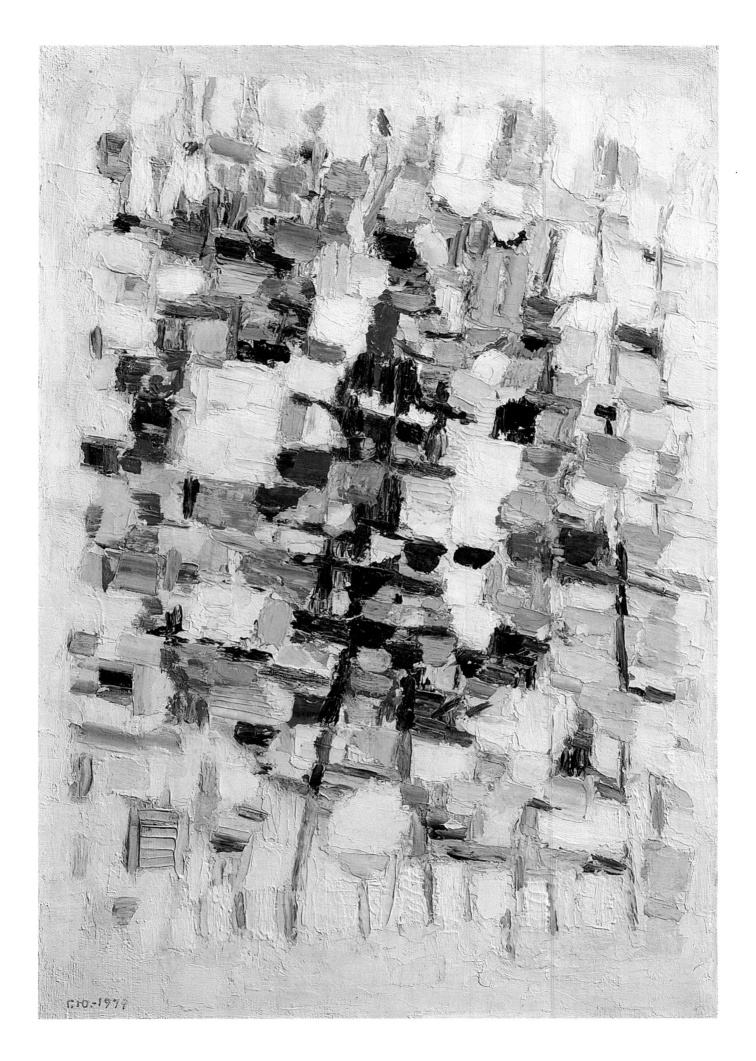

Composition with a Tree. 1979
Oil on canvas. 53.7 x 37.7

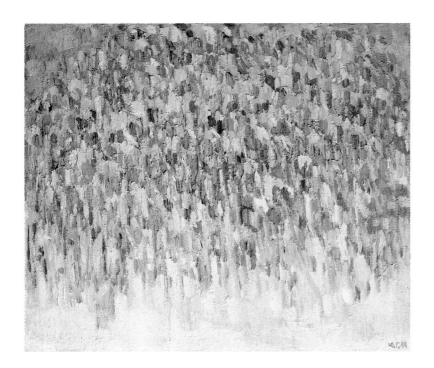
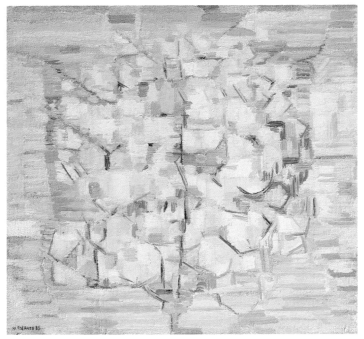

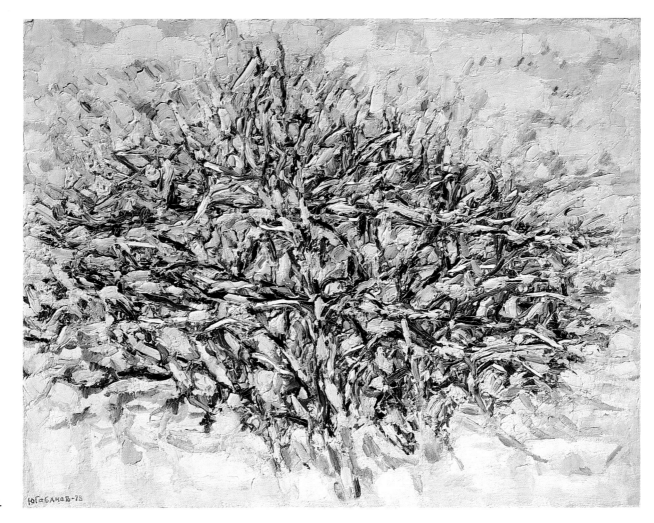

Landscape. 1988
Oil on canvas. 65 x 75.5. Russ. Mus.

Tree. 1985
Oil on canvas. 52.2 x 54. Russ. Mus.

Composition with a Tree. 1978
Oil on canvas. 59.8 x 73.7. Russ. Mus.

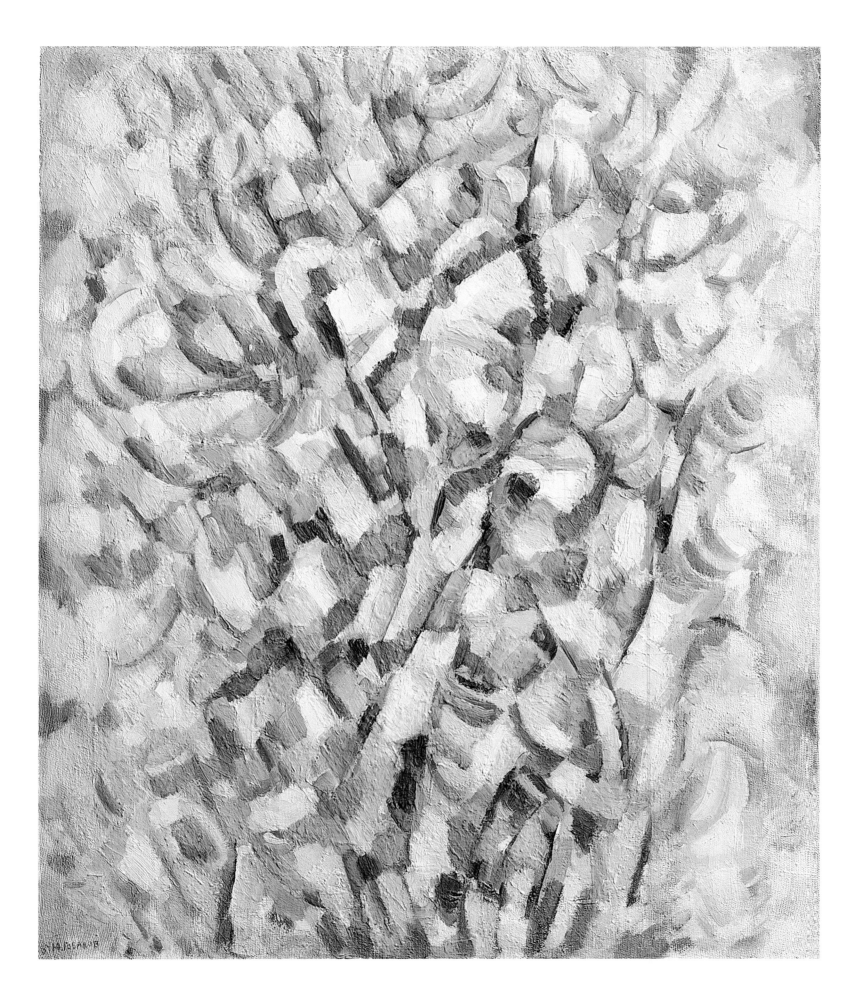

Landscape. 1984
Oil on canvas. 70 x 59.7. Russ. Mus.

andrei **KRASULIN**

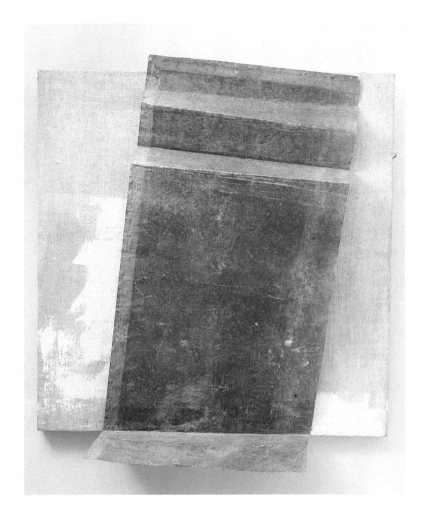

It is the object created for a utilitarian aim that brings to us, through dozens of millennia, with absolute authenticity, the act of the birth of non-objective art. These are the broken fragments of a modelled pot covered in rows of holes and furrows, applied to the damp clay with a sharp stick. In their disposition, we observe rhythms and proportions – the main indications of the phenomenon called art.

The diversity and variations of the silhouettes of vessels and their purposes are incalculable. This extravagant wealth is required by the void, acquiring a form in them. Here we encounter the same generosity that we see in the plant kingdom. Only ornamentation is not the imitation of living nature. Waves of ornamentation and the outlinings of the neolithic axe or Brancusi's sculptures, unbelievably tense and perfect, visualise the power lines of life and death.

Steps. 1997
Tempera on canvas, wood and tin. 100 x 95. Russ. Mus.

Spring Study No. 12. 1997
Tempera on canvas and wood. 100 x 80

Heraldic Relief. 1979
Wood. 99 x 99 x 25. Russ. Mus.

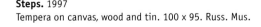

ANDREI KRASULIN

Envelope Relief
Oil on canvas and corrugated cardboard. 120 x 40 x 45

Envelope Relief
Oil on canvas and corrugated cardboard. 120 x 40 x 45

Envelope Relief
Oil on canvas and corrugated cardboard. 120 x 40 x 45

ANDREI KRASULIN

Spring Study No. 7. 1997
Tempera on canvas and wood. 100 x 70

Spring Study No. 2. 1998
Tempera on canvas and wood. 100 x 80

Monument. 1994
Black watercolours on paper. 49.9 x 30.6. Russ. Mus.

Spring Study. 1995–98
Tempera on canvas and wood. 82.5 x 65. Russ. Mus.

vadim **OVCHINNIKOV**

I would like several of my statements on painting, which became common property in three or four quarters of the current year, to be considered an error.

From the *Crimea* Series. 1980
Watercolours and Indian ink on paper. 29.1 x 39.5. Russ. Mus.

From the *Crimea* Series. 1980
Indian ink on paper. 29.2 x 39.7. Russ. Mus.

From the *Crimea* Series. 1980
Watercolours and Indian ink on paper. 29.1 x 39.6. Russ. Mus.

Life of Plants. 1989
Oil on canvas. 102 x 150. Russ. Mus.

Life of Plants. 1989
Oil on canvas and waffle-fabric. 99.5 x 150. Russ. Mus.

Life of Plants. 1989
Oil on canvas. 143 x 202. Russ. Mus.

elizaveta **GRACHEVA**

My pictures are geometric abstractions founded on the principle of contrast, the relations of lines and colour, the rhythm of vertical and horizontal lines and the harmony of pure forms. Straight lines express calm and measured movement. Verticals and horizontals are static and composed. The predomination of some over others creates an emotional ring. Black-and-white compositions are more active in perception. Black unites and fortifies the composition and creates a clear motif. Rhythmic movement in the form of repeated motifs, moves from light to dark and the proportions of tonal relations and areas are other items in the compositional principle.

Light and Shade. 1981
Oil on canvas. 141 x 244. Russ. Mus.

Light Ray. 1983
Oil on canvas. 152 x 233. Russ. Mus.

City View. 1981
Oil on canvas. 152.5 x 243.5

Construction. 1985
Oil on canvas. 226 x 157

yevgeny **VAKHTANGOV**

I define my abstraction by the term "spontansur", which stands for Spontaneous Surrealism. I endow this concept with confirmed chance which ceases to be accidental.

Penetration. 1981. Diptych
Oil on canvas. 60 x 160. Yevgeny Nutovich collection, Moscow

alexander **DUBOVIK**

The language of art is a universal tongue that does not require translation or a detailed, direct explanation. It is based on subtle perception, the willingness to listen, think, meditate, correlate to one's own feelings and to receive from all this the joy of discovery, above all the discovery of oneself, and then, through oneself, the discovery of the Creation of the world. What is needed for this is a broad internal space not overfilled with ready formulae and prejudices, i.e. one needs to be free.

Tocsin. 1983
Oil on canvas. 100 x 100. Russ. Mus.

Overcoming. 1981
Oil on canvas. 100 x 100. Russ. Mus.

alexander **KOZHIN**

The main task, for me, is to express the spatial-temporal image of the world, that "stream" of life, which fills me and which is close to my heart.
Sterligov said: "Draw a problem!" That is what I am truly scared of departing from.

Composition. 1986
Oil on canvas. 70 x 85. Russ. Mus.

Tree. 1982
Mixed media on canvas. 31.8 x 30.9. Russ. Mus.

Tree. 1986
Mixed media on canvas. 41.8 x 34.2. Russ. Mus.

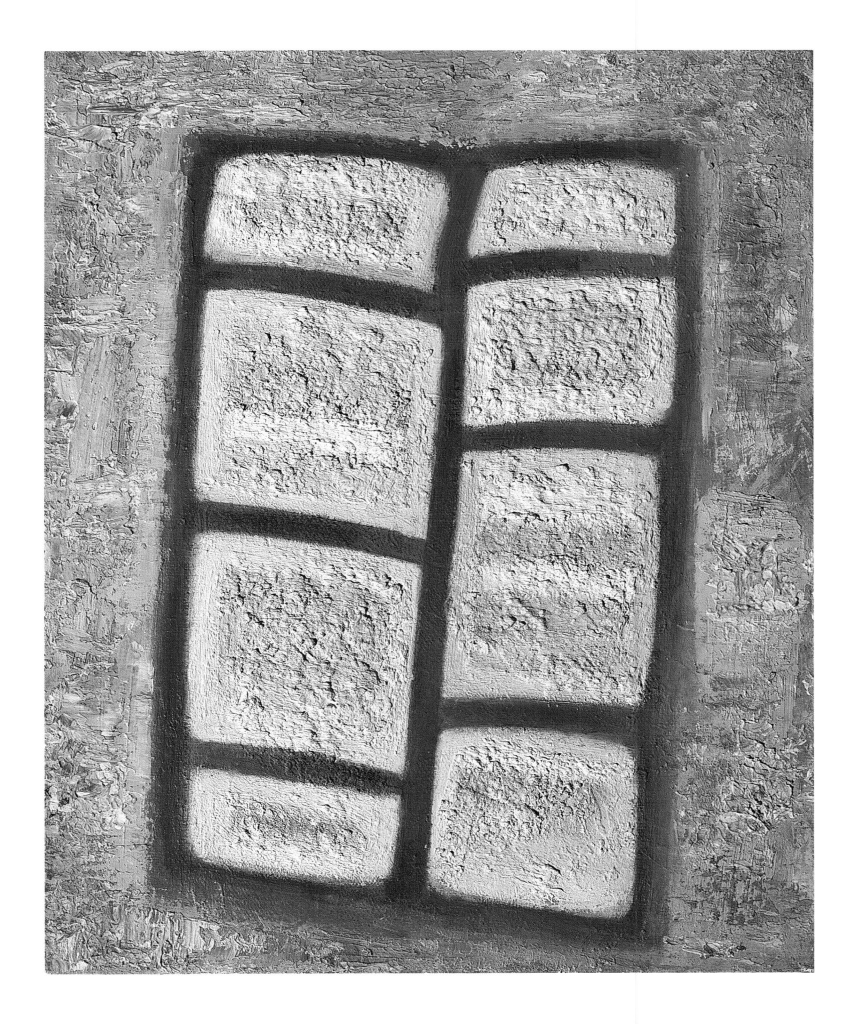

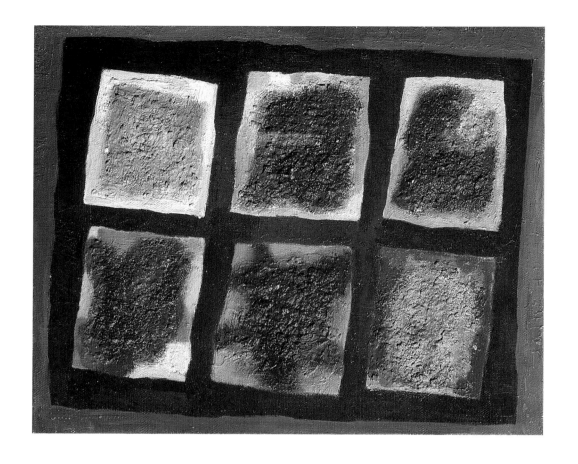

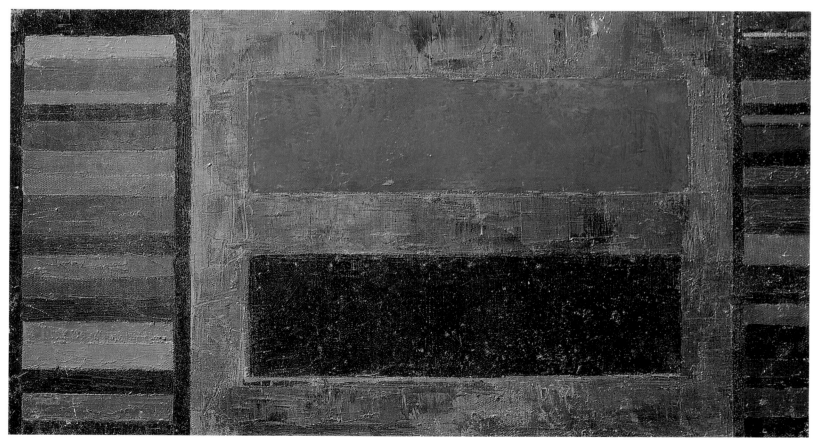

Composition. Windows. 1986
Oil and mixed media on canvas. 33.1 x 40. Russ. Mus.

Composition. 1982
Oil on canvas. 36.5 x 66.5. Russ. Mus.

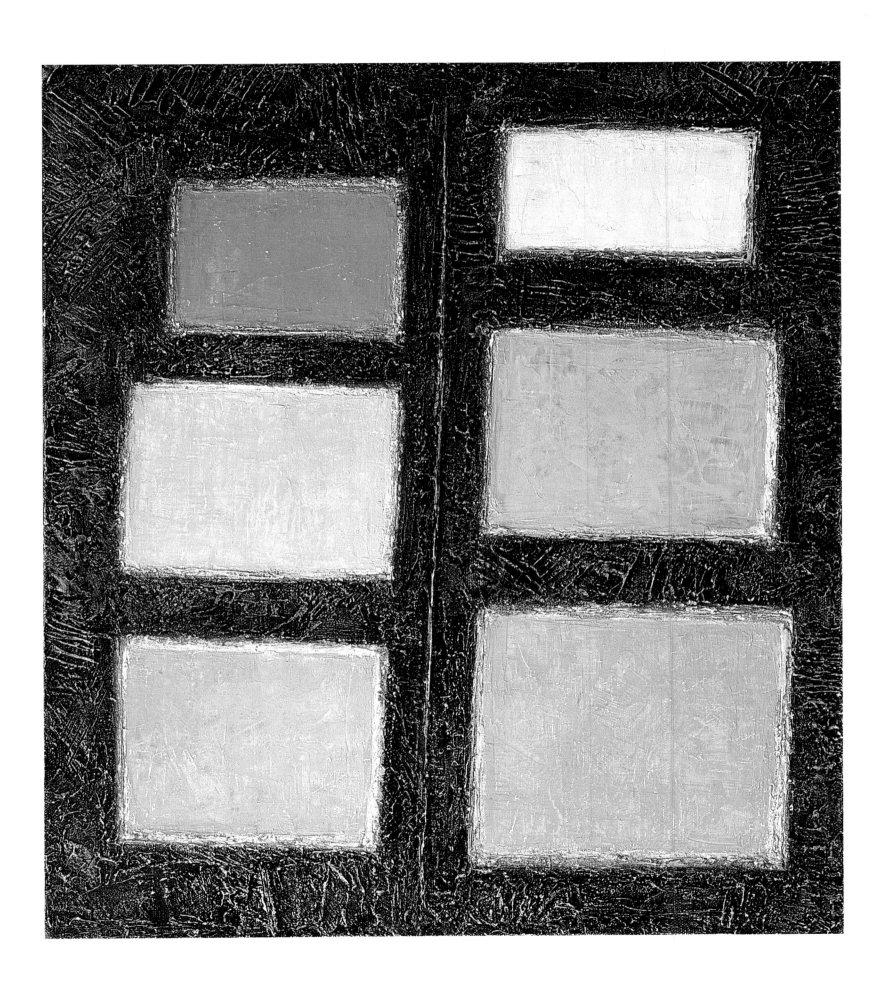

Composition. Windows. 1982
Oil on canvas. 60 x 54.5. Russ. Mus.

Stream. 1979
Charcoal pencil on paper. 27.2 x 34.9. Russ. Mus.

Untitled. 1988
Charcoal pencil on paper. 14.4 x 20.3

Large Calendar. 1992
Mixed media, papier-mâché, collage and tempera on canvas. 111 x 111

White Version. 1989
Oil on canvas. 111 x 128

Landscape with Walkers and an Angel. 1977
Mixed media on canvas. 78 x 73. Russ. Mus.

Fragments. 1990
Oil on canvas. 85 x 100

Composition. 1976
Oil on canvas. 84.5 x 79

anatoly GALBRAIKH

*The imminent death of abstractionism has already been predicted –
and in vain. Although it only assumed form as a separate artistic
movement in the early twentieth century, abstraction existed long
before, in man's perception of the world, and will exist in one form or
another for as long as humanity exists.*

Antiquity. 2000
Oil on canvas. 100 x 100

Oriental Motif. 1999
Oil on canvas. 100 x 85. Russ. Mus.

Stravinsky – Suite. 1999
Oil on canvas. 145 x 120

djaid **DJEMAL**

The abstract form of painting is, for me, the logical development of the preceding accumulation of painterly styles. A form of creative directions. For me, it is a form of thinking. The immobile in the mobile. The matter is transparent in its infiniteness.

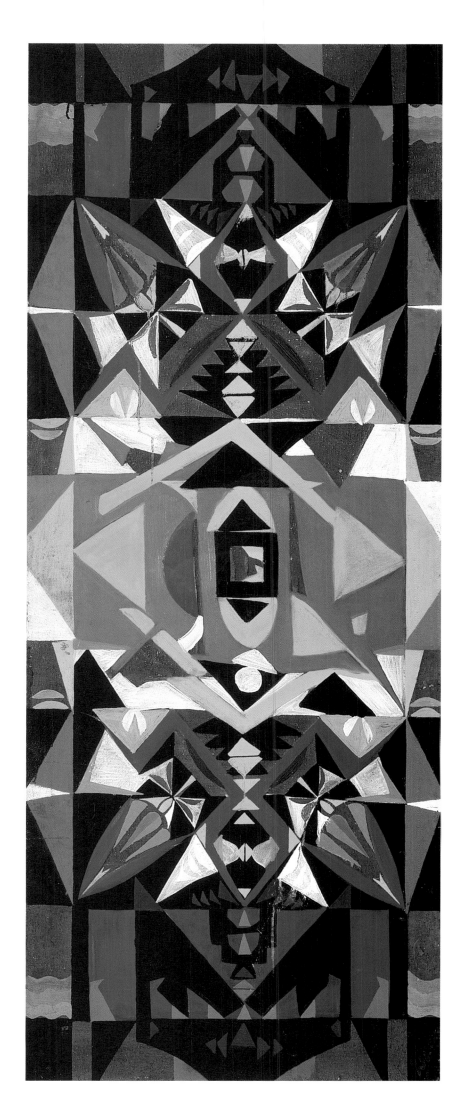

Castle in the Hills
Levkas and oil on fibreboard. 145.5 x 58.5. Russ. Mus.

alexei CHISTYAKOV

Abstraction is unrecognised reality.

The Birds Fly Away South and the Flowers Remain. 1991
Oil on canvas. 149 x 199

sergei **SHUTOV**

Videofeedback abstract images bear a close relationship to Jackson Pollock's method of constructing space, the self-organisation of colour and composition and the meditative demonstration of the life of physical processes and the interrelations of electrons – abstract from anthropocentric positions and profoundly logical from the point of view of heroes of display, light and time and the unity of the opposit-ions of chaos and cosmos.

Silver Wall – Midnight. 1984
Mixed media on canvas. 97.3 x 90.3. Russ. Mus.

yevgeny **DOBROVINSKY**

Absorbing the seen into itself, calligraphy can turn into a memory of a landscape or, alternatively, into a distinct structural sign. If one is to speak of calligraphy as a form of abstraction, then abstraction is regarded here as an emblematic direction. A form born of a sign.

Letra Incognita No. 768. 1988
Coloured ink, black ink, brush and reed quill on steeped paper
73.9 x 104.9. Russ. Mus.

Landscape No. 785. 1988
Coloured ink, black ink, brush and reed quill on steeped paper
73.8 x 104.8. Russ. Mus.

The expression of artistic tongue and the realisation of the narrative on the plane are what is correct and eternal in art.

Composition. 1988
Oil on canvas. 66 x 96. Yevgeny Nutovich collection, Moscow

Composition. 1987–88
Mixed media on cardboard. 82 x 110. Yevgeny Nutovich collection, Moscow

victor ANDREYEV

Abstractionism is extremely intelligible, emotional and veritable art. It could probably be taught at drawing lessons in high schools. It is living, "cutting-edge" art – free form-creation.

It is such hard work, dialogue, an absorbing meeting with oneself in the field of an abstract picture.

The path of the contemplative absurd, where there are reason and intelligence, which I do not love, is replaced by attention and perceptibility, even heightened perceptibility, towards all that is happening around and inside one.

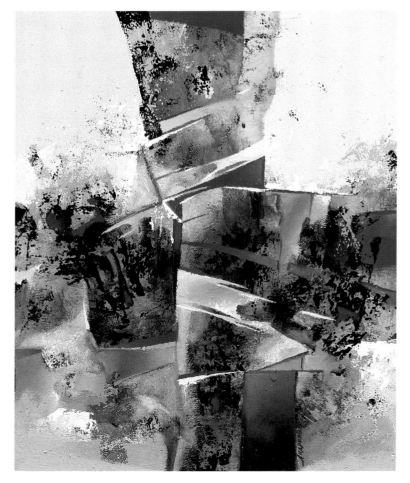

Composition. 2000
Oil on canvas. 70 x 60

Composition. 2000
Oil on canvas. 60 x 40

giya **EDZGVERADZE**

I attempt to investigate the interval between the rational and the humane, on the border of the idea and the matter. I attempt to create a line, on one side of which the subjective would be situated and, on the other, the external. In one case, my pictures are the traces remaining from splashes of pure energy created by concrete phenomena. In the other, they are ideas reduced to a graphic scheme (spatial formulae).

Noise in the Heart. 1986
Oil and sand on canvas. 80 x 60. Tatyana and Natalia Kolodzei collection, Moscow

valery **EISENBERG**

Why do I produce works in an abstract style? I am concerned above all with form. An exact form permits the maximum expression of what I want. Form is structure. Structure is, in essence, abstraction. Spots, lines and colour are the first to be seen with the eyes in any work of any direction of visual art. When I make pictures, objects, installations or performances, I am therefore above all concerned with patches, lines and colour.

Black Mirror. 1990
Oil and tempera on wood. 70.2 x 70.2; 70.2 x 70.2 x 8. Russ. Mus.

Blue Expanse. 1988
Oil on canvas. 90 x 100. Yevgeny Nutovich collection, Moscow

ilya **ZAUTASHVILI**

I follow my inner feelings, like an independent individuum. The creative element is materialised in colour and texture, as well as the possibility of form to invent and organise space, where these elements begin to interact on the surface of the plane. The artist only has to think about uniting the absolute quality with his imagination and experience.

Black and Blue. 1988
Oil on canvas. 110 x 110. Tatyana and Natalia Kolodzei collection, Moscow

alyona **KIRTSOVA**

Billiard I. 1982
Oil on canvas. 41 x 160

Billiard II. 1989
Oil on canvas. 50 x 151

I remember how I first prised open my box of watercolour paints large in it on a white semi-gloss shone with the matt roughness of colour to destroy the exact game of outlined windows to tear them with the brush was impossible for me it remained only to observe it was still possible to dribble a finger and touch from the edge and sniff so yellow light smell slightly bitter in the mouth there appeared a brass taste while ochre smelt like hot summer dust suddenly battered by rain once as an old woman washing in the village a floor splashed water onto the white-hot stone and suddenly the head reeled a familiar smell although I know that the Russian stove is white but coloured ochre since then in the imagination a cold grey this washed the smell and warm generally kindred something like a mother or bread over forty years of course everything in the memory could misrelate but to me the blues always smelt of poison or medicine from them was born a sharp subtle sound all the reds were tried since they never attracted any more too much blood the greens created joy everything all without exception even those that sailed away into the blue from them drawn towards the orange browns back and created and on the fingers and in the nose something like the sensation of palpitating naturalness yet white with black did not show and only long after saw more with my mind than the eye the shining of black and the abyss of white my doctors homeopathics and Freudists and now we discover the root of evil in my family everything was resolved spontaneously we go to a little mite's birthday party there is no present here is a new box of watercolours a few patches scratch with the nail I howled and then aren't you sorry no not sorry although shame no words at the birthday party we ate white cake the birthday boy with his brutal brush at the moment my treasures destroyed everything turning into the horridest fuse perhaps in me was born a painter after all in order to paint and not sniff otherwise before you manage to look round they are always given away to someone else. ("Paints", Memorial Plaques, 1998)

Large Box. 1988
Mixed media on wood, plaster and glass. 116 x 41 x 10. Russ. Mus.

y u r y **ALBERT**

My work is similar to Yulikov's pictures – white relief surface, not saying anything to the normal viewer. When I exhibited such works for the first time in the late 1980s, I never accompanied them with explanations – the viewers truly regarded them as abstractions.
Unlike Yulikov's works, mine contain a hidden message. If a blind viewer touches the picture, he or she can read the following inscription in Braille – "I am not Sasha Yulikov."

I Am Not Sasha Yulikov.
From the *Elite-Democratic Art – Painting for the Blind* Series. 1988
Enamel on wood-shavings plate. 122 x 201.5. Russ. Mus.

d m i t r y **LION**

Graphic art as part of art is the visible in the invisible, the known in the unknown, the finite in the infinite, the material in the spiritual and the concrete in the abstract.

The universe. The universe of white. The white world. The density of white. White is not merely emptiness. It is the density of the absent, immaterial density – the density of the spirit.

Parable of the Burnt Offering. 1990
Indian ink, brush and quill on paper. 61.3 x 86. Russ. Mus.

Fettered. 1986
Indian ink and quill on paper. 61.1 x 86.2. Russ. Mus.

vladimir **MARTYNOV**

In the passionate silence of its "unknowing knowledge", someone grasps the internal, in the "secret light" of the void buried in the void, the limit of existence and, consequently, the absolute value of life.

Approaching Chaos. 1989
Graphite pencil on paper. 83.2 x 58.2. Russ. Mus.

Geomancy. 1990
Graphite pencil on paper. 83.1 x 59. Russ. Mus.

Heaven and Earth. 1991
Lithograph. Image: 61.4 x 45.8; sheet: 82.9 x 61. Russ. Mus.

genrikh **ELINSON**

When preparing for an exhibition, I try to create one work from many. I look to see whether the sum total of works creates the sensation of chaos or balance.

Composition No. 26. 1982
Wax pencil, gold, bronze and quill on paper. 76.3 x 56.6. Russ. Mus.

kirill **PROZOROVSKY**

In his oeuvre, Kirill Prozorovsky-Remennikov attempted an original and, perhaps, logical combination of ancient Oriental wisdom imbibing the experience of thousands of generations and the diversity of modern life and philosophical quests, offering painterly and plastic resolutions of the philosophical problems of existence. (V. P.)

Internment of Hunnu. 1985
Mixed media and collage on canvas. 110 x 82. Yevgeny Nutovich collection, Moscow

victor **UMNOV**

I first took up abstract art in 1982, after I began to employ my own verbal texts as themes and the content of my plastic works. I do not consider myself either a Minimalist or a Suprematist. Initially, operating with the means of abstract construction, I followed the path of creating works in the spirit of abstract symbolism. Then, intensifying my visual drama and recording the free emotional reaction to the plastic lie of verbal logoforms, I approached the style of the impulsive abstract gesture.

Opposite (Yin–Yang) No. 42. 1983–88
From the *Opposites (Yin–Yang)* cycle
Oil on canvas. 100 x 100. Russ. Mus.

Opposite (Yin–Yang) No. 7. 1983–88
From the *Opposites (Yin–Yang)* cycle
Oil on canvas. 100 x 100. Russ. Mus.

Opposite (Yin–Yang) No. 17. 1983–88
From the *Opposites (Yin–Yang)* cycle
Oil on canvas. 100 x 100

Opposite (Yin–Yang) No. 9. 1983–88
From the *Opposites (Yin–Yang)* cycle
Oil on canvas. 100 x 100

andrei POZDEYEV

No canons exist for me. The canon is a living, universal language. Different languages for different times. A canon should be mobile. An artist should not elevate his language into a habit, which might not then release the artist. I need constant injections in the form of new ideas and new moves. A wider range of the artistic language offers a prospect for the consequent development of our art.

Composition I. 1984
Oil on canvas. 140 x 140

Composition. 1986
Oil on canvas. 89.5 x 94.5

Opus I. 1984
Oil on canvas. 65 x 60

Assumption. 1986
Oil on canvas . 140 x 119. Tret. Gal.

boris **BICH**

My concept is to displace the concepts of the viewer's positive and negative perception, for I believe that the positive, a purely spontaneous perception of the picture, is impossible today. Modern painting is now an intellectual game only accessible to the preprepared viewer.

Dialogue with Kazimir Malevich. 2000
Acrylic on canvas. 90 x 80

Geomed-5 (Geometric Medium). 1984
Tempera on canvas. 130.5 x 120. Russ. Mus.

gleb BOGOMOLOV

I do not lock the door of my heart...

Composition. 1984
Indian ink, nitro enamel and aluminium with varnish on paper. 58.8 x 61.3. Russ. Mus.

Cataklizmodius No. 3. 1984
Indian ink, quill, nitro enamel aluminium with varnish and stencilling on paper. 45.7 x 67.9. Russ. Mus.

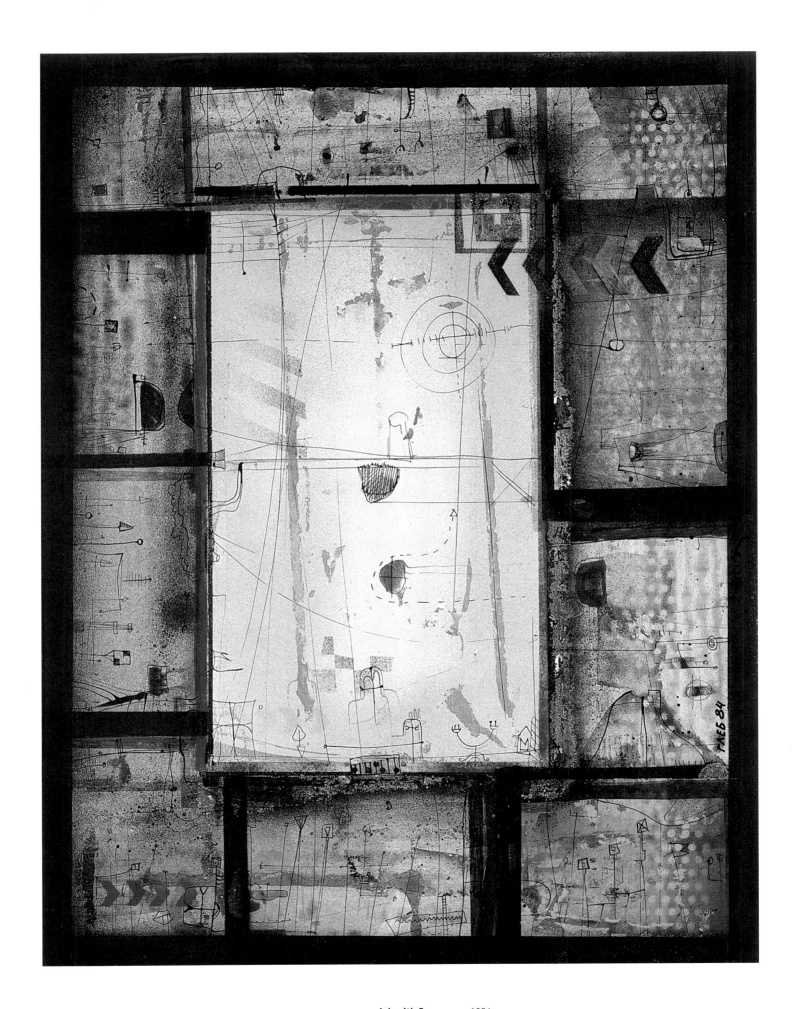

Ark with Seascapes. 1984
Indiank ink, nitro enamel and aluminium with varnish on paper. 65 x 49.5. Russ. Mus.

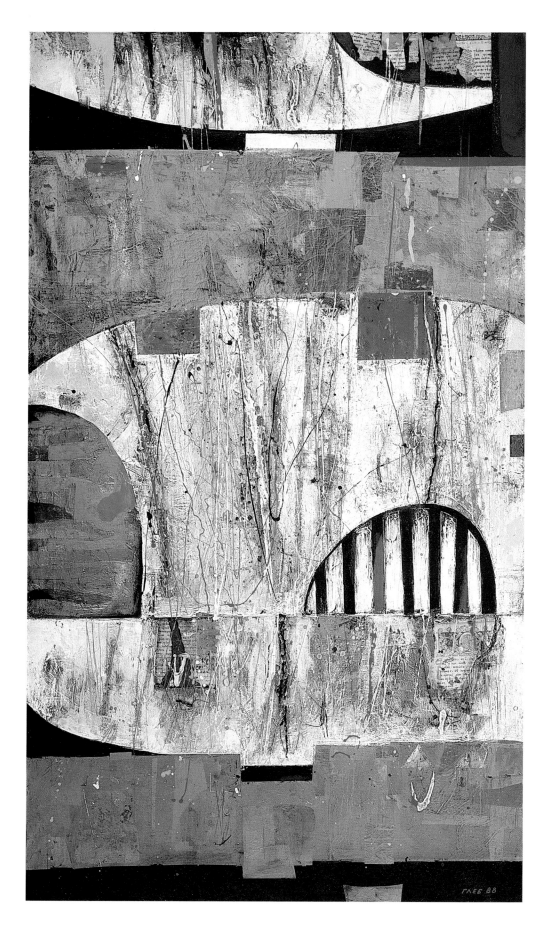

Space behind the Madonna. 1988
Mixed media on canvas. 195 x 110. Russ. Mus.

Composition in Red. 1984
Oil on canvas. 52.5 x 111. Zimmerli Museum, Rutgers University, USA

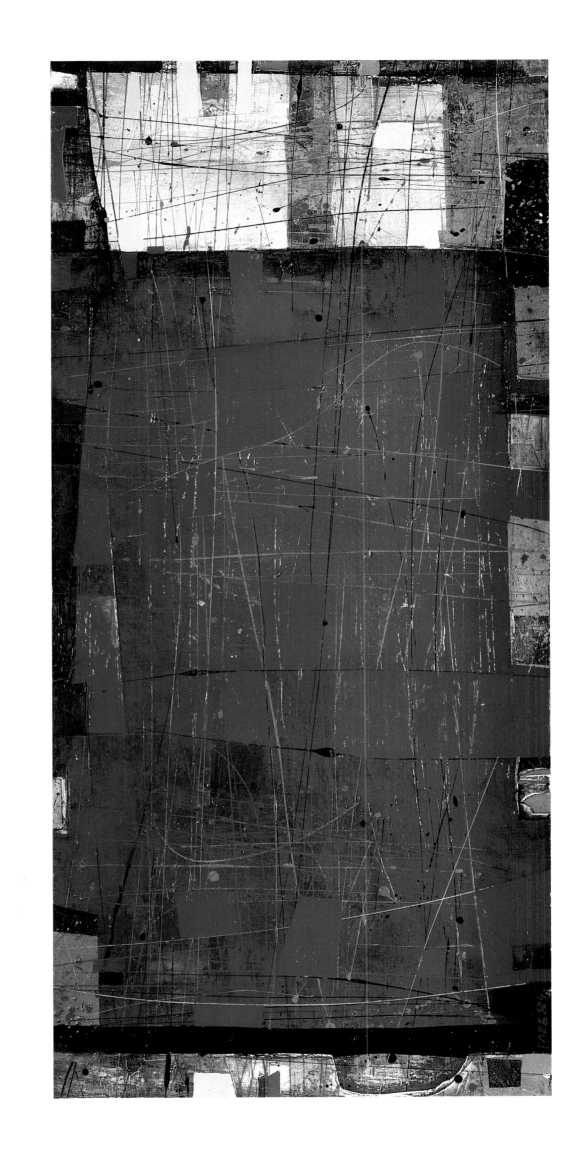

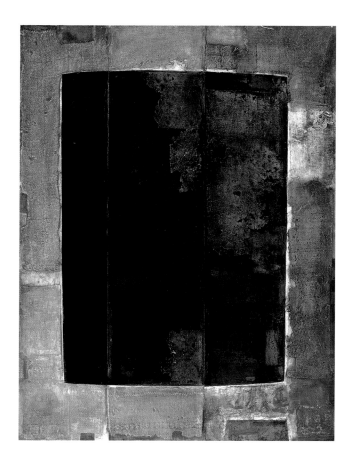

Op. 910. Ark. 2000
Mixed media on canvas. 195 x 145

Op. 915. Shroud. 2000
Mixed media on canvas. 195 x 145. Russ. Mus.

Op. 913. Shroud. 2000
Mixed media on canvas. 195 x 145

boris **MESSERER**

The appearance of a whole series of etchings by Boris Messerer entitled Non-Objective Compositions *coincided in time with the first major exhibitions of the pioneers of Russian non-objective art – Malevich and Kandinsky. Messerer naturally continued the traditions of the Russian non-objectivists. The artist's large sheets (a special easel had to be designed for their printing), however, also retain a genetic link with the artist's theatrical designs, in which handicraft and technique are just as important as decorativity. (Y. D.)*

Composition No. 4. 1984
Mixed media on etching. Image: 64.4 x 48.4; sheet: 79.5 x 59. Russ. Mus.

Composition No. 1. 1984
Mixed media on etching. Image: 64.4 x 48.9; sheet: 77.5 x 58.6. Russ. Mus.

Non-Objective Composition No. 2. 1990
Mixed media on etching. Image: 59.5 x 49.5; sheet: 71.7 x 57.8. Russ. Mus.

zhirair POLADIAN

*I would call my abstract painting "abstract realism".
It is based on realistic sensations and feelings expressed in a non-concrete (abstract) way with an invariable musical ring.
Abstractionism, for me, is the conveyance of the realistic "sound" of nature, like in music.*

Nerve. 2000
Oil on cardboard. 30.5 x 61. Russ. Mus.

Autumn. 1994
Oil on canvas. 76 x 76. Russ. Mus.

Night. 1985. Diptych
Oil on canvas. 76 x 121.3. Russ. Mus.

elena **KELLER**

The classical line is essential and powerful in all works, including abstract compositions.

Milky Way. 1996
Oil on canvas. 120 x 100 x 7. Russ. Mus.

Memory of Victims of Terror. 1988. Left volet of triptych
Oil on canvas. 150 x 130. Tret. Gal.

yury **TRIZNA**

Abstract forms are not typical of Yury Trizna, an artist who more highly rates direct impressions from life. The appearance of a sheet with a non-objective composition in 1989, however, was extremely symptomatic. The artistic interpretation of the political realities of those years demanded a less realistic tongue, while acquaintance with modern European art guided the direction of his quests. (Y. D.)

Disconnection. 1989
Monotype. Image: 50 x 62.2; sheet: 54 x 72.9. Russ. Mus.

valentina **BAKHCHEVAN**

The majority of my works are deliberately "taciturn". There is virtually no action in them. The compositions are built on fluid, smooth rhythms. For all its multiple tones, colour has the dominating one.

Untitled. 1989
Oil on canvas. 310 x 210. Marat Gelman Gallery, Moscow

Untitled. 1989
Oil on canvas. 306 x 201. Marat Gelman Gallery, Moscow

alexander **BANDZELADZE**

I first officially exhibited my abstract paintings in 1986. Recently, the democratic process has burst its banks and gushed in a turbid stream reminiscent of anarchy. The avant-garde is tossed in the whirlpool of "talents" aspiring towards fame... Yet again I am faced with the question – where am I?

Untitled. 1987
Oil on canvas. 141.2 x 130. Tatyana and Natalia Kolodzei collection, Moscow

luka **LASAREISHVILI**

What I do can be explained by the following sentences: "A white curt-ain covers the window and outside the window is the external world. Although I do not see the external world, I know that it is there." I feel that it is or might be there. And when I observe this, the process of painting begins. Each work for me today is an absolute minimal beginning. Because everything lies in the beginning...

Wind of my Soul. 1987
Oil on canvas and paper. 89.5 x 109.5. Tatyana and Natalia Kolodzei collection, Moscow

m i k h a i l **KAZAKOV**

In the 1950s, Mikhail Kazakov studied the Russian avant-garde and came to an understanding of plastic space as the basic factor of fine art. He wrote that consciousness was the source of the energy of internal work. The manifestation in the outside – the form (Andrei Yaroshevich, student of the artist).

Composition
Oil on wood-fibre plate. 68.5 x 59.5

victor NIKOLAEV

I first took up abstract art in the early 1970s. Established works appeared ten years later. The Zen Buddhist orientation of interior, manual painting completely satisfied me, not evoking the desire to follow topical movements in modern culture. Modernity naturally invaded the space of spontaneous structure-formation. Various periods passed, yet I retained my loyalty to the spontaneous interior process almost to the present time. I have regularly, though less often, engaged in abstraction in recent years (red period). Conceptual projects are increasingly captivating. I work from photographs and plotters, employing an abstract, calligraphic gesture.

Spontaneous **Series. Sheet No. 2.** 1987
Tempera and polyvinyl acetate emulsion on paper. 59.8 x 48

Spontaneous **Series. Sheet No. 4.** 1989
Tempera and polyvinyl acetate emulsion on paper. 59.8 x 47.1

Spontaneous **Series. Sheet No. 3.** 1987
Tempera and polyvinyl acetate emulsion on paper. 58.9 x 48.7

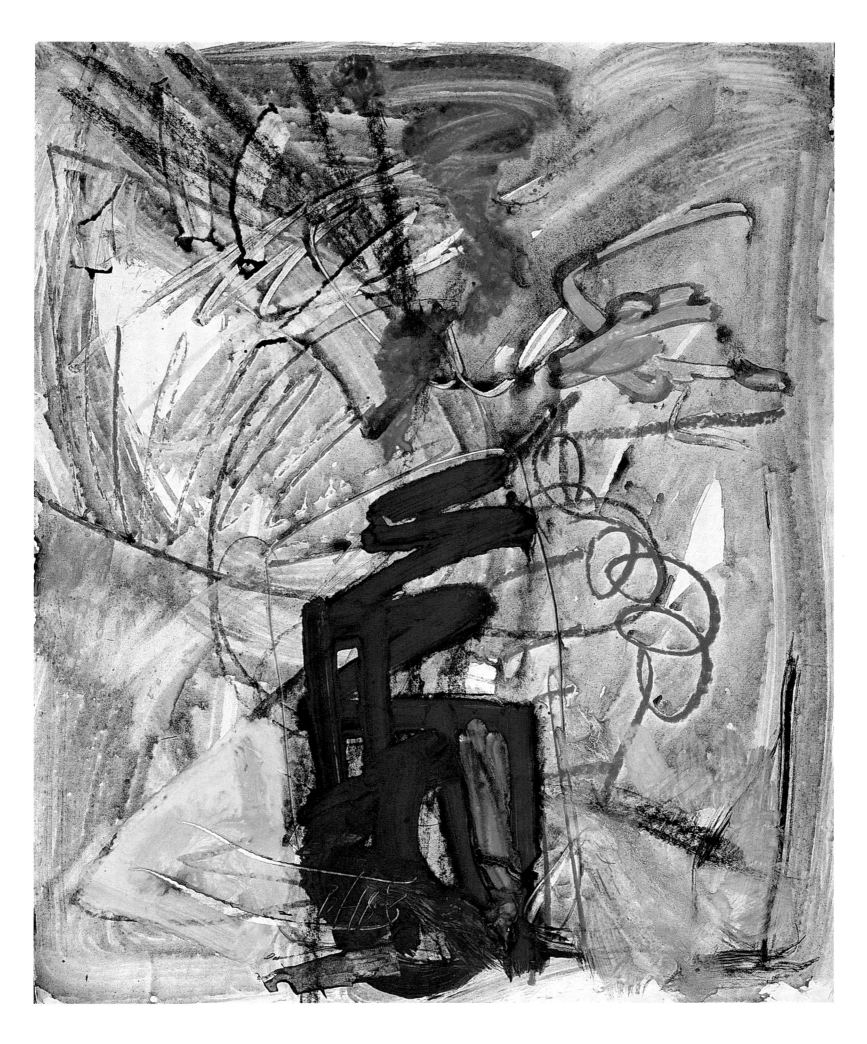

***Spontaneous* Series. Sheet No. 1.** 1987
Tempera and polyvinyl acetate emulsion on paper. 59.8 x 48.7

felix **VOLOSENKOV**

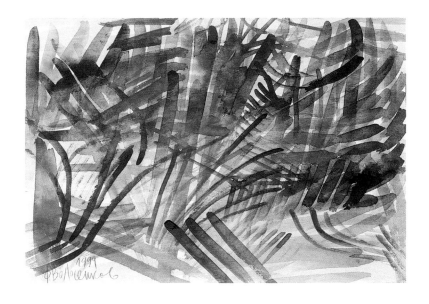

The creation of a work of abstract art is based on the aspiration to approach a "Platonic" idea hanging in the "air", after its realistic incarnations. The closer one is to the idea, the less reality there is. Although the reality of the material from which the work is made does not provide the possibility of achieving an ideal, various means of transforming reality, which can co-exist in the one work, are present in each work.

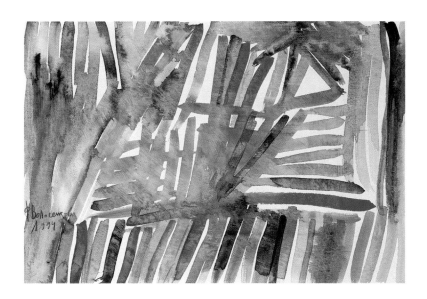

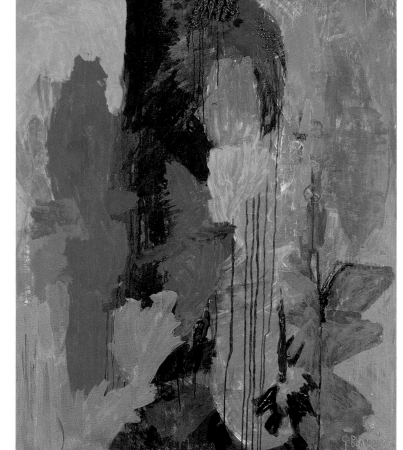

Composition in Dark Tones. Japan in a Garden. No. 3. 1994
Watercolours and ink on paper. 43.5 x 61. Russ. Mus.

Composition. Japan in a Garden. No. 2. 1994
Watercolours, ink and scratching on paper. 43.1 x 61. Russ. Mus.

"Who Are We?" 1988
Left volet of *Vision of the God Volos in the Form of a Multi-Scaled Triptych*
Mixed media on canvas. 200 x 150. Dimensions with frame: 206.5 x 156.5. Russ. Mus.

"Where Have We Come From?" 1988
Central volet of *Vision of the God Volos in the Form of a Multi-Scaled Triptych*
Mixed media on canvas. 200 x 149.5. Dimensions with frame: 206.5 x 157. Russ. Mus.

"Where Is Our Home?" 1988
Right volet of *Vision of the God Volos in the Form of a Multi-Scaled Triptych*
Mixed media on canvas. 200 x 150. Dimensions with frame: 207 x 157. Russ. Mus.

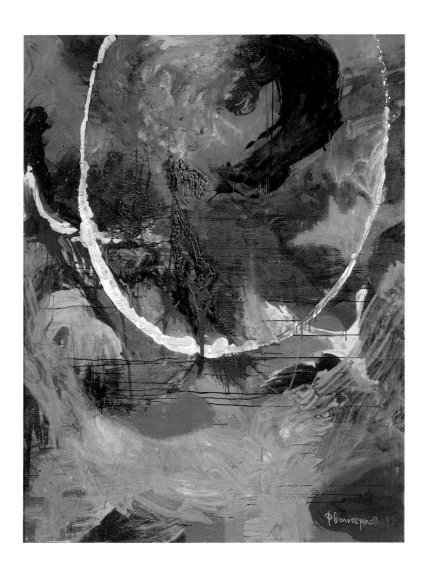

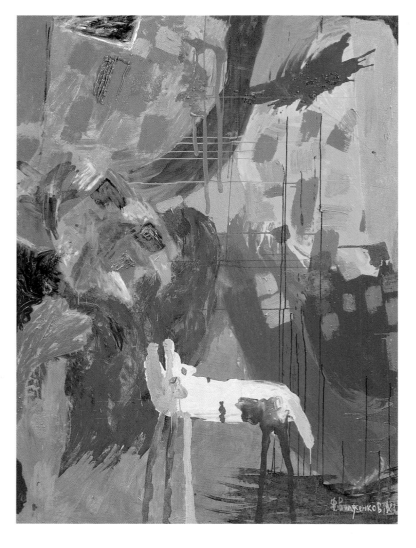

FELIX VOLOSENKOV

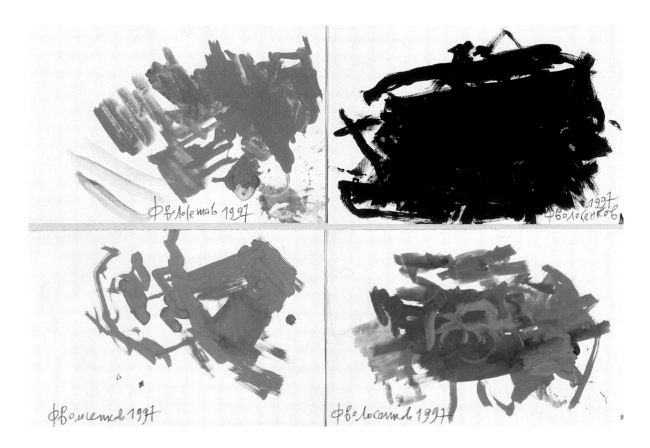

**From the *Reply to Beuys* Series.
Four Sheets.** 1997
Gouache, tempera and watercolours on paper.
22.2 x 32.2. Russ. Mus.

Vision of the God Volos in This Form. 1996
Mixed media on canvas. 102 x 143.
Russ. Mus

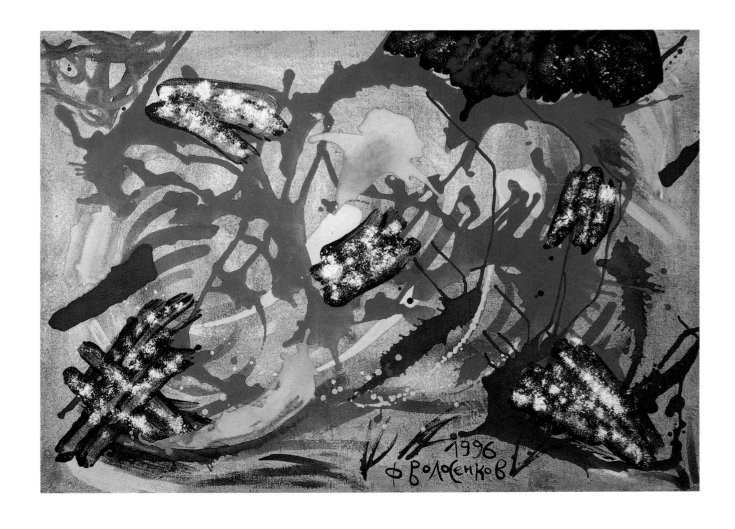

Vision of the God Volos in Three Persons (I). 1996. Double-sided composition
Mixed media on canvas mounted on fibreboard. 124 x 32

Vision of the God Volos in Three Persons (II). 1996. Double-sided composition
Mixed media on canvas mounted on fibreboard. 124 x 32

Vision of the God Volos in Three Persons (III). 1996. Double-sided composition
Mixed media on canvas mounted on fibreboard. 124 x 32

Metamorphoses of the God Volos. 2000
Coloured wood. 95 x 29 x 21

Vision of the God Volos in the Form of a Portrait of Dmitrenko. 1989
Double-sided composition. Side 1
Mixed media on fibreboard. 125 x 79; 125 x 79 x 26

Vision of the God Volos in the Form of a Portrait of Dmitrenko. 1989
Double-sided composition. Side 2
Mixed media on fibreboard. 125 x 79; 125 x 79 x 26

pavel **KERESTEI**

Composition. 1989
Oil on canvas. 145 x 140. Marat Gelman Gallery, Moscow

Composition. 1989
Oil on canvas. 145 x 140. Marat Gelman Gallery, Moscow

Abstinence. 1989
Oil and acrylic on canvas. 300 x 200. Russ. Mus.

vitaly **STESIN**

Abstract art is the greatest marvel of the twentieth century. Only it can offer hope and answers. It harbours the shrewd secret of all sciences and religions of everything visible and invisible – the secret of all symbolics, the centre of all knowledge and information.

Questions and Answers II. 1988–2000
Oil on canvas. 59 x 79

Questions and Answers I. 1988–2000
Oil on canvas. 58.5 x 78

victor **KAZARIN**

It is only one step from Symbolism to abstraction. But when I took it, the great secret of painting was revealed to me – the psychology of colour, rhythm, composition, texture and so forth. Malevich opened my eyes to much...

Sailing Ship. 1988
Oil on canvas. 90 x 95. Tret. Gal.

yevgeny **GOR**

Victim. 1988
Oil on canvas. 95 x 148

Pascal. 1988
Oil on canvas. 148 x 95. Russ. Mus.

A mobile painterly sign originally arose on the canvas as an emotional reaction to a concrete subject, sensation and experience. Several ideas, "transparent motifs", were gradually sewn and took root in the consciousness. Arranging into a single connected series, they defined the form and material of the new works. Pascal's "double infinity", various strains of the "tree of life", "overturned trees" and the "tree of sefirot" are all joined by the theme of infinity and offer their own systems of symbols, spatial structures and materials. Crude aggressive materiality, emptiness and transparency, ideal surfaces and constructions become the means of expression, while the theme of the statement is the clash of the physical with the metaphysical, and the finite and limited with the infinite.

Overturned Tree. 2000. Object
Polished aluminium, wood, fabric, string and stone. 470 x 102

Emanation. Triptych. Volet I. 1996
Acrylic and plywood, lace and wood. 190 x 25. Russ. Mus.

index of artists represented by works reproduced in the publication

Director of the Russian Museum
Vladimir Gusyev

Editor-in-Chief
Yevgenia Petrova

Concept *Joseph Kiblitsky* and *Yevgenia Petrova*
with input from *Larisa Kashuk (Tret. Gal.), Alisa Lyubimova
(Russ. Mus.)* and *Olga Shikhireva (Russ. Mus.)*

Publisher
Joseph Kiblitsky

Introduction
Yevgenia Petrova

Authors of articles
*Olga Shikhireva, Jean-Claude Marcadé,
Maurice Tuchman, Alexander Borovsky,
Larisa Kashuk, Maria Sheinina (Terenia),
Alexei Loginov, Elena Ivanova*

Artistic design
Joseph Kiblitsky

Translation from the Russian
Kenneth MacInnes

Proofreader
Irina Tokareva

Coordination
Tatyana Melnik

Layout
Anastasia Smirnova

Assistants
*Kirill Kryukov
Anna Loseva*

Photography
*Vladimir Dorokhov, Valery Kyuner,
Sergei Petrov, Mark Skomorokh*

Compilation of catalogue:

Russian Museum, St Petersburg:
Painting, Objects
*Ekaterina Andreyeva, Lyubov Bolshakova,
Alexander Borovsky, Alisa Lyubimova,
Olga Shikhireva, Natalia Vasilyeva*

Engraving
*Yulia Demidenko, Ekaterina Klimova,
Galina Pavlova*

Drawing
*Victoria Belaya, Natalia Kozyreva, Tatyana Kukla,
Antonina Marochkina, Natalia Rumyantseva,
Lyudmila Vostretsova, Natalia Zvenigorodskaya*

Sculpture
*Olga Naumova, Lyubov Slavova, Marina Stekolnikova,
Olga Yakubovich, Ekaterina Yevseyeva*

Applied art
Elena Ivanova

Tretyakov Gallery, Moscow:
Larisa Kashuk

Exhibition catalogue publishing coordination
Alexander Kofman

© 2001, State Russian Museum, St Petersburg
© 2001, Palace Editions

ПИ № 2-4957
ISBN 5-93332-070-6 (Russia)
ISBN 3-935298-50-1 (International)

The State Russian Museum presents: Abstraction in Russia: XX Century.
Almanac, Edn. 17, Palace Editions, St Petersburg, 2001

Internet: http://www.rusmuseum.ru
E-mail: info@rusmuseum.ru

Printed in Italy by GRAFICART - Formia (Latina)
Bookbindery: TONTI - Napoli (ITALY)